THE PHOTOMONTAGES OF HANNAH HÖCH

ORGANIZED BY

MARIA MAKELA

PETER BOSWELL

ESSAYS BY

PETER BOSWELL

MARIA MAKELA

CAROLYN LANCHNER

CHRONOLOGY BY

KRISTIN MAKHOLM

WALKER ART CENTER

MINNEAPOLIS

A Note on the Term "Photomontage"

Throughout this book, we use the term *photomontage* rather than *collage* or *photocollage*. The term was associated with the German word *montieren* (to assemble, or fit), which the Berlin Dadaists used to describe their piecing together of photographic and typographic sources, usually cut from the printed mass media. They enjoyed the mechanical—and proletarian—connotations associated with the term and used it to distinguish their work from Cubist collages, or *papiers collés*, whose formalist abstraction they considered a dead end. For most of her life, Hannah Höch consistently used the term *photomontage* to describe her work, although early on she also used *Klebebild* (glued picture) or *Klebezeichnung* (glued drawing). Subsequent to the Dada period, the term *photomontage* has often come to have a more restricted meaning: a seamless, composite image achieved either by manipulating negatives in the darkroom or rephotographing a collage of photographs, techniques favored by such disparate artists as John Heartfield and the Russian Constructivists, on the one hand, and the Surrealists, on the other. Höch never engaged in such photographic artifice (other than in an occasional double-exposure self-portrait), preferring to accept the evidence of hand cutting over the creation of seamless illusion or the mass-production of images. In employing the term *photomontage*, we are, therefore, seeking to restore its original usage and to remain consistent with Hannah Höch's own language.

A Note on the Dating of Höch's Photomontages

Until the 1950s, Höch frequently did not date her photomontages at all, or did so only years after she made them, at times using ball-point pen (a post–World War II invention) to annotate pieces in the tremulous hand of her old age. These dates are therefore highly unreliable. In many cases, the works on which they are inscribed are composed of photographic reproductions that first appeared in the mass media only years later. Indeed, Höch was so uncertain of the dating of her work that she often crossed out or erased a date she had previously written on a photomontage and replaced it with another. In other instances, dates have been ascribed to works by owners or dealers based on the year in which they were first exhibited. Although we have been unable to resolve such issues entirely, we have nevertheless called attention here to the most glaring of these discrepancies. While the captions to the plates in this catalogue give the dates assigned to the works by Höch or their current owners, the essay texts and annotations frequently suggest alternative dates based on media sources, existing documentation, and stylistic and technical analysis. We hope that these notes will contribute to a more accurate dating of Höch's works in the future.

Copyright and Library of Congress Cataloging-in-Publication Data appear on the last printed page of this book.

DIRECTOR'S FOREWORD

WHILE HANNAH HÖCH'S importance as a member of the Berlin chapter of the international Dada movement has been acknowledged widely, within the last fifteen years or so a new generation of critics and historians, primarily feminist in orientation, has begun to underscore her individual achievements. Of particular importance in this regard have been the writings of Jula Dech, Hanne Bergius, and Ellen Maurer in Germany and Maud Lavin in the United States. Their work has laid the foundation for ours. This exhibition is the first comprehensive survey in the United States of Hannah Höch's most influential body of work, the photomontages. Höch, whose life spanned from 1889 to 1978, is an historical figure with a particularly contemporary voice. Her photomontages—composed of images lifted from the mass media and incisive in their detailing of the social construction of gender roles— speak directly to the concerns of many artists and scholars working today.

Professor Maria Makela, who approached us initially with the concept for this exhibition, was joined in her efforts by Peter Boswell, who, until his recent appointment as Andrew Heiskell Arts Director at the American Academy in Rome, was the Walker's associate curator for the visual arts. Their collective research has resulted in an exhibition and publication of unusual lucidity, elegance, and penetrating intelligence. The curators were propelled by two intertwining challenges: to trace the artist's incorporation of images from popular periodicals and to map the impact on her career of the cataclysmic political events that shaped Germany during the period 1918 to 1972. Marked by crushing defeats in two world wars, Germany was compelled to seek a moral as well as economic center after the Nazi period and the subsequent partitioning of the country during the cold-war era. Höch's career, unlike that of many of her artistic contemporaries who fled their homeland in the 1930s, was shaped by her decision to remain in Germany; her emotional and intellectual odyssey can be traced in the shifting images in, sources for, and methods of her photomontages.

In focusing on Höch's use of images appropriated from the mass media, the curators have been extremely diligent in documenting, often for the first time, the individual magazines, newspapers, and patternbooks for handicraft designs from which these images were taken. This approach yields new insights into Höch's own theoretical and stylistic evolution. One sees graphically how she moved from a specific political critique—in which the identity of individuals depicted in the photomontages is critical to their interpretation— to a more generalized sociological exploration, to an increasingly formalized and fantasy-driven approach beginning in the mid-1930s, when the transformation and, ultimately, obliteration of the images all but denied the significance of the original sources. The wealth of documentary materials preserved in the Hannah Höch Archive at the Berlinische Galerie—from daybooks and letters to ticket stubs—allowed the curators to connect the public and private events that shaped Höch's life and career.

In any such exhaustive enterprise, the product of several years' work on the part of the curators, the contributions of many collaborators must be acknowledged. First among these are the members of the Höch family, whose support and generosity have been of paramount importance: Hannah's sisters, Grete König and Marianne Carlberg, both of whom passed away during the organization of this exhibition; her nephew Peter Carlberg, niece Karin König, and niece Eva-Maria Rössner and husband, Heinrich—all of whom have been exceptionally generous in their hospitality and in permitting access to their artworks and related materials.

The exhibition would not have been possible without the participation of a host of private and institutional lenders of Höch's work. Special thanks must be extended to the Berlinische Galerie and its director, Jörn Merkert, whose enthusiastic support for this exhibition was critical. His colleagues Freya Mülhaupt and Katherina Hoffmann of the Graphische Sammlung generously shared both their time and their knowledge of Höch's work, while Maiken Schmidt expedited photography and helped with questions regarding the artist's designs for domestic handiwork. The staff of the Künstlerarchiv der Berlinischen Galerie could not have been more accommodating, and we are deeply grateful to Wolfgang Erler and Eva Züchner for their help. Despite deadlines that loomed as volume two of the invaluable documentation of the artist's life, *Hannah Höch: Eine Lebenscollage,* went to press, Ralf Burmeister and Eckhard Fürlus, archivists of the Hannah Höch Archive, patiently answered all questions regarding the Höch materials at the Berlinische Galerie. Without their assistance, this catalogue would have been greatly diminished.

Erna Haist of the Institut für Auslandsbeziehungen graciously adjusted the travel schedule of the museum's outstanding collection of Höch works to allow them to be included in the exhibition's full tour. Alexander Dückers, director of the Kupferstichkabinett, Staatliche Museen zu Berlin–Preußicher Kulturbesitz, made available his museum's full holdings of Höch photomontages; and Rainer Schoch of the Graphische Sammlung, Germanisches Nationalmuseum, Nuremberg, was kind enough to make available works on loan to his museum. Claudia Marquart and Katja Holzer at the Bankgesellschaft Berlin also have also been enormously helpful. Liselotte and Armin Orgel-Köhne have been extremely generous with materials generated through their close friendship with Hannah Höch. The early support of Louise Noun and of Gesche Poppe and her late husband, Siegfried, was as essential to ensuring the viability of the exhibition as their enthusiasm, hospitality, and intellectual curiosity were stimulating.

We are extremely delighted that our colleagues Glenn Lowry, director of the Museum of Modern Art, New York, and Graham Beal, director of the Los Angeles County Museum of Art, have made it possible for this exhibition to be seen at their museums. Carolyn Lanchner, curator of painting and sculpture at the Museum of Modern Art, New York, has written eloquently on Höch for this catalogue. Her advice, along with that, at the Los Angeles County Museum of Art, of Stephanie Barron, curator of twentieth-century art, and Timothy O. Benson, associate curator of the Rifkind Center for German Expressionist Studies, was instrumental in helping us bring form to this exhibition and catalogue.

An exhibition and publication of this ambition requires the faith of many funders. An early grant from the National Endowment for the Arts permitted essential research at the conceptual stages of this ambitious project. A keen commitment to scholarly pursuits, coupled with an abiding interest in Höch's art, led Lucia Woods Lindley to support this exhibition. Jo Carole and Ronald Lauder, devoted patrons of many art forms and institutions, were characteristically generous in helping us realize the catalogue in a manner that matches Höch's achievements. The efforts on our behalf of Nadine and Bill McGuire have been extraordinarily helpful; Nadine's tenure as a trustee of the Walker Art Center has been marked by an unusual intellectual and financial commitment.

Goldman, Sachs and Company, Dayton's Frango® Fund, Voyageur Companies, and the American Express Minnesota Philanthropic Program have all contributed essential financial support, for which I am particularly appreciative. We also are extremely grateful for the contributions made by Robert and Carrie Lehrman, and by the law offices of Aaron M. Levine, Washington, D.C.; Sybil Shainwald, New York; and Zimmerman and Reed, Minneapolis. Oskar Friedl and Angela Greiner were helpful in securing support from the German American Arts Foundation and the Goethe-Institut Chicago, respectively. Dietrich Papenfuß and the Alexander von Humboldt-Stiftung have helped defray the cost of photographic materials from German museums, libraries, and archives. Apple Computer, Inc., and the Agfa Division of Bayer Corporation have provided financial and in-kind support. The Maryland Institute, College of Art, also provided support through its faculty enrichment program for Professor Makela's research.

Peter Fritzsche, Atina Grossmann, Charles Haxthausen, Anton Kaes, Frank Trommler, and Joan Weinstein, participants in an advisory panel for the exhibition, provided incisive commentary which was of invaluable help to the curators; Griselda Pollock also was kind enough to contribute her insights. Jula Dech has offered her considerable expertise and resources in creating didactic materials relating to Höch's opus, *Cut with the Kitchen Knife.*

Valentine Plisnier has been generous in sharing her research on Höch's sources for the Ethnographic Museum series. Portions of the catalogue have benefited from the insights of Ralf Burmeister, Lou Cabeen, and Nancy Owen. Maud Lavin also has been helpful in providing advice regarding the exhibition and its related programs.

We have benefited as well from the assistance of the many commercial galleries that have aided us in locating works and resources. We would like to thank especially Inge and Florian Karsch of the Galerie Nierendorf, Berlin; Peter Barth and Herbert Remmert of Galerie Remmert und Barth, Düsseldorf; Viola Roehr-von Alvensleben of Galerie Alvensleben, Munich; Hendrik Berinson of Galerie Berinson, Berlin; Marcel Fleiss of Galerie 1900–2000, Paris; and Annely Juda of Annely Juda Fine Arts, London. Assistance in locating and supplying photographic sources for Höch's photomontages has been provided by Gabriele Toepser-Ziegert at the Institut für Zeitungsforschung, Bibliotheken der Stadt Dortmund; and William Hooper, archivist, Time, Inc., New York.

Rochelle Steiner, NEA curatorial/education intern for two years, has juggled the organizational demands of this project with grace, intelligence, and curiosity; her commitment to this often daunting project was unflagging, and optimism in the face of thousands of details, inspiring. We know she will be held in equally high esteem by her colleagues at the Saint Louis Art Museum as she assumes her new role as assistant curator of contemporary art there. Kristin Makholm, in the final stages, and Toby Kamps early on, have been instrumental in providing research support. Janet Jenkins has done her usual superb job of editing the catalogue with superhuman attention to both detail and style. Michelle Piranio ably coordinated the publication of the catalogue, and Laurie Haycock Makela and Santiago Piedrafita put in untold hours honing the design to perfection. Matthew Siegal has handled the complex task of coordinating loans and shipment of the artwork. Rhonda Loverude and Henrietta Dwyer have supplied essential secretarial assistance. The fundraising skills of Aaron Mack and Kathie DeShaw have been vital to securing the support necessary for the exhibition and catalogue to achieve their final forms. David Galligan, Mary Polta, and Howard Oransky have provided administrative guidance and support. Bruce Jenkins, John Killacky, and Karen Moss have contributed their efforts to related programming for the exhibition.

Last but not least, the unstinting support of Neal Benezra and Julie Yanson have allowed Maria Makela and Peter Boswell the time and emotional resources necessary to see such a project to its conclusion. In ways too countless to enumerate, they have been essential to the making of this exhibition, and I am as grateful to them as I am to their extraordinary spouses.

KATHY HALBREICH
DIRECTOR
WALKER ART CENTER

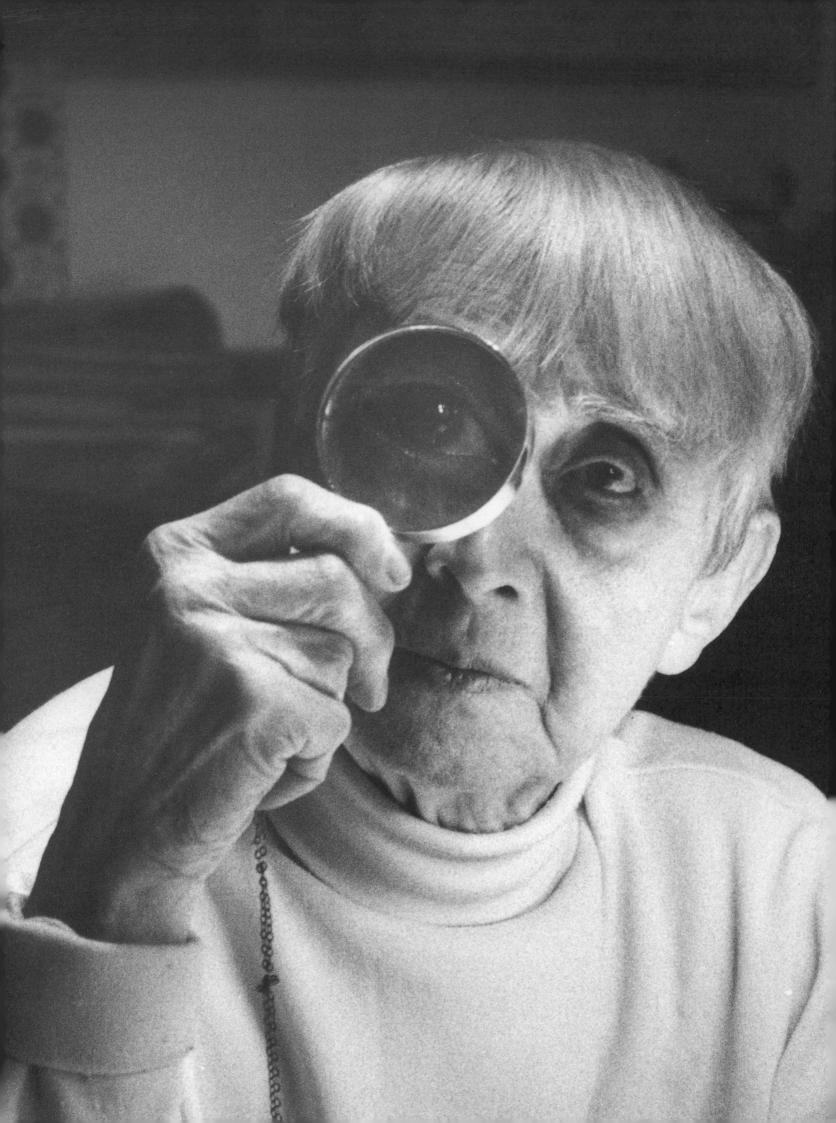

HANNAH HÖCH: THROUGH THE LOOKING GLASS

PETER BOSWELL

HANNAH HÖCH's lifelong obsession with photomontage has made her one of the most resilient and adventuresome media artists of our time. She worked in the medium for better than half a century—all the while using photographs cut from mass-media periodicals as the sources for her constructed images. Over the course of this career the work changed considerably, evolving from mordant social commentary to surrealist fantasy to outright abstraction. Yet despite the range and innovation she displayed across a sustained practice in the medium, Höch remains known primarily for the work she produced during a short span of time at the beginning of her artistic life, when she was the only woman among that group of artists who made up the legendary Dada circle in Berlin.[1] As a result of her association with such incendiary talents of the movement as Johannes Baader, George Grosz, Raoul Hausmann, John Heartfield, and Richard Huelsenbeck, Höch furthermore has been miscast as something of a Dada manqué—"a quiet girl from the little town of Gotha" whose "tiny voice would only have been drowned by the roars of her masculine colleagues."[2]

While the Dada period was clearly a formative moment in her career, Höch went on to chart a decidedly independent course in her work—one that eschewed the revolutionary bombast of her early contemporaries in favor of a more intimate exploration of the intersection between social force and private persona. From the first, Höch had been more attuned to the inner voice than to public proclamation. Her works, even when they deal with social issues, are endowed with an open-ended ambiguity that hardly could be more at odds with the exhortatory outrage of her fellow Dadaists in Berlin. In light of her subjectivity, her whimsy, her openness to fantasy, and her dedication to issues of artistic form, it is perhaps more appropriate, in the end, to link her with those colleagues with whom she herself expressed the greatest affinity—Kurt Schwitters, Hans Arp, Max Ernst—than with the Berlin Dadaists who actively marginalized her.[3]

History, for the most part, has followed the lead of Höch's Dada contemporaries in minimizing her role within the movement and, until recently, has given scant attention to her subsequent career. After years of virtual anonymity beyond the confines of Berlin, she did attain some commercial success in the 1960s; but it was only after a 1976 retrospective exhibition of her work in Paris and Berlin and her death in 1978 that she began to be accorded serious critical attention.[4] Since that time, a new generation of feminist critics and historians, first in Germany and then elsewhere, has focused its attentions on her elegant dissection of the representation of women in the mass media during the Weimar era. But even today, Höch's post-Weimar work has received only limited exposure and almost no critical scrutiny.

HÖCH AND BERLIN DADA
(1918–1922)

The near-exclusive association of Höch with Berlin Dada is rooted in two related causes: her early involvement with the development of photomontage (a medium that for many is synonymous with the movement) and her creation of a single, tour-de-force work—*Schnitt mit dem Küchenmesser Dada durch die letzte weimarer Bierbauchkulturepoche Deutschlands* (*Cut with the Kitchen Knife Dada through the Last Weimar Beer-Belly Cultural Epoch of Germany*, 1919–1920) (pl. 1)—which stands as a visual summa of Berlin Dada's exuberant condemnation of contemporaneous German society and its wholehearted immersion in the revolutionary chaos of post-Wilhelmine Germany.

Despite these notable contributions, it is clear that Höch's "masculine colleagues" of the Berlin Dada movement were little inclined to include her in their midst. Heartfield and Grosz are said to have vehemently opposed her inclusion in the celebrated First International Dada Fair of 1920 and yielded only when Hausmann, the indispensable "broadsword of Dada," threatened to boycott the event. Later, in their memoirs, Huelsenbeck, Grosz, and Hausmann mentioned her only in passing or omitted reference altogether—a neglect that is particularly onerous in Hausmann's case, given that he and Höch were lovers for

more than seven years and exerted a mutual influence on each other's work that is readily apparent. Walter Mehring, in his *Berlin Dada* (1959), had the courtesy to include a passage by Höch that recalled her involvement with the movement, but he had little to say about her himself. Hans Richter, in his 1964 *Dada: Art and Anti-Art,* was more considerate (he was the only one to note that Höch continued to work beyond the Dada period) but still patronizing, characterizing her as "a good girl" with "a slightly nun-like grace" and a "small, precise voice."[5] Although in a later account he praised Höch for her "conviction, talent, and courage," he hailed her above all for preserving the work of her Dada colleagues, which he then chided her for hoarding.[6]

Perhaps Höch's greatest sin in the eyes of her fellow Dadaists (and, at least until recently, of history) was her continued respect for the notion of "Art" and her persistence in looking at the world from a woman's perspective. In contrast to the anti–fine art pretensions of her colleagues, Höch continued to attend the School of the State Museum of Applied Arts throughout the critical Dada years (1918–1920) and to value tradition even as she participated in radical innovation—painting still lifes and landscapes as well as nonobjective abstractions, all of which were anathema to her revolutionary compatriots. Even her photomontages and collages consistently reveal her respect for purely formal concerns such as composition, color, and craft. Devoted to the visual, she showed little interest in proclaiming her revolutionary aspirations via written manifestos, the Dadaists' preferred form of self-expression; nor did she participate as more than an occasional supporting player in their readings or performances. In short, she was not "one of the boys" and on occasion didn't mind making that distinction clear. She lightly mocked her fellow Dadaists' flamboyant bravura in *Cut with the Kitchen Knife* by placing their heads on women's bodies and parodied their self-satisfied narcissism in *Da Dandy* (1919) (pl. 6).

Höch was also devoted to such unrevolutionary pursuits as domestic handicraft and fabric and fashion design. From 1916 to 1926 she worked three days a week for Ullstein Verlag, the largest publishing house in Berlin, producing handiwork patterns and writing articles on crafts for domestically oriented publications. Even before her breakup with Hausmann in 1922—by which time the fragile Berlin Dada movement had fallen victim to the vituperative bickering of its constituents—Höch had begun to meld the twin worlds of Dada and domesticity in photomontages that examined the equivocal status of women in post–World War I Germany. Her ambivalent response to the illustrated print-media's representation of Germany's widely publicized New Woman can be seen in such early photomontages as *Das schöne Mädchen* (*The Beautiful Girl*, 1919–1920) (pl. 9) and an untitled work from 1921 (pl. 11), and it even forms an important subtext to *Cut with the Kitchen Knife.* Once liberated from the daily presence of the redoubtable Hausmann, her photomontages from the 1920s focused almost exclusively on issues relating to the construction of women's identity and gender relationships, and did so with a detached irony that contrasts sharply with Berlin Dada's exuberant egotism.

These lines of inquiry had little resonance among the male Dadaists. After the dissolution of the movement, Höch had only intermittent contact with many of her erstwhile confreres, and years later she testified to their grudging demurral: "Thirty years ago, it was not very easy for a woman to impose herself as a modern artist in Germany. . . . Most of our male colleagues continued for a long time to look upon us as charming and gifted amateurs, denying us implicitly any real professional status."[7]

Photomontage and "High" Art: The Struggle Between Public and Private

(1922–1929)

Sexual bias and the internal jealousies of the Dada movement, however, are not the only circumstances that have kept Höch's work from the art-historical limelight. Several other factors, intrinsic to her production, also have contributed significantly: her prodigious, variegated, and sometimes disconcertingly uneven output in a variety of media, which makes it difficult to present a concise view of her artistic personality; and the complex interplay between public and private that permeates her photomontages, which confounds our historical expectations of the medium, shaped as they have been by the publicizing and proselytizing approaches of Berlin Dada, Russian Constructivism, and commercial advertising of the interwar period.

Although now best known for her photomontages, Höch also worked extensively in oil painting, watercolor, and gouache for the full length of her career. In all these media her boundless curiosity, enthusiasm, and willingness to experiment led her to work in an astonishing diversity of styles, often at the same time. During the years 1918–1922, for example, precisely at the time of her initial involvement with photomontage and Dada, Höch produced works that bear the imprint of a variety of influences: Orphism, Constructivism, Futurism, Pittura Metafisica, Expressionism, and Cubist papiers collés, as well as other branches of Dada, such as Ernst's and Picabia's merging of man, machine, and nature (see, for example, figs. 1–3 and pls. 12–15). This heterogeneity

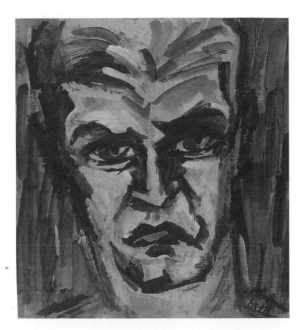

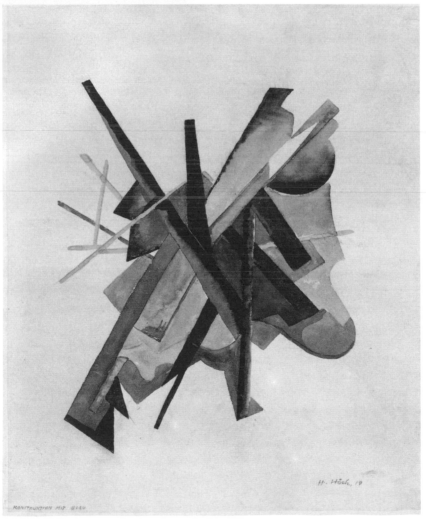

1. (opposite) *Mechanischer Garten* (*Mechanical Garden*), 1920, watercolor. Collection H. Marc Moyens, Alexandria, Virginia.

2. *Raoul Hausmann*, 1922, watercolor. Private collection. 3. *Konstruktion mit Blau* (*Construction with Blue*), 1919, watercolor. Germanisches Nationalmuseum, Nuremberg (on loan from private collection).

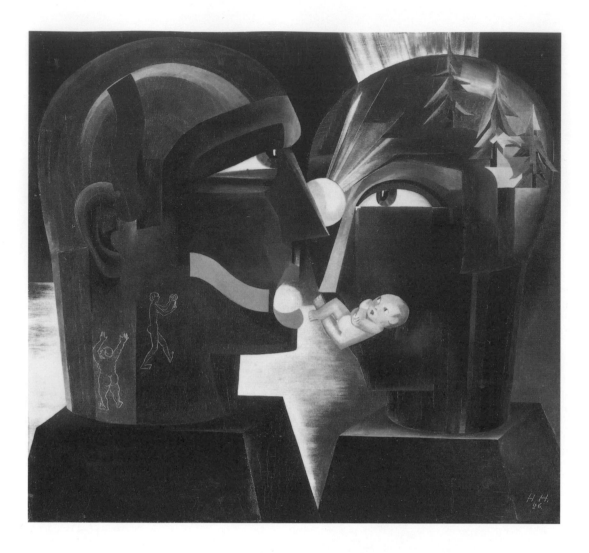

4. *Imaginäre Brücke* (*Imaginary Bridge*), also known as *Zwei Köpfe* (*Two Heads*), 1926, oil on canvas. Collection National Gallery of Australia, Canberra.

of style and medium, which persisted throughout her career, can make it tempting to dismiss Höch as a talented dilettante: an artistic butterfly who flitted from style to style, seemingly without discipline or intent.[8]

Even in the field of photomontage, where Höch's reputation principally and properly rests, the works are strikingly varied. During her fifty years of production she engaged a bewildering array of styles and subjects, ranging from her anarchically composed Dada creations of 1919–1922 to her intimate psychological portraits and gender examinations of the 1920s, the dark epic of her Ethnographic Museum series, her anti-Nazi parodies of the early 1930s, her full-blown adoption of Surrealism during the years of the Third Reich (which she maintained in various forms throughout the rest of her career), her espousal of non-objective abstraction in the 1940s and 1950s, and—ultimately—her reengagement of the female image and the symbolic portrait-form in the 1960s. The protean character of Höch's achievement makes her work resistant to categorization. But this versatility should not be read as inconstancy. With respect to her work in photomontage, in particular, it

becomes evident that it is rather the product of her obsession with the medium and its manifold possibilities. For Höch, as we shall see, the practice of photomontage was a voyage of exploration, a continuing journey into the new, the possible, the fantastic: a journey through the looking glass.

Despite the persistence and intensity of her engagement with photomontage, however, it is apparent that Höch initially was ambivalent about the medium's place within her creative output.[9] After displaying *Cut with the Kitchen Knife* and several other photomontages at the anarchic First International Dada Fair in Berlin in 1920, she did not publicly exhibit her photomontages again until almost a decade later when, presumably at the bidding of her friend László Moholy-Nagy, seventeen were shown in the landmark *Film und Foto* exhibition in Stuttgart in 1929. Throughout the 1920s, Höch exhibited extensively in group exhibitions throughout Germany, but she consistently represented herself through paintings, whether oils, watercolors, or gouaches. It appears, therefore, that much of the work for which she is now best known was created without the overt intention—or at least without the immediate intention—of being viewed publicly.

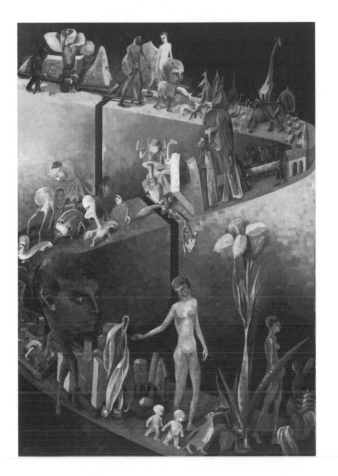

5. *Der Weg* (*The Path*), 1927, oil on canvas.
Collection Louise Rosenfield Noun, Des Moines, Iowa.

Höch's hesitance to exhibit her photomontages may have stemmed from her strong desire for public acceptance as an artist. Although she had painted watercolors since her youth, when she was finally permitted to leave her native Gotha to study art in Berlin, after years of tending to her younger siblings, she studied the applied rather than the fine arts. Her early work consisted primarily of drawings, watercolors, and linoleum prints; she did not produce her first oil painting until 1916, only two years before her discovery of photomontage.[10]

Painting had a legitimacy and an established iconography that the new medium of photomontage lacked. Indeed, the mass-media periodicals that Höch used as sources for her photomontages were considered vulgar and superficial by many, particularly among the intellectual and cultural elite. Accordingly, once Dada—with its clannish, self-curated exhibitions—vaporized as a movement, painting became her form of public expression. In keeping with its traditions, it became the vehicle for her most intimate autobiographical concerns as well as her most universal aspirations. Such paintings as *Das Paar (Selbst mit Raoul Hausmann)* (*The Couple [Self with Raoul Hausmann]*, c. 1920), *Frau und Saturn* (*Woman and Saturn*, 1922), and *Imaginäre Brücke*

(*Imaginary Bridge*, 1926) (fig. 4), for example, stem directly from her relationship with Hausmann and their disagreements over having children together.[11] At the opposite end of the spectrum are such symbolic paintings as *Vita Immortalis* (*Immortal Life*, 1924), *Die Treppe* (*The Staircase*, 1926), *Kubus* (*Cube*, 1926), *Der Weg* (*The Path*, 1927) (fig. 5), and *Der Zaun* (*The Fence*, 1927–1928), which, while they may display autobiographical references, aspire to more universal concerns as they engage such themes as the course of life, the interaction of male and female, and the communion of humanity and nature. With their metaphysical yearnings, these works fall fully within the German romantic tradition, an inheritance that the critic Hans Hildebrandt, a close friend of Höch's, acknowledged in his 1928 book *Die Frau als Künstlerin* (*The Woman as Artist*): "The urge toward the mysterious, the dreamlike, the magical, the ancient legacy of Germanic spirituality, is also found in the strange, striking creations of Hannah Höch, whose forms continually metamorphose before our very eyes."[12]

Photomontage, of course, had no such accepted tradition to rely on for legitimization. Höch consequently seems to have engaged in it primarily as a private passion after the dissolution of Dada. The sharp formal distinctions between her photomontages of the Dada period and those that followed—as well as distinctions in their subject matter—make it clear that the earlier pieces had been made for a particular audience, the Dada circle. She showed them publicly only in the First International Dada Fair;[13] and—for the only time in her career as a photomonteur—she supplemented many of the images, in proper Dada fashion, with text. Such works as *Cut with the Kitchen Knife, Dada-Rundschau* (*Dada Panorama*, 1919) (pl. 2), and *Dada-Tanz* (*Dada Ball*, 1922) (pl. 8) contain repeated references to the movement, not only in their titles but within the compositions themselves, which include such favored slogans as *Dada Siegt!* (Dada rules!) and *Liegen Sie Ihr Geld in dada an!* (Invest your money in Dada!). Höch's montaged works from this period typically feature centrifugal compositions and maintain the distinctive Dada emphasis on fracture and disjunction. Machine parts, particularly circular motifs such as gauges, gears, or automobile tires, which were common symbols of progress and modernity in Dada montages by Grosz, Hausmann, and Heartfield (figs. 6, 7), are also common to Höch's works of this period.

Höch's photomontages from after 1922 differ significantly in character from their Dada predecessors. They are smaller in size and simpler in composition, abandoning the centrifugal composition bleeding out to a blank ground that had typified such works as *The Beautiful Girl* and *Hochfinanz* (*High Finance*, 1923) (pl. 10). The compositions now have a strong rectilinear quality, reflecting Constructivist influence, and often feature either single images centered on a ground—particularly in portraits such as *Kinder* (*Children*) (pl. 32) or *Der Melancholiker* (*The Melancholic*) (pl. 33), both from 1925—or semi-narrative vignettes anchored by strips of colored papers that parallel the edges of the frame, as in *Die Kokette I* (*The Coquette I*, 1923–1925) (pl. 26) or *Liebe* (*Love*, c. 1926) (pl. 55). Höch used both colored paper and watercolor to enliven these works visually, creating either minimal settings for her figures, as in

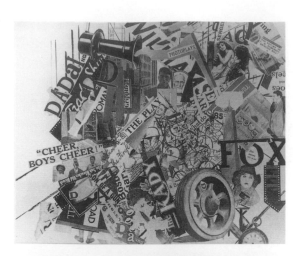

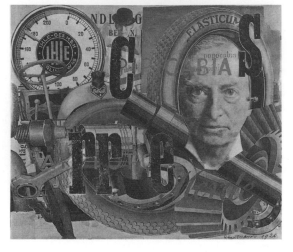

6. John Heartfield, *Leben und Treiben in Universal-City, 12 Uhr 5 mittags* (*Life and Times in Universal City at 12:05 Noon*), 1919, photomontage. Collection Akademie der Künste, Berlin. **7.** Raoul Hausmann, *Elasticum*, 1920, photomontage with gouache. Courtesy Galerie Berinson, Berlin.

Flucht (*Flight*, 1931) (pl. 63), or striking chromatic effects, as in *Equilibre* (*Balance*, 1925) (pl. 34) or *Die Süße* (*The Sweet One*, 1926) (pl. 50). She also was adept at exploiting the varied ink tones of different periodicals—sepia, blue, green, gray—for coloristic effect.

The most important change in these works of the 1920s, however, occurred in their subject matter, which became more focused as Höch's meditations on gender roles and the relationship between the sexes came to dominate the compositions. The Liebe (Love) series, which features such works as *The Coquette I* and *Die Kokette II* (*The Coquette II*, c. 1925) (pl. 27), cunningly mocks the mating rituals of modern life. Other works, mostly from after 1926, when Höch began a nine-year lesbian relationship with the Dutch poet Til Brugman, depict same-sex or androgynous couples. The monumental Ethnographic Museum series, made between 1924 and 1930, provides a profound meditation on the alienation of the female, who is placed on a pedestal and isolated from social intercourse, and whose demeanor is obscured by a mask that both conceals her individual identity and reveals her

psychic unease.[14] A series of "portraits" features images of what may be called psychological types—"the Melancholic," "the Victor" (pl. 41) "the Half-Caste" (pl. 29), "Children." Together, they take on a sort of taxonomic quality that is reminiscent of August Sander's contemporaneous photographic compilation, *The Face of Our Time*, and recall other scientific or pseudo-scientific type-catalogues so popular during the period (and which the Nazis would take to extremes with their grotesque manipulations of genetic anthropology).

In contrast to her paintings from this period, Höch's photomontages eschew the universal and the timeless in favor of the immediate. Filled with wit, irony, and critical awareness, they are certainly reflective of the artist's personal concerns; but it is difficult to read them as overtly autobiographical, not in the least because of the public nature of their sources.[15] In these works, Höch composed personalities by piecing together bits of publicly shared material, mimicking the manner in which private identity is composed from a variety of socializing forces. Making exclusive use of images from popular periodicals, she took the (printed) stuff of everyday life as her source of inspiration in order to create highly personal—or private—images, ones that speak more of inner being than of public persona.

Predominantly psychological rather than narrative, these works are highly subjective and are receptive, therefore, to the viewer's own reading. To establish such an intimate rapport between the viewer and the artwork, Höch repeatedly utilized a few basic strategies (which she would continue to use throughout her career in photomontage). Invariably they feature one or two (or, very rarely, three) figures, usually female or androgynous, with an emphasis placed on the head. Female eyes and lips—the windows of the soul and the most sexual facial attributes—are highlighted. The characters almost invariably gaze straight out of the image, fixing the viewer with their unblinking regards, which Höch further accentuates by either enlarging the eye out of proportion to the rest of the face (as in *The Melancholic* or *The Sweet One*); by endowing them with mismatched eyes (as in *Balance* or *Deutsches Mädchen* [*German Girl*, 1930] [pl. 64]) or two identical ones (*Children*); or by combining two faces that gaze out at the viewer together (as in *Flight* or *Die starken Männer* [*The Strong Men*, 1931] [pl. 62]).

During the mid-1920s, Höch briefly attempted to bridge the gap between the allegoric impulse of her canvases and the psychological thrust of her photomontages in several paintings—*Journalisten* (*Journalists*, 1925) (fig. 8), *Roma* (*Rome*, 1925) (fig. 9), and *Die Braut* (*The Bride*, 1927) (fig. 10)—all of which evoke the technique of photomontage through their mismatching of body parts, distortions of scale, and use of positive and negative form. *Journalists*, for example, reveals the same kinds of facial distortions, particularly the mismatched eyes, that typify her photomontaged portraits from the period. The gender blending we have seen in the photomontages is recreated in the painting's right-hand figure, which features a mustachioed head atop a female body.

8. *Journalisten* (*Journalists*), 1925, oil on canvas. Collection Berlinische Galerie, Landesmuseum für Moderne Kunst, Photographie und Architektur, Berlin. **9.** *Roma* (*Rome*), 1925, oil on canvas. Collection Berlinische Galerie, Landesmuseum für Moderne Kunst, Photographie und Architektur, Berlin.

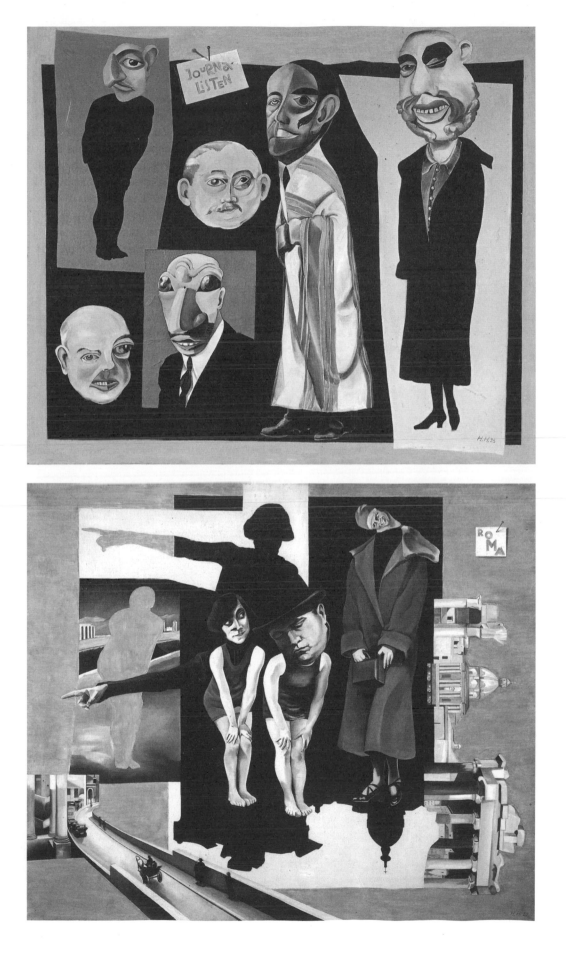

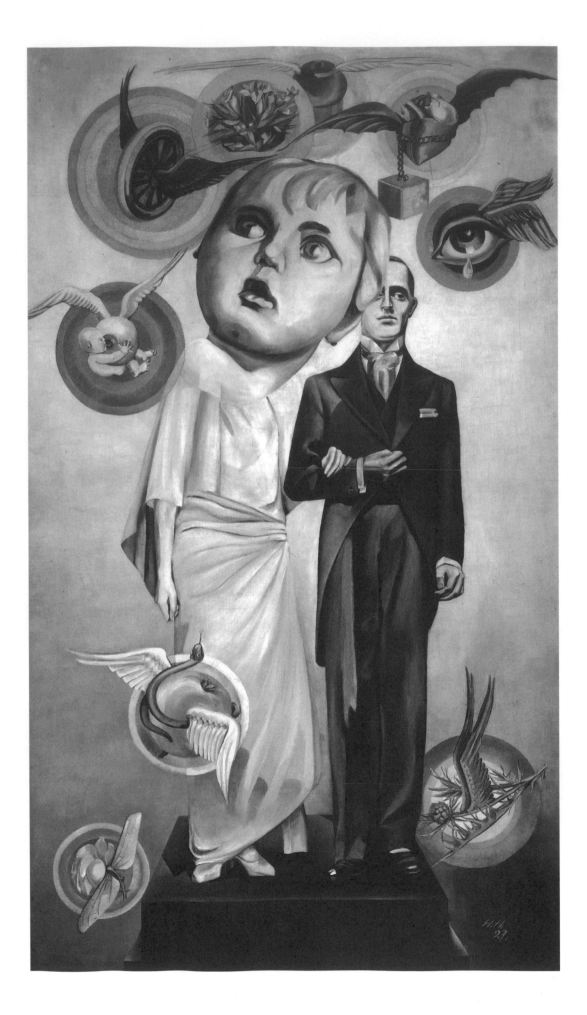

This body, as well as that of the left-hand figure—rendered in "cutout" silhouette—reappear in *Roma*, which features a particularly dynamic interplay of positive and negative form. Here, the crouching bather and pointing figure appear cut out and separated from their surroundings, as do the Roman monuments at the right of the painting. The pointing figure, in fact, was copied directly from a photograph of the actress Asta Nielsen in the role of Hamlet (more gender blending), while the bowler-topped man's head derives from an image of Mussolini that Höch had used in her photomontage *Pax* (*Peace*, 1923).[16] *The Bride* features the white-clad figure of a bride surmounted by the incongruously large head of a frightened girl, who looks in horror at emblems of marital life that swirl menacingly around her.

These paintings probably reflect Höch's awareness of Max Ernst's collage-influenced canvases, such as *Oedipus Rex* (1922) and *La Belle Jardinière* (1923), which he began to make as early as 1921. Whether Höch ever met Ernst is uncertain, although certainly she knew his work at an early date and, at least late in her career, openly expressed her admiration for it. Höch's 1920 watercolor *Mechanischer Garton* (*Mechanical Garden*) (fig. 1) shows a marked affinity with Ernst's imprinted drawings of 1919–1920, several of which were included in the 1920 Dada Fair.[17] Two early photomontages may also make reference to him: *Dada-Ernst* (1920–1921) (pl. 7), whose title may play on the artist's "Dada-Max" moniker, and *Da Dandy*, which features a male silhouette whose aquiline profile strongly resembles that of Ernst.

Although Höch's collage-based paintings now seem to be among her most innovative, she abandoned the approach after completing *The Bride*. One can only speculate that the attempt to replicate the effects of one medium in another may have felt excessively mannered to her, distancing the finished works from the source of their inspiration and draining them of the intimacy and immediacy she found in photomontage.

In 1929, a few months after the *Film und Foto* exhibition opened in Stuttgart, Höch, who for the previous three years had been living with Brugman in The Hague, returned to Berlin. The success of the *Film und Foto* show (which identified Höch as a German painter in its checklist) appears to have persuaded her of the public validity of her work in photomontage, for her reticence about exhibiting works in this medium soon disappeared. She showed a group of photomontages at the Kunstzaal d'Audretsch in The Hague in 1929[18] and included fifteen more in the 1930 *Große Berliner Kunstausstellung*. During the early 1930s Höch's work was included in a number of important international exhibitions, including the 1931 *Fotomontage* show in Berlin (organized by César Domela, whom Höch had befriended while in Holland) and the 1932 *Exposition internationale de la photographie* at the Palais des Beaux-Arts in Brussels (where she showed again in 1933). In 1934, the largest exhibition of her photomontages to date was held in Brno, Czechoslovakia, where forty-two works were shown.

10. *Die Braut* (*The Bride*), 1927, oil on canvas.
Collection Berlinische Galerie, Landesmuseum für Moderne Kunst,
Photographie und Architektur, Berlin.

A "Savage Outbreak" and a "Journey of Discovery"
(1930–1945)

Upon her return to Germany in late 1929, Höch created a number of photomontages that revived, albeit obliquely, the social activism of her earlier Dada works. This change may have been in part a response to growing public acknowledgment (made manifest in exhibitions such as *Film und Foto* and *Fotomontage*) of the seminal role Dada had played in the development of photomontage, which had become increasingly influential as a technique in avant-garde and commercial art throughout the decade of the 1920s. But it was also, in part, Höch's response to the political changes that had occurred in Germany during and after her Dutch sojourn. Later in life, Höch recalled that upon her return to Berlin she had felt alienated in her own country: "From 1930 on I lived in growing isolation. During my stay in Holland I had lost contact with the art world in Berlin. When I came back to Germany the atmosphere was not very favorable to artistic work."[19] Thanks in part to the international economic crisis that followed the stock market crash in the United States, 1929 marked the year that Hitler's National Socialist party began expanding its power base beyond Bavaria and rapidly emerged as the most powerful political party in Germany.

Some of the earliest evidence of this growth of Nazi influence occurred in Höch's native state of Thuringia. In the 1929 elections, Thuringia elected Wilhelm Frick to the National Assembly, and he was subsequently named the state's Minister of Education. The first Nazi to hold such a ministerial position, Frick, among other things, issued an "Ordinance Against Negro Culture" and appointed the architect Paul Schultze-Naumburg—author of the anti-modernist *Kunst und Rasse* (*Art and Race*, 1928), which compared modernist artworks to images of deformed and diseased people in medical texts—to head the School of Applied Arts in the former Bauhaus buildings in Weimar. Among Frick's and Schultze-Naumburg's reforms were the removal of works by Paul Klee, Otto Dix, Ernst Barlach, Wassily Kandinsky, Emil Nolde, and Franz Marc from the Schloß Museum in Weimar and the painting-over of Oskar Schlemmer's celebrated Bauhaus murals.[20] In 1930, the Reichstag was dissolved, and in the subsequent round of elections the Nazi party increased its representation ninefold, becoming second only to the centrist Social Democratic Party (SPD) in the number of seats held.

Höch parodied the Nazis in such works as *Der kleine P* (*The Small P*, 1931) (pl. 65), *Bäuerliches Brautpaar* (*Peasant Wedding Couple*, 1931) (pl. 66), and *Die ewigen Schuhplattler* (*The Eternal Folk Dancers*, 1933) (pl. 68), depicting them as infantile whiners and bumpkins. Nazi racial theories are mocked in *German Girl*, where the Aryan ideal is presented in deformed caricature, and in *Peasant Wedding Couple* and *Die Braut* (*The Bride*), c. 1933) (pl. 67), whose rural couple (the man in storm-trooper boots) and swan-necked beauty (from a type of German Renaissance portrait favored by Hitler) are endowed with apelike and Negroid features, which the Nazis vilified as signs of genetic inferiority.

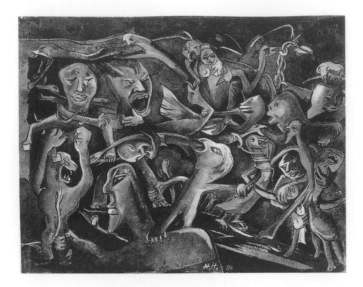

Mixed in with such caricatures are darker, more brooding images indicative of Höch's unease. The doll-like figure of *Flight*, half chimpanzee and half woman, is pursued by a man-faced bird whose wing seems to rise in a Nazi salute. The looming silhouette of boxer Max Schmeling, who had become a German idol by winning the world heavyweight championship in 1930, presides over *The Strong Men*.[21]

During the early 1930s, then, as Höch's photomontages drew increasing public exposure, they also took on a political tone that had been missing since 1922. (This, of course, is not to say that her work from 1922 to 1930 had not been socially engaged; rather its social dimension had been confined exclusively to the realm of gender issues.) But this brief period of renewed political engagement came to an abrupt halt in 1932–1933. A planned exhibition of her work in 1932 at the Dessau Bauhaus, which was to have included fifteen photomontages and thirty-one watercolors, was canceled days before its scheduled opening when the Nazi majority in the newly elected local government closed the Bauhaus down. From then until the fall of the Nazi regime in 1945, Höch was unable to show her work in Germany altogether.[22]

Shortly after Hitler's ascension to the chancellorship in 1933, the Nazis established a Reichskulturkammer (State Culture Board) to which all artists had to belong in order to sell, exhibit, or even produce their work. Jews, Communists, and artists with unacceptable styles were excluded from membership and, as a result, most avant-garde artists left Germany during the years 1933–1937. The few who stayed, Höch among them, lived in isolation and in constant fear of visits from the Gestapo. The situation grew worse after 1937, when Nazi cultural policy crystallized. Höch was among the group of artists vilified as "cultural Bolshevists" in Wolfgang Willrich's *Säuberung des Kunsttempels* (*The Cleansing of the Temple of Art*), which provided the framework for the notorious *Entartete Kunst* (*Degenerate Art*) exhibition of that year. Although her painting *Journalists* had been illustrated in Willrich's book, she was not included in the exhibition for the simple reason that it was limited to artists represented in public collections. (There were, in fact, only four women among the more than one hundred artists held up for public ridicule, a telling indication of the status of women artists at the time.)

11. *Ewiger Kampf I* (*Eternal Struggle I*), 1924, watercolor.
Germanisches Nationalmuseum, Nuremberg (on loan from private collection).
12. *Sturm* (*Storm*), 1935, watercolor. Germanisches Nationalmuseum,
Nuremberg (on loan from private collection).

The mid-1930s were dark years for Höch for other reasons as well. Her dear friend Theo van Doesburg died in 1931. In 1934 a hyperactive thyroid brought her to the brink of death; even after a successful operation, she claimed for a year to be "nothing but a creature struggling for life."[23] The following year, Höch and Brugman parted ways. And with the departure from Germany of Arp, Schwitters, Hausmann (with whom she had resumed contact in 1931), and other friends from the avant-garde, she lived in complete artistic isolation. Just before the outbreak of the war in 1939, she retreated from Berlin to the rural suburb of Heiligensee, a move precipitated by her growing sense of danger: "Those of us who were still remembered as 'Cultural Bolshevists' were all blacklisted and watched by the Gestapo. Each of us avoided associating even with his dearest and oldest friends and colleagues for fear of involving them in further trouble."[24]

In reaction to the personal and social crises of the times, Höch's photomontage work took a marked turn after 1933. Like many contemporaneous artists and intellectuals who endured in private isolation during the Nazi period, she seems to have engaged in what has become known as the *innere Immigration* as a means of coping with the oppressive facts of everyday life.[25] For Höch this meant a retreat into a private realm of fantasy and imagination in which she used her scissors to transform her photographic source material from fact into fiction.

There is little in Höch's photomontage work from this period that directly chronicles the convulsive events taking place in Germany at the time. To be sure, works such as *Siebenmeilenstiefel* (*Seven-League*

Boots, 1934) (pl. 71), *Der Unfall* (*The Accident*, 1936) (pl. 72), and *Ungarische Rhapsodie* (*Hungarian Rhapsody*, 1940) (pl. 78), which exhibit a sense of almost giddy weightlessness and instability, can be seen as suggesting the turmoil and insecurity she felt as a result of the cataclysmic changes in German society. The mood of her work also darkened perceptibly during the war years of 1939 to 1945, particularly in the series of Surrealist-inspired nocturnal dreamscapes that includes *Am Nil II* (*On the Nile II*, c. 1940) (pl. 76) and *Lichtsegel* (*Light Sails*) (pl. 81) and *Traumnacht* (*Dream Night*) (pl. 82), both 1943–1946. Even a work such as *Resignation* (pl. 69), made during the earlier part of the decade, may be interpreted as a fairly overt reflection of Höch's despondency over the course events. But for the most part, Höch's imaginative photomontages from this period seem to reflect the escapist attitude expressed in the title of a work from 1940: *Nur nicht mit beiden Beinen auf der Erde stehen* (*Never Keep Both Feet on the Ground*) (pl. 75).

Höch's inward turn was almost surely also a reaction to the increasing use of photomontage to propagandistic ends in the mass media. In a 1931 article occasioned by the *Fotomontage* exhibition, Höch's former collaborator Raoul Hausmann declared that "over time the technique of photomontage has undergone considerable simplification, forced upon it by the opportunities for application that spontaneously presented themselves . . . primarily those of political or commercial propaganda. The necessity for clarity in political and commercial slogans will influence photomontage to abandon more and more its initial individualistic playfulness."[26] A 1934 statement by Höch, written in conjunction with the exhibition of her photomontages in Brno, reads like a rebuttal to Hausmann's prediction. Contrasting the "applied" photomontage techniques of advertising with "free-form photomontage"— "an art form that has grown out of the soil of photography"—she wrote:

> The peculiar characteristics of photography and its approaches have opened up a new and immensely fantastic field for a creative human being: a new magical territory, for the discovery of which freedom is the first prerequisite. . . . Whenever we want to force this "Photomatter" to yield new forms, we must be prepared for a journey of discovery, we must start without any preconceptions; most of all, we must be open to the beauties of fortuity. Here more than anywhere else, these beauties, wandering and extravagant, obligingly enrich our fantasies.[27]

Certainly Höch's written tribute to the pleasures of the imagination calls forth a vocation that is far from the practices of Berlin Dada, with its revolutionary criticism of bourgeois society and the German political and military hierarchy. It seems evident that Höch had found in photomontage a means to discover the unknown in the familiar. From the first, the impulse to make photomontage had been to subvert the apparent "reality" of the photograph and to create a new means of expression in keeping with the times. Now, like Max Ernst, Höch was putting Dadaist means to Surrealist ends and, in so doing, found a path to freedom amid the "nightmarish" pressure of "the illusionary world of National Socialism."[28]

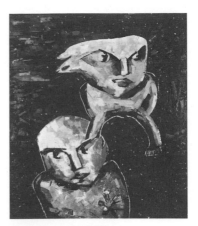

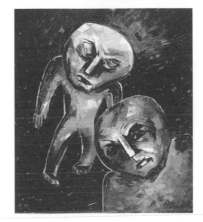

13. *Wilder Aufbruch* (*Savage Outbreak*), 1933, oil on canvas. Collection Landesbank Berlin.
14. *1945*, 1945, oil on canvas. Collection Landesbank Berlin.

Although certainly stimulated by the oppressive political climate, it should be noted that Höch's turn to the freedom of fantasy in her photomontages during the Nazi period had its roots in her earlier paintings, gouaches, and watercolors. That strong current of "the mysterious, the dreamlike, the magical" that Hans Hildebrandt had noted in her painted work of the 1920s is particularly evident in watercolors featuring whimsical, imaginative creatures, such as *Drei Lindenkäfer* (*Three Linden Beetles*, 1924) or the more ominous *Ewiger Kampf I* (*Eternal Struggle I*, 1924) (fig. 11). While Höch's photomontages from the 1930s and 1940s show the mark of Surrealism, with its emphasis on the metamorphic powers of the subconscious, these earlier painted works reveal that her own brand of Surrealism—a movement that never took a strong hold in Germany during the interwar years—was ultimately rooted in the fevered visions of Northern Renaissance artists such as Grünewald, Bosch, and Brueghel.[29]

In an ironic reversal of the previous direction of her work, while Höch's photomontages from the Nazi period took on an increasingly escapist tone, a number of her paintings and watercolors reflected more directly the turmoil she felt as a result of social conditions.[30] Some of these—such as the watercolor *Sturm* (*Storm*, 1935) (fig. 12), which shows figures being violently buffeted by a gale amid overscaled vegetation, and *Angst* (page 132), a 1936 oil painting that depicts a figure

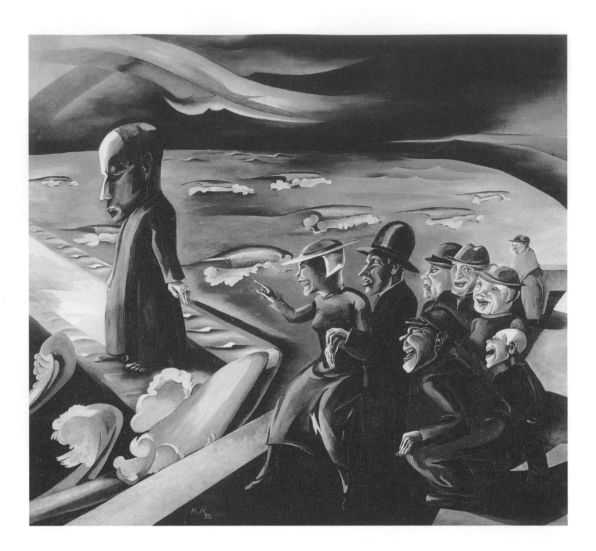

15. *Die Spötter* (*The Mockers*), 1935, oil on canvas. Collection Landesbank Berlin.

cowering in fright in a tree-lined lane—may be read as images of general psychic turmoil, conceivably as much personal as social. But other works are more explicitly reactions to the political and social realities of the time. *Wilder Aufbruch* (*Savage Outbreak*, 1933) (fig. 13), painted in the year of the Nazi takeover, shows a small, aggressive creature springing from the head of another figure. According to her biographer, Heinz Ohff, Höch described this image as that of "a brutal male [who] rips himself away from a maternal being."[31] Höch later wrote of this work to the critic Will Grohmann, claiming that "it originated in 1933, when it was unmistakably revealed that the German 'World of Men' had begun this savage outbreak into national arrogance, injustice, and a madness for world domination. The women, especially the mothers, accepted this downfall with great anxiety, with mistrust, but resigned themselves to it."[32] The year the war ended, Höch painted a pendant to this work, *1945* (fig. 14), which shows the creature submissively returning to its "mother." Another oil painting, *Die Spötter* (*The Mockers*, 1935) (fig. 15), which depicts a man being jeered by a malicious crowd, reads as a bitter denunciation of the scapegoating mob mentality so expertly manipulated by the Nazis.

Several watercolors are even more explicit. One from 1938 (now in the collection of the Staatsgalerie Stuttgart) displays, amid a barren landscape, a placard that bears a Hitler-like caricature and the legend "Halt" (Stop), perhaps in anticipation of the war that would erupt the following year. During the war, Höch also produced two series of watercolors, Totentanz (Dance of Death) and Notzeit (Time of Suffering), which depict, respectively, embattled figures and derelict women and children amid war-torn landscapes. An oil painting, *Trauernde Frauen* (*Grieving Women*, c. 1945), which presents a row of darkly clad women with downcast eyes against a muted ground, is clearly related to, and perhaps culminates, the Notzeit series.

The contrast between the bleak forthrightness of these painted works and the fanciful evasion of Höch's photomontages from the period indicates that the latter played a specific role within her œuvre. No longer was photomontage a vehicle for social criticism or examination, as it had been for her until 1933. It now offered a means for achieving an unimpeded freedom of the imagination, the public origin of its materials serving as a link between the artist's creative enterprise and the viewer's experience.

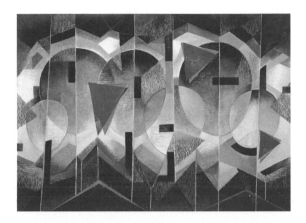

THE POLITICS AND
PLEASURES OF ABSTRACTION

(1946–1963)

Given the fanciful bent of her Nazi-era photomontages, Höch's eventual move to a purely nonobjective abstraction in her postwar collages becomes comprehensible, though it remains a stunning turn. The defeat of Nazism brought about dramatic changes for Höch and other artists who had endured twelve years of tyranny and isolation. The German art world as a whole had to rebuild and redirect itself after the long-term domination of Nazi ideology, the flight of many of its most talented figures (most of whom never returned to Germany to live), and, after 1948, the physical division of Germany into East and West. For the first time since 1933, Höch was free to exhibit her work publicly in Germany and to pursue her art without fear of reprisal. In accordance with this newfound freedom—and in order to make a living during a period of intense deprivation—Höch took on a role more public than any she had assumed before, joining numerous arts organizations that sprang up (often with Allied support) to assist artists in exhibiting their work and earning an income.

Dominated by the twin specters of its Nazi past and divided present, the postwar German art world became polarized by an ideological battle between those who advocated representation in art and those who favored abstraction. Advocates of representational art argued in favor of its democratic accessibility. But for its detractors, representational art was too vulnerable to co-optation by the state for propagandistic purposes, as exemplified by the Nazi art of the all-too-recent past and the current, officially sanctioned Socialist Realism of the Soviet bloc, which included, of course, East Germany. In opposition, they argued that modern art, and specifically abstraction, represented the freedom of the individual, a freedom supposedly immune to manipulation by the state.[33]

There can be little doubt as to which side Höch took in the debate. Her postwar production in both painting and photomontage was consistently abstract, and frequently completely nonrepresentational. Even though she joined several left-wing organizations set up during the Soviet occupation of Berlin (some of which were disbanded after the subsequent division of Berlin into zones of Allied influence), she also was active in a number of different organizations that pointedly abstained from imposing ideological leanings on their memberships. Her stance here seems in keeping with the one she had taken during the Dada years, when she avoided the ideological wing of Berlin Dada—as represented by the Grosz-Heartfield-Herzfelde triumvirate—and allied herself first with the more anarchic Hausmann-Baader faction and, ultimately, with such apolitical artists as Schwitters and Arp.

Höch's painted œuvre from the postwar period is relatively tame. Many of the canvases rework such conventional themes as the harmony of nature, the integration of man and nature, and family unity. Executed in soft planes of color knitted together by sinuous line, these works are permeated by a sentimentalized spirituality. Quietly reassuring but still appearing "advanced" due to their abstraction, they are typical fare for the period. Many in the German art world, shaken and demoralized by the Nazi era, preferred to deal with their society's turmoil and anxiety by presenting reassuring images of peace and tranquility.[34]

While there always had been a sentimentalizing streak in Höch's painted œuvre, in considering her works from this period we must keep in mind the degree to which they may also have been commercially driven. In the immediate postwar years, Höch was in particularly difficult economic straits. Although she received a comparatively generous ration card in 1947, she still relied heavily on her own garden for food. She showed her work frequently in small exhibitions in her home district of Heinickendorf and delivered lectures to local inhabitants on how to look at modern art. Naturally, the type of work she produced for these organizations was geared to their audiences. The Freunde der bildenden Kunst (Friends of Fine Art) in Berlin, for example, to which she consigned her works, specifically requested pieces with flower themes. Höch may well have made a distinction between this work intended for the marketplace and her more serious art, such as her nonobjective paintings (fig. 16). Composed of radiating biomorphic forms and featuring a darker, contrasted palette, these paintings are both more adventurous and successful, combining a Surrealist biomorphism with the synesthesia of the early modernist works of Robert Delaunay, Arthur Dove, or Kandinsky.

Höch's photomontages of the period—which, by contrast, she exhibited only in downtown galleries devoted to avant-garde art (principally, the Galerie Gerd Rosen, which was the first private gallery to open in Berlin after the war)—also eschew representation or, in other cases, feature extensive use of botanical imagery. Yet here the difference in medium yields astonishingly different results. Making use of the increasing number of color reproductions available in magazines during the

16. *Kadenz (Cadence),* 1958, oil on canvas.
Collection Berlinische Galerie, Landesmuseum für Moderne Kunst,
Photographie und Architektur, Berlin.

1950s and early 1960s, they are dense with lush, high-contrast color. The nonobjective works are virtuoso performances of artmaking. Working in direct opposition to the very raison d'être of photomontage—to exploit the recognizability of a preexisting image—Höch sliced and shredded her source material to a degree that all but obliterates the original images. Here, photographs are exploited for their formal rather than representational properties—line, color, and texture.

Given the violence inherent to such acts of mutilation, in which the integrity of the source imagery is completely annihilated, it is impossible not to consider these works within the context of Abstract Expressionism and the more gestural manifestations of Art Informel. But at the same time, it is worthwhile to compare them compositionally to some of Höch's earliest abstract watercolors, from the 1910s. *Gesprengte Einheit* (*Burst Unity*, 1955) (pl. 89), whose background image is a time exposure of multiple points of light careening chaotically through space, seems linked particularly closely to the gesturalism of Jackson Pollock, Willem de Kooning, Hans Hartung, or Georges Mathieu. Yet with its collaged parts seeming to explode outward from a centralized point, the work is also closely related to Höch's early Futurist-inspired watercolor, *Konstruktion mit Blau* (*Construction with Blue*) (fig. 3), from 1919.[35] Unlike the Abstract Expressionist–inspired collagists of the 1950s— Raymond Hains, Jacques de la Villeglé, Mimmo Rotella, Wolf Vostell, Robert Rauschenberg, and others—Höch maintained an intimacy of scale and achieved a sense of energy in her works through meticulous composition rather than from the appearance of spontaneity.

At the heart of the magic of these ingenious abstractions is the tension created by the transformation of image to abstraction, a transformation that occurs to varying degrees of completeness in different works or even within the same work. Because photographic images are the materials from which these pieces are constructed, the viewer can become enmeshed in an elaborate game of guessing what each part had been before the artist turned it into something new. In this sense, the transformational magic of Surrealism is still at work. Yet at the same time, Höch seems to be anticipating those artists of the 1980s who used the mass media as fodder for their deconstructivist tactics of negation.

When Höch does allow the representational viability of her source photographs to remain intact in her collages of this period, they are ripe with allusions to the natural world. Works from the mid-1950s sometimes combine images of natural and man-made objects (pls. 85, 87) in somewhat ominous compositions that echo with the Dadaist commingling of man, machine, and nature. But more often Höch permits herself to become unashamedly, exuberantly sensual. Works such as *Fata Morgana* (1957) (pl. 92) and *Wenn die Düfte blühen* (*When the Fragrances Bloom*, 1962) (pl. 95) are permeated with a sense of lushness and luxuriance that stems both from the imagery and from their textural and coloristic richness.

"Certain Recurring Obsessions": The Return to the Female Image

(1963–1973)

In the early 1960s, Höch abruptly reintroduced the figure—specifically the female figure—to her work after an absence of roughly twenty-five years. A number of factors may have contributed to this move. Most important among these perhaps was the revival of interest in Dada, both in Europe and the United States, which had been gaining momentum throughout the 1950s. Signal events included the publication in 1951 of Robert Motherwell's anthology *The Dada Painters and Poets*; the 1956 Schwitters retrospective at the Kestner-Gesellschaft in Hanover (which Höch traveled to see); the 1957 exhibition *Dada: Dokumente einer Bewegung* (*Dada: Documents of a Movement*) in Düsseldorf; and the appearance of autobiographical memoirs by aging Dadaists: Huelsenbeck's *Mit Witz, Licht und Grütz* (*With Wit, Light, and Nerve*, 1957), Hausmann's *Courrier Dada* (*Dada Mail*) (1958), Mehring's *Berlin Dada* (1959), and Richter's *Dada: Kunst und Antikunst* (*Dada: Art and Anti-Art*, 1964). The pervasiveness of an international "neo-Dada" revival was documented in the Museum of Modern Art's landmark 1961 exhibition, *The Art of Assemblage*, which included Höch's untitled photomontage from 1921 (pl. 11) and to which she lent Hausmann's celebrated *Mechanischer Kopf (Der Geist unserer Zeit)* (*Mechanical Head [The Spirit of our Time]*, 1919).[36] As a result of the interest generated by such publications and exhibitions, Höch was increasingly pursued by artists, curators, and scholars eager to meet her and see her trove of Dada-related materials. 1963—the year in which she produced *Hommage à Riza Abasi* (*Homage to Riza Abasi*) (pl. 96) and *Grotesk* (*Grotesque*) (pl. 98)—was also the year that Pop Art, with its celebration of the mass media, became an international phenomenon.

Events in Germany may also have contributed to Höch's decision to reengage the female figure. During the immediate postwar years, fallout from the collapse of the Third Reich had led German society to look to the private sphere rather than the public for a source of social stability, and the family unit was identified as the bedrock upon which a new society could be built. The role of wife and mother was thrust on women with as much vigor as it had been during the Nazi era. But by the early 1960s the West German "Economic Miracle" was in full flower. The depredations of the war had finally been overcome, and West Berlin, in particular, had been rebuilt and transformed, its physical past having been all but obliterated. With the new prosperity came a new freedom for women. Although the market became flooded with consumer goods, incomes were still low, and women began to go to work to supplement

their spouses' wages. In addition, the advent of the birth-control pill increased women's ability to determine whether and when to become mothers.[37] Magazines became filled with color images of stylish women in advertisements for fashion, beauty products, cars, cigarettes, and liquor, and these no doubt inspired Höch to return once more to the haunts of her youth.[38] "Every artist tends to revert, every once in a while, to an earlier style which has meanwhile been modified to some extent by later experiments and achievements," she had presciently recalled to an interviewer in 1959. "I suppose that every artist has certain recurring obsessions."[39]

The titles of Höch's photomontages from the 1960s intentionally recall her earlier work: *Fremde Schönheit II* (*Strange Beauty II*, 1966) (pl. 101) directly references her *Fremde Schönheit* from 1929 (pl. 47); *Das Fest kann beginnen* (*On with the Party*, 1965) (pl. 97) summons up the 1936 *Für ein Fest gemacht* (*Made for a Party*) (pl. 74); and *Entartet* (*Degenerate*, 1969) (pl. 105) recalls the epithet that had been used to characterize Höch and her colleagues of the Weimar era. But the new works betray none of the anxious melancholy so typical of the psychological portraits or the Ethnographic Museum series of the 1920s. Instead, they are brash, gaudy, and filled with a deliciously cunning wit. As before, Höch highlights the erogenous zones of the face—the eyes and lips—but she also parodies the era's obsessions with girdled waists and accentuated busts, the missilelike aggressiveness of the latter caricatured in *Degenerate*. So blatant is the sexuality of works like *Um einen roten Mund* (*About a Red Mouth*, c. 1967) (pl. 104), *Degenerate*, and *On with the Party*, that it is a shock to remember that by this time Höch was well over seventy years old. Brimming with self-confidence, these works are "public" both in their inspiration and their no-holds-barred assertiveness.

CONCLUSION

The complex interplay between public and private that typifies Höch's work in photomontage stands in utter defiance of our historically conditioned expectations. Given her roots in the most socially active wing of the international Dada movement and her near-exclusive use of illustrated periodicals for the source imagery of her pieces, there is an expectation that Höch's photomontages be "public"—that is, deal with public issues and public perceptions. But her work in photomontage only partially fulfills these expectations, giving us instead a highly personal, subjective reaction to issues and events that shaped Germany and, by extension, Western history in the middle of this century. As an

individual's response to the influence of society, Höch's work tells us—by omission as much as inclusion—what it was like to be a woman and an artist during the times in which she lived.

Höch's career coincided with the fitful emergence of women into the public sphere. It is tempting, then, to consider the back-and-forth between public and private in her work as the reflection of an evolving dialectic between socially determined masculine ("public") and feminine ("private") impulses that held sway over the course of the century. Such a scenario is, of course, too simplistic. But it is surely no accident that the status of women was the focus of her work both in the 1920s—when women had just gained the right to vote and sent their first representatives to the Reichstag, and when the New Woman emerged to challenge conventional thinking about gender roles—and again in the 1960s, when Höch's wedding of the private world of women to the public world of cultural critique anticipated the emergence of the modern women's movement.[40] Nor can it be only coincidental that Höch's most "private" work was done during the period marked by the "savage outbreak" of "the German 'World of Men'" and the subsequent emphasis on women as pillars of the home. One of the abiding contributions of Höch's work and career must certainly be her bridging of the gap between the early promise of the Weimar years and the reemergence of the women's movement in the 1970s.[41]

Hannah Höch's genius lies in the sensitivity with which she took in the world around her. The image of Höch in her old age, peering owl-like through her magnifying glass, is indelible. Her gaze is implacable. Windows to the soul though they may be, her eyes reveal only that they see, very acutely. Hunched over her worktable, looking through her glass at the printed ephemera of her world, she slices it delicately apart and pieces it carefully back together so that we may see it more clearly.

It is to her work in the medium of photomontage that Höch's significance as an artist is due. By contrast, her painted output, though certainly not without interest, is of secondary importance. When there was an established tradition to respond to, her tendency was to accept conventions of subject and style set by others, whether these were the centuries-old traditions of Northern romantic painting or the modern stylistic innovations of her contemporaries, and to adapt them to her own personality. As a critical figure in the "invention" and development of photomontage, Höch had no such guideposts to direct her on her journey through this medium; she was thus free to establish her own benchmarks. Paramount among these was her resolution to allow her materials to propel her forward. But if the mass media provided the vehicle for her art, there can be no doubt that Höch charted her own course on her voyage—through the looking glass—of discovery.[42]

I would like to thank Maria Makela and Kristin Makholm, without whose research and insights this essay would not have been possible.

1 It is not unusual, of course, for history to overlook the full accomplishments of an artist in favor of his or her contribution to a noteworthy moment in time. But Höch, as the only woman to participate actively in the Berlin Dada movement, has furthermore suffered the fate of many women artists: to be acknowledged only insofar as their achievements coincide with the activities of their male counterparts.

2 Hans Richter, *Dada: Art and Anti-Art*, trans. David Britt (London: Thames and Hudson, 1966; reprint, New York and Toronto: Oxford University Press, 1978), p. 132. Originally published as *Dada: Kunst und Antikunst* (Cologne: DuMont Schauberg, 1964).

3 Höch met Schwitters in 1918 and became close to Arp in the early 1920s; she remained fast friends with both artists for the rest of their lives. In a 1959 interview with Edouard Roditi (*Arts* 34, no. 3 [December 1959], p. 29) Höch praised them both as "rare examples of the kind of artist who can really treat a woman as a colleague," and there is evidence in her work of her respect for each. In 1922–1923, as Höch recalls in the same interview (p. 27), she began "to try my hand at 'Merzbilder' . . . I mean at the same kind of collages as those of my friend Schwitters." *Collage (Dada)* (c.1922) (pl. 22) and *Das Sternfilet* (*The Lace Star,* 1924) (pl. 23) are particularly salient examples of these. Höch also contributed two "grottoes" to Schwitters's environmental *Merzbau* sculpture in his Hanover home. Two works in the collection of the Fondazione Marguerite Arp in Locarno, Switzerland—*Huldigung an Arp* (*Homage to Arp*, 1923) and *Schnurenbild* (*String Picture*, 1923–1924)—are examples of her work in the style of Arp. For Höch's relation to Ernst, see p.15 and note 17.

4 See the exhibition catalogue *Hannah Höch: Collages, Peintures, Aquarelles, Gouaches, Dessins/ Collagen, Gemälde, Aquarelle, Gouachen, Zeichnungen* (Paris and Berlin: Musée d'Art Moderne de la Ville de Paris and Nationalgalerie Berlin Staatliche Museen Preußicher Kulturbesitz, 1976). For posthumous critical recognition see, for example, Götz Adriani, ed., *Hannah Höch: Fotomontagen, Gemälde, Aquarelle* (Cologne: DuMont Buchverlag, 1980) and Gertrud Jula Dech and Ellen Maurer, eds., *Da-da zwischen Reden zu Hannah Höch* (Berlin: Orlanda Frauenverlag, 1991).

5 Richter, supra, note 2, p. 132.

6 Hans Richter, *Begegnungen von Dada bis heute: Briefe, Dokumente, Erinnerungen* (Cologne: DuMont Schauberg, 1973), pp. 28–30.

7 Höch quoted in Roditi, supra, note 3, p. 29.

8 On the issue of Höch's stylistic pluralism and its reception, see Ellen Maurer, *Hannah Höch: Jenseits fester Grenzen: Das malerische Werk bis 1945* (Berlin: Gebr. Mann Verlag, 1995).

9 In this she may not have differed from many of her Dada colleagues. For all their devotion to the written word, the Berlin Dadaists wrote little about the medium they claimed to have "invented" until the 1930s. Höch's earliest statement on the medium did not appear until 1934, and it makes clear that it was the proliferation of photomontage in the fields of photojournalism and, in particular, the graphic arts of postermaking and advertising that convinced her of the medium's legitimacy. See Hannah Höch, "Nekolik poznámek o fotomontázi" (A Few Words on Photomontage), *Středisko* 4, no. 1 (April 1934), unpaginated; English translation by Jitka Salaguarda in *Cut with the Kitchen Knife: The Weimar Photomontages of Hannah Höch,* by Maud Lavin (New Haven and London: Yale University Press, 1993), pp. 219–220.

10 An inscription in Höch's hand on the back of an oil painting entitled *Der Anfang* (*The Beginning*, 1916) identifies the work as her first oil painting.

11 On this subject, see Maria Makela's essay in this volume, p. 64.

12 Hans Hildebrandt, *Die Frau als Künstlerin* (Berlin: Rudolf Mosse Buchverlag, 1928), p. 128.

13 Even during the period 1919–1922, when Höch exhibited outside of the Dada context, as in the annual *Große Berliner Kunstausstellung*, she showed watercolors and oils.

14 The figures in the Ethnographic Museum series are identifiable as female on the basis of the human body parts they contain, as distinct from the sculptural fragments that are incorporated into them. Still, not all the figures in the Ethnographic Museum series are female. I suspect that the series grew out of the "psychological portrait" type discussed below, and that Höch only gradually began to think of it as a separate series. *Mit Mütze (Aus einem ethnographischen Museum IX)* (*With Cap [From an Ethnographic Museum IX]*) (pl. 42) and *Hörner (Aus einem ethnographischen Museum X)* (*Horns [From an Ethnographic Museum X]*) (pl. 43), both from 1924 and generally considered among the earliest works in the series, present identifiably male subjects, and both focus exclusively on the heads, as do the psychological portraits. The only other works in the Ethnographic Museum series that do not feature explicitly female characteristics are *Aus einem ethnographischen Museum IX* (*From an Ethnographic Museum IX*, c. 1926), which features one figure with both male and female parts and another that seems more male than female (but, perhaps significantly, has no photographs of human body parts); an untitled

piece from 1930, now in the Museum für Kunst und Gewerbe, Hamburg (page 137), with its muscular male legs; and *Der heilige Berg (Aus einem ethnographischen Museum XII)* (*The Holy Mountain [From an Ethnographic Museum XII]*, 1927) (pl. 52), which features carved Buddhist sculptures from India representing male Buddha or bodhisattva types that are nonetheless distinctly androgynous in appearance.

15 Protracted, in-depth analysis of Höch's photomontages may well reveal them to be more autobiographical than I am characterizing them here, but the fact remains that at a surface reading, it is the public rather than autobiographical aspect of the work that predominates. Unlike her paintings, which make us acutely aware that the source of the imagery lies in the artist's imagination, the photomontages always remind us that the source of the imagery derives, quite literally, from the public realm: the mass media.

16 The image of Mussolini is from a photograph of the Italian leader and the Futurist poet Gabriele D'Annunzio that is reproduced (reversed) in a recent translation of Richard Huelsenbeck's *Dada Almanach* (London: Atlas Press, 1993), p.113. We do not know the original printed source for Höch's photomontage. The current whereabouts of *Peace* are unknown, and it is believed lost.

17 A postcard from George Grosz to Raoul Hausmann, 5 June 1920, bids Hausmann to come to Otto Burchard's home the next day: "All the Dadas are there (Dada Max [Ernst] from Cologne is also there). . . . Dada Max has brought many things with him." See *Hannah Höch: Eine Lebenscollage*, vol. 1 (1889–1920), ed. Cornelia Thater-Schulz (Berlin: Berlinische Galerie and Argon, 1989), p. 663 (13.22). I have been unable to determine whether Höch accompanied Hausmann to this meeting and know of no other reference that suggests they may have met. In 1951, however, Höch testified to the kinship she felt with Ernst: "Through all phases of development, he [Ernst] has been my closest relative. It began with Dada" (undated journal entry of December 1951 in the Hannah Höch Archive, Berlinische Galerie, Berlin).

18 Although there is no known checklist for this exhibition, it may have included works from the Stuttgart *Film und Foto* exhibition that did not travel with the show.

19 Uncited quotation in Götz Adriani, "Biography—Documentation," trans. Eileen Martin, in *Collages: Hannah Höch, 1889–1978*, exh. cat. (Stuttgart: Institut für Auslandsbeziehungen, 1985), p. 51.

20 On Frick and Schultze-Naumburg, see Lynn H. Nicholas, *The Rape of Europa: The Fate of Europe's Treasures in the Third Reich and the Second World War* (New York: Alfred A. Knopf, 1994), pp. 8–9, 10, 11; and John Willett, *Art and Politics in the Weimar Period: The New Sobriety, 1917–1933* (New York: Pantheon Books, 1978), p. 187. Höch's fondness for the Thuringia-based Bauhaus is evidenced in her watercolor *Den Leuten vom Bauhaus gewidmet* (*Dedicated to the People of the Bauhaus*, 1921).

21 It is perhaps significant to note that Schmeling was a hero to many German men, regardless of their political views. The Dadaists had openly celebrated the masculine art of boxing. In *The Strong Men*, Höch may be tracing a thread of male agression that binds together such mortal enemies as the Dadaists and the Nazis.

22 She did show more than forty photomontages in her 1934 exhibition in Brno, Czechoslovakia, although she did not see the show herself. This would be the largest exhibition of her photomontages until the 1960s.

23 Hannah Höch, "Lebensüberblick" (1958), trans. Peter Chametzky, in Lavin, supra, note 9, p. 214.

24 Quoted in Roditi, supra, note 3, pp. 24–29.

25 The term "innere Immigration," coined during the postwar era, has subsequently come under scrutiny. Conceived as a description of a private, sub rosa effort on the part of individuals to carry on an intellectual and cultural life that had been banned from the public sphere, it is now viewed by some as a rationalization for a lack of active resistance to the Nazis among the intelligentsia. Given the harshness of the Nazi's domestic reign of terror and the fact that many intellectuals fled Germany during the period 1933–1937, leaving those who remained in a weakened political position, such condemnation by hindsight seems unrealistically severe.

26 Raoul Hausmann, "Fotomontage," originally published in *a bis z* (May 1931), pp. 61–62; English translation in *The Weimar Republic Sourcebook*, ed. Anton Kaes, Martin Jay, and Edward Dimendberg (Berkeley, Los Angeles, and London: University of California Press, 1994), pp. 651–652.

27 Höch, "A Few Words on Photomontage," supra, note 9.

28 Höch, supra, note 23, pp. 214, 215.

29 A 1940 painting by Höch, *Die Versuchung* (*The Temptation*), takes up the theme of the temptation of Saint Anthony, a favorite subject of the northern fantastic tradition, although Höch substitutes an androgynous figure of indeterminate age (who may well represent the artist) for the Christian saint, traditionally represented as an old, bearded man. In the isolation imposed on her by the war, Höch may well have identified with the hermit saint.

30 Höch's official status as an artist during this period is still unclear. We do know that she did not show in Germany during the entire Nazi period and in 1933 withdrew from the Künstler-Läden (the Artists' Co-op, which took artworks on consignment) when asked to sign a letter affirming her support of National Socialism and confirming that she was not of Jewish descent. This suggests that she probably was not registered with the Reichskulturkammer, although many "modern" or "degenerate" artists who were not allowed to pursue their craft often did so in secret. Nonetheless, the number of Höch's paintings from this period indicates that she had access to art materials, and she designed book jackets for the Antony Bakels publishing house throughout the era. A rather mysterious entry in her journal, dated 14 December 1937, says that she finished eleven works and delivered them to the "Luftschiffahrtsministerium" (probably the Luftfahrtministerium, the ministry of civil aviation in Berlin). See a letter from the Künstler-Läden to Höch, 28 April 1933, *Hannah Höch: Eine Lebenscollage*, vol. 2 (1921–1945) (Berlin: Berlinische Galerie and Hatje, 1995), p. 500 (33.25); and Höch's *Tagebuch* from 1937, in ibid., p. 592 (37.14).

31 Heinz Ohff, *Hannah Höch* (Berlin: Gebr. Mann and Deutsche Gesell'schaft für Bildende Kunst e. V., 1968), p. 35.

32 Letter from Höch to Will Grohmann, 19 September 1964, Hannah Höch Archive, Berlinische Galerie, Berlin.

33 The pro-modernist viewpoint is eloquently summarized in the concluding chapter of Hellmut Lehmann-Haupt's *Art Under a Dictatorship* (New York: Oxford, 1954). Lehmann-Haupt served as an art liaison officer to Germany for the United States in 1946. For a view of the political implications of the individualism championed by postwar advocates of modernism, see Serge Guilbaut, *How New York Stole the Idea of Modern Art: Abstract Expressionism, Freedom, and the Cold War* (Chicago and London: University of Chicago Press, 1983).

34 On German art of the immediate postwar period, see Yule F. Heibel, *Reconstructing the Subject: Modernist Painting in Western Germany, 1945–1950* (Princeton, N.J.: Princeton University Press, 1995).

35 I am grateful to Carolyn Lanchner for pointing out the compositional links between Höch's photomontages from this period and her early watercolors.

36 The catalogue for the exhibition also illustrates Baader's *Gutenberggenkblatt* (*Commemorative Leaf for Gutenberg*, 1919), from Höch's collection, although the work itself does not appear to have been included in the exhibition. See William Seitz, *The Art of Assemblage*, exh. cat. (New York: Museum of Modern Art, 1961).

37 This synopsis of the status of German women in the postwar era is based largely on Ute Frevert, *Women in German History: From Bourgeois Emancipation to Sexual Liberation* (Oxford and Providence: Berg Publishers, 1988), pp. 255–288.

38 As yet, the only sources we have been able to identify for Höch's photomontages from the 1960s are *Life International* and *Hör zu*, a German television guide. In her figurative works, these often provided source material for background imagery; further research is needed to identify specific sources for her female imagery. It is interesting to note that both the identified sources and the clothing styles in the works suggest that Höch repeatedly used images published several years before the dates of the photomontages. Being fashionable and up-to-date does not seem to have been a priority for her.

39 Roditi, supra, note 3, p. 27.

40 The general consensus is that the modern women's movement in Germany, born amidst the turmoil of 1968, emerged into the public sphere in 1971, the signal event of that year being an open letter published in the magazine *Der Stern* in which 374 women, many of them well-known public figures, announced that they had had abortions, even though abortion was still illegal. See Frevert, supra, note 37; and Gisela Kaplan, *Contemporary Western European Feminism* (New York: New York University Press, 1992), p. 114 ff.

41 Frevert, supra, note 37, in particular, makes the point that, due to the emphasis on the role of women in the private world of the family during the Nazi and postwar reconstruction periods, by the 1960s any sense of continuity with the women's movement of the Weimar era had been all but obliterated.

42 This essay is dedicated to my grandmother, Suzanne Bredaz Werner (1890–1979).

Exhibition Plates

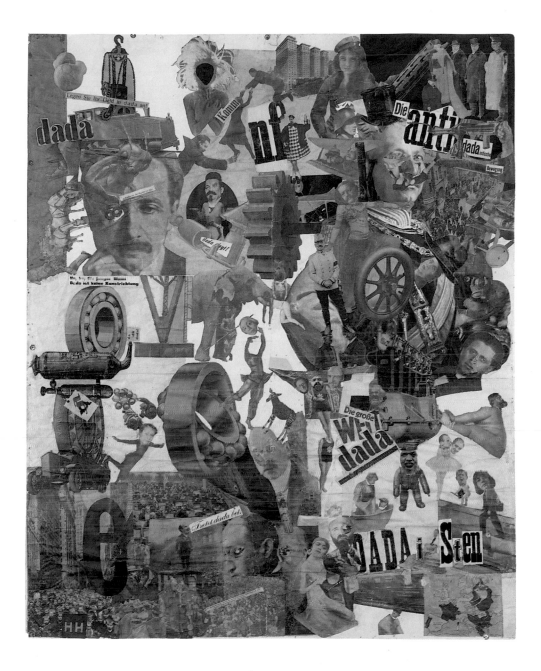

I

SCHNITT MIT DEM KÜCHENMESSER DADA DURCH DIE LETZTE WEIMARER BIERBAUCHKULTUREPOCHE DEUTSCHLANDS
(Cut with the Kitchen Knife Dada through the Last Weimar Beer-Belly Cultural Epoch of Germany) 1919–1920
PHOTOMONTAGE
44 7/8 X 35 7/16 IN. (114 X 90 CM)
COLLECTION STAATLICHE MUSEEN ZU BERLIN—PREUßISCHER KULTURBESITZ, NATIONALGALERIE

This large and complex photomontage unites representatives of the former Empire, the military, and the new, moderate government of the Republic in the "anti-Dada" corner at the upper right, while grouping Communists and other radicals together with the Dadaists at the lower right. These mostly male figures are paired with photographic fragments of active, energetic women—dancers, athletes, actresses, and artists—who animate the work both formally and conceptually. The newspaper fragment at the lower right identifies the European countries in which women could or would soon be able to vote, including Germany, which granted women suffrage in its 1919 constitution. By placing the clipping in the corner she normally reserved for her signature and including a small self-portrait head at the upper-left edge of the map, Höch identified herself with the political empowerment of women, who, she envisioned, would soon "cut" through the male "beer-belly" culture of early Weimar Germany. A full treatment of this work, including extensive documentation of Höch's source images (most of which came from issues of *BIZ*), can be found in Gertrud Jula Dech's *Schnitt mit dem Küchenmesser Dada durch die letzte weimarer Bierbauchkulturepoche Deutschlands: Untersuchungen zur Fotomontage bei Hannah Höch* (Münster: Lit Verlag, 1981). — MM

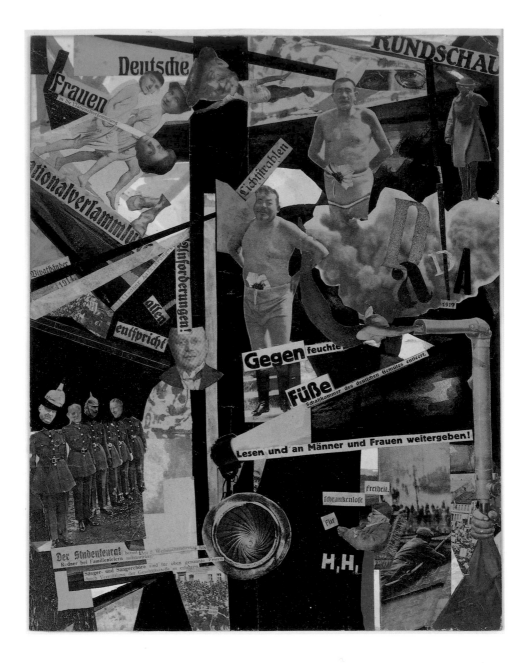

2

DADA-RUNDSCHAU (Dada Panorama) 1919
PHOTOMONTAGE WITH GOUACHE AND WATERCOLOR ON CARDBOARD
17 ⁵⁄₁₆ X 13 ⁹⁄₁₆ IN. (43.7 X 34.5 CM)
COLLECTION BERLINISCHE GALERIE, LANDESMUSEUM FÜR MODERNE KUNST, PHOTOGRAPHIE UND ARCHITEKTUR, BERLIN

Höch glued the photographic reproductions in this montage onto the verso of a photoengraved portrait of Emperor Wilhelm II, who had abdicated his imperial throne in November 1918 and fled to the Netherlands. By grotesquely disfiguring his features with watercolor and irreverently scrawling the word *Fridensfürst* (a misspelling, perhaps deliberate, of the term for "Prince of Peace") above and across his chest, Höch unambiguously conveyed her disdain for this erstwhile German ruler. Most of the images in the photomontage reference Germany's politics in the aftermath of the abdication. The head of American president Woodrow Wilson, author of the famous Fourteen Points upon which Germany based its appeal for an armistice, is collaged atop the body of a female gymnast beside the word *Deutsche* (German) at the top edge, while his eyes and pince-nez glasses appear just below *Rundschau* (panorama) at the upper-right corner. Photographic fragments of mass demonstrations at the left, bottom, and right edges reference the widespread nationalist opposition to the terms of the peace, while the newly emerging political order is parodied with ludicrous images of Reich President Friedrich Ebert and Defense Minister Gustav Noske in bathing suits, also used in *Heads of State* (pl. 3). By appending military boots to Ebert's figure and including, in the lower-right corner, a well-known image of a soldier atop the Brandenburg Gate during the brutal government suppression of the Spartacist revolt, Höch connects the representatives of the new, supposedly democratic Republic to the old militaristic order of the Empire, referenced at the lower left by a row of uniformed officers standing stiffly at attention. Notable among the few women pictured is Anna von Giercke, one of thirty-six female representatives elected to the National Assembly in 1919, when German women voted for the first time. She appears at the upper left with Gertrud Bäumer and Agnes von Harnack, two other female politicians. The phrase at the lower right, "schrankenlose freiheit für H.H." (unlimited freedom for H[annah] H[öch]), may refer to the impact Höch hoped these women would have in restructuring Germany's socio-political order. — MM

BIZ 24, no. 8 (21 February 1915), p. 100 / *BIZ* 25, no. 3 (16 January 1916), cover / *BIZ* 28, no. 3 (19 January 1919), p. 19 / *BIZ* 28, no. 4 (26 January 1919), p. 26 / *BIZ* 28, no. 4 (26 January 1919), p. 29
BIZ 28, no. 6 (9 February 1919), p. 48 / *BIZ* 28, no. 8 (23 February 1919), p. 58 / *BIZ* 28, no. 13 (30 March 1919), p. 101 / *BIZ* 28, no. 17 (27 April 1919), p. 136 / *BIZ* 28, no. 34 (24 August 1919), cover / *BIZ* 28, no. 34 (24 August 1919), p. 328

3

STAATSHÄUPTER (Heads of State) 1918–1920
PHOTOMONTAGE
6 ⅜ X 9 3/16 IN. (16.2 X 23.3 CM)
COLLECTION INSTITUT FÜR AUSLANDSBEZIEHUNGEN, STUTTGART

For this work, Höch used a well-known photograph of German Reich President Friedrich Ebert and Defense Minister Gustav Noske, taken at a Baltic Sea resort just two weeks after the Weimar constitution had been signed into law. Höch— at the time a Communist sympathizer—parodied these Social Democratic "heads of state" by collaging their paunchy figures atop an iron-on embroidery pattern, associating them not with the traditionally male realm of state formation but with the female domain of leisured relaxation. Höch used the same source image of Ebert and Noske in the related *Dada Panorama* (pl. 2). — MM

BIZ 28, no. 34 (24 August 1919), cover

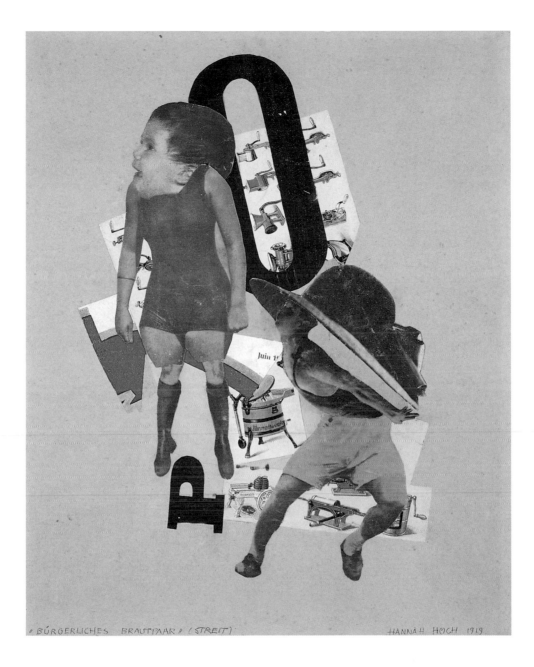

4

BÜRGERLICHES BRAUTPAAR (STREIT) (Bourgeois Wedding Couple [Quarrel]) 1919
PHOTOMONTAGE
15 X 12 1/16 IN. (38 X 30.6 CM)
PRIVATE COLLECTION

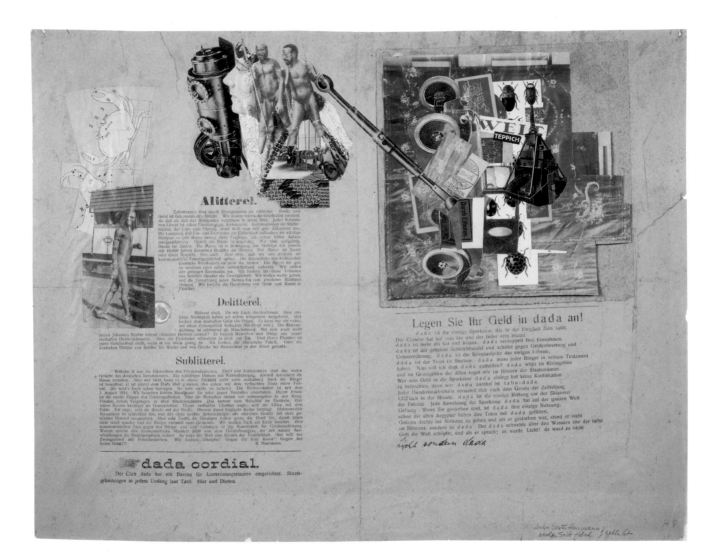

5

DADA CORDIAL c. 1919 *(with Raoul Hausmann)*
PHOTOMONTAGE WITH COLLAGE
17 ¾ X 22 ¹³/₁₆ IN. (45 X 58 CM)
COLLECTION BERLINISCHE GALERIE, LANDESMUSEUM FÜR MODERNE KUNST, PHOTOGRAPHIE UND ARCHITEKTUR, BERLIN

Raoul Hausmann made the left side and Höch the right side of this collaborative collage, the various elements of which are glued to a double-page spread from a proof of the first issue of *Der Dada* (15 July 1919). Although usually dated on these grounds to c.1919, one of its media sources comes from a January 1920 issue of *BIZ*, which featured a photograph of a Masai warrior traveling by train in East Africa among a group of mostly European passengers. Hausmann excised the image of the naked black man and superimposed it atop a fragment of an astrology chart. The chart, together with the scrap of paper on Höch's side that illustrates various types of beetles, ally this work with *Proverbs to Live By* (pl.19), which features similar photographic reproductions. The piston rod that links the two halves is also used in *High Finance* (pl.10). — MM

BIZ 29, no.3 (18 January 1920), p.31

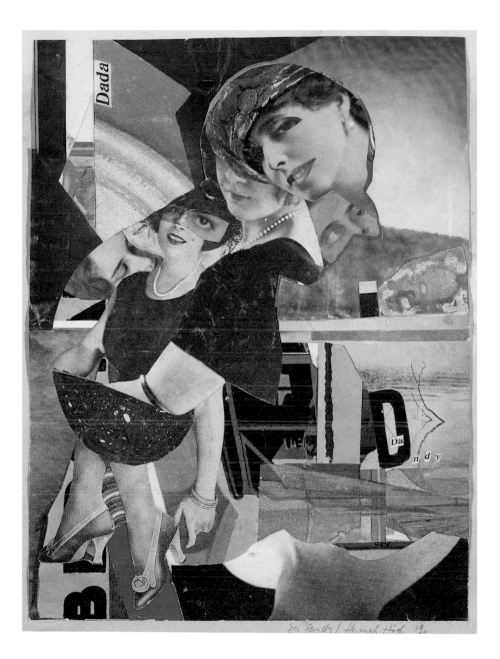

6

—

DA DANDY 1919
PHOTOMONTAGE
11 ¹³⁄₁₆ X 9 ¹⁄₁₆ IN. (30 X 23 CM)
PRIVATE COLLECTION

During the early Weimar era Höch often made silhouette portraits, cut from black or white paper, of friends such as Nelly van Doesburg, Hans Arp, Salomo Friedlaender, and others. Here, the silhouette of a man, accentuated by a bit of red backing paper Höch left exposed around the outline of his head, subsumes fragmented images of fashionable, seductive "New Women." By titling the work *Da Dandy*, Höch identified this male figure as both a Dadaist and a dandy, thus referencing the fascination of the Dadaists (in particular, George Grosz and Raoul Hausmann) with fashion. — MM

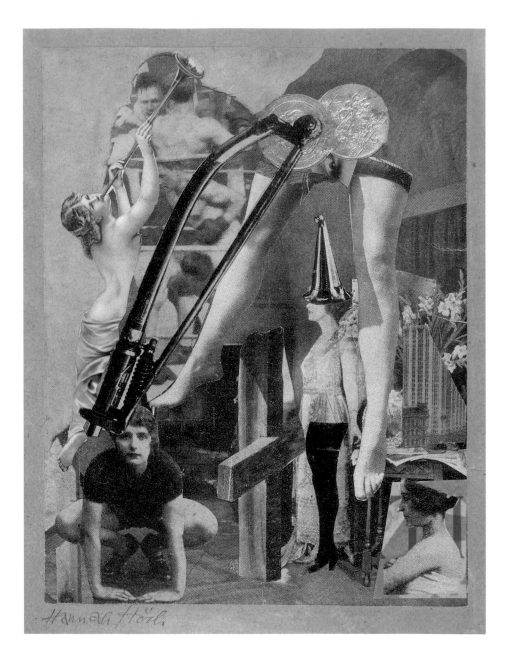

7

DADA-ERNST 1920–1921
PHOTOMONTAGE
7 5/16 X 6 9/16 IN. (18.6 X 16.6 CM)
COLLECTION ARTURO SCHWARZ, MILAN

This title can be read literally, as "Dada-Serious," or as a possible punning reference to Max Ernst, the Cologne-based Dadaist who, like Höch, also worked extensively in collage and photomontage. — MM

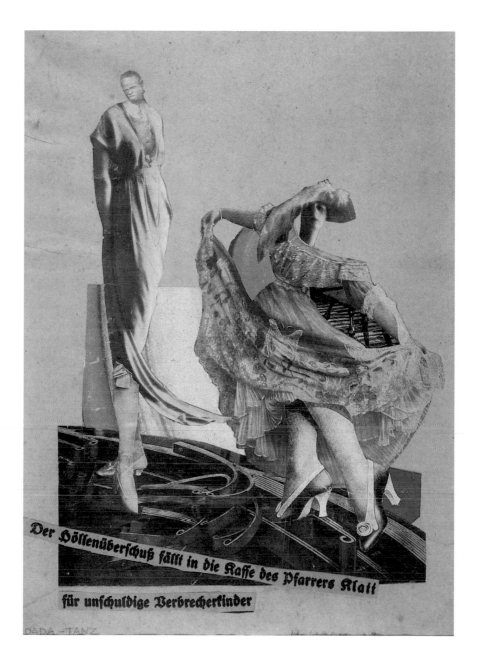

8

DADA-TANZ (Dada Ball) 1922
PHOTOMONTAGE WITH COLLAGE
12 ⅜ X 9 1/16 IN. (32 X 23 CM)
COLLECTION ARTURO SCHWARZ, MILAN

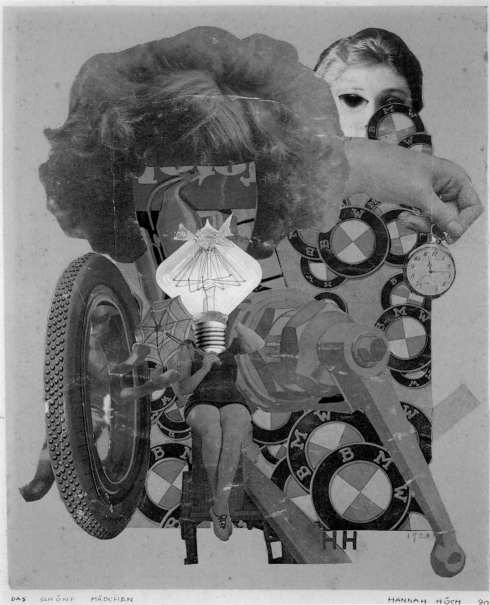

9

DAS SCHÖNE MÄDCHEN (The Beautiful Girl) 1919–1920
PHOTOMONTAGE
13 ¾ X 11 ⁷⁄₁₆ IN. (35 X 29 CM)
PRIVATE COLLECTION

Höch not only removed or obliterated the faces of the women in this photomontage but surrounded them with such signs of mechanization as a crank shaft, an I-beam, and an automobile tire. The colorful BMW insignia may have been provided by Höch's brother-in-law, an engineer at Knorr-Bremse, whose chief stockholder had purchased BMW after World War I. The only media source discovered to date for this work is a reproduction of the black American boxer Jack Johnson in a fight with Jim Jeffries, illustrated in one of the many articles on boxing that appeared in the popular press of the early Weimar era. So similar are the size, composition, and theme of this photomontage to *High Finance* (pl. 10) that the two works may have been conceived as counterparts. — MM

BIZ 29, no. 35 (29 August 1920), p. 399

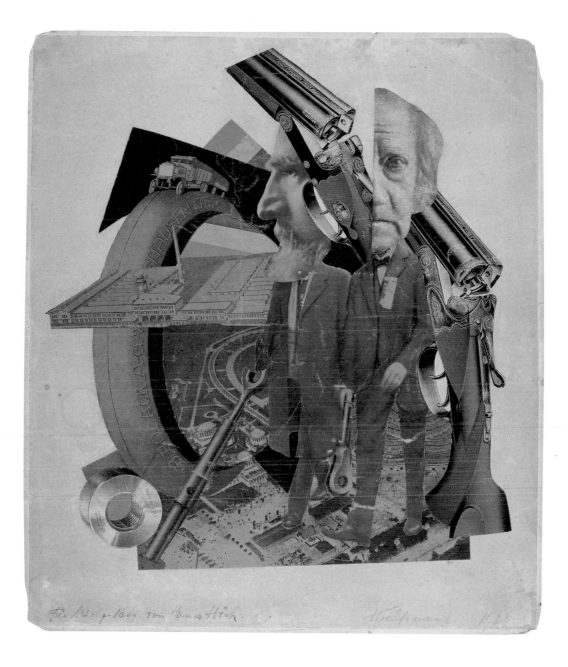

10

HOCHFINANZ (High Finance) 1923
PHOTOMONTAGE WITH COLLAGE
14 ³⁄₁₆ X 12 ³⁄₁₆ (36 X 31 CM)
COURTESY GALERIE BERINSON, BERLIN

Although this work is signed and dated 1923, it is possible that Höch made it earlier: the piston rod held by the bearded male figure is a duplicate of that which links the two halves of *Dada cordial* (pl. 5), made by Höch and Raoul Hausmann around 1919; and the imagery and compositional format of the work relate more to the photomontages Höch produced in the years she was tangentially affiliated with Berlin Dada than to her work after 1922, when she was associated with international Constructivism. The piece, in fact, is very similar to *The Beautiful Girl* (pl. 9), which also dates to around 1920. The only media source for *High Finance* located to date derives from a 1920 article on old photography that reproduced a portrait by Julia Margaret Cameron of the chemist Sir John Herschel, from which Höch fashioned the head of the male figure on the right. In 1925, Lázsló Moholy-Nagy illustrated Höch's photomontage in his book *Malerei, Photographie, Film*, where it was given two alternate titles: *Der Milliardär* (*The Multi-Millionaire*) and *Das zweifache Gesicht des Herrschers* (*The Dual Countenance of the Ruler*). Höch dedicated the work to the artist with an inscription at the lower left: "Für Moholy Nagy von Hannah Höch." — MM

Die Dame 47, no. 15 (mid-May 1920), p. 5

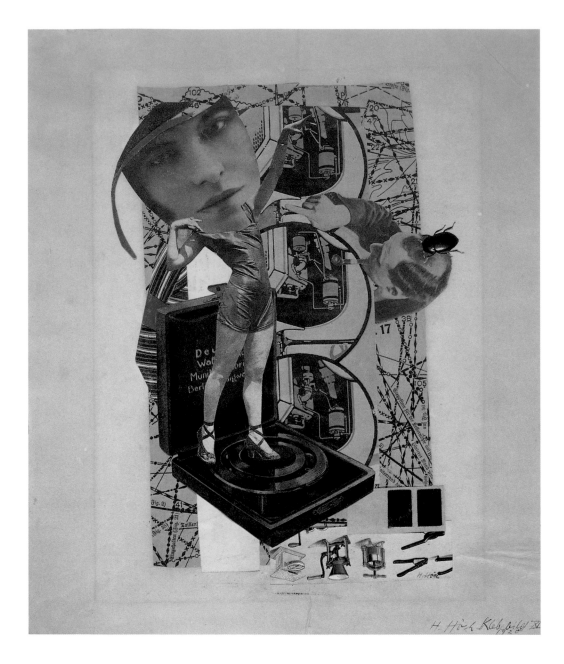

I I

OHNE TITEL (Untitled) 1921
PHOTOMONTAGE
14 X 12 IN. (35.6 X 30.5 CM)
MORTON G. NEUMANN FAMILY COLLECTION

Although this work often has been dated to 1920, its central media source—a photographic reproduction of a dancer posing on the beach (identified in the caption as Claudia Pawlowa, then on tour in Germany with the Saint Petersburg ballet)—came from a June 1921 issue of *Die Dame*. Höch replaced the dancer's smiling face with that of a woman who appears pensive, even melancholic, and moved her from the glamorous and spacious beach setting to one crowded with mechanical and domestic objects. These include a ball bearing nestled in a case, whose inside lid refers to the Borsigwerke, a suburban Berlin factory that produced trains and munitions; encircled and upended diagrams of a car engine; and, at the lower right, kitchen appliances turned on their heads. All these objects float on a fragment of a sewing pattern that Höch doubtless obtained through her job as a designer in the handicraft division of Ullstein Press. — MM

Die Dame 48, no. 18 (late June 1921), p. 6

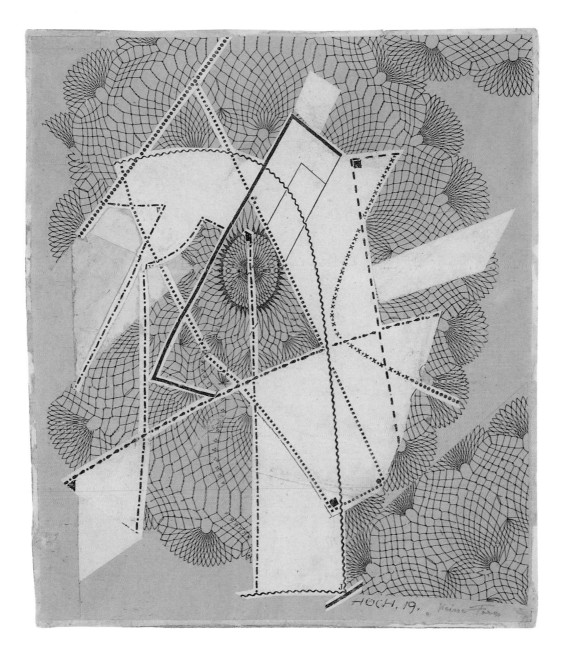

12

WEIßE FORM (White Form) 1919
COLLAGE
12 ³/₁₆ X 10 ¼ IN. (31 X 26 CM)
COLLECTION STAATLICHE MUSEEN ZU BERLIN, KUPFERSTICHKABINETT

As a designer of embroidered and lace cloths in the handiwork division of Ullstein Press, Höch had easy access to multiple copies of the sewing and handiwork patterns produced by the firm. For the ground of this collage she used three copies of a pattern for a lace doily from an Ullstein book on net work and tulle embroidery, and she created the "figure" atop the ground from sewing patterns. Rather than being printed side by side as they are today, the solid and broken, straight and curved lines of sewing patterns, which denoted the shapes of the component pattern pieces, were superimposed one atop the other at the time in order to conserve paper. — MM

Musterfilet und Tüllarbeiten, Ullstein Handarbeits Bücher 17 (Berlin: Verlag der Ullstein-Schnittmuster, n.d.)

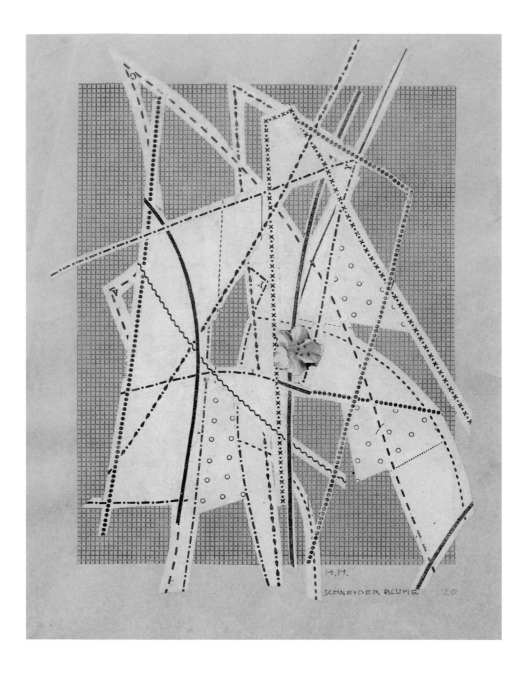

13

SCHNEIDERBLUME (Tailor's Flower) 1920
COLLAGE
20 ¼ X 17 ¼ IN. (51.4 X 43.8 CM) (FRAMED)
COLLECTION LOUISE ROSENFIELD NOUN, DES MOINES, IOWA

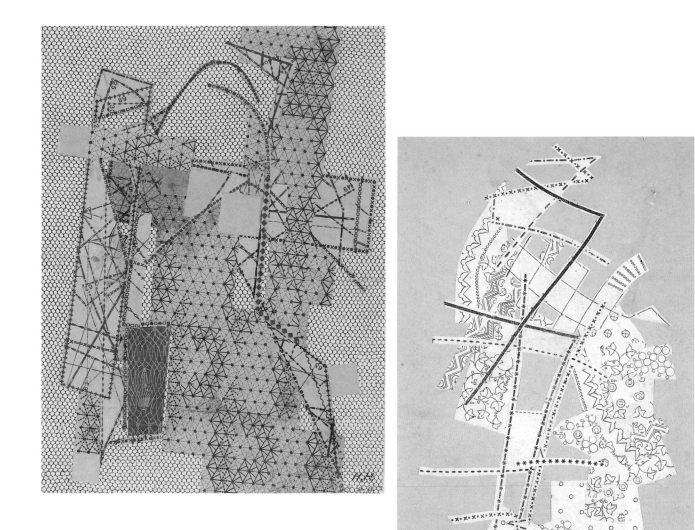

14

AUF TÜLLGRUND (On a Tulle Net Ground) 1921
COLLAGE WITH PRINTED PAPERS
12 ³⁄₁₆ X 9 IN. (31 X 22.8 CM)
COURTESY BUSCH-REISINGER MUSEUM, HARVARD UNIVERSITY ART MUSEUMS, CAMBRIDGE, MASSACHUSETTS
GIFT OF ROSE FRIED GALLERY

15

ENTWURF FÜR DAS DENKMAL EINES BEDEUTENDEN SPITZENHEMDES (Design for the Memorial to an Important Lace Shirt) 1922
COLLAGE
10 ¼ X 7 ¹¹⁄₁₆ IN. (26 X 19.5 CM)
COLLECTION HAMBURGER KUNSTHALLE, HAMBURG

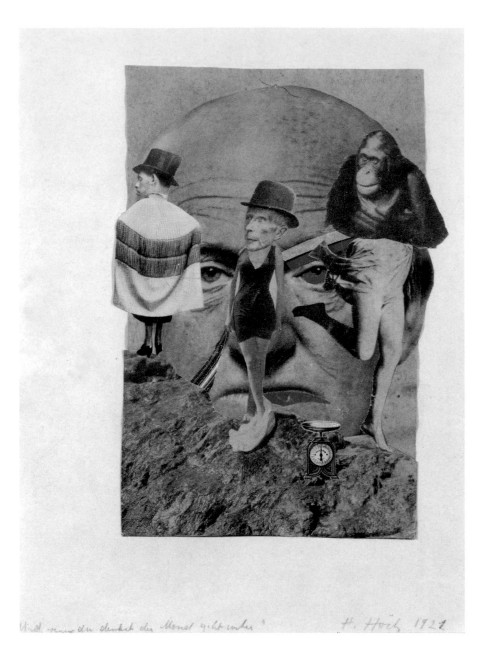

16

UND WENN DU DENKST, DER MOND GEHT UNTER (And When You Think the Moon is Setting) 1921
PHOTOMONTAGE WITH COLLAGE
8 ¼ X 5 ¼ IN. (21 X 13.4 CM)
PRIVATE COLLECTION

"When You Think the Moon is Setting" was the title of a popular 1921 song, the last verse of which suggested that, like the moon, which only appears to set every night, Germany (then suffering political, social, and economic problems in the postwar hyperinflation) would rise again. Pictured here are the well-known financial tycoon John D. Rockefeller and the erstwhile radical author Gerhart Hauptmann, by this time regarded by the left as a political opportunist who had sold out. By shearing Hauptmann of his trademark bushy white hair and using his now-bald head to evoke the moon, Höch identified the writer with the sort of nationalistic sentiment implicit to the lyrics of the song. The only media source located to date provided Höch with the legs of the unidentified figure at left. — MM

Die Dame 47, no. 21 (mid-August 1920), p. 14

17

NEW YORK c. 1922
PHOTOMONTAGE
11 ⅝ X 7 5/16 IN. (29.5 X 18.5 CM)
COLLECTION STAATLICHE MUSEEN ZU BERLIN, KUPFERSTICHKABINETT

18

GELD (Money) c. 1922
PHOTOMONTAGE
3 15/16 X 6 ⅞ IN. (10 X 17.5 CM)
COLLECTION INSTITUT FÜR AUSLANDSBEZIEHUNGEN, STUTTGART

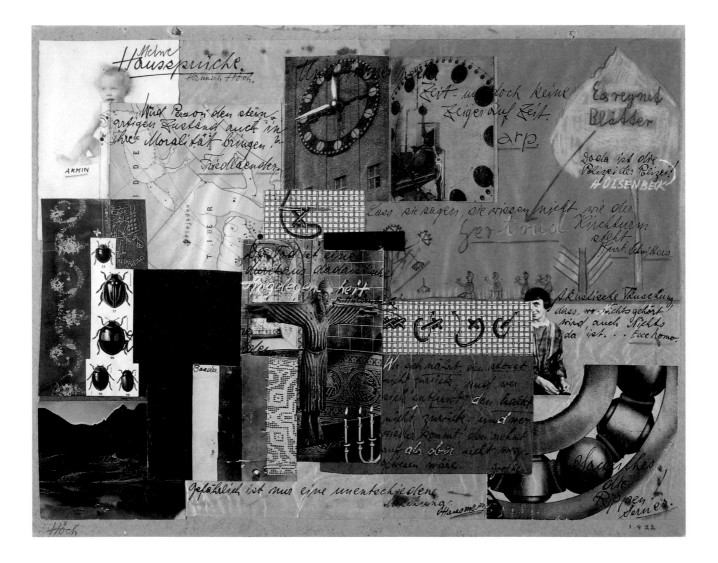

19

MEINE HAUSSPRÜCHE (Proverbs to Live By) 1922
PHOTOMONTAGE WITH COLLAGE, INK, ZINC WHITE, CRAYON, GRAPHITE, COLORED PENCIL, AND ORIGINAL PHOTOGRAPHS ON CARDBOARD
12 ⅝ X 16 3/16 IN. (32 X 41.1 CM)
COLLECTION BERLINISCHE GALERIE, LANDESMUSEUM FÜR MODERNE KUNST, PHOTOGRAPHIE UND ARCHITEKTUR, BERLIN

In 1922 Höch separated from Raoul Hausmann and took her leave from Berlin Dada as well, bidding her adieu in this complex, multilayered photomontage. In it, quotes from the Dadaists and like-minded writers are paired with well-chosen images on a vertical-horizontal grid that is more Constructivist than Dada in format. Indeed, at least one interpreter of this work has argued that the text-image interplay operates as an ironic critique of Dada art and philosophy rather than as homage. Thus, for example, Richard Huelsenbeck's statement "Der Tod ist eine durchaus dadaistische Angelegenheit" (Death is a thoroughly Dadaist affair) is written over a medieval crucifix, while Salomo Friedlaender's query "Wird Person den sternartigen Zustand auch in ihre Moralität bringen?" (Will a person bring the heavenly condition into her morality as well?) is inscribed atop an astrology chart of the constellations. However one interprets Höch's stance on these and other statements included here—by Hans Arp, Johannes Baader, Goethe, Raoul Hausmann, Kurt Schwitters, Walter Serner, and Nietzsche—the work represents an important visual/textual compendium of Dada philosophy. — MM

20

ASTRONOMIE (Astronomy) 1922
COLLAGE
10 ⅛ X 8 1/16 IN. (25.7 X 20.5 CM)
COURTESY THE MAYOR GALLERY, LONDON

21

POESIE (Poem) 1922
COLLAGE WITH INK
10 1/16 X 7 11/16 IN. (25.5 X 19.5 CM)
PRIVATE COLLECTION

22

COLLAGE (DADA) C. 1922
COLLAGE
9 ¾ X 13 IN. (24.8 X 33 CM)
COLLECTION MERRILL C. BERMAN

23

DAS STERNFILET (The Lace Star) 1924
COLLAGE WITH FABRIC AND PAPER ON CARDBOARD
10 15/16 X 7 5/8 IN. (27.8 X 19.3 CM)
COLLECTION STAATLICHE MUSEEN ZU BERLIN, KUPFERSTICHKABINETT

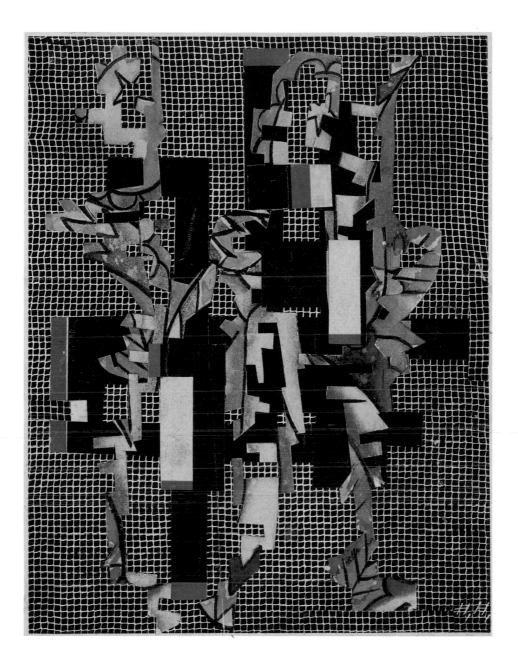

24

OHNE TITEL (Untitled) 1925
COLLAGE WITH PRINTED AND COLORED PAPERS
9 ¾ X 7 ⅛ IN. (24.5 X 19.2 CM)
COLLECTION THE MUSEUM OF MODERN ART, NEW YORK
GIFT OF MISS ROSE FRIED

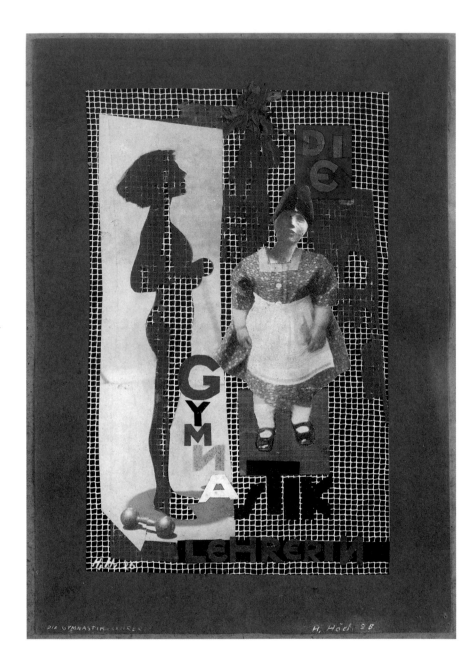

25

DIE GYMNASTIKLEHRERIN (The Gymnastics Teacher) 1925
PHOTOMONTAGE WITH COLLAGE
11 X 7 ¹³⁄₁₆ IN. (27.9 X 19.8 CM)
COURTESY REINHOLD BROWN GALLERY, NEW YORK

BY DESIGN: THE EARLY WORK OF HANNAH HÖCH IN CONTEXT

MARIA MAKELA

IN THE SUMMER OF 1920, when residents of Berlin's upscale Tiergarten district visited the gallery of the local art dealer Dr. Otto Burchard, they saw not an exhibition of the Chinese porcelain that was Burchard's specialty but a group of 174 works by some twenty-seven German and foreign artists affiliated with the so-called "Dada" movement. Acknowledged since that time as a watershed event in the history of modern art, the exhibition was then known only as the First International Dada Fair, a title chosen by its organizers—George Grosz, Raoul Hausmann, and John Heartfield—for its implicit critique of the conventional ways in which fine art was defined and exhibited. Instead of oil paintings and carved or cast sculpture, Burchard's gallery was filled with political posters, cheap reproductions of artworks, advertisements, collaged paintings, and photomontages. Alerted to the anti-militarism of Grosz's print portfolio *Gott mit uns!* (*God with Us!*) and of Heartfield and Rudolf Schlichter's collaborative "sculpture" *Preußicher Erzengel* (*Prussian Archangel*), which was suspended from the ceiling and portrayed an army officer in a pig's mask, legal authorities charged the exhibition's participants with "insulting the military" and brought several of them to court for violating the penal code. Burchard, Schlichter, and Johannes Baader were ultimately exonerated, but Grosz and Wieland Herzfelde were each punished with fines.[1]

Anna Therese Johanne Höch, known to her family and friends simply as Hanna or Hannah Höch,[2] was represented in this exhibition by a poster, two handmade dolls, two "reliefs," and four collaged works—most notably the photomontage *Schnitt mit dem Küchenmesser Dada durch die letzte weimarer Bierbauchkulturepoche Deutschlands* (*Cut with the Kitchen Knife Dada through the Last Weimar Beer-Belly Cultural Epoch of Germany*, 1919–1920) (pl. 1).[3] Like most other works in the Dada Fair, this photomontage—monumental in both its theme and scale—implicitly critiqued currently received notions of art and its purported mission. Composed solely of photographs and photographic reproductions that Höch had cut from widely accessible mass-media periodicals, the work was remarkably self-effacing in style—a testament to Dada's impatience with the Expressionist affirmation of individuality and subjectivity. It shared the Fair's underlying theme of anti-militarism, too, for it spoofed well-known male politicians and military figures by endowing them with the body parts of women and animals. Even the riotous tone of Höch's densely packed composition echoed the carnivalesque atmosphere of the Dada Fair as a whole. Indeed, *Cut with the Kitchen Knife* telescoped the methods and meanings of the First International Dada Fair into a single, iconic image.

It is largely through the lens of this work, in particular, and of the Dada Fair, in general, that Höch's career has been viewed to date. Perennially flashed on the screen in courses on modern art history, *Cut with the Kitchen Knife* is also presented in survey texts as the sine qua non of Höch's career. Yet, ironically, the piece is more the exception than the rule in her work. Even during the years she was most closely affiliated with Dada, Höch preferred to work on a smaller, more intimate scale and to use a more quiet, subtle form of address. It is perhaps for this reason that she has been disregarded not only by generations schooled to equate Berlin Dada with bombast but by the Berlin Dadaists themselves. For her part, Höch viewed the movement with a jaundiced eye, despite her myriad personal and professional connections to it. Her sense of propriety was so deeply ingrained that she was often embarrassed by the antics of her colleagues,[4] and she certainly did not wholly approve of their bohemian lifestyles.[5] Höch's respect for artistic tradition was equally strong and, unlike the other Berlin Dadaists, she never abandoned, even temporarily, the "bourgeois" medium of painting. On the contrary, between the Dada Fair of 1920 and the *Film and Foto* exhibition in Stuttgart in 1929, Höch chose to represent herself to the public exclusively by means of her easel paintings, watercolors, drawings, and—notably—her handiwork and applied art. Beginning in 1916, her detailed designs for embroidery, lace, textiles, and wallpaper, together with her many publications on these subjects, both earned her keep and won her awards and critical acclaim.

Recent feminist art history has argued that the activity taking place on the so-called fringes of modernism defines the values of this tradition as much as the acclaimed activity taking place at its center.[6] It is in this spirit that I want to disentangle Höch from the knot of Dada and to

1. *Vase mit Chrisanthemen (Vase with Chrysthanthemums),* 1909, watercolor. Private collection.

elaborate some of the other contexts in which she lived and worked. I will argue, for example, that Höch's work in traditional women's crafts and in commercial design was as significant to her and to the development of her aesthetic as her involvement with Dada and other modernist art movements such as Expressionism and Constructivism.[7] And I will emphasize the importance for the artist of the newly illustrated mass-media periodicals produced by her employer, Ullstein Verlag, Germany's largest publishing company.[8] By uncoupling (though not severing) the narrative from Dada, I hope to show that the richness of Höch's work resides at least in part in the multiplicity of its myriad sources.

Early Training in Design and Handicraft

Höch was born in 1889 in the city of Gotha, a small town in Thuringia where her father was an official of an insurance company and her mother, an amateur painter, managed a large home and family of seven. By her own account, Höch's family life in Gotha was "bourgeois" and "well-ordered,"[9] and it is likely that her early attempts at art were thus encouraged as a suitable avocation for a young lady. A precocious talent with an eye for observation, Höch trained her artistic attention first on family members and then on the countryside surrounding her home, especially on the flowers that her father, an avid gardener who inspired Höch with a lifelong love of nature, cultivated in his spare time (fig. 1). Although Höch's parents initially balked when their daughter declared her desire to study art in Berlin,[10] they ultimately acquiesced. It was probably at their wish that Höch pursued the "applied" rather than the "fine" arts; many parents of aspiring artists felt this to be a more secure career path and one especially suited to women. Accordingly, in 1912, Höch enrolled at the Kunstgewerbeschule Charlottenburg (Charlottenburg School of Applied Arts).

As part of her training there, Höch studied calligraphy and later recalled how much she enjoyed the painstaking exercises in lettering.[11] Indeed, she became an accomplished calligrapher and was employed, for one, by the city of Charlottenburg to design elaborately scripted and decorated certificates of honor for its employees (fig. 2).[12] She also attended classes under Harold Bengen, a specialist in glass design who encouraged his students to work in a variety of media. Under Bengen's tutelage Höch began to focus on embroidery, winning recognition for at least two designs that were subsequently featured in the prestigious needlework journal *Stickerei- und Spitzen-Rundschau* (*Embroidery and Lace Review*). One (now lost), a sketch of a couple in a stylized landscape (fig. 3), was part of a series of Jugendstil-inspired designs for embroidered cloth panels that depict nude or classically draped figures in luxuriant arcadian settings.[13] Another, a dense floral arrangement embroidered atop a boldly striped cloth backing, adorned a folding screen (fig. 4).[14]

It was decorative designs like these that first won Höch accolades and awards.[15] Yet she ultimately became dissatisfied with the training provided by the Kunstgewerbeschule and, after a brief hiatus at the outbreak of World War I, transferred in January 1915 to the Unterrichtsanstalt des königlichen Kunstgewerbemuseums (School of the Royal Museum of Applied Arts). By her own account she was attracted to the institution's reputation for integrating the "fine" and the "applied" arts.[16] She was also, no doubt, impressed by its internationally recognized teaching staff, directed by the designer, architect, and *Simplicissimus* caricaturist Bruno Paul. Paul presided over a curriculum that then included architecture and interior design, decorative sculpture, metal design, set design and scene painting, graphic and book art, decorative painting and pattern design, and glass painting.[17] With her background in calligraphy, Höch was accepted into the graphic- and book-art division headed by Emil Orlik, a consummate printmaker known for his *japoniste* woodcuts. She thrived here, too, winning numerous awards and fellowships for work such as her striking design for the dust jacket of a book (fig. 5), which documents her early interest in tribal culture.[18]

2. (top left) Certificate of commendation designed by Höch, c. 1913, color lithograph. Collection Berlinische Galerie, Landesmuseum für Moderne Kunst, Photographie und Architektur, Berlin. **3.** (bottom left) Design for embroidered panel, c. 1915, published in *Stickerei- und Spitzen-Rundschau*, February 1916. **4.** (top right) Embroidered panel for a folding screen, c. 1915, published in *Stickerei- und Spitzen-Rundschau*, February 1916. **5.** (bottom right) Design for book cover, 1915, ink and gouache on cardboard. Collection Berlinische Galerie, Landesmuseum für Moderne Kunst, Photographie und Architektur, Berlin.

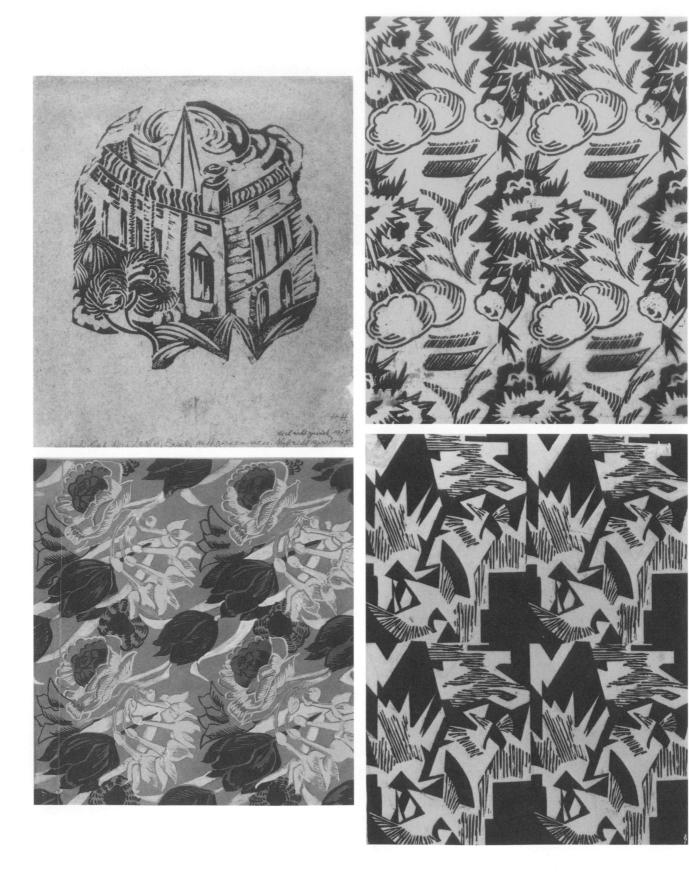

6. (top left) *Ohne Titel* (*Untitled*), c. 1916, linocut. Private collection. 7. (bottom left) Design for wallpaper, c. 1920, ink, watercolor, and gouache. Courtesy Galerie Alvensleben, Munich. 8. (top right) *Frost*, c. 1915, linocut. Germanisches Nationalmuseum, Nuremberg (on loan from private collection).
9. (bottom right) *Kommen flatternde Vögel* (*Flapping Birds Coming*), 1915, linocut. Germanisches Nationalmuseum, Nuremberg (on loan from private collection).

10. Design for the cover of *NG*, 1921, woodcut on paper. Collection Merrill C. Berman.

This interest in ethnography was very likely sparked by Höch's discovery of Expressionism, whose main practitioners in both northern and southern Germany were all enthusiasts of African and Oceanic cultures. Höch could have first encountered Expressionism the very year she came to Berlin, for it was in 1912 that Herwarth Walden opened the gallery Der Sturm (The Storm), a clearinghouse for art of the international avant-garde, especially Expressionism and Futurism. In that year alone Walden mounted a one-man show of the work of Oskar Kokoschka and group shows of artists affiliated with the Blaue Reiter (Blue Rider), Italian Futurist, and Berlin "Pathetiker" (Pathetic Ones) movements. Höch may also have been reading Walden's *Der Sturm* magazine, which featured, above all, Expressionist graphic art. But certainly by 1915 Höch was fully conversant with the Expressionist vocabulary, for it was at this time that she became romantically involved with the writer and artist Raoul Hausmann, who was friendly with a number of the Brücke (Bridge) artists and tangentially affiliated with Der Sturm.[19] Höch later recounted that she and Hausmann were enthusiastic about almost everything Walden did at the time,[20] and her estate is indeed a rich repository of Sturm magazines and exhibition catalogues.[21]

An undated linocut by Höch from about 1916 (fig. 6) bears witness to the artist's encounter with Expressionism. The swinging curves of Jugendstil are still very much present here and in other contemporaneous prints she made, but now they are of uneven width and massed together in striated areas that seem to quiver with nervous tension. Even the house facade is animated, swelling outward as if heaving some great architectural sigh. This cityscape, energized by a restless life force very different from the one that pervades the calm arcadias of her earlier embroidery designs, testifies to Höch's engagement with Expressionism via Hausmann.

Höch soon adapted the Expressionist idiom to her "decorative" art, especially to her designs for printed fabrics. Although she had probably begun to experiment with textile design as part of her studies with Orlik, she evidently enjoyed the work, for she continued to make fabric patterns well into the 1920s.[22] Executed either in pencil, ink, or gouache (fig. 7) or in black-and-white or hand-colored linocut (figs. 8, 9), this work is distinguished above all by bold patterns, both abstract and representational, that are tilted slightly off-center or organized on the diagonal. The intricate, asymmetrical rhythms of these dynamic compositions immediately distinguish them from the more delicate and static patterns favored by the Jugendstil textile designers, and they so impressed Germany's preeminent patron of the decorative arts, Alexander Koch, that he tried to help Höch market them to firms in Berlin and Frankfurt.[23] Koch also published at least three of her fabric patterns in a 1920 issue of *Stickerei- und Spitzen-Rundschau*, along with a glowing review that emphasized their contemporaneity.[24] Declaring Höch "a new talent who deserves attention," its author employed musical metaphors in an analysis of the works' "melodies of lines," "Asian-influenced color harmonies," and "complex rhythms."[25] One year later, the critic Adolf Behne similarly praised Höch's textile designs for their lively rhythms, ornamental qualities, and "thoroughly modern feeling for color and form." Behne was also taken with Höch's magazine and book-cover designs, singling out those she made for a 1921 issue of *Die Kornscheuer*, a monthly publication dedicated to the arts, and for *NG*, the official publication of the November Group, a socially and politically oriented artists' organization (fig. 10).[26]

11 a–c. Dress designs, 1920s, graphite on parchment paper.
Collection Berlinische Galerie, Landesmuseum für Moderne Kunst,
Photographie und Architektur, Berlin.

12. Design for darned filet, 1920s, graphite on paper. Collection Berlinische Galerie, Landesmuseum für Moderne Kunst, Photographie und Architektur, Berlin.

It was doubtless her training in graphics and book design, together with her expertise in embroidery and textile design, that landed Höch a job on the editorial staff of Ullstein Verlag's handiwork division, where she worked three days a week from 1916 to 1926, designing and making patterns for embroidered and lace cloths. Founded by Leopold Ullstein in 1877, Ullstein Verlag had developed into one of Germany's largest publishing companies by the time Höch was hired. Its success was based largely on mass-circulation periodicals such as *Berliner Morgenpost* (Berlin Morning Post) and *BZ am Mittag* (B[erliner] Z[eitung] at Noon), both dailies, and the weekly *Berliner Illustrirte Zeitung* (Berlin Illustrated Newspaper, or *BIZ*). But Ullstein also published a large number of smaller circulation magazines and ran a sewing- and handicraft-pattern business that became especially profitable during World War I. At that time the company began to mass-produce patterns in standardized rather than made-to-order sizes and to market them widely in special Ullstein pattern shops and in department stores in Germany, Austria, the Netherlands, and Switzerland.[27] As the first and, at the time, only producer of such patterns, Ullstein developed a very profitable market throughout Europe, where women everywhere were looking to cut costs. The company's *Schnittmusterdienst* (Pattern Service) grew exponentially, and Höch, who specialized not in sewing but in needlework patterns, was one of many to be hired as this division expanded. Because few if any men were trained in this field, it was a secure position during the postwar period of demobilization, when hundreds of thousands of German women otherwise lost their jobs to returning soldiers.

Höch's duties at Ullstein Press included designing stuffed animals, women's fashions (fig. 11a-c),[28] and layouts and advertising vignettes for handiwork publications and patterns. But her principal job consisted of sketching patterns for embroidered and lace cloths (fig. 12) and then fabricating these pieces in various techniques, including cutwork, drawn- and pulled-thread work, needle lace, darned filet, and embroidery (figs. 13a–d). Höch would then make drawings of the finished products (fig. 14), and these, or actual photographs of the objects, would appear in special Ullstein pattern books[29] or in Ullstein's women's magazines. Between 1922 and 1925, *Die Dame* (The Lady) alone featured at least twelve of Höch's designs, and before she left Ullstein in 1926, many more were likely published there and in such other Ullstein journals as *Die praktische Berlinerin* (The Practical Berlin Woman).[30] Readers could then purchase the patterns and instructions at the special Ullstein pattern stores or in regular department stores.

Although Höch occasionally complained about the time she had to invest in her job, she enjoyed the work and regarded it as an artistic vocation on a par with painting and sculpture.[31] In this regard, her work for *Stickerei- und Spitzen-Rundschau* is particularly telling. In addition to the embroidery designs from her student days published there in 1916 and the fabric designs featured in its 1920 issue, at least four of Höch's subsequent needlework patterns and three of her fabric designs (including one for a prize-winning tablecloth) were published in the journal.[32] She also wrote at least four articles for the magazine: "On Embroidery" (September 1918), "What is Beautiful?" (October–November 1918), "Whitework" (December 1918), and "The Fine Art of Embroidery" (October–November 1919). Central to each was Höch's conviction that needlework should command the same respect as other "fine" arts:

13 a–d. (opposite) Embroidered tablecloth with cutwork (background), needle-lace doily (top), runner with drawn-thread work (center), doily with drawn-thread work and crocheted edge (bottom), 1920s. Collection Berlinische Galerie, Landesmuseum für Moderne Kunst, Photographie und Architektur, Berlin.

14. Design for embroidered tulle tablecloth with crocheted edge, c.1924, published in *Die Dame*, February 1924.

"Embroidery . . . is an art," she wrote unequivocally at the end of 1918, "and it has the right to demand that it be treated as such."[33] Yet most needlework of the time was second-rate, according to Höch, produced by women who had no feel for color, composition, or form and who were still overly dependent on nature as a model. Just as painting had recently developed an abstract language of form and color, so too, Höch argued, should embroidery unfetter itself from illusionism. The true artist should produce not the endless "flowers, baskets, birds, and spirals" that still dominated contemporary European embroidery[34] but rather "pure" needlework "from her innermost intuition."[35]

The protagonist of Höch's short story "The Embroidering Woman" (1919), also published in *Stickerei- und Spitzen-Rundschau*, was just such an artist: a needleworker who looks inward rather than outward for inspiration. Moved by the beauty of a vase of red roses, she gives her "soul" free reign to play "with the most wonderful forms, letting them grow into organic expanses [of color] that intertwined; one didn't know if it was the night sky, a bit of meadow in May, or the infinitely tender embraces and games of love." When her mate enters the room, she hesitantly shows him her handiwork, by now covered with a densely stitched, glowing red design of interlocking abstract forms. "Therein lies the soul of the woman," he softly proclaims, to which Höch's ideal needleworker responds, in the story's final passage: "My soul wants to compose poetry, but my words are too poor. My heart wants to sing, but my voice does not move. Indeed, my eyes want to radiate everything for the pleasure of humanity, for your pleasure—I can only embroider."[36]

There is no record of the reception accorded Höch's story at the time of its publication, but it is doubtful that any of her contemporaries read it as we might today, as a celebration of traditional feminine work or of conventional feminity and the roles associated with it. On the contrary, at a time when most associated handiwork with craft, not art, and regarded the female needleworker, however original or talented, not as an artist but a craftsperson, the idea that embroidery, like painting or sculpture, could express deeply felt emotion was subversive in the extreme. Indeed, by locating the very "soul" of the needleworker in the finished embroidery, Höch adopted the discourse of the "fine" arts—specifically, of Expressionism, which held that the artwork was a cipher of individual subjectivity. Yet however unconventional Höch's stance on handiwork, it is nevertheless startling that she wrote the *Stickerei- und Spitzen-Rundschau* essays and produced the majority of her embroidery and fabric designs during the very years she was most closely affiliated with Berlin Dada. Höch was, in fact, as much a part of the world of women's "crafts" in the late 1910s and early 1920s as she was of the rough-and-tumble "avant-garde" world of Dada, and for her there was evidently no contradiction in this. It is perhaps not surprising that this aspect of her life and artistic production has been downplayed or ignored completely; but it is regrettable insofar as her early engagement with needlework and fabric design provided an important thematic, formal, and technical base for her collage aesthetic.

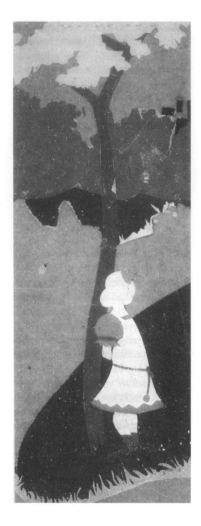

COLLAGE AND THE BEGINNINGS OF PHOTOMONTAGE

Like many, Höch experimented with collage while still a child, working with colored papers or cutting apart the many illustrated journals to which her family subscribed and then pasting the pictures into scrapbooks.[37] Her first mature work in the medium was *Nitte unterm Baum* (*Nitte under a Tree*, 1907) (fig. 15), a cut-paper portrait of the youngest member of the Höch family, Marianne, standing in a child's pose beside a tree. This was the only collage Höch would make for some time to come, for in subsequent years she devoted herself primarily to handiwork and design. She returned to the medium only in the late 1910s, when she simultaneously began to recycle the materials of her design work in collages and to use photographic reproductions from the mass media in photomontages.

Occasionally Höch cut up her own textile designs, using brightly colored bits of her hand-tinted linocuts to enliven abstract compositions (pl. 24). More often she recycled needlework patterns. Diagrams of filet, a kind of net made of knotted horizontal and vertical threads into which a design is darned, served as the background of many collages (pls. 13, 19–20, 24–25), as did patterns for hexagonal net (pl. 14). Höch also cut

15. (opposite) *Nitte unterm Baum* (*Nitte under a Tree*), 1907, collage. Collection Peter Carlberg, Hofheim, Germany.

16. *Der Anfang der Photomontage* (*The Origins of Photomontage*), n.d., steel engraving (military memento from 1897–1899) with color and collage. Collection Berlinische Galerie, Landesmuseum für Moderne Kunst, Photographie und Architektur, Berlin.

up and reconfigured needle-lace patterns (pl. 12) and embroidery patterns of abstract or stylized forms from nature (pl. 3). Although there is no evidence that she made sewing patterns for her work at Ullstein, Höch had access to them through her colleagues, and in cut-up form they, too, found their way into her collages. The scrap of paper with numbered lines that vertically anchors *Auf Tüllgrund* (*On a Tulle Net Ground*, 1921) (pl. 14) on the left is a fragment of a sewing pattern, as are the solid and broken flowing lines in *Entwurf für das Denkmal eines bedeutenden Spitzenhemdes* (*Design for the Memorial to an Important Lace Shirt*, 1922) (pl. 15) and in *Weiße Form* (*White Form*, 1919) (pl. 12).

At the same time, Höch was also producing collages made mostly or entirely from photographic reproductions—photomontages, as she and others of the period called them. Her first work in this medium dates to 1918, when she took a summer vacation with Hausmann on the Baltic Sea and, while visiting the town of Heidebrink on the island of Usedom, first became aware of the potential of the technique. There the couple encountered in the homes and businesses of the residents a popular type of engraving in which photographic portrait heads of local men away at war had been collaged atop generic, uniformed torsos (fig. 16).[38] Höch and Hausmann returned to Berlin and immediately began to experiment with the medium by clipping photographic reproductions from a wide variety of illustrated sources and then mixing and matching

them to create startling, often unsettling new imagery. Höch was especially well positioned to exploit this technique because of her employment with Ullstein, which had played an important role in developing and popularizing the picture magazine in Germany.

During most of the nineteenth century, mass-circulation periodicals had not contained photographic illustrations. At best they used wood engravings made from daguerreotypes or prints. The invention of the halftone printing process, in about 1880, made it possible to illustrate photographs along with type, since both could now be printed on the same press. But it was not until 1902, when Ullstein developed a process for printing on cylindrical, rotating presses, that photo-illustrated periodicals could be produced quickly and cleanly, with none of the ink-smudging common to the early picture papers that were printed on flat presses. The war briefly interrupted the development of the illustrated press, but the 1920s saw its efflorescence. Between 1918 and 1932 approximately thirty-two illustrated weeklies, bi-weeklies, or half-weeklies were published in Germany, and there were dozens of monthlies. Ullstein alone produced nine journals and nine newspapers

in 1929 that were photo-illustrated.[39] Although each of these periodicals targeted a slightly different audience, virtually all began to rely on photography for more than simple illustration or reportage: they used it especially to reveal familiar things from new angles. Particularly renowned for its innovative photographic spreads was Ullstein's *Der Querschnitt* (Cross Section), a cosmopolitan monthly read primarily by Berlin's artistic and literary avant-garde and, notably, frequently used by Höch as a source of imagery for her photomontages. By pairing, for example, a photograph of a yawning tiger with a close-up of an orchid blossom, one layout in the March 1926 issue called attention to the startling similarities between the feline's cavernous mouth, with its fanged teeth and tongue, and the interior of a bud just about to bloom. Another spread, in the June 1926 issue, paired a photograph of camels capable of traveling at 150 kilometers daily with a picture of an airplane, described as one of the fastest in the American airforce. Only indirectly related to the subjects covered in that month's articles, such ensembles suggested new ways of seeing the world and its natural, technological, and social structures.

Ullstein periodicals like *Der Querschnitt* were an important popular equivalent of photomontage, which similarly paired incongruous photographs or portions of photographs to suggest different ways of perceiving the world. Yet unlike the essentially uncritical photographic spreads of the mainstream illustrated press, Höch's photomontages of the Weimar era usually challenged the political or social status quo in some way. This is evident above all in her works that date to the years immediately following the end of World War I, when Germany was in shambles and Höch was tangentially affiliated with Berlin Dada.

EARLY PHOTOMONTAGE AND DADA

Höch's first photomontage has not been identified, but she must have made it sometime in the late summer or early fall of 1918, following her vacation with Hausmann on the Baltic coast. This was, of course, a time of tremendous social and political upheaval in Germany. In November alone, the armistice that ended World War I was signed, Emperor Kaiser Wilhelm II abdicated his imperial throne, and a republic was proclaimed by Social Democratic Party leader Philipp Scheidemann. Two months later, in January, elections were held to select delegates to a constitutional convention, and the moderate coalition of representatives elected from the Social Democratic Party, the Catholic Center Party, and the Democratic Party went on to prepare a constitution that was formally adopted in August 1919. This document provided legal status for the shift from autocracy to popular sovereignty and included, among other things, provisions for universal suffrage. For the first time, German women could vote.

The country's path toward parliamentary democracy was not, however, an easy one; on the contrary, it was marked by dissent and controversy from the beginning. Scheidemann's November proclamation of a republic had been made to forestall a similar declaration by the more radical Spartacist Party, which mounted an uprising in advance of the January elections. Desperate to maintain its tenuous power, the provisional government, led by President Friedrich Ebert, called on the old Imperial Army to suppress the revolt and murdered Spartacist leaders Rosa Luxemburg and Karl Liebknecht. These were bad precedents for a new democracy, and Luxemburg and Liebknecht were mourned by many on the left as martyrs to a government that had compromised itself even before it had formally assumed power. Indeed, Ebert's government failed either to break up the General Staff, as the Versailles treaty had demanded, or to dismantle the Junker estates of eastern Germany (the economic base of the Prussian military caste); nor did it dilute the influence of big business in either economic or political life. To many on the left of the political spectrum, the Weimar Republic seemed not all that different from Imperial Germany.

Höch's reaction to these tumultuous events was doubtless influenced by the radical Hausmann and his colleagues in the Berlin Dada movement. In almost every published and unpublished account of the period, Höch emphasized how naive she had been when she left Gotha for Berlin and credited Hausmann with extricating her from her ordered, bourgeois existence and teaching her to think for herself.[40] At the beginning of their stormy seven-year relationship she served as Hausmann's unofficial secretary, transcribing his own essays and others—on philosophy, psychology, sexuality, and politics—that interested him.[41] She also sometimes accompanied him to meetings of the Club Dada; attended, and occasionally participated in, Dada demonstrations and theatrical events; and familiarized herself with the Communist thought of Dadaists Grosz, Heartfield, and Herzfelde, as well as with the anarcho-communism of Hausmann, Huelsenbeck, and Franz Jung.[42] Although she never formally joined the Communist party, by her own account, Höch, too, believed at the time that of all the political factions, only the Communists could provide a more equitable and peaceful future for Germany.[43]

Of the many works by Höch that address the tumultuous political events discussed above, none is more unambiguous than *Staatshäupter* (*Heads of State*) (pl. 3). Although often dated in the literature to 1918–1920, the work was probably not made before August 24, 1919. On that day the *Berliner Illustrirte Zeitung* (*BIZ*) published on its front page the source of Höch's piece, a photograph of Defense Minister Gustav Noske and Reich President Friedrich Ebert, who just two weeks earlier had signed the Weimar constitution into law.[44] In stark contrast to the typical honorific portraits of such state officials in military uniform or respectable dress suits, the photograph showed the middle-aged Ebert and Noske in swim trunks, wading in the waters of a Baltic Sea resort. Höch heightened the comical effect of the original photograph by collaging the two men atop an iron-on embroidery pattern (which she may well have made herself at her job at Ullstein) depicting a woman

with a parasol reclining in a luxuriant landscape. By disassociating the politicians from the realm of masculinity and the noble endeavor of state formation and resettling them within the domain of femininity and leisured relaxation, she unambiguously parodied the politicians and their roles as the leaders of a newly democratized Germany.

Höch especially liked the photograph of Ebert and Noske and used a duplicate of it in *Dada-Rundschau* (*Dada Panorama*, 1919) (pl. 2).[45] In this densely configured work, Ebert—now with a flower tucked into his swimsuit—stands front and center, while just above and to the right the potbellied Noske emerges transcendent from a cloud of smoke. This placement and its attendant allusion was doubtless deliberate, for it was Noske who had saved Ebert's moderate government from sure demise when he commandeered the brutal put-down of the Spartacist revolt in January, referenced at the lower right of the work by a well-known photograph of government troops positioned atop the Brandenburg Gate during the uprisings. By dressing Ebert in knee-high military boots, Höch emphasized the symbiotic relationship between the new government of the Weimar Republic and the General Staff of the old Imperial Army, invoked at the lower left by the heads of Generals Ludendorff and von Seeckt. The first and last in a group of four, they bob ineffectually above the bodies of uniformed soldiers standing stiffly at attention. Höch further spoofed the government-military alliance by linking Ebert's military dress boots to the phrase "*Gegen feuchte Füße*" (against damp feet), a slogan then used to advertise a popular antiperspirant for feet.[46]

If *Heads of State* and *Dada Panorama* commented on Germany's political and military establishment, *Und wenn du denkst, der Mond geht unter* (*And When You Think the Moon is Setting*, 1921) (pl. 16) remarks on one of its great cultural icons, the writer Gerhart Hauptmann.[47] This former radical of the 1890s, whose play *Die Weber* (*The Weavers*) shocked audiences throughout Germany at the turn of the century, had become an imposing establishment figure long before Höch pictured him in her collage. Although Hauptmann had openly championed the war effort, in 1918 he threw his unequivocal support behind the Republic; by 1921, the year Höch made her photomontage, rumors even circulated that he would run as a candidate for the position of Reich president, which the publicity-loving author doubtless enjoyed but nevertheless denied.[48] Later, when Hitler consolidated his power, Hauptmann became one of his warmest admirers.[49] By this time, the left had long since written him off as a political opportunist who had sold out.

Höch, too, apparently saw this erstwhile radical as a trenchant symbol of Weimar Germany and its all-too-frequent accommodation to conservative political, military, and economic forces. "Wenn du denkst, der Mond geht unter" was a hit song in 1921, whose first two verses each end with a refrain about the moon: "Wenn du denkst, der Mond geht unter, er geht nicht unter, das scheint blos so" (If you think the moon is setting, it's not really setting, it only seems so). It is the third and all-important final verse that raises the subject of contemporary Germany, which, like the moon, only appeared to have "set" (or, more literally, "gone under"); Germans need only to believe in themselves, the lyrics tell us, and they, too, will soon rise up again.[50] By shearing Hauptmann

of his trademark bushy white hair and using his now-bald head, with its high forehead, to evoke a setting and rising moon, Höch identified the writer with the sort of nationalistic sentiment implicit in the song's lyrics. Insofar as both Hauptmann and the song were enormously popular in 1921, she also called attention here to the core of conservatism beneath Weimar Germany's liberal veneer.

Prominent among the other three figures in this photomontage is John D. Rockefeller, well known even in Germany as the financial tycoon who founded Standard Oil Trust. Given Höch's political inclinations at the time, it is not surprising that she spoofed Rockefeller by collaging his head atop the body of a woman in a bathing suit. Höch also took on big business in *Hochfinanz* (*High Finance*, 1923) (pl. 10), but here her tactic was rather different. The man at the right of the work is the nineteenth-century British chemist Sir John Herschel, whose portrait by the photographer Julia Margaret Cameron Höch found in an article in *Die Dame*. But viewers would likely have formed a rather different set of associations for Herschel and his unidentified colleague in the picture, largely because the landscape across which the two "financiers" stride was a well-known icon in Germany: the *Ausstellungsgelände* (Fair Grounds) and *Jahrhunderthalle* (Centennial Hall) in Breslau.[51] Seen here in an aerial photograph, this complex was built in 1913 by the architects Hans Poelzig and Max Berg as a centennial commemoration of the victory of the Germans over Napoleon in 1813. By the time Höch made *High Finance* in the early Weimar era, it had come to be regarded by many as a symbol of hope for a nation that once again had been defeated and occupied by the French. Every German would also have noted the conspicuous presence here of scraps of the red-white-and-black striped flag of the Empire (not of the Republic), one of which even seems to emerge from the mouth of the bearded man at left like a comic-strip balloon. Having thus associated the men of *High Finance* with the conservative ideologies of revanchism and monarchism, Höch further identified them as industrial producers of machinery or machine parts: their economic wealth is signified by the expensive hand-tooled, double-barreled shotgun that frames the image on the right; they use a piston rod and a rocker arm like canes; and a large ball bearing at the lower left brakes a tire with a truck atop it.

Taken together, *Heads of State*, *Dada Panorama*, *And When You Think the Moon is Setting*, and *High Finance* bespeak Höch's discomfort with the reigning political, cultural, and economic forces of the early Weimar Republic. Yet here, as elsewhere, the tone is more lightly ironic than heavily moralizing, the genre more spoof than satire. Höch had definite opinions, but already she expressed them with a tongue-in-cheek humor wholly unlike the vitriolic rancor of a George Grosz or John Heartfield. As a group, these early works also illustrate some key features of Höch's montage technique. With easy access through her job at Ullstein to multiple copies of the journals from which she took her source photographs, she sometimes used images she especially liked in two or more photomontages (as she did with the *BIZ* snapshot of Ebert and Noske). In a related practice, she often cut a single photograph into two or more separate pieces for use in different montages.

Or, by cutting a source image in two and using the pieces within the same montage, as with the Ebert-Noske photograph in *Dada Panorama*, she could play with tonal and formal harmonies—which she did with increasing complexity during the post-Weimar era.

Höch was, indeed, exceptionally sensitive to the wide range of "color" in the black-and-white illustrated periodicals of the time. These were printed in inks that ranged in tone from gray and blue to green and brown, and on paper that was white, ivory, or cream. Since even the best-quality newsprint yellows almost immediately on exposure to light, Höch also could introduce a range of golden tones into her work without hand tinting. To be sure, she often collaged bits of hand-colored paper into her photomontages or used whole sheets of watercolored paper as backing pages. She also used colored prints, like the red-roofed factory and the red-white-and-black flag scraps in *High Finance*. But in the main, the color in Höch's photomontages derives from the mere juxtaposition of the untinted, yet richly modulated, black-and-white photographic reproductions of the illustrated press.

This group of early works also bears eloquent witness to Höch's training in commercial art and, in particular, to her work with handicraft and textile design. On the most basic level, she had developed through her daily work at Ullstein an extraordinary manual dexterity with scissors, paper patterns, and small-scale, precision design. She put this skill to good use in her photomontages, clipping and reconfiguring media photographs with the same aplomb she applied to her handiwork patterns. Indeed, of all the artists working with photomontage in the late 1910s and early 1920s, probably only Max Ernst came close to rivaling Höch's extraordinary technical facility, and even his collage work from this time is less multilayered and complex.

Still more important than the technical is the conceptual debt Höch owed to patternmaking. As Kay Kallos has noted, Höch's diagrams for darned filet and needle lace (fig. 12) bear a marked similarity to the compositional structure of her neatly formatted collages and photomontages, which are basically two-dimensional and usually arranged on a vertical-horizontal grid.[52] Put differently, Höch's collage work is more surface-oriented than that, for example, of Ernst, just as it is more strongly patterned and rigorously structured than that of the Berlin Dadaists. To be sure, the diagonals that crisscross Höch's works from this time often animate them with a dizzying surface energy that ultimately derives from the artist's encounter with Expressionism. But they rarely explode her compositions as do the word fragments in contemporaneous collages by Hausmann, Baader, Grosz, and Heartfield (see illustrations, page 12). Their works are invariably more visually disruptive than Höch's, which became even more ordered around 1922 and 1923 under the added influence of Constructivism. From the outset, Höch's photomontage aesthetic was deeply rooted in design traditions, and it was perhaps this as much as anything that led many to discount her work. The exception to the rule is *Cut with the Kitchen Knife*, the only of her photomontages to have partaken of the visual chaos that characterized Berlin Dada.

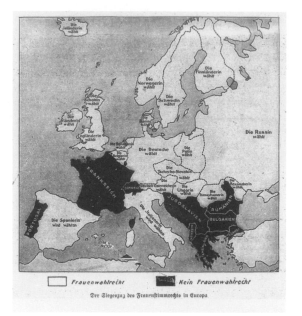

17. Map captioned "The Triumph of Women's Right to Vote in Europe," from *Berliner Illustrirte Zeitung* (*BIZ*), November 1919.

"Cut with the Kitchen Knife" and Gender Relations

Höch made *Cut with the Kitchen Knife*, her largest and most celebrated photomontage, around the same time as the works discussed above.[53] Here, in this teeming, phantasmagoric zoo, crossbred men, women, and animals twist and turn, leap and lunge, and animate the shallow space they inhabit through the centrifugal force of their collective dance. Höch once said that she wanted this cast of hundreds to represent a cross section of the turbulent times in which she then lived,[54] and, indeed, the collage is a virtual encyclopedia of every important political, military, and cultural figure in early Weimar-era Germany. Predictably, representatives of the recently defunct Empire, the military, and the moderate government of the new Republic fill the "anti-Dada" corner at the upper right, while Vladimir Lenin, Karl Marx, Communist leader Karl Radek, and other radicals consort with the Dadaists. This motley crew has connoted different things to different people; I want to address here only one of the most salient issues raised by this important work—the role of women in post–World War I Germany.

Let there be no mistake: it is the women of *Cut with the Kitchen Knife* who animate the work both formally and conceptually. Although men are in the majority, they are either stationary or merely lend their heads to agile, active female bodies such as that of the ice skater beside the automobile at the lower-left edge of the work. She had been featured in *BIZ* together with her skating partner, who is also portrayed in the photomontage behind the phrase *Komm* at top center.[55] The popular contemporary dancer Sant M'hesa is seen behind the spoked wheel in

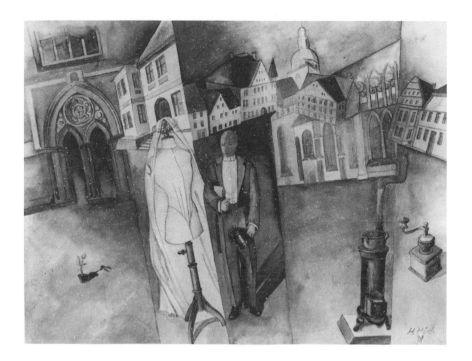

18. *Bürgerliches Brautpaar* (*Bourgeois Wedding Couple*), 1920, watercolor. Private collection.

the upper-right quadrant of the picture, while at the bottom-center edge the actress Pola Negri is represented in her film role in Ernst Lubitsch's *Carmen*. The only woman with a male body is the actress Asta Nielsen, seen at the lower-right edge of the picture, just above the word *Dada-isten*; significantly, Nielsen was renowned for playing the role of Hamlet, for which she sported a bobbed coiffure that spawned the popular women's hairstyle of the 1920s known as the *Bubikopf*. Even those women who are motionless in *Cut with the Kitchen Knife* were celebrated in the popular press of the period for their physical energy. The two swimsuited figures to the left of the phrases *Die große* and *dada* in the bottom-right quadrant of the picture, for example, were German divers photographed after winning a competition. Indeed, the very center of the photomontage is occupied by a double image of female and mechanical movement: surrounded by an area of blank space that highlights her figure, the child-dancer Niddi Impekoven (frequently featured in *BIZ* and other contemporary illustrated journals and newspapers of the day) pirouettes gracefully as she playfully tosses above her the disembodied head of the artist Käthe Kollwitz; at the same time, the petite Impekoven seems to kick into motion the oversized ball bearing below her.

Such images of energetic, active women were thoroughly familiar to the viewing public in early Weimar Germany. With health reformers placing a new emphasis on physical fitness in the postwar period, women of all classes became far more involved with athletics, and contemporary magazines regularly featured active, sporty females like the divers and ice skaters in *Cut with the Kitchen Knife*. Yet Höch's photomontage does more than just paraphrase mainstream discourse about energetic women; the newspaper fragment at the bottom-right corner of the work (fig. 17) politicizes it. This scrap of paper—a map of Europe that Höch clipped from a November 1919 issue of *BIZ*—identifies those countries

in which women could already or would soon be able to vote, including Germany, which granted women suffrage in the constitution that became law in August 1919. By placing this clipping at the lower right, where she normally signed her work, and including a small self-portrait head at the top-left corner of the map, Höch identified herself with the political empowerment of women in postwar Germany. Because the reference to a kitchen knife in the title of the photomontage—*Cut with the Kitchen Knife Dada through the Last Weimar Beer-Belly Cultural Epoch of Germany*—alludes to women's work, the image as a whole seems to suggest, among other things, that the bourgeois, patriarchal culture of the Weimar era would soon come to an end precisely because women could now participate in the political process. It is, after all, usually middle-class men, in the common parlance, who have beer bellies.[56]

With different emphasis, Höch restated her disdain for conventional, middle-class mores in a number of works that unambiguously critique the institution of marriage. *Bürgerliches Brautpaar (Streit)* (*Bourgeois Wedding Couple [Quarrel]*, 1919) (pl. 4) shows a couple against a background of small kitchen utensils made by Alexanderwerk, then one of Germany's largest producers of household appliances. The petulant bride, with the body of an adult but the head of a child, at once attracts and repels her groom, who strains under the weight of his "hat" and the letter *O* that is precariously balanced on its brim. When combined with the recumbent *P* below, it spells *PO*, German slang for a child's fanny and an allusion, no doubt, to the married couple's puerile behavior. The similarly titled *Bürgerliches Brautpaar* (*Bourgeois Wedding Couple*) (fig. 18), a watercolor from the next year, shows the newlyweds just after the

wedding ceremony, standing in a cubistic cityscape of apartment-house facades and church portals. Having lost all capacity for independent thought and action, the bride is now quite literally a dressmaker's "dummy," apparently capable only of servicing the coffee grinder and stove in the foreground. *Die Braut* (*The Bride*, 1927) (page 14)—one of only four paintings that Höch made using the principle of collage[57]—features a wide-eyed child looking for all the world like an innocent lamb en route to the slaughter. Anxiously anticipating her new role as mate to her wooden, unresponsive husband, she gazes with trepidation at the symbols of maternity and fidelity that float around her.

Late in life, Höch said that she considered the institution of marriage a "good brake on wildness,"[58] but her work suggests that in the immediate postwar years she had serious reservations about matrimony and, especially, its impact on women. Here Hausmann may well have been instrumental, for his disdain for the conventions of bourgeois life, and, in particular, for marriage, was pronounced. In both published essays and in private letters to Höch, he repeatedly argued that the Communist economic revolution could not be viable without a corresponding sexual revolution. Assailing the patriarchal organization of the family, he even went so far as to describe marriage as "the projection of rape into law."[59] For Hausmann, the alternative was a matriarchy in which women could experience a full range of sexuality outside the bonds of matrimony. This would include the experience of motherhood. Only by bearing a child with him, he argued, could Höch reach her full potential as a woman.[60]

Höch wanted children very much and gave visual testimony to her preoccupation with motherhood in a remarkable series of watercolors and paintings from the late 1910s and early 1920s.[61] But, ironically, Hausmann, who was already married and had a daughter, proved unwilling (his rhetoric to the contrary) to separate legally or emotionally from his wife during the seven years he was together with Höch. Elfriede Hausmann-Schaeffer did not, evidently, find this triangular relationship as repugnant as did Höch, who never condoned the arrangement.[62] Her repeated demands to Hausmann that he break with his wife, and his tendency to respond by describing her emotional needs as "bourgeois" and rooted in the pernicious teachings of her father, were the underlying cause of numerous confrontations between the two, some of them violent. Not only did Hausmann strike Höch, he even fantasized about killing her precisely so that she could no longer oppose him.[63] It is not surprising that Höch chose not to bear the two children she conceived with Hausmann; she underwent abortions in May 1916 and in January 1918.

Hausmann's inability to practice what he preached was not atypical of the men involved in Berlin Dada. Höch later remarked on the profound contradictions in the behavior of Georg Schrimpf, Franz Jung, and Johannes Baader as well—all of whom paid lip service to women's emancipation but, in her view, mistreated their wives and girlfriends.[64] The same double standard applied in the professional realm, where women were by and large *personae non grata* in the circle of Berlin Dada. George Grosz and John Heartfield opposed Höch's participation in the Dada Fair,[65] while Hans Richter remembered her primarily for the "sandwiches, beer and coffee she managed somehow to conjure up despite the shortage of money." This now infamous description of

Höch as the "good girl" caused her much anguish when it was published in Richter's 1964 memoir,[66] but probably no more than Hausmann's lifelong disrespect for her work. While they were still together he lectured Höch like a child about her more traditional views on aesthetics and ridiculed her continued interest in easel painting.[67] In a devastating but unperceived slight, Hausmann once even asked Höch to help him financially on the grounds that he—the artist—should not have to waste time on pecuniary affairs; she agreed, using her salary from Ullstein to support herself and Hausmann during much of the time they were together.[68]

For the remainder of her life, Höch would remember her relationship with Hausmann and the Berlin Dadaists only with considerable pain. Half a century later she still considered it "torture" to think about how her high hopes for a fulfilled personal and professional life had been dashed at that time: "I was so disappointed, crushed, destroyed, that even today it is almost impossible for me to reflect on these years."[69] Yet however victimized Höch felt throughout much of her life, she never let her feelings get the better of her; early on she learned to parlay her bitterness into a rich body of work that focuses on gender relations.

At first Höch targeted Hausmann and the Dadaists. As early as 1920 she publicly performed a skit that spoofed her mate's inability to cook, his treatment of women, and his aesthetic dogmatism. Hausmann was deeply embarrassed by this[70] and probably even more so by Höch's portrait of him in "The Painter," an undated short story she wrote about an artist who is thrown into an intense spiritual crisis when his wife asks him to do the dishes. Knowing "enough about psychoanalysis to confront the woman with the truth that such demands always arise out of the desire to dominate, no matter what other reasons there might be," Gotthold Heavenlykingdom (Hausmann's fictional counterpart) first theorizes and then sets about painting the treacherous female soul that would thwart "the boundless flight of his genius." Although "in theory he had to agree with the equality of the sexes," in his "own house" it was a very different matter indeed.[71] Dadaist hypocrisy is also an implicit theme of *Da Dandy* (1919) (pl. 6), a portrait of five fashionable women who are depicted not as active, independent subjects but as fragmented objects of titillation for the man in whose head they exist. His profile highlighted by a bit of red paper that circumscribes his silhouette, this "Da(daist) Dandy" evidently supports the liberation of women from male domination in theory only.

If such works critiqued gender relations within the Dada circle, others more generally problematized popular media stereotypes of Weimar Germany's so-called "New Woman."[72] Höch had already addressed the phenomenon of the New Woman in *Cut with the Kitchen Knife*, which, as we have seen, was in part a celebration of the energetic, professional women who would invigorate postwar Germany. Yet even as she was putting the finishing touches on this work, Höch apparently was beginning to question whether the New Woman of the Weimar Republic was really all that different from the "old" woman of the Empire. To be sure, like Höch, the New Woman was more likely to hold a job outside the home and to spend at least some of her wages on leisure activities. She was also apt to be physically as well as sexually active and to use contraceptives and have abortions. The New Woman presented herself differently, too, bobbing her hair (again like Höch) in

a short, boyish style suited to her active life, smoking in public, shaving her legs, and wearing makeup. Yet these "advances" were compromised by some very real setbacks, discussed at the time in liberal and left-wing women's journals. Germany's demobilization policies shuttled working women into lower-paying, unskilled jobs or fired them altogether to make room for returning soldiers who, more often than not, were unwilling to accept the hard-won independence of their mothers, wives, and sisters.[73] The political inroads made by women also proved disappointing. With the exception of the Communists, all the major political parties proved consistently reluctant to integrate women into the inner circles of their organizations, thereby making it difficult for the few women legislators who had been elected after 1919 to advocate legislation that would significantly help their constituency. Although women now had the vote, it did them little good.[74]

None of Höch's works better alludes to the underbelly of the New Woman phenomenon than an untitled photomontage from around 1921 (pl. 11) that focuses centrally on the altered figure of a Russian ballet dancer, identified as Claudia Pawlowa in the source photograph that Höch cut from a June 1921 issue of *Die Dame*. The dancer, then on tour in Germany, is seen in this original fan photo at the beach, relaxing from her presumably demanding schedule. Glamorous, physically fit, and apparently wholly satisfied with her career and personal life, she appears here as the quintessential New Woman of the 1920s, an icon of the new social and professional freedoms. By replacing the dancer's smiling face with one that is pensive—even melancholic—and by moving her from her glamorous and spacious beach setting to one crowded solely with mundane mechanical and domestic objects, Höch plaintively calls into question the popular media stereotypes of her time. Her pensive dancer is less the vital and energetic New Woman of the source photograph than an immobilized mannequin who endures the probing examination of the pipe-smoking male figure leaning inward from the right edge of the montage.

If this photomontage testifies to Höch's acute awareness of the limited roles women could play in early Weimar-era Germany, later works she made about gender relations bespeak changes in her own personal and professional situation that may have led her to see things differently. After attempting to leave Hausmann on several occasions, in 1922 Höch severed all relationships with him and, more or less, with Berlin Dada. The subsequent years were evidently very happy ones for Höch, despite the financial problems that she and all other Germans endured because of runaway inflation, referenced in *Geld* (*Money*, c. 1922) (pl. 18).[75] She had a flurry of activity at Ullstein, publishing at least twelve handiwork designs in *Die Dame* alone between 1922 and 1925. She also became close to Kurt and Helma Schwitters, whom she had first met through Hausmann and who introduced her in turn to Hans Arp and Sophie Taeuber-Arp and to Theo and Nelly van Doesburg. More lighthearted and playful than the deadly serious Hausmann and his colleagues in Berlin Dada, these artists invited Höch to accompany them on vacations and regularly visited her in Berlin. She, in turn, frequented their homes and studios, where she was introduced to a wide array of new professional contacts. On one memorable trip to Paris in 1924, Höch visited the van Doesburgs and through them met, among others, Piet Mondrian, Tristan Tzara, Jacques Lipschitz, Man Ray, Constantin

Brancusi, Amédée Ozenfant, and Sonia Delaunay, with whom she shared textile designs.[76] After she separated from Hausmann, Höch also came into frequent contact with the Bauhaus artists, most especially László Moholy-Nagy and his wife, Lucia Moholy, whom she visited in Weimar on several occasions. Collaborations ensued. She worked intensively with Schwitters on plans for an "anti-cabaret" that was, unfortunately, never realized,[77] and constructed not one but two grottoes in his legendary *Merzbau* in Hanover. Indeed, Höch became particularly close to Schwitters, in part, perhaps, because she shared his respect for formal and aesthetic issues. Together they painted naturalistic landscapes while Schwitters practiced his tone poems and made assemblages from driftwood.[78]

Perhaps for the first time since she had come to Berlin, Höch felt like an artist, not simply an appendage to Hausmann. Also for the first time, she had ample opportunity to observe artistic couples whose personal and professional relationships were characterized by mutual respect. Arp was particularly supportive of his wife's artistic endeavors, and Höch later said that he and Schwitters were among the very few male artists she knew who could genuinely appreciate a woman's talents and treat her as a colleague.[79]

It is perhaps not surprising, then, that the tone and style of Höch's works about gender relations changed subtly around this time. Like *Die Kokette I* (*The Coquette I*, 1923–1925) (pl. 26), they became sparer and more rectilinear, showing the formal influence not of Expressionism or Dada but of international Constructivism. And although a critical subtext is still present in them, they now take the woman's part less obviously. The New Women of *The Coquette I* and of *Die Kokette II* (*The Coquette II*, c. 1925) (pl. 27) are indeed objectified by the bestial men below them, but now their coquettish poses undeniably invite the gaze. *Der Traum seines Lebens* (*The Dream of His Life*, 1925) (pl. 28) pokes fun at both the bride and the groom, who, the title implies, deserve each other. The humor is at the expense of everyone in these works, which exude the good-natured, rollicking fun that Höch shared with the Schwitterses, the Arps, and the van Doesburgs in the mid-1920s.

It was while visiting the Schwitterses in the Netherlands in 1926 that Höch met Til Brugman, a gifted linguist and writer with whom she immediately began a lesbian relationship that lasted nine years.[80] Both Schwitters and van Doesburg had already published Brugman's tone poem "R" in their respective journals, *Merz* and *De Stijl*, in 1923, and Mondrian had been friends with Brugman since childhood, so it is likely that Höch already knew of the writer prior to their introduction. Höch would later speak of Brugman and Hausmann in the same breath, claiming that "dominant personalities have always been attracted to me. . . . That was something of my misfortune."[81] Yet, although she maintained that her own energy had been sapped by Brugman's "strong personality and pronounced desire to dominate,"[82] extant letters from Brugman to Höch portray an exceptionally caring and concerned individual who was very much in love with Höch and often doubted that her own intense feelings were reciprocated.[83] At least at the outset, there is no doubt that they were. Writing to her sister Grete from The Hague soon after she met Brugman, Höch spoke of how thoroughly disgusted she was with men, noting that she and Brugman would "be a model of how two women can form a single rich and balanced life. . . . To be closely connected with another woman for me is something totally new, since

it means being taken by the spirit of my own spirit, confronted by a very close relative."[84] Within weeks of their first meeting, Höch packed up her Berlin residence and moved into Brugman's apartment in The Hague, whose interior design by Vilmos Huszár and furniture by Gerrit Rietveld defined its Constructivist look. In 1929 the couple returned to Berlin, where they lived together until 1935.

Again, Höch's gender-relation photomontages underwent a subtle metamorphosis. Same-sex couples now made frequent appearances, as in *Auf dem Weg zum siebenden Himmel* (*On the Way to Seventh Heaven*, 1934) (pl. 70),[85] a reprise in photomontage of Höch's Dada dolls from 1916 (fig. 19). These adult female dolls—with their pinched waists, pursed red lips, and pronounced breasts and nipples—have been said to subvert the long-established function of baby dolls, which is to inculcate young girls with conventional feminine values of nurturing.[86] The saucy, irreverent dolls are furthermore said to have turned the tradition of handicraft against itself by sabotaging the sort of traditional femininity that handicraft would normally seem to promulgate. Yet Höch's contemporaneous writings on handiwork, discussed above, suggest that she likely meant the dolls not so much to subvert as to extend handicraft traditions. It is, in fact, probable that Höch called them "Dada" dolls only when some were shown at the First International Dada Fair in 1920; when she made them in 1916, she very likely had hoped to publish them in one of Ullstein's women's magazines.[87] By the time she made *On the Way to Seventh Heaven* in the early 1930s, however, she doubtless intended the female dolls, here translated into photomontage, transgressively. Like the similarly upbeat pair of *Vagabunden* (*Vagabonds*) (fig. 20) from around 1926, they are a testimony to the joys that a lesbian relationship could bring.

Less celebratory is the photomontage *Liebe* (*Love*, 1931) (pl. 61), which also features two women. The title of the work derives from the Love series of which it was a part, which Höch began as early as 1923 and worked on intermittently through about 1931.[88] Each of the six or seven works in this series, including the two *Coquette* images discussed above, problematizes sexuality in some way, but *Love* is unique in its portrayal of homosexual love. It is also unique for the level of anxiety it generates: only the most unusual viewer would feel no discomfort at the sight of its drowsy female nude, reclining on "pillows" at the bottom of the picture, who is either unaware of or undisturbed by the bug-headed, winged pair of legs that hovers directly above her. More subtly disquieting is the simple yet remarkable effect that is the result of a cut-and-paste operation Höch performed on the recumbent woman. By snipping two arcs into the top of her lower leg and positioning their point of intersection precisely at the pubic region of the torso to which they are attached, Höch created the illusion that this single leg is really two; when we look at the woman's feet, she appears to be normally two-legged, but if we shift our gaze to the groin she becomes disconcertingly three-legged.

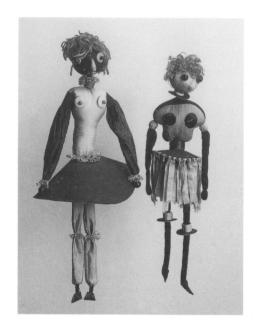

If same-sex couples now began to appear more frequently in Höch's photomontages, so too did androgynous figures, although this was probably as much a reflection of Höch's evolving collage aesthetic as it was of her relationship with Brugman. In her early work, Höch frequently crossbred men and women. *Cut with the Kitchen Knife*, for example, is filled with female torsos topped by male heads. Yet because the differently gendered body parts are so obviously mismatched in this and other of her Dada works, none of these hybrid figures seem androgynous. By the mid-1920s, however, Höch had largely abandoned the irreverent mode of address that characterized her work from the early Weimar period and had begun to develop instead a more evocative aesthetic, influenced, perhaps, by her encounter in Paris with Surrealism. During the late Weimar era, Höch almost always chose to use *similarly* scaled photographic fragments of body parts in her collages, as she did with the figural elements of *Love*, skillfully cutting and fitting them together so that any discrepancies of proportion were minimized. In *Dompteuse* (*Tamer*, c. 1930) (pl. 60), for example, the female mannequin's head and neck seem to grow organically out of male shoulders and arms, which, in turn, are crossed in front of a female torso that is precisely scaled to size. Although the figure can never be resolved as a unity, neither can it be torn apart, and it is thus that it functions androgynously.[89]

Androgyny, of course, was not merely a personal concern of Höch's at this time.[90] Because the phenomenon of the New Woman blurred what formerly had been clear-cut definitions of sexual identity and gender roles, androgyny was a highly charged issue throughout Germany in the 1920s. The popular press addressed the topic time and again, occasionally in articles with such titles as "The Supremacy of the Glands" or "The Riddle of the Glands," which appeared, respectively, in two of Höch's favorite Ullstein magazines, *Die Koralle* (The Coral) and *Uhu* (Yoo-Hoo).[91] Sober and matter-of-fact, these essays argued that certain secretions of the glands could produce true hermaphrodites who possess both male and female sex characteristics. Yet for every nonjudgmental article about women who were like men, there were

19. *Dada Puppen (Dada Dolls)*, 1916 (reconstruction by Isabel Kork, 1988), fabric, cardboard, and beads. Collection Berlinische Galerie, Landesmuseum für Moderne Kunst, Photographie und Architektur, Berlin.

20. (opposite) *Vagabunden (Vagabonds)*, 1926, photomontage. Collection Guido Rossi.

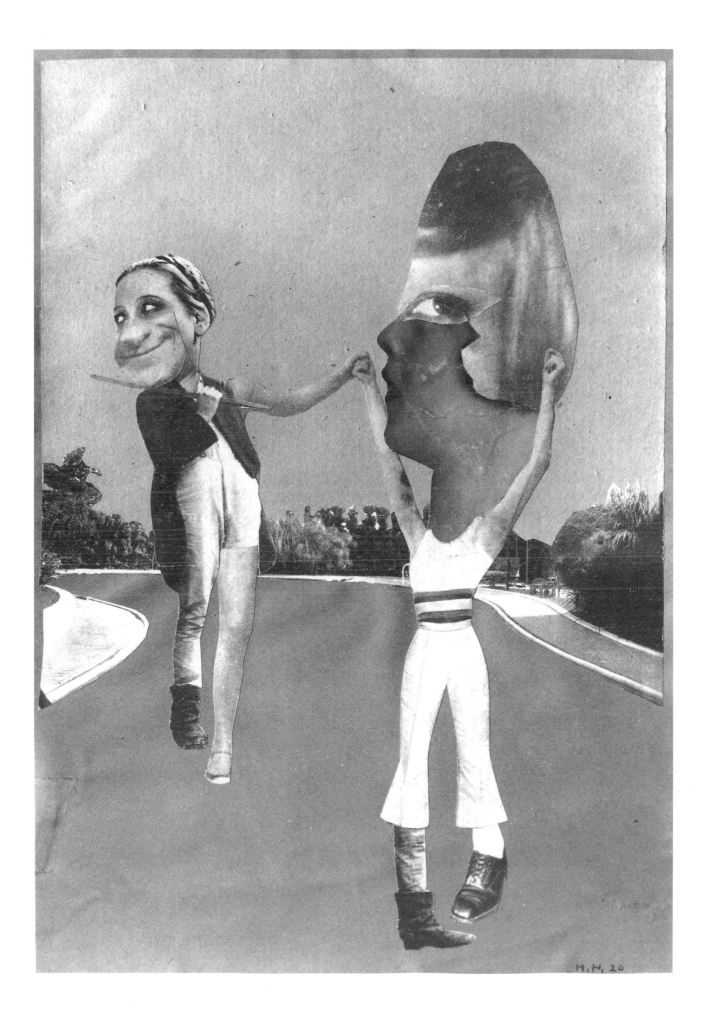

Weibliche Inkonsequenz. Männlicher Haarschnitt, männlicher Anzug und — — Puder und Schminke

Modische Bilanz
KURIOSITÄTEN DES LETZTEN JAHRES

Die Linie der modischen Entwicklung des letzten Jahres hat bizarre Kurven und seltsame Capriolen geschlagen und das Kuriositätenkabinett der weltbeherrschenden Göttin ist um einige extravagante Schaustücke bereichert worden. Es ist sicherlich nicht mehr als eine amüsante Anekdote, wenn man sich erzählt, daß ein Amerikaner in Paris einen Herrn auf der Straße um ein wenig Feuer für die Zigarette ansprach und dieser „Herr"

Vorgetäuschte Geistigkeit. Eine extravagante, modische Intelligenzbrille

*

Rechts: Man muß nicht glauben, daß Strumpfbänder nur zum Festhalten der Strümpfe dienen. Es gibt Frauen, die sie, aus Hermelin gefertigt, als Schmuck „herrlich" finden

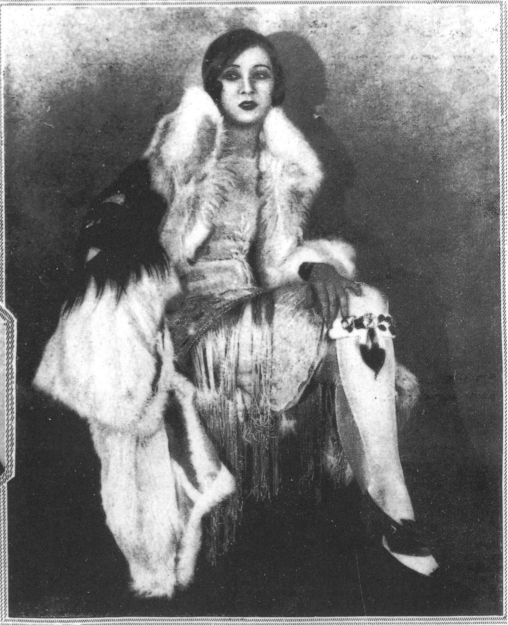

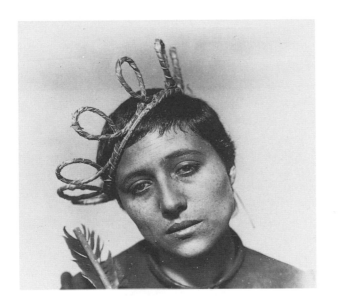

21. (opposite) Page from *Die Woche* (The Week), January 2, 1926.
22. Falconetti as Joan of Arc in Carl-Th. Dreyer's
La Passion de Jeanne d'Arc, 1928.

three or four others in the popular press that were implicitly or explicitly critical. One photograph in *Die Woche* (The Week), another journal Höch often used for source material, showed four short-haired women, dressed in suits and applying makeup (fig. 21).[92] Accompanied by the caption "Female inconsistency: masculine haircut, masculine clothes, and—powder and makeup," it unambiguously conveyed the sneering message that while women, in general, are silly and inconsistent, those who try to be like men are even more so.

Höch's *Die starken Männer* (*The Strong Men*, 1931) (pl. 62) disputed this mainstream discourse on androgyny as well as its corollary: the popular celebration of feminine women and masculine men. The silhouetted male figure in the background of this photomontage is Max Schmeling, the world heavyweight boxing champion whose photograph Höch clipped from a 1926 issue of *Der Querschnitt*. Boxing, of course, was all the rage in Weimar Germany, especially among members of the literary and artistic avant-garde, who celebrated the pugnacious sport not just as an antidote to effete modernism but, as David Bathrick has described it, as "Darwinian license to revalorize and reassert the threatened male ego in the age of collectivization."[93] Schmeling, in particular, was lionized in the 1920s, and any contemporary German would have recognized the silhouette in Höch's photomontage as his, even though his features are hidden by the colored papers collaged over the photographic reproduction. As if to negate everything Schmeling stood for, Höch superposed a half-male, half-female face over his muscular chest; by virtue of the way in which the two halves are joined together, the face seems to puzzle over the antics of the male figure behind it. Höch often positioned such androgynous figures on top of or above other elements in her photomontages, thereby privileging them and underscoring what they represent: a breakdown of rigid gender definitions.

Indische Tänzerin (*Indian Dancer*, 1930) (pl. 53),[94] which Höch made around the same time as *The Strong Men*, also addresses the issue of androgyny. Although the work can be read on the simplest level as an iconic representation of a classical Eastern dance pose, with tilted head and elaborate headdress, it also resonates in different ways.[95] The central figure is composed from an image of the actress Renée (Maria) Falconetti in Carl-Theodor Dreyer's *La Passion de Jeanne d'Arc* (*The Passion of Joan of Arc*, 1928) (fig. 22), a legendary silent film that chronicles the final twenty-four hours of the young medieval heroine's life, when she is accused of witchcraft and brought before an ecclesiastical tribunal.[96] Dreyer's idiosyncratic recounting of the trial turns in part on the issue of a female in male dress. Joan refuses to renounce the garb she had donned to fight in the French army until God instructs her to do so; ultimately she is condemned as a heretic and burned at the stake as much for this as for her insistence that she is divinely inspired.

The specific media source of the Falconetti photograph Höch used in her collage has not yet been located, but the image is a still from the film itself. Falconetti has just refused to abandon her "indecent costume," even if the sacraments are thus withheld from her. "You are no daughter of God," the judges tell her, but rather "the tool of Satan." At those harsh words Joan closes her eyes in misery; tears dampen her lashes and leave their trace on her cheek, but nothing she can do or say moves the all-male tribunal of priests that condemns her. In *Indian Dancer* Höch has superposed a rigid wood mask over this close-up of the saint's face and mouth, thus creating a powerful visual metaphor of Joan's inability to speak and be heard. Of particular note is the crown the martyr wears here, which is fashioned not of plaited straw, like the one Joan makes for herself in one particularly poignant moment of the film, but of stark gray papers decorated with knife and spoon cutouts. Höch's Joan of Arc is thus not merely the celebrated Christian saint but, more generally, a tragic symbol of Everywoman, whose voice is silenced by overdetermined gender roles. Even the bright foil that gleams from behind her domestic tiara does little to lighten the mood of this haunting image, with its complex and multilayered references to film, religion, and, above all, inspirational women whose power is feared and destroyed by men.

It is not surprising that Höch should reference a movie as popular as *The Passion of Joan of Arc* in one of her photomontages, particularly since she was a devotee of the cinema almost from the time she arrived in Berlin. Especially in the late 1920s, when she was living with Brugman in the Netherlands, Höch regularly attended screenings of avant-garde films in The Hague, Rotterdam, and Amsterdam. On her return to Germany, she not only joined a German film league but published on film censorship and sat on the editorial board of the Czech film periodical *Ekran* (Screen).[97] But as much as *Indian Dancer* is about film, so, too, is it about tribal art and ethnography. The photographic fragment superposed atop Falconetti's face, which Höch clipped from a 1925 issue of *Der Querschnitt*, is a wooden dance mask from the Bekom tribe of Cameroon. The work is part of the series Höch called Aus einem ethnographischen Museum (From an Ethnographic Museum), a group of some seventeen photomontages remarkable for their formal and thematic coherence as well as for their technical sophistication. Although much interpretive work remains to be done on this complex series, the recent discovery of many of Höch's media sources has significantly added to what is known about both the form and content of these fascinating works.

From an Ethnographic Museum: Race and Ethnography in 1920s Germany

When Germany began its colonial expansion in the early 1880s, most of its citizens assumed that the acquisition of overseas territories would help the nation economically and militarily. Few if any realized then that the violent suppression of tribal peoples in Africa and Oceania would also have a tremendous impact on Germany's culture. Yet with the conquest of distant lands came the booty that formed some of the greatest ethnographic collections in the world, including the Ethnographisches Museum in Dresden and the Museum für Völkerkunde in Berlin. Prior to World War I, the Brücke artists drew on these and other local repositories of tribal culture, including the displays of natives in ersatz habitats that were featured in German zoological gardens and the exotic acts then popular in cabarets and circuses.[98] By copying artifacts in ethnographic museums and fashioning elaborate "primitive" studio decorations and wood carvings, the Expressionists simultaneously paid homage to the cultures of Africa and Oceania and laid bare the imperialist and racist consciousness of their times. The painter Ernst Ludwig Kirchner, in particular, called up stereotypes of the voracious, sexualized black body to promote his own ideas of sexual liberation and to validate his artistic style.[99]

It was doubtless by way of Expressionism that Höch was initially exposed to tribal art. Hausmann (who, as mentioned, had been affiliated with the artists of Walden's largely Expressionist Der Sturm gallery) especially admired Carl Einstein, author of Germany's first scholarly study of African sculpture, *Negerkunst* (*Negro Art*), published in 1915; he obtained a copy of the book and added marginalia identifying the plates late in 1916.[100] It was around this same time that Höch, too, had first engaged with tribal art, with her 1915 student book-cover design (fig. 5). Yet, ultimately, Höch's concern with gender issues took precedence in her work of the late 1910s and early 1920s, and it was not until the mid-1920s, at the earliest, that she began to engage with ethnography in any significant way in her art.

By this time, the cultures of Africa and Oceania had taken on different associations in Germany, for, with its defeat in the First World War, the country had lost its overseas territories. Rather than abandon its colonialist aspirations in 1918, however, Germany's new republican government, together with the nation's most important colonialist lobbying group, the Deutsche Kolonialverein (German Colonial Society), mounted a propaganda campaign designed to foster the reacquisition of African and other non-Western territories. Public opinion in the early Weimar era was significantly shaped by spurious yet ubiquitous arguments that the Germans were a people without *Lebensraum* (space to live), that colonies were a symbol of national honor, that the Germans had a right to colonies, and, above all, that it was their mission as part of the white race to help civilize "undeveloped" races.[101] The flames of colonialism were further fanned when Germany defaulted on its reparations payments in 1923 and the Rhineland was occupied by nonwhite troops from France's overseas territories. Newspaper articles, pamphlets, novels, and even movies told of the "Black Horror on the Rhine," where hordes of savages allegedly roamed the countryside at will, raping the women, infecting the population with all manner of tropical and other diseases, and, worst of all, polluting the native German blood with *Mischlingskinder* (children of mixed race).[102]

Höch did not address these issues directly in either her diaries or her letters. But as early as 1924 she pointedly referenced the contemporary discourse about race in *Mischling* (*Half-Caste*) (pl. 29), a photomontage that conjoins the mouth of a white woman with the face of an otherwise dark-skinned woman. More critical is *Liebe im Busch* (*Love in the Bush*, 1925) (pl. 30), which portrays a black male embracing a white female in a stand of bamboo trees. Although it is the man who hugs the woman here, her smiling face and coquettish glance suggest not only that she enjoys the contact, but that she may, in fact, have flirtatiously initiated the embrace—a truly radical statement at a time when many Germans were describing all liaisons between black men and native white women as rape.

If *Half-Caste* and *Love in the Bush* questioned contemporary discourse about non-European peoples, the Ethnographic Museum series (pls. 42–53) went even further by investigating mainstream *representations* of non-European culture in the 1920s. Like *Indian Dancer*, all of the photomontages in this series prominently feature photographic fragments of non-European sculpture from Africa (pls. 42–46, 48, 50, 53), East and Southeast Asia (pl. 52), the Pacific Islands (pl. 49), and North America (pl. 51). These are combined with image-fragments of human figures, most of them women, and the composite figures are then usually framed within rectangles or squares or sit on forms that are suggestive of pedestals. In both title and compositional format, then, these works make explicit reference to the ethnographic *museum* and its categorization and display of tribal artifacts.

In fact, the series evidently was inspired, at least in part, by actual ethnographic museum displays. Late in life, Höch credited the series to a visit she had paid in 1926 to the Rijks Ethnographisch Museum in Leiden, where she saw ethnographic artifacts installed both in vitrines and in anthropological mise-en-scènes that portrayed tribal life.[103] That same year, the Museum für Völkerkunde in Berlin reinstalled its ethnographic collection to great acclaim, and this doubtless provided Höch with additional inspiration.[104] Yet she may well have begun to work on the series as early as 1924,[105] when a subsidiary of Ullstein, the Propylaen Verlag, began to publish Alfred Flechtheim's *Der Querschnitt*. Flechtheim, a Francophile dealer of modern art with galleries in Düsseldorf and Berlin, also collected and sold tribal art.[106] In May 1926, just before Höch left on the trip to the Netherlands where she would meet Til Brugman, Flechtheim mounted a spectacular exhibition of his own personal collection of South Seas sculpture in his Berlin gallery and published an accompanying catalogue that included a foreword by Carl Einstein. He popularized tribal art even more effectively in *Der Querschnitt*, publishing artifacts from Africa and Oceania, photographs of tribal peoples, and, occasionally, articles on tribal life and art by historians and ethnographers. This periodical was, in fact, the main media source of the Ethnographic Museum series; of the twenty-six photographic reproductions of tribal objects that have been located to date, twenty derive from *Der Querschnitt*.[107]

The January 1925 issue was a particularly rich source of tribal-art imagery, and Höch used it to full advantage. No fewer than seven of the works in the Ethnographic Museum series are composed of photographs she clipped from this issue, some of which served as a source for two or more photomontages. Indeed, by cutting a single photograph into multiple pieces and then using the fragments in several different works, Höch not only maximized her means but established tonal, compositional, and thematic harmonies that resonate throughout the series. The composite heads of *Mit Mütze (Aus einem ethnographischen Museum IX)* (*With Cap [From an Ethnographic Museum IX]*, 1924) (pl. 42) and *Hörner (Aus einem ethnographischen Museum X)* (*Horns [From an Ethnographic Museum X]*, 1924) (pl. 43)—two of only three figures in the series that are clearly male-gendered—seem related not only because they are silhouetted against the same combination of rectangular black and brown papers, but also because a photograph of a mask from Nigeria is their common source. Höch snipped the image out of *Der Querschnitt* and cut it horizontally in half, using the top fragment in *Horns* and the bottom in *With Cap*. Even works as otherwise dissimilar as *Trauer* (*Sadness*, 1925) (pl. 44) and an untitled piece from the series from 1930, now in the Museum für Kunst und Gewerbe, Hamburg (page 137) have the same origin: a *Der Querschnitt* photograph of three ivory pendants from the former Congo. Höch fashioned a head for the figure in *Sadness* out of a portion of the center pendant, and one for the figure in the untitled piece from the pendant on the right.[108]

As striking as such interserial relationships are, the alliances within individual photomontages—whose eerie, hybrid figures read simultaneously as whole and part—are even more compelling. The head, torso, and "legs" of *Denkmal I* (*Monument I*, 1924) (pl. 46) seem organically connected because they are similarly scaled and precisely trimmed to avoid any discrepancy of proportion; yet because each is of a different color, the figure can never be unified into a cohesive whole. The silver-gray of the figure's head, a photograph of a carved sculpture from Gabon that was published in a 1924 issue of *Der Querschnitt*, contrasts subtly with the gray-green of the female torso below, a photographic fragment of a stone statue that was published in the 1925 issue of the magazine discussed above. More visually jarring are the orange "legs": one is actually an upended, folded arm and hand; the other—the slippered foot and leg of the actress Lilian Harvey—derived from a 1928 issue of *BIZ*, whose black-and-white photographic reproductions were typically more sepia in tone than those of *Der Querschnitt*. The strategy is reversed in *Die Süße* (*The Sweet One*, 1926) (pl. 50), in which the body parts are all of one color but differ in scale. Whatever tactic is employed, throughout the series Höch consistently undermines the viewer's initial perception that these hybrid creatures are real and whole by pointedly calling attention to their fragmentary and constructed nature.

This approach contrasts strikingly with the treatment of the figure by artists in the Surrealist movement, some of whom Höch met and socialized with on her 1924 trip to Paris. Georges Hugnet also used photographs of bodies to bizarre effect, but typically he did not fragment them and so they remain resiliently whole. Max Ernst, too, created strange hybrid creatures by cutting up and reassembling Victorian steel engravings in his collage-novels *La Femme 100 Têtes* (*The Hundred Headless Woman*, 1929) and *Une Semaine de Bonté* (*A Week of Plenty*, 1934) (fig. 23), yet his composite figures, while fantastic, always seem

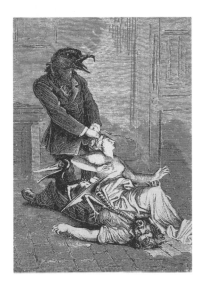

23. Max Ernst, page from the collage-novel *Une Semaine de Bonté*, 1934

utterly real because there is no disjuncture of scale or color. Indeed, the Surrealist dream narrative depends on a seamless technique, which evidently was of little interest to Höch.[109]

Surely it is of some significance that here, as elsewhere, Höch did not disguise the diverse origins of the photographic reproductions she used but rather called attention to them, thereby implicitly referencing the mainstream press and its representations of non-European cultures. Not surprisingly, these were patronizing to the extreme. Wholly typical was that January 1925 issue of *Der Querschnitt*, which provided Höch with so many sources for the series. Its lead article—Albert C. Barnes's "Die Negerkunst und Amerika" (Negro Art and America)[110]—linked the evolution of Negro spirituals to the history of black slavery and oppression, and although the author is effusive in his praise of the rhythms and harmonies of this African-American art form, his description of "the average Negro" who created the spirituals as more "natural" and "soulful" than the civilized white man lays bare his essentialist prejudices: "If the Negro is the simple creature of his past, guileless, without bitterness, easy-going, wise, and helpful, then he can make a pact with us to promote a rich American civilization." The essay was not illustrated with photographs related to Negro spirituals, and thus readers were left to draw connections between the issue's many photographs of African tribal art and the author's characterization of composers of American Negro spirituals as "simple," "natural," and "uncivilized." The vast differences between the cultures of black America and black Africa were thereby elided in favor of an essentializing presentation of the black "Other."

It would certainly be foolish to ascribe to Höch a postcolonial consciousness fully cognizant of the underlying racism that informed such representations. Yet Höch was a sly commentator on contemporary issues and events, and as such was perhaps struck by the simplistic characterizations and sanctimonious tone that typified the mass-media coverage of non-European culture. Indeed, her technique of silhouetting the figures in her Ethnographic Museum series against framed

squares or rectangles or perching them on pedestals seems to suggest that they have been categorized, aestheticized, and, ultimately, denied active function. Here it is doubtless significant that only three of the some seventeen figures in the series are unambiguously male in gender; the others unite photographic fragments of tribal sculptures with media images of contemporary women. Perhaps because she, as a woman, had so often been trivialized, Höch intuitively empathized with the disrespected and exoticized "Other" of non-European culture.

The technical finesse Höch brought to the Ethnographic Museum series was now so refined that she could suggest a wide range of emotions by combining just a few fragments of photographic reproductions from the mass media. While the female figure in *Denkmal II: Eitelkeit* (*Monument II: Vanity*, 1926) (pl. 48) seems haughty and disdainful, the woman in *Monument I* appears annoyed. With her arm rigid and her fist clenched, she glances over her shoulder through eyes that have been narrowed to slits. The puckish figure in *Negerplastik* (*Negro Sculpture*, 1929) turns its face jauntily to the side, but the melancholic women of *The Sweet One* and *Mutter* (*Mother*, 1930) (pl. 51) gaze outward with quiet resignation. By working her cut-and-paste wizardry on media photographs, Höch now fashioned figures so eloquent that they seem quite literally to speak.

HÖCH IN THE LATE WEIMAR ERA

It was while making the Ethnographic Museum series that Höch first began to receive recognition for her work in photomontage. Indeed, few of her artistic efforts, aside from her textile and poster designs, were acknowledged publicly until the end of the 1920s, a period that, notably, saw the onset of the Great Depression and the rise of Hitler and National Socialism in Germany—economic and sociopolitical developments that affected Höch's art and career decisively for years to come.

For reasons that are not entirely clear, after her initial exhibition of nontraditional works at the First International Dada Fair in 1920, for most of the subsequent decade Höch chose to represent herself publicly only with her textile designs or paintings, although her exposure in this latter medium was extremely limited.[111] (Throughout the 1920s, she exhibited at the most a few oil paintings and works on paper annually, and these were hardly ever reviewed.[112]) It was not until 1929 that she again showed photomontages, this time at the invitation of the Deutscher Werkbund committee that organized the landmark *Film und Foto* (*Film and Photo*, or *FiFo*) exhibition in Stuttgart. Höch was represented at this tremendously popular event with eighteen or so photomontages, which were seen by well over 10,000 visitors in Stuttgart alone and by thousands more when a smaller version of the exhibition traveled to Zurich, Berlin, Vienna, Danzig, Agram, Munich, Tokyo, and Osaka.[113] It was also in 1929 that Höch had her first one-person exhibition at the De Bron gallery in The Hague, where she showed sixteen oil paintings and numerous drawings and watercolors. This exhibition subsequently traveled to Rotterdam and Amsterdam, and, together with *FiFo*, elicited extensive comment in the local press. Höch's public career as a painter and photomontagist was thus launched.

The majority of Dutch reviewers disliked the paintings, which they felt were "shrill," "sarcastic," "bitter," and overly "intellectual."[114] By contrast, Höch's photomontages were well received in Germany; there, critics emphasized how "ingenious" they were, and if some called attention to the "satirical" nature of the work, unlike their Dutch counterparts, they did not do so pejoratively.[115] Höch's colleagues were equally impressed with the photomontages they saw at *FiFo*. The critic Franz Roh and typographer Jan Tschichold asked if they could reproduce one of them—*Von Oben* (*From Above*, 1926–1927) (pl. 38)—in their forthcoming book *foto-auge* (*photo-eye*), and Josef Albers, who evidently first encountered Höch's work when *FiFo* was shown in Berlin, inquired if she would trade one of her photomontages for one of his industrial glass paintings.[116]

Other successes were soon forthcoming. In 1931 Höch was invited to participate in a major exhibition of photomontage that took place at the Kunstgewerbemuseum in Berlin. Along with John Heartfield, André Kertesz, Alice Lex, László Moholy-Nagy, Oskar Nerlinger, Albert Renger-Patsch, and other prominent artists of the day, Höch was represented here with at least nine photomontages, which were shown at another photography exhibition in Essen later that year.[117] It was at the Kunstgewerbemuseum show that Höch met the wealthy banker Eduard von der Heydt, then well known as the owner both of the health spa Monte Verita in Ascona, Switzerland, and of an impressive collection of modern, tribal, and Asian art.[118] When Höch told von der Heydt that she had used mass-media photographs of works in his collection as the basis for two of her Ethnographic Museum pictures, he promptly scheduled a studio visit and purchased both pieces from her.[119] This was perhaps her first major sale of photomontage, and it was doubtless tremendously validating.

By 1932 Höch had even established a reputation for her work in photomontage beyond Germany and the Netherlands. That year she was invited to participate in both the *Philadelphia International Salon of Photography* at the Pennsylvania Museum of Art (now the Philadelphia Museum of Art)[120] and in the *Exposition internationale de la photographie* at the Palais des Beaux Arts in Brussels, where she exhibited eight pieces.[121] But the biggest feather in her cap was doubtless the planned exhibition of her photomontages and watercolors at the Bauhaus in Dessau.[122] Höch was first contacted in April 1932 by Christof Hertel, business manager of the Bauhaus, who proposed to mount an exhibition of her work that would open in mid-May. Hertel later revealed that Höch's exhibition had special significance, for it was the twenty-fifth that the Bauhaus had organized and thus an anniversary show. But because Hertel became ill, the opening was delayed until the end of May, and Höch, who planned to attend, sent fifteen photomontages and thirty-one watercolors that arrived at the Bauhaus on May 24. Only then did it become clear that the Dessau city council, which had always provided public funds for the Bauhaus but was now dominated by National Socialists who disapproved of the faculty's politics and art, was determined to close the school. Although the council wrangled over the fate of the building, staff, and students until August, already by June 1 Höch's work arrived back in Berlin, having been seen by neither faculty nor students.[123]

By this time, of course, Höch was acutely aware of National Social-ism. The onset of the depression in Germany, in 1929, had created mass discontent with the mainstream political parties of the Weimar Republic and swelled the ranks of both the far left and right. As a result of the Reichstag elections of September 1930, the Nazis increased their parliamentary representation from twelve to 107 deputies, an astonish-ing gain that brought the party to the attention of many who had previ-ously considered it to be on the lunatic fringe of German nationalism. Like so many others, though, Höch did not initially fully comprehend the danger, and this is evident in her work.

One photomontage is especially telling. A composite image of a male adult and a bawling baby, the collage has been known for years as *Der kleine P* (*The Small P*, 1931) (pl. 65), based on the inscription at the lower right of the image. Yet, as Höch noted somewhat enigmatically on the back of a photograph she later made of the work, this nonsensical title was not the original one.[124] "Der kleine Pg" was first inscribed just below the "H.H." that is now at the lower left of the photomontage, on a piece of paper that Höch subsequently removed. When the collage is held in a raking light, this unmistakable reference to a *Parteigenosse* (a member of the National Socialist Party) is still evident in the form of indentations in the backing page that were created by the pressure from the artist's pen or pencil.[125] The exact position of the now-missing scrap of paper is also evident from the discoloration of the areas below Höch's initials, where it was originally glued. But if there is little doubt that Höch later removed the *Parteigenosse* reference and retitled the collage from fear of sure retribution, it is equally certain that when she made the work in 1931 she was not yet intimidated by the Nazis. This infantile "little party member" is made to look ridiculous, not threaten-ing, and the mode of address here is spoof, not critique.

A more problematic image in terms of its statement on National Socialism is *Bäuerliches Brautpaar* (*Peasant Wedding Couple*) (pl. 66), which Höch made in the same year as *Der kleine P*. Silhouetted against a schematized farm landscape that includes a pair of arms holding a milk canister, a cow's head, a herd of cattle, and a barn is the "wedding couple" of the title. The bride is represented by an ape's head with blond braids and the legs of a child, and the groom by a black head that wears a hat and boots. These boots are central to the reading of this image, for they would have been recognized by any German of the time as those of a Nazi storm trooper. Likewise, the blond braids of the bride would have been immediately associated with the pervasive *Blut und Boden* (blood and earth) rhetoric of National Socialism, which held that the Nordic, Aryan race was purest amidst the peasantry of Germany that worked the land. By endowing this stereotypically Aryan wedding couple with the heads of a black man and an ape, Höch ridiculed this very notion of racial purity while simultaneously betraying the extent to which she had internalized it. For although *Peasant Wedding Couple* does indeed suggest that the German race "degenerates" through the intermarriage of Nazi to Nazi, it does so only at the expense of the black man, who is ranked here, as in National Socialism, together with the animals in the (d)evolutionary chain. That Höch, who consciously rejected the Nazis and everything they stood for, could nevertheless unconsciously implicate herself here is some indication of the strength and pervasiveness of the racist ideology of the times.

After the National Socialists came to power in 1933, Höch became more acutely aware of the threat to herself and others. In April 1933 she received a letter from an artists' cooperative to which she belonged,

asking her to sign a declaration supporting National Socialism and pro-claim her gentile descent; she refused and promptly resigned from the organization.[126] She similarly refused to fly the Nazi flag outside her win-dow on official holidays and thus brought unwelcome scrutiny from neighbors and Nazi officials, who visited her in her Friedenau apartment on several occasions.[127] Letters from friends outside of Germany make veiled references to Höch and Brugman's plans to emigrate and repeat-edly express curiosity about their remaining in Berlin.[128] The couple's decision not to leave may have been influenced by the fact that Höch became critically ill with an exophthalmic goiter in the summer of 1934. Her operation on July 12 in Berlin possibly saved her life, but it left her physically, emotionally, and financially devastated for some time to come. For whatever reasons, Höch stayed where she was, and in so doing effectively undermined her public career for years.

Initially it was still possible for her to exhibit outside of Germany. In 1934 she had a large show of forty-two photomontages in Brno, Czechoslovakia[129] and an exhibition of watercolors in The Hague, where she showed again in 1935. Yet this was Höch's last significant profes-sional appearance until after World War II. In 1937 her work appeared in Wolfgang Willrich's book *Die Säuberung des Kunsttempels* (*The Cleansing of the Temple of Art*), a Nazi tract devoted to exposing the cultural enemies of the Third Reich.[130] Although she was not repre-sented in the infamous *Entartete Kunst* (*Degenerate Art*) exhibition, most of her friends and colleagues were, and she obsessively visited the show at its venues in Munich, Berlin, and Hamburg in 1937 and 1938.[131] By this time, Höch had separated from Brugman, having fallen in love with a businessman whose lucrative trade provided her for a time with a comfortable lifestyle and, perhaps, a certain degree of political immunity.[132] She moved with him to the distant Berlin suburb of Heiligen-see in 1939; in 1942, he left her and she lived out the remainder of the Third Reich in relative isolation. Although forced to keep a low profile because of her past political and cultural affiliations, she was still able to work and, above all, to survive.

Thus the Weimar era ended for Höch much as it had begun, with her work in photomontage again marginalized. At the very outset of her career, the all-male group of Berlin Dadaists had spurned the essential formal and thematic characteristics of her art, with its aesthetic roots in design and handiwork traditions and its thematic base in the phe-nomenon of the New Woman. We cannot know the extent to which the contacts Höch made with more like-minded artists after she separated from Hausmann in 1922 might have afforded her more public acclaim, for her move to The Hague in 1926 distanced her from the Constructi-vists and Surrealists. Only on her return to Berlin in 1929 did she finally begin to receive accolades for her photomontages; but these voices were all too soon silenced by the assumption to power of the National Socialists. That Höch continued to work in photomontage with little public validation throughout the Weimar and Nazi eras is a tribute not only to her abiding love for the medium but to her strength of purpose. Against all odds, she kept faith in herself and in her medium of choice, and only thus was able to craft a body of work that is unique in both form and content.

1 For an overview of the Dada Fair, see Helen Adkins, "Erste Internationale Dada-Messe," in *Stationen der Moderne: Die bedeutenden Kunstausstellungen des 20. Jahrhunderts in Deutschland*, exh. cat. (Berlin: Berlinische Galerie, 1988), pp. 157–183.

2 Höch's full name is cited on a copy of her birth certificate, in the Höch Family Estate. Most accounts credit the artist Kurt Schwitters with the addition of the final *h* to her nickname. He insisted that her name, like his own literary creation "Anna" Blume, be spelled the same backward as forward. In conversation with the photographers Liselotte and Armin Orgel-Köhne in 1973, however, Höch noted that even before Schwitters, both she and others occasionally wrote her name as a palindrome. I am grateful to the Orgel-Köhnes for granting me access to their taped conversations with Höch and for providing me with transcripts of these tapes, referred to hereafter as the Orgel-Köhne Transcripts.

3 The "catalogue" to the exhibition—a single sheet of paper, imprinted on one side with a reproduction of Heartfield's photomontage *Leben und Treiben in Universal-City, 12 Uhr 5 mittags* (*Life and Times in Universal City at 12:05 Noon*, 1919) (page 12) and on the other with a list of works exhibited—cites Höch's contributions to the fair as two Dada puppets; a poster, *Ali Baba-Diele* (*Ali Baba Restaurant*), now lost; *Cut with the Kitchen Knife*; and two "relief" collages: *Diktatur der Dadaisten* (*Dictatorship of the Dadaists*) and *Mechanisches Brautpaar* (*Mechanical Wedding Couple*), both now lost. Hausmann cited the same works on a typed list he made shortly after the Dada Fair closed, although he refers to *Mechanisches Brautpaar* as *Menschliches Brautpaar* (*Human Wedding Couple*); see *Hannah Höch: Eine Lebenscollage*, vol. 1 (1889–1920) , ed. Cornelia Thater-Schulz (Berlin: Berlinische Galerie and Argon, 1989), p. 669 (13.27). Höch, however, noted on this list that she actually showed more works than Hausmann had enumerated. Hanne Bergius, who knew Höch personally, has identified these additional works as two that are now lost—*Collage mit Pfeil* (*Collage with Arrow*) and *Dada Montage*—and *Dada-Rundschau* (*Dada Panorama*, 1919) (pl. 2); see Bergius's essay "'Dada-Rundschau': Eine Photomontage," in *Hannah Höch 1889–1978: Ihr Werk, Ihr Leben, Ihre Freunde*, exh. cat. (Berlin: Berlinische Galerie and Argon, 1989), p. 101.

4 Höch once described how uncomfortable she had felt helping Hausmann advertise a Dada event during rush hour on the Friedrichstraße. Passersby kept throwing to the ground the fliers the pair distributed, and Höch—by her own account, one who never liked to force people to do things against their wishes—insisted they should leave. This story is recounted on an undated scrap of paper Höch stored with many other such notes in a television guide from 1964, *Hör zu*, now in the Hannah Höch Archive at the Berlinische Galerie, Berlin, and hereafter referred to as the *Hör zu* Autobiographical Notes. See also Höch's account of her first and only appearance in a Dada performance, from her lecture "Erinnerungen an Dada" (Düsseldorf, 1966), in *Hannah Höch 1889–1978*, supra, note 3, p. 205. Here, too, Höch describes her profound discomfiture during the noisy, confrontational event.

5 Hausmann (like his colleague Franz Jung) maintained a relationship with two women—Höch and his wife—for many years. Yet unlike Elfriede Hausmann-Schaeffer, Höch could neither condone nor accept this bohemian arrangement, which proved to be among the most enduring conflicts of their relationship. See the Hausmann-Höch correspondence in *Lebenscollage*, vol. 1, supra, note 3, especially the draft of a letter from Höch to Hausmann, 17 June 1918, pp. 401–402 (10.48).

6 Although less focused on art interpretation and more on the deconstruction of historical narratives, Irit Rogoff's work on Gabriele Münter is exemplary here. See Rogoff, "Tiny Anguishes: Reflections on Nagging, Scholastic Embarrassment, and Feminist Art History," *Differences* 4, no. 3 (1992), pp. 38–65. An older, yet still classic, study in this vein is Rozsika Parker, *The Subversive Stitch: Embroidery and the Making of the Feminine* (1984; reprint, New York: Routledge, 1989).

7 I have been gratified to find my ideas here confirmed and amplified by Kay Klein Kallos in "A Woman's Revolution: The Relationship between Design and the Avant-Garde in the Work of Hannah Höch 1912–1922," Ph.D. diss., University of Wisconsin–Madison, 1994. Regrettably, I learned of this dissertation only late in my research. I thank Barbara Buenger of the University of Wisconsin–Madison for calling my attention to Kallos's work.

8 This approach was also taken by Maud Lavin in her *Cut with the Kitchen Knife: The Weimar Photomontages of Hannah Höch* (New Haven and London: Yale University Press, 1993). Although my approach to Höch's work and my interpretations of it often differ substantially from Lavin's, this essay and exhibition are nevertheless indebted to her pioneering study.

9 Edouard Roditi, "Interview with Hannah Höch," *Arts* 34, no. 3 (December 1959), p. 24; and Johannes Freisel, "Das Porträt: Hannah Höch," *Deutsche Welle*, 2 July 1970.

10 Höch later recalled that her father "shared the general turn-of-the-century bourgeois opinion that held a girl should get married and forget about studying art." Höch, "Lebensüberblick" (1958), trans. Peter Chametzky, in Lavin, supra, note 8, p. 211.

11 Radio interview with Wolfgang Pehnt, "Jene zwanziger Jahre: Ein Gespräch mit Hannah Höch," broadcast 4 March 1973, Deutschlandfunk; transcript in Hannah Höch Archive, Berlinische Galerie, Berlin, p. 12. Many pages of Höch's calligraphy, in a wide variety of scripts, are still extant in the artist's estate.

12 The Hannah Höch Archive at the Berlinische Galerie also contains her ink and gouache sketch for this lithographed certificate (see *Lebenscollage*, vol. 1, supra, note 3, p. 61 [2.9]). I date both the study and final print to around 1913 on the basis of similar designs that have been firmly dated. See especially documents 2.8 and 2.10 in *Lebenscollage*, vol. 1, pp. 61–62.

13 *Stickerei- und Spitzen-Rundschau* 16, no. 5 (February 1916), p. 126. Höch's name is not cited here, but the caption "Kunstgewerbeschule Charlottenburg, Fachkl. Harold Bengen" clearly identifies the artist as a Bengen student. Given that Höch saved the page along with other published embroidery designs that are firmly attributed to her, and given that the design is virtually identical in style and subject to the still extant series of sketches, there is little doubt that this was from her hand. Both the published handiwork designs and the sketches are now preserved in the Höch Family Estate.

14 *Stickerei- und Spitzen-Rundschau* 16, no. 5 (February 1916), p. 128. This design was captioned "Fachklasse Harold Bengen, Entwurf u. Ausführung: Hanna Höch. Stickerei für einen Wandschirm, Wolle in verschiedenen Stichen."

15 In 1914, for example, Höch won a fellowship from the school to attend the Werkbund exhibition of applied arts in Cologne. See "Lebensüberblick," supra, note 10, p. 211.

16 Ibid.

17 I am indebted here to Kristin Makholm, who gleaned much of the following information on Höch's studies at the School of the Royal Museum of Applied Arts from the files on that institution at the Hochschule der Künste, Berlin.

18 Since no book entitled *Geschichte der Plastik aller Zeiten und Völker* (History of the Sculpture of All Ages and Peoples) was ever published by the author cited on Höch's book design (H. W. Singer, a noted authority on the history of sculpture), the sketch, now preserved in the Hannah Höch Archive, Berlinische Galerie, Berlin, must have been a school exercise. Höch won second prize in the 1915–1916 and 1916–1917 schoolwide competitions, first prize in the 1917–1918 and 1918–1919 competitions, and an honorable mention in the 1919–1920 competition. She was further awarded tuition stipends for the third quarter of the 1917–1918 academic year and for all three quarters of the 1918–1919 and 1919–1920 years. (Files of the Unterrichtsanstalt des königlichen Kunstgewerbemuseums, Hochschule der Künste, Berlin.)

19 In 1912 Hausmann published two essays—"Wider Herrn Scheffler" and "Die gesunde Kunst"—in *Der Sturm*, and in 1916 he was invited to participate in one of the Sturm exhibitions. This never came to pass because, as Hausmann explained in a letter to Georg Muche, he did not want to exhibit his work with that of "youths" such as Hans Richter and Georg Schrimpf. See *Lebenscollage*, vol. 1, supra, note 3, p. 103.

20 Roditi, supra, note 9, p. 24. Although Hausmann ultimately distanced himself from Walden and Der Sturm, he, too, was initially impressed with the gallery. "It doesn't matter how dumb Walden is," Hausmann wrote to Höch on 24 August 1915, "he has the great artists and one can only exhibit with him" (*Lebenscollage*, vol. 1, supra, note 3, p. 132 [6.28]).

21 It is unclear when Höch actually acquired these publications. Cornelia Thater-Schulz (*Lebenscollage*, vol. 1, supra, note 3, p. 82) speculates that it was probably after she met Hausmann in 1915, and, indeed, Höch's catalogue to Der Sturm's 1912 *Blaue Reiter* exhibition contains a handwritten note that intimates as much. Höch sent the catalogue, with its foreword by Franz Marc and essay by Wassily Kandinsky, to her sister Grete with the following undated inscription on the title page: "Dear Grete, *we're* sending you this in response to your recent inquiry; there are good things in it. Please give it also to Father to read. Hannah" (*Lebenscollage*, vol. 1, supra, note 3, p. 84 [5.2], emphasis mine). The "we" probably refers here to herself and Hausmann, who together carried on a debate with Höch's family about art.

22 Although none of these patterns are firmly dated, compositionally they bear witness to Höch's engagement first with Expressionism and then, in the mid-1920s, with Constructivism. In 1925 Höch attended the *Exposition internationale des arts décoratifs et industriels modernes* in Paris, where she admired the handiwork exhibited and evidently tried to sell some of her own fabric or handiwork patterns. See the entries in her travel diary, England–France, 1925, in part 2 of *Hannah Höch: Eine Lebenscollage*, vol. 2 (1921–1945) (Berlin: Berlinische Galerie and Hatje, 1995), pp. 234 and 235 (25.51). I am grateful especially to Viola Roehr-von Alvensleben of the Galerie Alvensleben in Munich and to Heinrich and Eva-Maria Rössner for sharing some of these fabric designs with me.

23 See the letters from the Alexander Koch Verlag to Höch, 2 June and 1 December 1920, *Lebenscollage*, vol. 1, supra, note 3, pp. 663–665 (13.23) and 725 (13.70). There is no evidence, however, that the company was successful in helping Höch to market her designs.

24 Koch published *Stickerei- und Spitzen-Rundschau* in Darmstadt and also brought out the design journals *Deutsche Kunst und Dekoration* (German Art and Design) and *Innendekoration* (Interior Design). For valuable information about Koch and his efforts to elevate the quality of German decorative arts and improve the market for them, see Sigrid Randa, *Alexander Koch: Publizist und Verleger in Darmstadt: Reformen der Kunst und des Lebens um 1900* (Worms: Wernersche Verlagsgesellschaft, 1990)

25 K. G. v. H., "Hanna Höchs Muster-Kunst," *Stickerei- und Spitzen-Rundschau* 20, no. 12 (September 1920), p. 224.

26 The source and exact date of this review remain unidentified, but the clipping service that sent Höch the copy that is still extant in the Hannah Höch Archive, Berlinische Galerie, Berlin, stamped it with the date 1921.

27 Prior to that time, a small group of Ullstein seamstresses produced relatively expensive, cut-to-size patterns that were mail-ordered by clients who wanted to sew fashions featured in such Ullstein magazines as *Die Dame* (The Lady) or *Die praktische Berlinerin* (The Practical Berlin Woman). It was Hermann Ullstein, the youngest son of the founder, who initiated the profitable new system. On the fashion and handiwork divisions of the Ullstein Verlag, see *Fünfzig Jahre Ullstein: 1877–1927* (Berlin: Ullstein Verlag, 1927), pp. 59–65 and 344–346; and *Hundert Jahre Ullstein: 1877–1977*, ed. W. Joachim Freyburg and Hans Wallenberg (Berlin: Ullstein Verlag, 1977), vol. 1, pp. 121–124 and 133–152.

28 It is unclear whether these specific dress designs, preserved in the Graphische Sammlung of the Berlinische Galerie, Berlin, ever actually appeared in an Ullstein magazine. They are, however, of the type that appeared as line drawings in *Die Dame* and *Die praktische Berlinerin* throughout the 1910s and 1920s, and it is thus likely that Höch sketched them in the course of her work at Ullstein. As early as 1916, *Die praktische Berlinerin* published some of Höch's dress designs, which she described as "Richelieu" dresses in a letter to her sister Grete, c. 1916 (*Lebenscollage*, vol. 1, supra, note 3, p. 195 [8.7]).

29 See, for example, *Musterfilet und Tüllarbeiten*, Ullstein-Handarbeitsbücher 17 (Berlin: Verlag der Ullstein-schnittmuster, n.d.), which probably contained designs by Höch. As usual, the individuals who made the patterns remained anonymous here, but Höch saved a copy of this book and subsequently used one of the needle-lace patterns in it as the basis of a collage, *Weiße Form* (*White Form*, 1919) (pl. 12). Copies of this rare book can be found in the Höch Family Estate and in the Lippenheidische Kostümbibliothek at the Kunstbibliothek, Staatliche Museen zu Berlin, Preußischer Kulturbesitz.

30 Like all other Ullstein patternmakers, Höch was usually not credited for her published designs. However, tear pages from the journals in which they appeared are still extant in the Hannah Höch Archive, Berlinische Galerie, Berlin; though lacking pertinent issue and page numbers, they bear Höch's handwritten notations identifying her own designs. I am indebted to Michelle Cutler for the time and effort she took to locate the missing information for me.

31 In a letter to her sister Grete, 18 November 1916 (*Lebenscollage*, vol. 1, supra, note 3, p. 233 [8.54]), Höch, by way of apologizing for not writing sooner, says that she has been continually interrupted by readers of *Die praktische Berlinerin*, who wanted more details about a pattern of hers that had just appeared; I have been unable to identify the design. When recounting her youth late in life, Höch often spoke as passionately about handiwork as she did about Expressionism, Dada, and Constructivism. In particular, the Orgel-Köhne Transcripts, supra, note 2, contain long passages in which Höch describes her work for Ullstein with evident enthusiasm and joy.

32 The competitions that Koch's various journals sponsored, such as the one for embroidered pillows and tablecloths in which Höch's design won a prize, were an important component of his program to enhance the stature of the decorative arts in Germany.

33 Höch, "Vom Sticken," *Stickerei- und Spitzen-Rundschau* 18, no. 12 (September 1918), p. 220.

34 Höch, "Die freie Stick-Kunst," *Stickerei- und Spitzen-Rundschau* 20, nos. 1–2 (October–November 1919), p. 22.

35 Höch, "Was ist schön?" *Stickerei- und Spitzen-Rundschau* 19, nos. 1–2 (October–November 1918), p. 16.

36 Höch, "Die stickende Frau," *Stickerei- und Spitzen-Rundschau* 20, nos. 1–2 (October–November 1919), p. 26.

37 Some of the periodicals to which Höch's family subscribed are enumerated in the Orgel-Köhne Transcripts, supra, note 2. These included *Über Land und Meer*, *Die Gartenlaube*, *Jagd und Dorf*, *Kladderadatsch*, *Mettendorfer Blätter*, and *Jagd*. Heinz Ohff, in his monograph *Hannah Höch* (Berlin: Gebr. Mann and Deutsche Gesellschaft für Bildende Kunst e.V., 1968), p. 10, additionally mentions *Heim und Welt* and *Kunst für Alle* and recounts that Höch, drawing upon her "feminine sense for order," organized the books she made with illustrations from these periodicals thematically.

38 Such military memorabilia were not, of course, the first instances of photomontage, but merely the most immediate inspiration for Höch and Hausmann. On the beginnings of the medium, see Robert Sobieszek, "Composite Imagery and the Origins of Photomontage, Part 1: The Naturalistic Strain," *Artforum* 17, no. 2 (September 1978), pp. 58–65; and "Part 2: The Formalist Strain," *Artforum* 17, no. 3 (October 1978), pp. 40–45. Dadaist accounts of the discovery of photomontage and photocollage vary, but military memorabilia figure in all. Höch first discussed the medium in "Nekolik poznámek o fotomontázi," *Středisko* 4, no. 1 (April 1934), unpaginated; translated by Jitka Salaguarda as "A Few Words on Photomontage," in Lavin, supra, note 8, pp. 219–220. Subsequent accounts by Höch include "Die Fotomontage," in *Fotomontage von Dada bis heute*, exh. cat. (Berlin: Galerie Rosen, 1946), reprinted in *Hannah Höch 1889–1978*, supra, note 3, pp. 218–219; Roditi, supra, note 9, p. 26; Hans Richter, *Dada: Art and Anti-Art* (New York: McGraw Hill, 1965), p. 117; "Erinnerungen an Dada" (lecture, Düsseldorf, 1966), in *Hannah Höch 1889–1978*, supra, note 3, pp. 207–208; "Zur Collage," in *Hannah Höch: Collagen aus den Jahren 1916–1971*, exh. cat. (Berlin: Akademie der Künste, 1971); interview with Pehnt, supra, note 11, p. 8; and in Heiko Gebhardt and Stefan Moses, "Ein Leben lang im Gartenhaus," *Stern*, 22 April 1976, p. 103. Hausmann's slightly different recollections are recounted in Raoul Hausmann, "New Painting and Photo Montage," in *Dadas on Art*, ed. Lucy R. Lippard (Englewood Cliffs: Prentice Hall, 1971), p. 61; and *Am Anfang war Dada*, ed. Karl Riha and Günter Kämpf, 2nd ed. (Giessen: Anabas Verlag, 1980), p. 45.

39 On Ullstein's role in the development of the picture magazine see, in particular, *Hundert Jahre Ullstein*, supra, note 27. A more general discussion of the development of the illustrated press in the Weimar Republic is provided in Wilhelm Marckwardt, *Die Illustrierten der Weimarer Zeit: Publizistische Funktion, ökonomische Entwicklung und inhaltliche Tendenzen* (Munich: Minerva Publikation, 1982). Useful information on this subject also appears in Jean-Claude Lemagny and Andre Rouille, eds., *A History of Photography: Social and Cultural Perspectives*, trans. Janet Lloyd (Cambridge: Cambridge University Press, 1986).

40 See, for example, Höch's notes from an undated radio interview with her by SFB (Sender Freies Berlin), in the Hannah Höch Archive, Berlinische Galerie, Berlin. Efforts to ascertain when and if this interview was aired have been unsuccessful.

41 See, for example, a letter from Hausmann to Höch, 30 May 1917 (*Lebenscollage*, vol. 1, supra, note 3, p. 279 [9.24]), in which he asks Höch to make a copy for him of his essay "Aus der Sphäre der Innersten, höchsten Realität," which she does as a matter of course. This manuscript appeared as "Notiz" in *Aktion* 7 (1917), columns 421–422.

42 On the politics of the Dadaists, see Richard Sheppard, "Dada and Politics," in *Dada: Studies of a Movement*, ed. Richard Sheppard (Buckinghamshire: Alpha Academic, 1979), pp. 39–74.

43 Roditi, supra, note 9, p. 26. In this and other late interviews, Höch almost always qualified her youthful engagement with communism by emphasizing how naive and apolitical it had been. This may or may not be true, but during the cold war, when these conversations took place, distancing herself from communism was certainly politically circumspect. The Hannah Höch Archive at the Berlinische Galerie, Berlin, contains several Communist handbills from the immediate post–World War I period; these were the only such political leaflets that Höch saved from this period.

44 This was not the first publication of the photograph. The "bathing picture," as this image of Ebert and Noske came to be called, had in fact appeared on the cover of a right-wing illustrated weekly, the *Bilder zur Zeitgeschichte* of the *Deutsche Tageszeitung*, where it was accompanied by a sarcastic text that attempted to humiliate and discredit the Ebert regime. I learned of this from Brigid Doherty, who discussed the photograph and its many implications in "Long Live the Belly of the Revolution: Berlin Dada and the Body Politic," a paper delivered at the College Art Association convention, San Antonio, Texas, 25 January 1995. I am grateful to Doherty for providing me with a copy of this paper. Höch's source, however, was the *BIZ* photograph, which she had easy access to through her job at Ullstein.

45 Bergius, supra, note 3, pp. 101–106, discusses this work at length.

46 Doherty, supra, note 44, p. 17 n. 27, points out that this advertisement was published in nearly every issue of *BIZ* from 1915 to 1921.

47 It was Kristin Makholm who first suggested to me that the looming portrait head might be that of Hauptmann, and comparison of the image with contemporaneous photographs of the writer confirms this beyond any doubt. Although I have been unable to examine the photomontage itself to see if the verso contains any references to Hauptmann, at the 1929 *Film und Foto* exhibition in Stuttgart, Höch did, in fact, exhibit a work (now lost) entitled *Porträt Gerhart Hauptmann* (*Portrait of Gerhart Hauptmann*), which was subsequently reproduced in *Kunstblätter der Galerie Nierendorf*, no. 6 (Berlin: Galerie Nierendorf, 1964), p. 19. Although this reproduction is small and of poor quality, it appears that the original photographic source of the head in *And When You Think the Moon is Setting* is indeed the same as that in *Portrait of Gerhart Hauptmann*.

48 Peter Sprengel, *Gerhart Hauptmann: Epoche—Werke—Wirkung* (Munich: C. H. Beck, 1984), p. 226.

49 Gordon Craig, *Germany 1866–1945* (New York and Oxford: Oxford University Press, 1978), p. 640.

50 The song was certainly known by Höch and her friends. On a card to Höch from Hausmann, Arthur and Ernestine (Erna) Segal, Herwarth Walden, and Salomo Friedlaender, 14 June 1921 (*Lebenscollage*, vol. 2 (pt. 2), supra, note 22, p. 14 [21.4]), Erna Segal quoted the song's refrain. I am grateful to Sabine Schardt and Ralf Burmeister of the Berlinische Galerie for first alerting me to the fact that the phrase used by Segal was a line in a popular song, and to the staff at the Staatsbibliothek Preußischer Kulturbesitz for helping me locate the sheet music.

51 Herta Wescher, *Collage*, trans. Robert E. Wolf (New York: Abrams, 1968), p. 141, was the first to misidentify these men as Henry Ford and Emil Kirdorf. Probably because Wescher knew Höch, most subsequent scholars, including myself, have assumed this to be true. See, for example, my own misguided discussion of *Hochfinanz* in "Hannah Höch," in *Three Berlin Artists of the Weimar Era: Hannah Höch, Käthe Kollwitz, Jeanne Mammen*, exh. cat. (Des Moines: Des Moines Art Center, 1994), pp. 19–20. I am grateful to George Slade, former librarian at the Walker Art Center, Minneapolis, whose knowledge of photography led him to identify the Herschel portrait by Cameron, and to Michelle Cutler, who then located the source in *Die Dame* 47, no. 15 (mid-May, 1920), p. 5, where the caption misidentifies the photographer as Fox Talbot. I am further indebted here to Hendrik Berinson, who first identified the landscape below as the fairgrounds in Breslau.

52 Kallos, supra, note 7, passim.

53 The title of the work is frequently miscited. *Küchenmesser* (kitchen knife) is often referred to as *Kuchenmesser* (cake knife), which, being duller than a kitchen knife, implies an action more benign than that which Höch actually intended. On this, see Jula Dech, *Hannah Höch: Schnitt mit dem Küchenmesser Dada durch die letzte weimarer Bierbauchkulturepoche Deutschlands* (Frankfurt am Main: Fischer Taschenbuch Verlag GmbH, 1989), pp. 22–24. My discussion of *Cut with the Kitchen Knife* draws heavily on this pioneering study.

54 Suzanne Pagé, "Interview avec/mit Hannah Höch," in *Hannah Höch: Collages, Peintures, Aquarelles, Gouaches, Dessins/Collagen, Gemälde, Aquarellen, Gouachen, Zeichnungen*, ed. Suzanne Pagé et al., exh. cat. (Berlin and Paris: Musée d'Art Moderne de la Ville de Paris and Nationalgalerie Berlin Staatliche Museen Preußischer Kulturbesitz, 1976), p. 25.

55 Full citations for the source image of this and the other figures discussed below are given in Gertrud Jula Dech, *Schnitt mit dem Küchenmesser DADA durch die letzte weimarer Bierbauchkulturepoche Deutschlands: Untersuchungen zur Fotomontage bei Hannah Höch* (Münster: Lit Verlag, 1981).

56 On the image of the beer belly as metaphor for the Berlin Dadaists of the Weimar Republic, see Doherty, supra, note 44.

57 Höch, in a typescript she made regarding her exhibition *Fotomontagen und Gemälde* at the Kunsthalle Bielefeld in 1973 (now in the Hannah Höch Archive, Berlinische Galerie, Berlin), recounts that her work with photomontage inspired this painting, as well as *Journalisten* (*Journalists*, 1925), *Roma* (*Rome*, 1925), and an unidentified still life: "Working on a greatly enlarged scale, I transposed clippings of printed photos onto oil painting in new, meaningful combinations." While interesting, this technique of imitating the style of photomontage in painting ultimately made Höch "uneasy" because it seemed "contrary to the rules." She abandoned the effort and made no more oil paintings in this manner. See Peter Boswell's analysis of these works on pp. 12–15 of this volume.

58 Pagé, supra, note 54, p. 27.

59 See, for example, Raoul Hausmann, "Der Besitzbegriff in der Familie und das Recht auf den eigenen Körper," *Die Erde* 1, no. 8 (15 April 1919), pp. 242–245; and "Zur Auflösung des bürgerlichen Frauentypus: Unter besonderer Berücksichtigung eines Einzelfalles," *Die Erde* 1, nos. 16–17 (1 September 1919), pp. 519–520. The manuscripts for these essays, with some additional handwritten notes that did not appear in the published texts, are included in *Lebenscollage*, vol. 1, supra, note 3, pp. 547–552 (12.9) and 572–578 (12.22).

60 See especially the letter from Hausmann to Höch, 10/12/13 November 1917, *Lebenscollage*, vol. 1, supra, note 3, pp. 310–319 (9.54). Höch later referenced this aspect of Hausmann's philosophical speculations with an oil painting that dates to 1926 (page 10). Sometimes known as *Zwei Köpfe* (*Two Heads*), the work was originally exhibited under the title *Imaginäre Brücke* (*Imaginary Bridge*). It depicts the small figure of a baby emerging from the open mouth of a man in conversation with a woman.

61 Notable among these works is *Frau und Saturn* (*Woman and Saturn*, 1922), a self-portrait of Höch cradling a child in her arms with the glowering face of Hausmann behind. On this painting in particular and, more generally, on the significance of astrology for Höch and her relationship with Hausmann, see Ellen Maurer, "Dadasoph und Dada-Fee: Hannah Höch und Raoul Hausmann, Eine Fallstudie," in *Der Kampf der Geschlechter: Der neue Mythos in der Kunst 1850–1930*, exh. cat. (Munich: Städtische Galerie im Lenbachhaus, 1995), pp. 323–328. Regrettably, Maurer's in-depth analysis of Höch's paintings was published only as this catalogue entered its final stages of preparation; detailed consideration of the arguments contained therein is thus absent here, but I refer the reader to her *Jenseits fester Grenzen: Das malerische Werk bis 1945* (Berlin: Gebr. Mann Verlag, 1995).

62 See especially a letter from Elfriede Hausmann-Schaeffer to Höch, 27 April 1918, *Lebenscollage*, vol. 1, supra, note 3, pp. 372–375 (10.32).

63 In *Lebenscollage*, vol. 1, supra, note 3, the portions of Hausmann's letters that refer to some of the most violent of the couple's encounters are often merely described rather than quoted. See especially Hausmann to Höch, 23 March 1918, 27 March 1918, and 3 June 1918, pp. 351 (10.9), 352 (10.11) and 389 (10.38), originals of which are accessible in the Hannah Höch Archive, Berlinische Galerie, Berlin. See also Hausmann to Höch, 11 July 1917 and 4 June 1918, pp. 288–290 (9.33) and 389–393 (10.39), for insights into the couple's complicated relationship. Fantasies about killing Höch are expressed in Hausmann to Höch, 28 September 1917 and 5 February 1918, pp. 299–301 (9.44) and 341–342 (10.4).

64 According to Höch, "none of these men were satisfied with just an ordinary woman [mit einem Lischen Müller]." But, she continued, "neither were they inclined to abandon the [conventional] male/masculine morality toward the woman. Enlightened by Freud, in protest against the older generation . . . they all desired this 'New Woman' and her groundbreaking will to freedom. But—they more or less brutally rejected the notion that they, too, had to adopt new attitudes. . . . This led to these truly Strindbergian dramas that typified the private lives of these men. Many volumes would have to be written on the fates of the women in order to get a complete picture of those times." *Hör zu* Autobiographical Notes, supra, note 4.

lization, the unequal pay scale for men and women, and male intransigence toward women's rights, see the references listed in my essay "Hannah Höch," supra, note 51, p. 24 n15, 16.

74 The disappointment that liberal women felt in this regard is evident oven in generally upbeat articles such as Elfe Frobenius, "Parlamentarische Frauenberufe," *Neu-Deutschlands Frauen* (February 1920), pp. 11–13; and Ilse Hamel, "Politische Arbeitsgemeinschaften," *Neu-Deutschlands Frauen* (May 1920), pp. 39–40. For a lengthier treatment of the subject, see Renate Bridenthal and Claudia Koonz, "Beyond *Kinder, Küche, Kirche*: Weimar Women in Politics and Work," in *When Biology Became Destiny*, supra, note 72, pp. 33–65. Cornelie Usborne, *The Politics of the Body in Weimar Germany: Women's Reproductive Rights and Duties* (Ann Arbor: The University of Michigan Press, 1992), qualifies somewhat this uniformly negative verdict on Weimar-era feminism.

75 Höch recalled what it was like to live at the height of the inflation in the *Hör zu* Autobiographical Notes, supra, note 4. Among other things, she noted that the cost of a postcard stamp rose from six thousand marks on 20 September 1923 to two million marks just four weeks later.

76 Travel diary, Paris, 1924, *Lebenscollage*, vol. 2 (pt. 2), supra, note 22, pp. 177–190 (24.37). Here Höch also recorded the addresses of Theodor Fränkel, Leonce Rosenberg, and Pablo Picasso, and she mentions Max Ernst; so it is possible that she visited or tried to visit those artists, too. On a loose scrap of paper still extant in her estate, Höch made the following notation, probably also in reference to her 1924 trip: "April 22 Paris: Tzara Soupault Eluard Th. Fraenkel Huidobro Porot Ribemont-Dessaignes Satie Serner Selavy [Marcel Duchamp]." It is likely that she met these artists as well. Theo van Doesburg apparently provided the introductions in many cases; on his business card (still extant in the Hannah Höch Archive, Berlinische Galerie, Berlin), the following handwritten reference is inscribed: "Je vous recommande Mlle Hannah Hoech de Berlin, une artiste sincère et devouée. Belle Isle. Theo Van Doesburg."

77 Sabine Lange, "Die Entwürfe Hannah Höchs zur Anti-Revue," master's thesis, Albertus-Magnus-Universität, Cologne, 1984.

78 There are many reminiscences of Schwitters by Höch. Among the less accessible that contain pertinent information are her notes from the interview that SFB conducted with her, supra, note 40; and a Daybook from 1923, in the Höch Family Estate, which includes entries that recount the vacation she took with the Schwitterses and the Arps on the island of Rügen in that year.

79 Roditi, supra, note 9, p. 29.

80 Brugman supported herself mainly by teaching foreign languages. Her business card, in the Höch Family Estate, lists Dutch, French, German, English, Spanish, Danish, Norwegian, Italian, Russian, Japanese, Latin, and Greek as those languages in which she gave lessons.

81 B. van Garrel, "Fröbelen met een vlijmscherp lancet," *Nieuwe Rotterdamsche Courant/Handelsblad*, 30 September 1988, as cited in Chris Rehorst, "Hannah Höch und die Niederlande," in *Hannah Höch 1889–1978*, supra, note 3, pp. 51–52.

82 Ohff, supra, note 37, p. 25.

83 See the corpus of letters from Brugman to Höch, 1926–1935, in the Archiv für bildende Kunst am Germanischen Nationalmuseum, Nuremberg.

65 Hausmann recounted this in a letter to Doris Hahn, 24 January 1965, Staatsbibliothek Preußischer Kulturbesitz, Berlin.

66 Richter, supra, note 38, p. 132; and letter from Höch to Richter, 13 December 1965, Hannah Höch Archive, Berlinische Galerie, Berlin.

67 Heinz Ohff, in a short, unpublished text entitled "Was fürs erste nicht erscheinen kann," 3 February 1965 (Heinz Ohff Archive, Berlinische Galerie, Berlin) recalls that Höch painted only in secret, behind Hausmann's back. The text contains information about Höch that Ohff gleaned during interviews he conducted with the artist in preparation for his 1965 book (supra, note 37). Although much of this material provides important clues for understanding Höch's relationship with Hausmann, Ohff was nevertheless unwilling to publish it during Höch's life for fear of embarrassing her.

68 Letter from Hausmann to Höch, 21 August 1915, *Lebenscollage*, vol. 1, supra, note 3, pp. 128–129 (6.25); and Ohff, supra, note 67. In a letter to Doris Hahn, 3 February 1965 (Staatsbibliothek Preußischer Kulturbesitz, Berlin, Handschriften-Abteilung), Hausmann himself recounted an incident in which a common friend of the pair, Arthur Segal, took Hausmann to task for letting Höch support him.

69 *Hör zu* Autobiographical Notes, supra, note 4.

70 Forty-five years later, he still recalled this incident, which took place at a soirée at Arthur Segal's, with great bitterness. See a letter from Hausmann to Doris Hahn, 3 February 1965, Staatsbibliothek Preußischer Kulturbesitz, Berlin, Handschriften-Abteilung.

71 The story, first published in *Lebenscollage*, vol. 1, supra, note 3, pp. 746–749 (13.81), appears in English translation in Lavin, supra, note 8, pp. 216–218.

72 The last decade has seen considerable research on the phenomenon of the "New Woman" of Weimar Germany. I have found the following anthologies particularly useful: Renate Bridenthal, Atina Grossmann, and Marion Kaplan, eds., *When Biology Became Destiny: Women in Weimar and Nazi Germany* (New York: Monthly Review Press, 1984); Kristine von Soden and Maruta Schmidt, eds., *Neue Frauen: Die zwanziger Jahre: BilderLeseBuch* (Berlin: Elefanten Press, 1988); and Katharina Sykora, Annette Dorgerloh, Doris Noell-Rumpeltes, and Ada Raev, eds., *Die Neue Frau: Herausforderung für die Bildmedien der Zwanziger Jahre* (Marburg: Jonas Verlag, 1993).

73 See Susanne Rouette, "Gleichberechtigung ohne 'Recht auf Arbeit': Demobilmachung der Frauenarbeit nach dem Ersten Weltkrieg," in *Unter allen Umständen: Frauengeschichte(n) in Berlin*, ed. Christiane Eifert and Susanne Rouette (Berlin: Rotation Verlag, 1986), pp. 159–182. For contemporary reactions to demobi-

84 Letter from Höch to Grete König, 14 October 1926, Höch Family Estate, as cited in Lavin, supra, note 8, pp. 188–189.

85 According to Lavin, supra, note 8, pp. 236–237, this work is titled *Auf dem Weg zum F. Himmel*, which she hypothesizes is a reference to "Frauen-Himmel." Lavin does not cite the source for this alternative title in her intriguing note; the work itself is dated and inscribed with the title "Auf dem Weg zum siebenden Himmel," the word *siebenden* being an archaic form of *siebten* or "seventh."

86 See Jula Dech, "Marionette und Modepuppe, Maske und Maquillage—Beobachtungen am Frauenbild von Hannah Höch," in *Hannah Höch: Fotomontagen, Gemälde, Aquarelle*, exh. cat. (Tübingen and Cologne: Kunsthalle Tübingen and DuMont Buchverlag, 1980), pp. 79–94; and Kallos, supra, note 7, pp. 188–196.

87 An illustration of an adult female doll, very similar to Höch's but made by the well-known dollmaker Erna Pinner, was published in *Die Dame* 43, no. 15 (1 May 1916), p. 11. Pinner's doll was said in the caption to be in the collection of the "Hohenzollern-Kunstgewerbehaus, Berlin," which was probably the Kunstgewerbemuseum. Insofar as Höch made her dolls in the same year, it is not unlikely that she was familiar with Pinner's doll or the illustration of it.

88 It is unclear exactly how many and which works belong to this series. Höch sent two photomontages from this group to the International Salon of Photography in Philadelphia in 1932: *Liebe im Busch* (*Love in the Bush*, 1925) (pl. 30) and *Fechtbeine Schmetterling* (*Fencing-legs Butterfly*), which is probably the work now known as *Der große Schritt* (*The Large Step*, 1931). At her 1934 Brno exhibition she exhibited three works from the series, including *Love in the Bush*, one of the *Coquette* images, and another photomontage identified only as "Aus der Sammlung 'Liebe.'" *Bäuerliches Brautpaar* (*Peasant Wedding Couple*, 1931) (pl. 66) was also in the 1934 Brno exhibition; although not identified by Höch as part of the Love series, it appears in her handwritten checklist for the exhibition (Hannah Höch Archive, Berlinische Galerie, Berlin) directly above those photomontages that were, and it may thus be associated with them. Another photomontage with the title of *Liebe* (c. 1926) (pl. 55), now in the collection of Stuttgart's Institut für Auslandsbeziehungen, was probably part of this series, as well as a now-lost work entitled *Platonische Liebe* (*Platonic Love*), from around 1930.

89 One can only speculate about the meanings Höch intended for *Tamer*, but, as Peter Boswell has pointed out in conversation, the seal at the lower right is perhaps significant. Höch collaged a large seal head atop her own body in *Lebensbild* (*Life Portrait*, 1972–1973) (pages 148–149). This was her last major work, and it presents her life history through photographs of herself and her friends. If she similarly identified with the seal in *Tamer*, then the muscled figure above might well represent Brugman.

90 On the more public manifestations and meanings of androgyny in Weimar-era Germany, especially as they relate to Höch, see Maud Lavin's "Androgyny and Spectatorship," in Lavin, supra, note 8, pp. 185–204. See also Lavin's "Androgynität und der betrachtende Blick: Zu Hannah Höchs Photomontagen aus der Weimarer Zeit," trans. Sebastian Wohlfeil, in *Hannah Höch 1889–1978*, supra, note 3, pp. 146–152; and "Androgyny, Spectatorship, and the Weimar Photomontages of Hannah Höch," *New German Critique*, no. 51 (Fall 1990), pp. 62–86.

91 Georg Loewenstein, "Die Herrschaft der Drüsen," *Die Koralle* 2, no. 7 (late October 1926), pp. 536–541; and Curt Thomalla, "Das Drüsenrätsel: Die geheimnisvolle Wirkung der inneren Sekretion," *Uhu*, no. 2 (November 1924), pp. 82–91, 142–143.

92 *Die Woche*, 2 January 1926, p. 23.

93 David Bathrick, "Boxing as an Icon of Weimar Culture," *New German Critique*, no. 51 (Fall 1990), p. 123.

94 Höch dated the work 1930 at the lower right, but she did so in ballpoint pen, a post–World War II invention. Insofar as Höch's postdating is often incorrect, I think a more likely date is 1928, the year that Carl-Theodor Dreyer's *La Passion de Jeanne d'Arc* premiered. As discussed below, the photomontage contains many complex allusions to the film. I am grateful to Antoinette King at the Museum of Modern Art for her assistance with conservation issues.

95 It is uncertain when this work received the rather curious title inscribed at the lower left in ballpoint pen. It was not clearly titled *Indische Tänzerin* when it was originally exhibited: Höch noted on a questionnaire that she filled out for the Museum of Modern Art in 1965 that the collage had first been shown in Brussels at either the first or second *Exposition internationale de la photographie*, in 1932 or 1933, and then at her 1934 Brno exhibition; catalogues to the 1932 Brussels exhibition and the 1934 Brno exhibition titled pieces from the Ethnographic Museum series, including this one, generically, so that it is impossible to distinguish which of the works were shown; the 1933 Brussels exhibition catalogue is of even less help, for it simply lists catalogue numbers. And unlike the two other works to which *Indische Tänzerin* is closely related in title— *Englische Tänzerin* (*English Dancer*, 1928) (pl. 39) and *Russische Tänzerin* (*Mein Double*) (*Russian Dancer [My Double]*, 1928) (pl. 40)—the woman depicted here is not actually dancing.

96 On Dreyer's filmic work, particularly *The Passion of Joan of Arc*, see Jytte Jensen, ed., *Carl Th. Dreyer* (New York: Museum of Modern Art, 1988).

97 For evidence of Höch's engagement with film in 1928 alone, see *Lebenscollage*, vol. 2 (pt. 2), supra, note 22, pp. 323–324 (28.22–28.25, 28.27), 325–326 (28.30–28.31), 328 (28.37), 337–338 (28.50), and 341 (28.63). The Höch Family Estate contains Höch's 1931 membership card for the Deutsche Liga für unabhängigen Film Ortsgruppe Berlin (German League for Independent Film, Berlin Branch), an organization dedicated to fighting film censorship and the use of film as war propaganda. See *Lebenscollage*, vol. 2 (pt. 2), pp. 399–401 (30.30) for further information about this group and Höch's opposition to film censorship. On *Ekran*, see *Lebenscollage*, vol. 2 (pt. 2), p. 546 (34.47).

98 On these popular manifestations of "primitivism" see Jill Lloyd, *German Expressionism: Primitivism and Modernity* (New Haven and London: Yale University Press, 1991), pp. 30–31 and 88–91.

99 Joan Weinstein's review of Lloyd's book on primitivism in Expressionist art (supra, note 98) in *Art Bulletin* 75, no. 1 (March 1993), pp. 183–187, is especially illuminating on the complex ways in which German Expressionism mediated the primitive and the modern.

100 Timothy Bension, *Raoul Hausmann and Berlin Dada* (Ann Arbor: UMI Research Press, 1987), p. 25.

101 On this and other aspects of colonialism in the Weimar Republic, see Helmuth Stoecker, ed., *German Imperialism in Africa: From the Beginnings until the Second World War*, trans. Bernd Zöllner (London: C. Hurst & Company, 1986).

102 On the *Rheinlandsbastarde* controversy, see Sally Marks, "Black Watch on the Rhine: A Study in Propaganda, Prejudice and Prurience," *European Studies Review* 13, no. 3 (July 1983), pp. 297–333; and Reinhard Pommerin, *Sterilisierung der Rheinlandsbastarde* (Cologne, 1979).

103 Ohff, supra, note 37, p. 34. For a description of the ethnographic museum in Leiden, see Lavin, supra, note 8, p. 168.

104 For one reaction to the reinstallation, see Carl Einstein, "Das Berliner Völkerkunde-Museum anlässlich der Neuordnung," *Der Querschnitt* 6, no. 2 (1926), pp. 588–592.

105 Exactly when and where Höch began to work on this series is unclear, for she dated many, if not all, of the works years after they were made, usually incorrectly. *Entführung* (*Abduction*) (pl. 45), for example, is dated 1925 in Höch's shaky handwriting of her later years, but one of its media sources—the red "berry trees" in the background—dates to November 1926. Similarly, Höch dated *Denkmal I* (*Monument I*) (pl. 46) to 1924, but one of its sources—the single female leg—dates to 1928. Sometimes Höch actually altered a date, either erasing it, as in the case of *Mit Mütze* (*With Cap*) (pl. 42), or crossing it out and adding another, as on *Die Süße* (*The Sweet One*) (pl. 50). In fact, only one of the works from the Ethnographic Museum series, the now lost *Buddha* that was reproduced on the invitation to Höch's 1934 Brno exhibition, could have been made as early as mid-1924, when *Der Querschnitt* published a photograph of a Buddha figure from Barabudur that Höch used as a source. Yet even this date is a guess at best, for the work's other media sources have not yet been located. For the moment we can be certain only that Höch began to work intensively on the Ethnographic Museum photomontages sometime during or after 1925, when many of the media sources were first published, but before 1929, when she first exhibited *The Sweet One* at the *Film und Foto* exhibition in Stuttgart. Although this work is not listed in the catalogue to the exhibition, Höch included it on a handwritten checklist of works in the show that she dated 1 April 1929; see *Lebenscollage*, vol. 2 (pt. 2), supra, note 22, pp. 361–362 (29.30).

106 On Flechtheim and his activities, see *Alfred Flechtheim: Sammler, Kunsthändler, Verleger*, exh. cat. (Düsseldorf: Kunstmuseum Düsseldorf, 1987), especially the essays by Wilmont Haacke, "Alfred Flechtheim und 'Der Querschnitt'" (pp. 13–19); and Jill Lloyd, "Alfred Flechtheim: ein Sammler außereuropäischer Kunst" (pp. 33–35). Gerhard F. Hering, "Der Querschnitt," in *Hundert Jahre Ullstein*, vol. 2, supra, note 27, pp. 209–255, provides more detailed information on Flechtheim's journalistic activities.

107 For detailed information on the source imagery of specific works in the series, the reader is referred to the annotations that accompany their respective plate illustrations. All references in these annotations to the collections that now house the tribal artifacts used by Höch in reproductions derive from Valentine A. Plisnier, who generously shared her research with us prior to its publication in her doctoral dissertation, "Les arts ancestraux extra-européens dans l'imaginaire des photographes du début du siècle à nos jours," University of Paris, forthcoming.

108 The third head, on the far left of the source photograph, appears in a photomontage that is not a part of the Ethnographic Museum series: *Nur nicht mit beiden Beinen auf der Erde stehen* (*Never Keep Both Feet on the Ground*, 1940) (pl. 75).

109 In differentiating Höch's work from Surrealism, I have found particularly helpful Lora Rempel's essay "The Anti-Body in Photomontage: Hannah Höch's Woman without Wholeness," in *Sexual Artifice: Persons, Images, Politics*, ed. Ann Kibbey et al. (New York: New York University Press, 1994), pp. 148–170.

110 *Der Querschnitt*, 5, no. 1 (1925), pp. 1–8.

111 For a discussion of Höch's failure to exhibit her photomontages during this period, as well as an analysis of the complex interplay of public and private concerns that may have contributed to this state of affairs, see Peter Boswell's essay in this volume, pp. 10–11.

112 The only known reviews from before 1929 of her paintings or works on paper are an article by Lothar Brieger, "Berliner Kunstsommer," which comments negatively on Höch's entries in the November Group exhibition of 1925, and an article by Kasper Niehaus, "'De Onafhankelijken' openen de deuren," which comments negatively on her submissions to the 1928 group show of the Dutch artists' society De Onafhankelijken; both of these articles are preserved in the Hannah Höch Archive, Berlinische Galerie, Berlin, but their sources are not identified. See *Lebenscollage*, vol. 2 (pt. 2), supra, note 22, pp. 241–242 (25.54) and 326–327 (28.33). Höch was more frequently and positively reviewed for her textile designs, which had a greater audience because of her job at Ullstein.

113 The Hannah Höch Archive at the Berlinische Galerie contains a number of letters and documents that relate to this exhibition, including a handwritten list by Höch that enumerates the eighteen or so works she sent to Stuttgart in early April 1929. Only eleven of these went with the traveling exhibition. See *Lebenscollage*, vol. 2 (pt. 2), supra, note 22, pp. 361–362 (29.30). For information on the *Film und Foto* exhibition, see Inka Graeve, "Internationale Ausstellung des Deutschen Werkbunds Film und Foto," in *Stationen der Moderne*, supra, note 1, pp. 236–273.

114 Clippings of the many reviews of this show at its three Dutch venues are still extant in the Hannah Höch Archive, Berlinische Galerie, Berlin. See *Lebenscollage*, vol. 2 (pt. 2), supra, note 22, pp. 367–379 (29.40–29.54).

115 Höch is mentioned in several reviews of *FiFo*; see, for example, *Lebenscollage*, vol. 2 (pt. 2), supra, note 22, pp. 383–384 (29.62) and 386–387 (29.65).

116 Letter from Franz Roh and Jan Tschichold to Höch, 19 July 1929; and Josef Albers to Höch, 31 October 1929, *Lebenscollage*, vol. 2 (pt. 2), supra, note 22, pp. 351–352 (29.8) and p. 358 (29.16).

117 The catalogue to this important exhibition of photomontage in Berlin lists only the names of the exhibitors, not the specific works that were shown. However, a selection of nine works from this exhibition traveled to the show *Das Lichtbild Essen* sometime in July 1931 and were returned to Höch in early September 1931. See letter from Baur to Höch, 23 July 1931; and Wolfgang Hermann to Höch, 18 September 1931, *Lebenscollage*, vol. 2 (pt. 2), supra, note 22, pp. 413–415 (31.13 and 31.17).

118 On Eduard von der Heydt and his art-collecting activities, see Eduard von der Heydt and Werner von Rheinhaben, *Auf dem Monte Verita: Erinnerungen und Gedanken über Menschen, Kunst und Politik* (Zurich: Atlantis Verlag, 1958); and *Von Marees bis Picasso: Meisterwerke aus dem Von der Heydt-Museum Wuppertal*, exh. cat. (Ascona: Museo Comunale di Arte Moderne, 1986). Contemporaneous sources about von der Heydt and his modern, Asian, and tribal art collections include Eckart von Sydow, "Die Primitiven-Sammlung Eduard v. d. Heydt," *Kunst und Künstler* 30 (November 1931), pp. 44–47; E[ckart] v[on] S[ydow], "Im Heim des Sammlers: Wie Baron Eduard von der Heydt seine großartige Sammlung aufgestellt hat," *Die Dame* 59, no. 19 (June 1932), pp. 10–19; and Alfred Flechtheim, "Ascona, Lausanne, Winterthur," *Der Querschnitt* 9, no. 10 (October 1929), pp. 726–727.

119 See letters from von der Heydt to Höch, 4 May 1931 and 11 May 1931, *Lebenscollage*, vol. 2 (pt. 2), supra, note 22, pp. 410–411 (31.8 and 31.9). Although von der Heydt never names the two works he purchased from Höch, one was doubtless the 1929 untitled photomontage that is now in the Kunst und Gewerbe Museum in Hamburg. This work prominently features a photographic fragment of a Cambodian sculpture that was then in von der Heydt's collection; Höch found the photograph in Alfred Flechtheim's *Der Querschnitt* essay, supra, note 118. Although Höch apparently asked 75 DM for each work, she received 100 DM for each from von der Heydt. See the draft of her letter to von der Heydt, on the verso of von der Heydt to Höch, 4 May 1931, *Lebenscollage*, vol. 2 (pt. 2), p. 411 (31.8); and the draft of her letter to František Kalivoda, on the verso of Kalivoda to Höch, 26 February 1934, in the Hannah Höch Archive, Berlinische Galerie, Berlin. I am indebted to the Höch Family Estate for permission to see the Kalivoda correspondence before it became part of the Archive in 1995.

120 It is unclear whether Höch's work was actually exhibited in Philadelphia; it would appear that it was not. Höch sent a total of four photomontages (two from the Ethnographic Museum series and two from the Love series) in a package with other works by César Domela-Nieuwenhuis and Raoul Hausmann, who she proposed might also be included in the show. Curiously, Domela-Nieuwenhuis appears in the catalogue to the exhibition, but Höch and Hausmann do not. See the correspondence between Philip Youtz of the Philadelphia Museum and Höch, 24 January and 22 February 1932, *Lebenscollage*, vol. 2 (pt. 2), supra, note 22, pp. 449 (32.1) and 464–465 (32.27); and *Philadelphia International Salon of Photography*, exh. cat. (Philadelphia: Pennsylvania Museum of Art, 1932). Höch was invited back in the subsequent year, but again the exhibition catalogue does not cite her name. See the correspondence between Youtz and Höch, 14 February 1933, *Lebenscollage*, vol. 2 (pt. 2), supra, note 22, pp. 479–480 (33.4); and *2nd International Salon of Photography*, exh. cat. (Philadelphia: Pennsylvania Museum of Art, 1933). I am indebted to Gina Kaiser and Clarissa Carnell of the Philadelphia Museum of Art for locating and sending me copies of the 1932 and 1933 catalogues.

121 See the undated correspondence regarding this exhibition between Claude Spaak and E.L.T. Mesens and Höch, *Lebenscollage*, vol. 2 (pt. 2), supra, note 22, pp. 454–455 (32.13); and the catalogue to the *Exposition internationale de la photographie*, exh. cat. (Brussels: Palais des Beaux-Arts, 1932), referenced in *Lebenscollage*, vol. 2 (pt. 2), p. 467 (32.30).

122 Correspondence concerning this exhibition includes Christof Hertel to Höch, 15 April, 18 May, and 24 May 1932, *Lebenscollage*, vol. 2 (pt. 2), supra, note 22, pp. 451–452 (32.5), 453 (32.11), and 454 (32.12).

123 Höch saved a piece of the wrapping paper in which her works were returned. It contains the postmark 1 June 1932 and the return address "Bauhaus in Dessau." She wrote on the scrap of paper "46 Arbeiten zurück"; see *Lebenscollage*, vol. 2 (pt. 2), supra, note 22, p. 467 (32.34).

124 The photograph of the work is in Höch's own photo file, now in the Hannah Höch Archive, Berlinische Galerie, Berlin. Unfortunately, she did not indicate here what the original title was.

125 I am deeply grateful to Ulrike Gauss of the Stuttgarter Staatsgalerie for calling my attention to this.

126 Form letter from the Künstlerladen e.V. to Höch, 28 April 1933, the verso of which contains a partial draft of Höch's reply to the Künstlerladen; see *Lebenscollage*, vol. 2 (pt. 2), supra, note 22, p. 500 (33.25).

127 Ohff, supra, note 37, p. 7. See also Roditi, supra, note 9, p. 24; and Pawel Liška, "Der Weg in die innere Emigration," in *Hannah Höch: 1889–1978*, supra, note 3, pp. 64–65. Liška speculates that a 1932 robbery of valuable documents from Höch's apartment in the Rubensstraße was politically motivated, and correspondence from some of Höch's friends at this time also seems to intimate as much. See, for example, Thomas Ring to Höch, 10 June 1933, *Lebenscollage*, vol. 2 (pt. 2), supra, note 22, p. 485 (33.12), which makes reference not to a robbery but to the "unpleasant visit" that Höch and Brugman had in 1932 and asks somewhat fearfully if any of his things had been taken as well.

128 For example, Gertrud Ring to Höch, 20 June 1933; Otto and Hildegard Nebel to Höch, 22 October 1933; and Thomas Ring to Höch, 28 October 1933; *Lebenscollage*, vol. 2 (pt. 2), supra, note 22, pp. 487–489 (33.14), 492 (33.18), and 492–493 (33.19).

129 The correspondence pertaining to this exhibition, organized by the architect František Kalivoda, is extensive. I am grateful to the Höch Family Estate for allowing me access to letters from Kalivoda to Höch before they became part of the Hannah Höch Archive at the Berlinische Galerie in 1995, and to Lenka Kudělková-Krčálová of the Muzeum Města Brna for sending me copies of Höch's letters to Kalivoda.

130 Wolfgang Willrich, *Säuberung des Kunsttempels: eine kunstpolitische Kampfschrift zur Gesundung deutscher Kunst im Geiste nordischer Art* (Munich, Berlin: J. F. Lehmanns, 1937). Höch's painting *Journalisten* (Journalists) is illustrated on p. 54, in a montage of ten works by members of the Novembergruppe. Willrich does not cite Höch specifically in his text, but she is subsumed in the chapter "Ursprung und Verlauf der roten Kunstverseuchung" (Origins and Development of the Red Contamination of Art).

131 See Höch's daybook entries for 1937 and 1938, *Lebenscollage*, vol. 2 (pt. 2), pp. 575–593 (37.14) and 604–613 (38.2).

132 Heinz Kurt Matthies worked as a merchandiser for Fritz Schönthal, an entrepreneur who had built a successful soldering and welding business in Berlin prior to his emigration in 1938. Schönthal had developed a product, "Gussolit," essential to the welding of large machine parts, and it was this that Matthies successfully marketed throughout Germany; his letters to Höch are filled with proud references to his financial successes at various trade fairs. Although the details of Matthies's situation after Schönthal's emigration are unclear, it seems that he continued to represent the product, a position that enabled him to travel extensively, even during World War II, when Gussolit was doubtless in great demand. I am grateful to Ruth Schönthal for the information she was able to provide me on this matter in telephone interviews in April and October 1995, and in her own reminiscences in the unpublished manuscript "A Painting Entitled 'Der Lebensweg' (The Road of Life) by Hannah Höch."

exhibition plates **26–75**
**the
interwar
period**

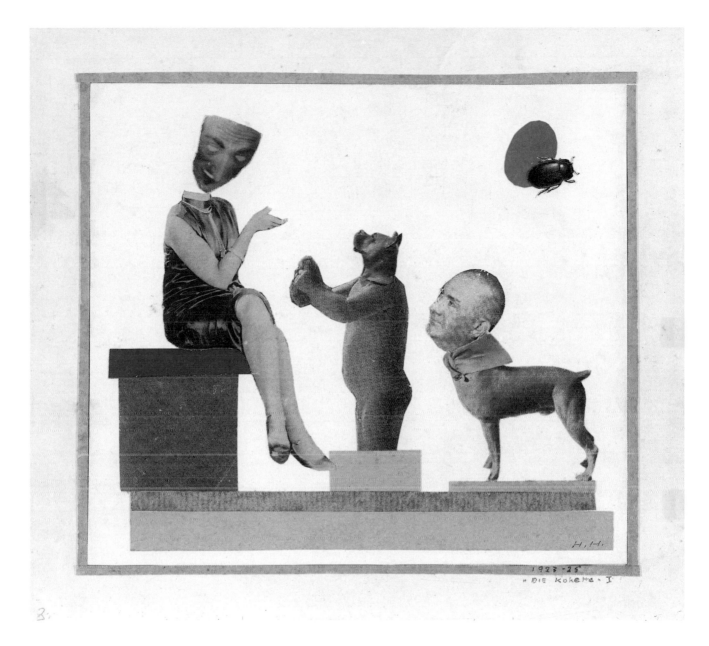

26

—————

DIE KOKETTE I (The Coquette I) 1923–1925
PHOTOMONTAGE WITH COLLAGE
7 5/16 X 8 1/16 IN. (18.5 X 20.5 CM)
COLLECTION INSTITUT FÜR AUSLANDSBEZIEHUNGEN, STUTTGART

At a 1934 exhibition of her work in Brno, Czechoslovakia, Höch showed a piece entitled *Die Kokette*, which she specifically identified as part of the Liebe (Love) series, a group of works made during the Weimar era that comment on heterosexual and homosexual, as well as platonic, relationships (see plates 27, 30, 55, 61, and 66). *The Coquette I* may well have been this work, for it portrays a masked New Woman and her bestial admirers: a baby with a dog's head and a dog with an adult-male head. Although similar in subject to many of her Dada photomontages, the work differs from Höch's more chaotic and cynical photomontages of the early Weimar era by virtue of its spare, rectilinear pictorial structure and its playful tone. Here, Höch's evolving friendships with Kurt and Helma Schwitters, Hans Arp and Sophie Taeuber-Arp, and Theo and Nelly van Doesburg may well have been influential, for unlike Raoul Hausmann and the Berlin Dadaists with whom she had been aligned previously, these artists all possessed a whimsical sense of humor and were very much involved with international Constructivism. — MM

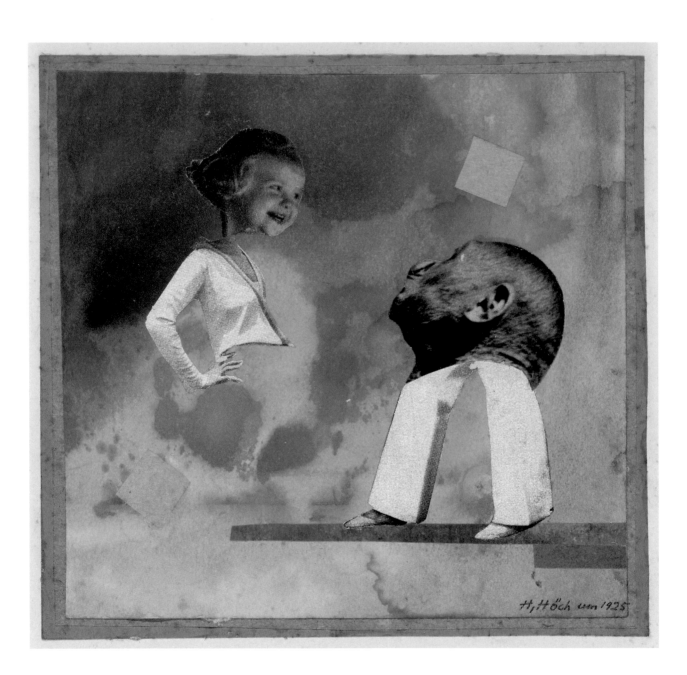

27

DIE KOKETTE II (The Coquette II) c. 1925
PHOTOMONTAGE WITH WATERCOLOR
5 ⅛ X 5 ¼ IN. (13 X 13.4 CM)
COLLECTION PETER CARLBERG, HOFHEIM, GERMANY

28

DER TRAUM SEINES LEBENS (The Dream of His Life) 1925
COLLAGE WITH PHOTOGRAPHS AND PRINTED PAPER ON MARBLEIZED PAPER
11 13/16 X 8 7/8 IN. (30 X 22.5 CM)
COLLECTION THE MUSEUM OF MODERN ART, NEW YORK
ANONYMOUS EXTENDED LOAN

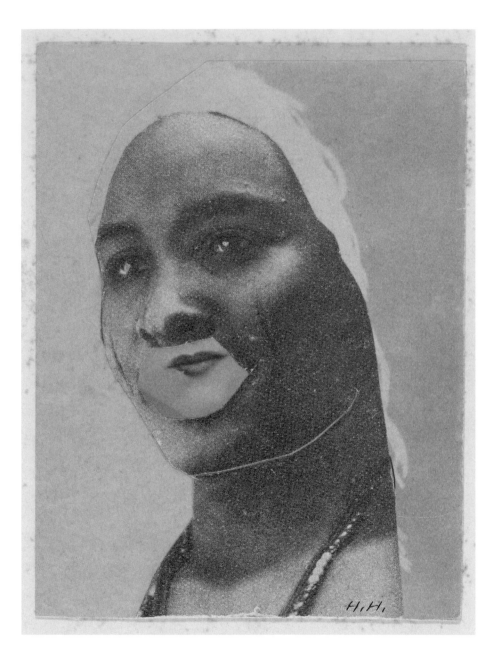

29

<hr />

MISCHLING (Half-Caste) 1924
PHOTOMONTAGE
4 ⁵⁄₁₆ X 3 ¼ IN. (11 X 8.2 CM)
COLLECTION INSTITUT FÜR AUSLANDSBEZIEHUNGEN, STUTTGART

During the post–World War I occupation of Germany by the Allies, France stationed indigenous troops from its overseas territories in the Rhineland. The presence there of black or mixed-race Africans and West Indians was intensely resented by many Germans, and racist propaganda began to spread about 40,000 "black savages" roaming the Rhineland at will, raping the women, infecting the population with all manner of tropical and venereal diseases, and—worst of all—fathering "Mischlingskinder," or children of mixed race. The "Rheinlandsbastarde" (Rhineland bastard) controversy reached its height in 1923, when territorial forces also occupied the Ruhr and President Friedrich Ebert denounced their presence as an "injury to the laws of European civilization." Here, Höch alludes to this heated debate by conjoining the head of a black woman to the lipsticked mouth of a white woman and titling the image *Mischling*, a term then firmly linked to the so-called "Black Horror on the Rhine." — MM

As reproduced in Höch's scrapbook, c. 1933, p. 58

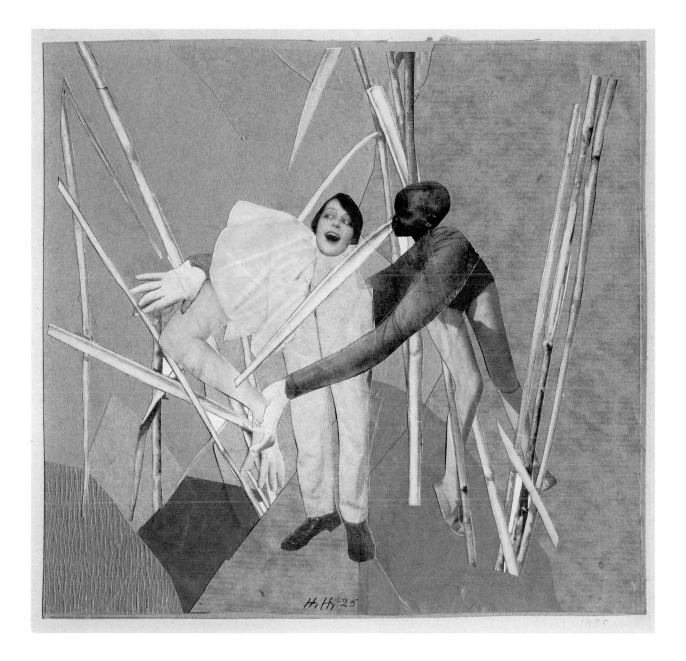

30

LIEBE IM BUSCH (Love in the Bush) 1925
PHOTOMONTAGE WITH COLLAGE
9 X 8 ½ IN. (22.8 X 21.6 CM)
COLLECTION MODERN ART MUSEUM OF FORT WORTH,
MUSEUM PURCHASE, THE BENJAMIN J. TILLAR MEMORIAL TRUST

Like *Half-Caste* (pl. 29), this photomontage doubtless references the "Rhineland bastard" controversy of the mid-1920s. Here, the woman's smiling face and coquettish glance suggest not only that she enjoys the embrace she is receiving but that she may have initiated it—a truly radical statement at a time when many Germans were describing all liaisons between black men and white German women as rape. This work is among the photomontages that belong to the Love series (see pl. 26). — MM

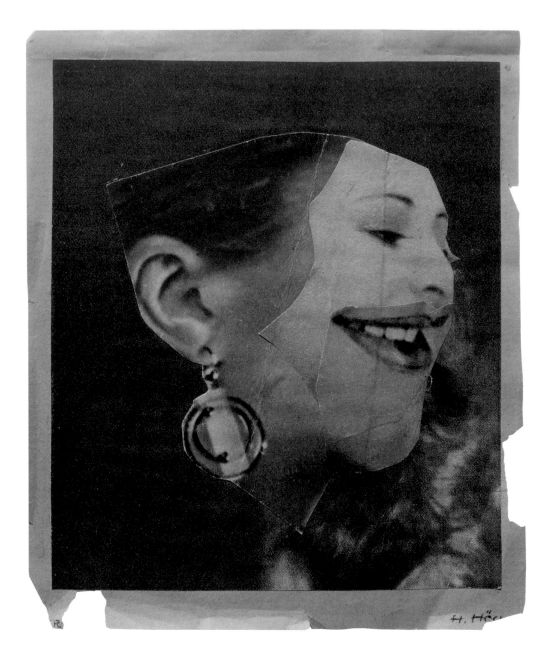

31

FRÖLICHE DAME (Merry Woman) 1923
PHOTOMONTAGE
5 ⅛ X 4 ⁷⁄₁₆ IN. (13 X 11.3 CM)
COLLECTION GREIL AND JENELLE MARCUS

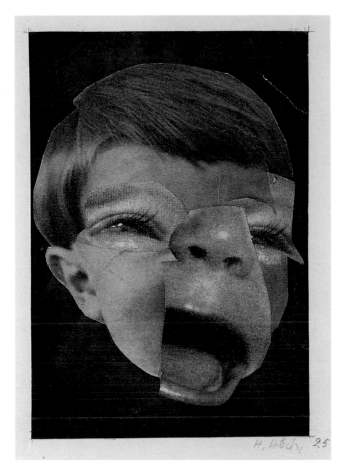

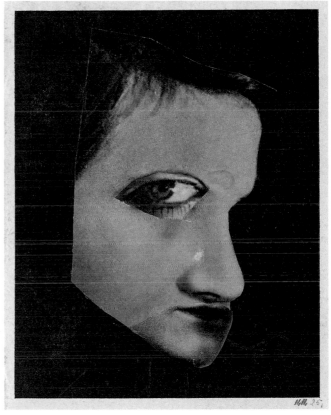

32

KINDER (Children) 1925
PHOTOMONTAGE
7 ¹¹⁄₁₆ X 5 ¼ IN. (19.5 X 13.3 CM)
COLLECTION INSTITUT FÜR AUSLANDSBEZIEHUNGEN, STUTTGART

33

DER MELANCHOLIKER (The Melancholic) 1925
PHOTOMONTAGE
6 ⅝ X 5 ⅛ IN. (16.8 X 13 CM)
COLLECTION INSTITUT FÜR AUSLANDSBEZIEHUNGEN, STUTTGART

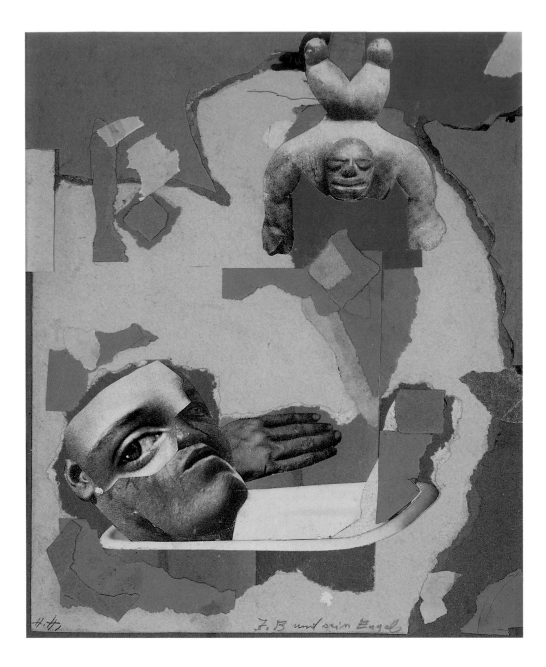

36

J. B. UND SEIN ENGEL (J. B. and His Angel) 1925
PHOTOMONTAGE WITH COLLAGE ON CARDBOARD
9 ⁷⁄₁₆ X 7 ¹³⁄₁₆ IN. (24 X 19.8 CM)
COLLECTION BERLINISCHE GALERIE, LANDESMUSEUM FÜR MODERNE KUNST, PHOTOGRAPHIE UND ARCHITEKTUR, BERLIN

The identity of the "J. B." mentioned in the title of this photomontage remains uncertain, but it may well have been Johannes Baader, who, in a text published in the 1920 *Dada Almanach* entitled "An Explanation of Club Dada," had written: "Die Menschen sind Engel und leben in Himmel" (People are angels and live in heaven). The media source for the "angel" flying above J. B.'s disembodied head was a photographic reproduction of a wooden bowl from Hawaii (now in the British Museum) that rests on three handstanding figurines, one of which forms the angel's body. Höch used the same figurine in a 1931 collage originally entitled *Fechtbeine Schmetterling (Fencing-Legs Butterfly)* but now known as *Der große Schritt (The Large Step)* (not illustrated). — MM

Der Querschnitt 5, no. 6 (June 1925), between pp. 488 and 489

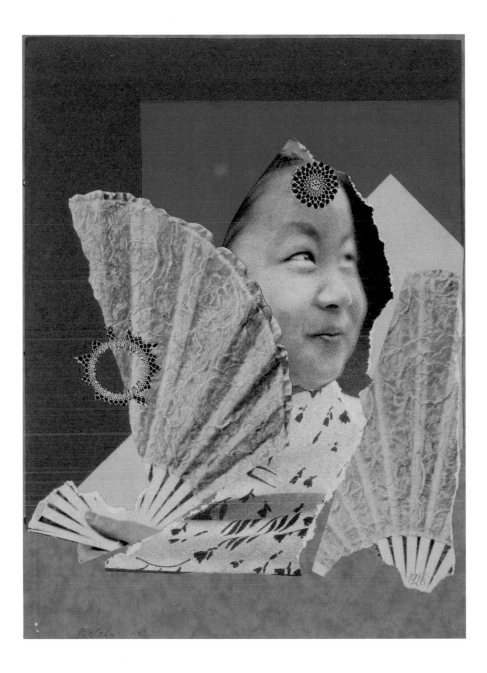

37

DAME MIT FÄCHER (Chinese Girl with Fan) 1926
PHOTOMONTAGE WITH COLLAGE
11 X 8 IN. (27.9 X 20.3 CM)
COLLECTION LOUISE ROSENFIELD NOUN, DES MOINES, IOWA

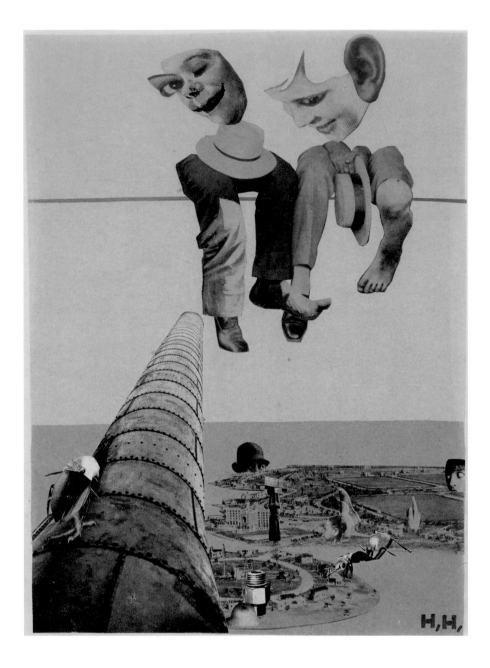

38

VON OBEN (From Above) 1926–1927
PHOTOMONTAGE WITH COLLAGE
12 ⅜ X 8 ⅝ IN. (31.4 X 21.9 CM)
COLLECTION LOUISE ROSENFIELD NOUN, DES MOINES, IOWA

Previously dated to around 1925, this photomontage, in fact, dates at the earliest to 1926–1927. *Die Koralle*, Ullstein's equivalent of *National Geographic*, provided Höch with three of her sources for the work: a photograph of a pigeon was used for the leg of the bug-bird perched atop the "pipe" at the lower left, while a page illustrating the biology of the black water beetle lent the imagery for the creature's body; the ant that straddles the two land masses at the lower right derived from a page depicting various types of grasshoppers and ants. What appears in the photomontage to be a massive, segmented pipe or cannon is actually a smokestack, while the two land masses at the lower right were originally reproduced in an article that detailed the damage done to the city of Miami by a hurricane. The work was first exhibited at the *Film und Foto* exhibition of 1929 and was later shown in Höch's 1934 exhibition in Brno, Czechoslovakia, from which its organizer, František Kalivoda, purchased the piece. The work sometimes has been known as *Two Children Above the City*. — MM

Die Koralle 2, no. 3 (late June 1926), p. 185
Die Koralle 2, no. 3 (late June 1926), p. 229
Der Querschnitt 6, no. 8 (August 1926), between pp. 584 and 585
BIZ 35, no. 46 (14 November 1926), p. 1517
Die Koralle 3, no. 8 (late November 1927), p. 443

41

DER SIEGER (The Victor) 1927
PHOTOMONTAGE
8 ⅞ X 7 1/16 IN. (22.5 X 18 CM)
COLLECTION GALLERIA NAZIONALE D'ARTE MODERNA E CONTEMPORANEA, ROME

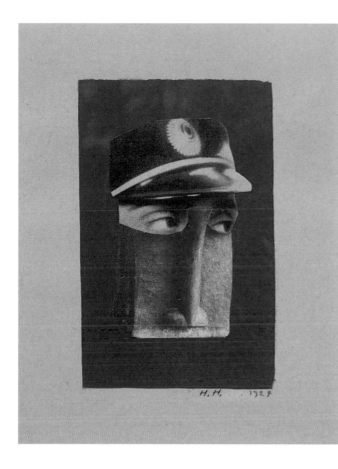

42

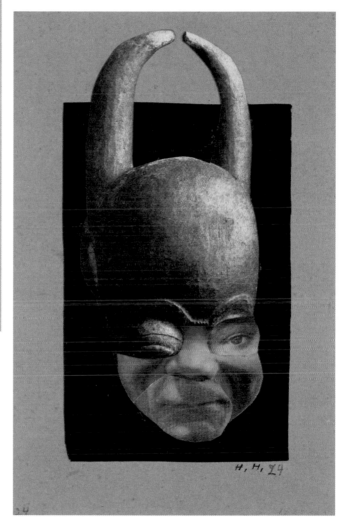

MIT MÜTZE (AUS EINEM ETHNOGRAPHISCHEN MUSEUM IX)
(With Cap [From an Ethnographic Museum IX]) 1924
PHOTOMONTAGE WITH COLLAGE AND INK ON CARDBOARD
10 ¹³⁄₁₆ X 6 ⅛ IN. (27.5 X 15.5 CM)
COLLECTION BERLINISCHE GALERIE, LANDESMUSEUM FÜR
MODERNE KUNST, PHOTOGRAPHIE UND ARCHITEKTUR, BERLIN

43

HÖRNER (AUS EINEM ETHNOGRAPHISCHEN MUSEUM X) (*Horns [From an Ethnographic Museum X]*) 1924
PHOTOMONTAGE WITH COLLAGE ON CARDBOARD
7 ¹¹⁄₁₆ X 4 ⅞ IN. (19.5 X 12.4 CM)
COLLECTION BERLINISCHE GALERIE, LANDESMUSEUM FÜR MODERNE KUNST, PHOTOGRAPHIE UND ARCHITEKTUR, BERLIN

Höch produced her Ethnographic Museum series, a group of some seventeen works, in the mid- to late-1920s. Each features photographic fragments of non-European sculpture combined with partial images of human figures. The hybrid creatures that result are usually framed within rectangles or squares or sit on forms suggesting pedestals. In both compositional format and title, then, the series makes reference to the ethnographic museum as such, and particularly to the way in which it categorized and displayed tribal artifacts. *With Cap* and *Horns* are unusual in that they portray unambiguously male figures, in contrast to most of the other works in the series, which depict females. Although both of these pieces are signed with Höch's initials and dated either "24" or "1924" at the lower right, the pencil inscription on *With Cap* bears traces of erasure marks where another date evidently once had been. Moreover, the source image for both—a photographic reproduction of a mask from Nigeria—came from a 1925 issue of *Der Querschnitt*. Höch cut the photograph in half horizontally and used the top portion in *Horns* and the bottom portion in *With Cap*. — MM

Der Querschnitt 5, no. 1 (January 1925), between pp. 8 and 9

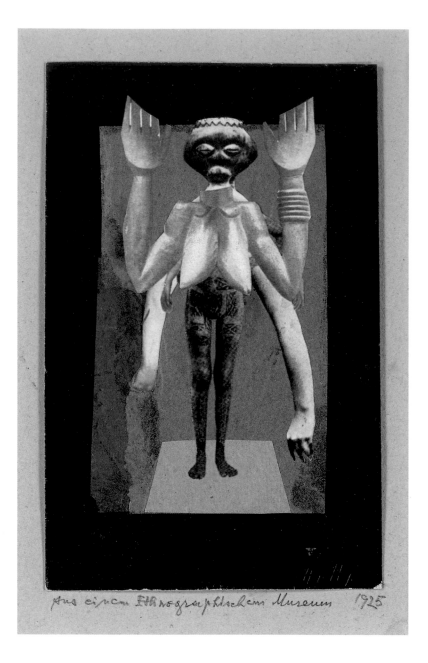

44

TRAUER (Sadness), from the series Aus einem ethnographischen Museum (From an Ethnographic Museum) 1925
PHOTOMONTAGE WITH COLLAGE
6 ¹⁵/₁₆ X 4 ½ IN. (17.6 X 11.5 CM)
COLLECTION STAATLICHE MUSEEN ZU BERLIN, KUPFERSTICHKABINETT

Two of the source images for this work derive from a single issue of *Der Querschnitt*: a photograph of a young tatooed woman from Borneo and an image of three carved-ivory sculpture heads from the former Congo, of the type typically used as pendants. The "Borneo Beauty" provides the legs of the composite figure in *Sadness*, while the top portion of the middle ivory pendant serves as its head. Höch used the two remaining pendants in *Never Keep Both Feet on the Ground* (pl. 75) and a 1930 untitled work from the Ethnographic Museum series (page 137). None of the other media sources for *Sadness* have been located, but the pendulous breasts with upheld arms and hands were components of a carved wooden stool, then in the Museum für Völkerkunde in Berlin. — MM

Der Querschnitt 5, no. 1 (January 1925), between pp. 18 and 19
Der Querschnitt 5, no. 1 (January 1925), between pp. 40 and 41
As reproduced in Eckart von Sydow, *Kunst und Religion der Naturvölker, 1926*

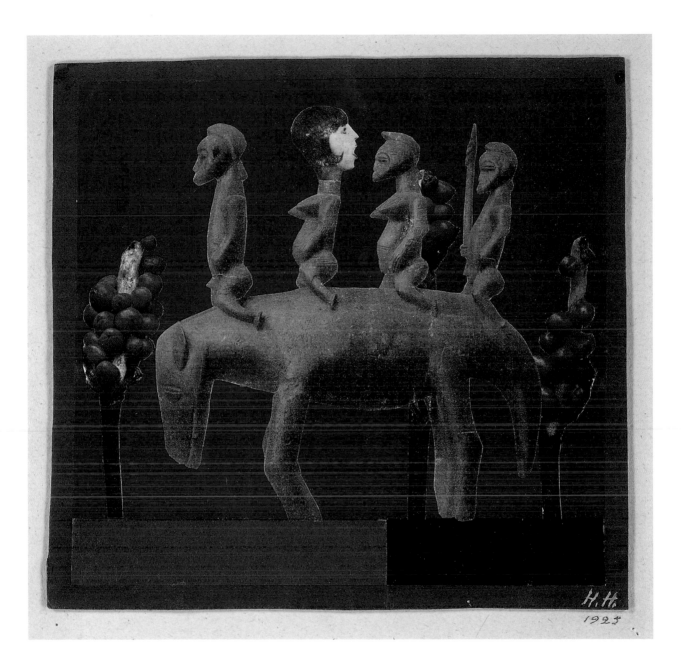

45

ENTFÜHRUNG (Abduction), from the series Aus einem ethnographischen Museum (From an Ethnographic Museum) 1925

PHOTOMONTAGE

8 ⅜ X 8 ¹¹⁄₁₆ IN. (21.3 X 22 CM)

COLLECTION STAATLICHE MUSEEN ZU BERLIN, KUPFERSTICHKABINETT

Although *Abduction* is dated 1925 below Höch's initials at the lower right, one of its photographic sources—the red "trees" in the background—was first published in an article on cures for malaria in *Die Koralle* in 1926. Höch used the bright red berries of the source photograph to enliven the otherwise muted tones that dominate this photomontage. Another photographic source—a reproduction of a wood sculpture from what was then the Congo—was published in at least two different Ullstein magazines in the mid-1920s. Höch got both the image and, evidently, the title of her photomontage from a 1924 issue of *BIZ*, where the sculpture was illustrated and captioned "Raub der Jungfrauen" (Abduction of the Virgins). — MM

BIZ 33, no. 38 (21 September 1924), p.1095
Die Koralle 2, no. 8 (late November 1926), p.622

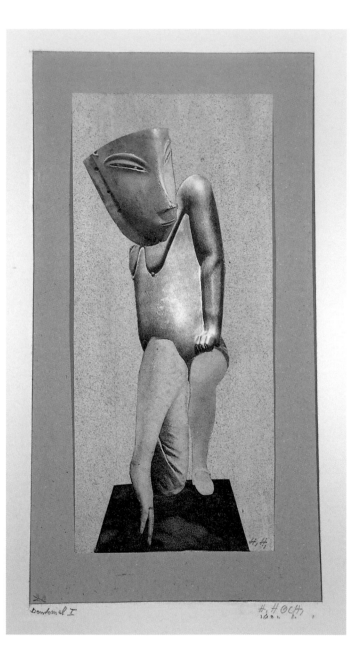

46

DENKMAL I (Monument I), from the series Aus einem ethnographischen Museum (From an Ethnographic Museum) 1924
PHOTOMONTAGE WITH WATERCOLOR ON PAPER
7 ¹¹/₁₆ X 6 ⅛ IN. (19.6 X 15.5 CM)
COLLECTION BERLINISCHE GALERIE, LANDESMUSEUM FÜR MODERNE KUNST, PHOTOGRAPHIE UND ARCHITEKTUR, BERLIN

Monument I is usually dated to 1924, but the left leg of its figure derives from a 1928 *BIZ* photograph of actress Lilian Harvey and friends at the beach. (The source for the figure's other "leg"— as yet unlocated—is an upended reproduction of a bent female arm and hand.) The head was snipped from a photograph of a mask from Gabon (now in the Barnes Foundation) while the torso and arm derive from a reproduction of a stone statue of a Theban goddess. By precisely trimming and fitting these various body parts together, Höch created an illusion of cohesive wholeness that is nonetheless immediately subverted by the variously colored component paper scraps. The eerie, hybrid figure in this way functions, like the other figures in the Ethnographic Museum series, as a psychological irritant of the first order. — MM

Der Querschnitt 4, nos. 2–3 (Summer 1924), between pp. 120 and 121
Der Querschnitt 5, no. 1 (January 1925), between pp. 64 and 65
BIZ 37, no. 30 (22 July 1928), p. 1259

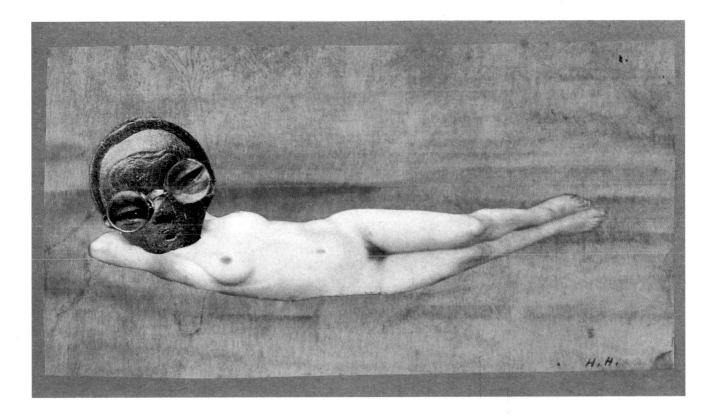

47

FREMDE SCHÖNHEIT (Strange Beauty), from the series Aus einem ethnographischen Museum (From an Ethnographic Museum) 1929
PHOTOMONTAGE WITH WATERCOLOR
4 7/16 X 8 IN. (11.3 X 20.3 CM)
COLLECTION JEAN-PAUL KAHN, PARIS

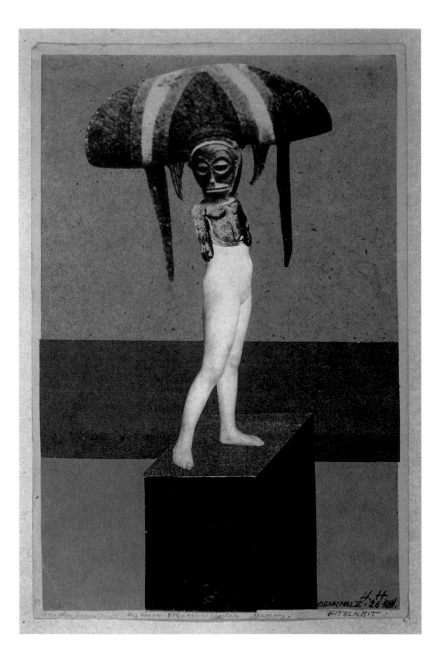

48

DENKMAL II: EITELKEIT (Monument II: Vanity), from the series Aus einem ethnographischen Museum (From an Ethnographic Museum) 1926
PHOTOMONTAGE WITH COLLAGE
10 3/16 X 6 9/16 IN. (25.8 X 16.7 CM)
GERMANISCHES NATIONALMUSEUM, NUREMBERG (ON LOAN FROM PRIVATE COLLECTION)

Höch scratched out the original date at the lower right of the image, replacing it with her initials, the title *Denkmal II: Eitelkeit*, and the year "26." Yet one of her sources for this photomontage—an elaborate headdress and mask of an African medicine man—seems to have first appeared in a 1930 issue of the Ullstein periodical *Uhu*. It is unlikely that *Monument II* predates this publication. The subtitle "Vanity" aptly describes the demeanor of this haughty hybrid creature with female legs, who seems to peer over her shoulder with disdain from her elevated perch on a gray pedestal. — MM

Uhu 6, no. 9 (June 1930), p. 56

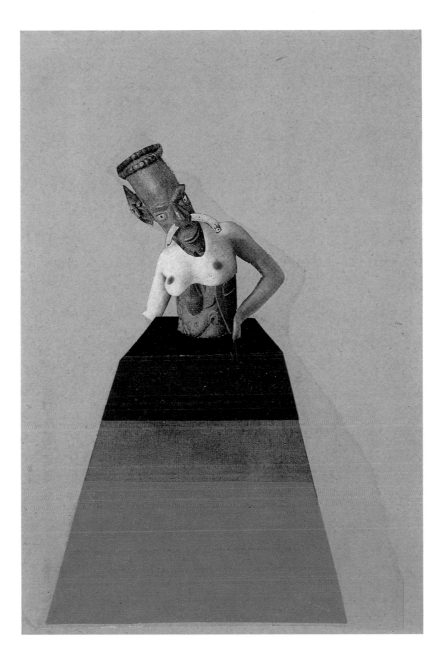

49

AUS DER SAMMLUNG AUS EINEM ETHNOGRAPHISCHEN MUSEUM (From the Collection of an Ethnographic Museum) 1929
PHOTOMONTAGE WITH COLLAGE
19 5/16 X 12 13/16 IN. (49 X 32.5 CM)
ON LOAN FROM THE FEDERAL REPUBLIC OF GERMANY

Höch fashioned the head of this hybrid female figure from a photograph of an ancestral figure from New Guinea. Now in the Musée de l'Homme, Paris, the object was then in the collection of Alfred Flechtheim, who published it in a 1926 issue of his magazine, *Der Querschnitt*. Höch may, in fact, have been familiar with the work itself, for Flechtheim displayed his collection of artifacts from New Guinea in an exhibition at his gallery in May 1926, just before Höch left on the trip to the Netherlands where she would meet Til Brugman. — MM

Der Querschnitt 6, no. 9 (September 1926), between pp. 688 and 689

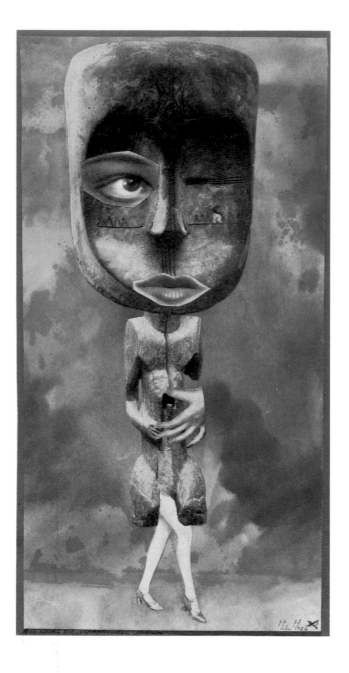

50

DIE SÜßE (The Sweet One), from the series Aus einem ethnographischen Museum (From an Ethnographic Museum) c. 1926
PHOTOMONTAGE WITH WATERCOLOR
11 ¹³⁄₁₆ X 6 ⅛ IN. (30 X 15.5 CM)
MUSEUM FOLKWANG ESSEN, PHOTOGRAPHY COLLECTION

A handwritten note by Höch on the back of a photograph of *The Sweet One*, in the Hannah Höch Archive at the Berlinische Galerie, indicates that she dated this work during the war. Another photograph in the Archive bears the date 1930, which Höch crossed out with the accompanying explanation: "is much earlier, *before* the Holland travels, that is, before 1926." Höch's confusion about when she made *The Sweet One* can be seen on the work itself, where she similarly crossed out the date "30" at the lower right and replaced it with "um 1926." Insofar as the brilliantly colored background of this photomontage is similar to that used in *Balance* (pl. 34), which is dated to 1925, and its source images date to 1924 and 1925, Höch probably did indeed make the work sometime in the mid-1920s. She fashioned the head from a photograph of a mask from the former French Congo (now in the Musée de l'Homme, Paris) and the body from an idol figure of the Bushongo tribe. — MM

Der Querschnitt 4, nos. 2–3 (Summer 1924), between pp. 136 and 137
Der Querschnitt 5, no. 1 (January 1925), between pp. 8 and 9

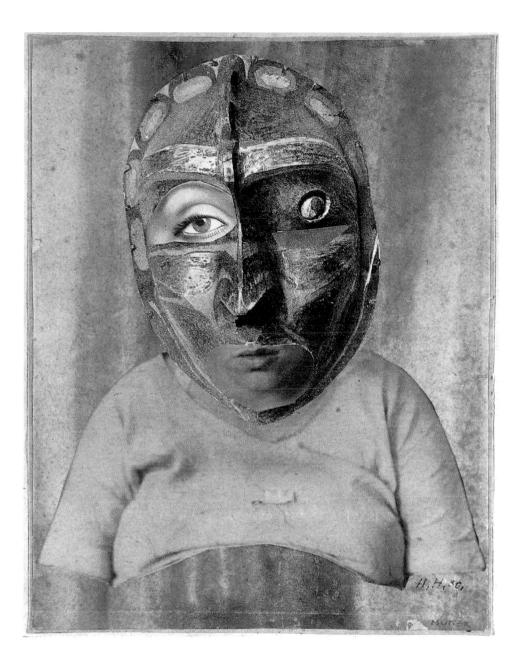

51

MUTTER (Mother), from the series Aus einem ethnographischen Museum (From an Ethnographic Museum) 1930
PHOTOMONTAGE WITH WATERCOLOR
16 ⅛ X 13 ¾ IN. (41 X 35 CM)
COLLECTION MUSÉE NATIONAL D'ART MODERNE, CENTRE GEORGES POMPIDOU, PARIS (1967)

One of the media sources for *Mother* was a reproduction of a dance mask made by the Northwest Coast Kwakiutl Indians, an object Höch may have seen in the collection of Berlin's Museum für Völkerkunde. She collaged this mask atop a reproduction of a pregnant proletarian woman whom John Heartfield had photographed in his studio. Heartfield used this woman's image in his work at least twice, most notably in a photomontage he published in *Arbeiter Illustrierte Zeitung—Zwangslieferantin von Menschenmaterial Nur Mut! Der Staat braucht Arbeitslose und Soldaten!* (*Forced Supplier of Human Ammunition Take Courage! The State Needs Unemployed and Soldiers!*)—which shows the woman in the foreground and a fallen soldier behind. Höch probably used the *AIZ* photomontage as the source for her mother, eliminating Heartfield's prescriptive title as well as the woman's swollen belly and creating a powerful image of exhausted maternity merely by focusing on the figure's drooping shoulders and mouth. The brilliant striped backing paper of *Mother* is similar to papers used in *Liebe* (pl. 55) and *Marlene* (pl. 57), photomontages that also date to around 1930. — MM

Der Querschnitt 5, no. 2 (February 1925), between pp. 168 and 169
Arbeiter Illustrierte Zeitung 9, no. 10 (1930), p. 183

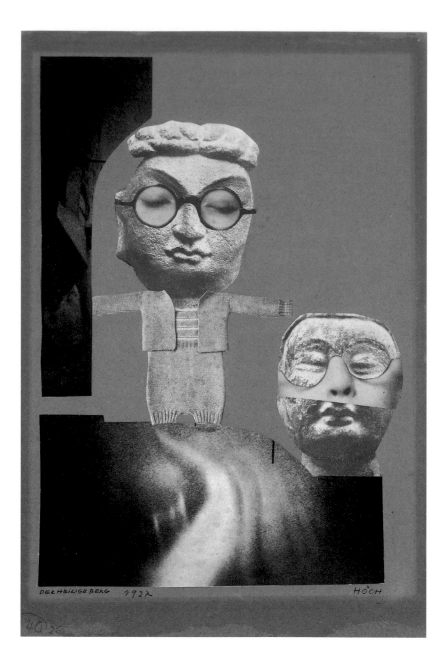

52

DER HEILIGE BERG (AUS EINEM ETHNOGRAPHISCHEN MUSEUM XII) (*The Holy Mountain [From an Ethnographic Museum XII]*) 1927
PHOTOMONTAGE ON WRAPPING PAPER
13 ¼ X 8 ⅞ IN. (33.7 X 22.5 CM)
COLLECTION BERLINISCHE GALERIE, LANDESMUSEUM FÜR MODERNE KUNST, PHOTOGRAPHIE UND ARCHITEKTUR, BERLIN

Like *Indian Dancer* (pl. 53), *The Holy Mountain* has a cinematic reference, specifically to the 1926 film *Der heilige Berg*—a melodramatic tale of two men who die atop a mountain while trying to prove their love for a fickle dancer (Leni Riefenstahl). Contemporaries may well have associated this film (and especially its ending, in which the bodies of the two friends are brought down from the mountain in a torchlight procession) with Höch's photomontage of the same name, which features two ghostly male figures, their eyes seemingly shut as they hover above an inky black "ground" illumined by an indeterminate glow of light. Höch used fragments of photographs of two sculpted Asian heads for the faces here. — MM

Der Querschnitt 5, no. 6 (June 1925), between pp. 504 and 505
Der Querschnitt 5, no. 6 (June 1925), between pp. 504 and 505

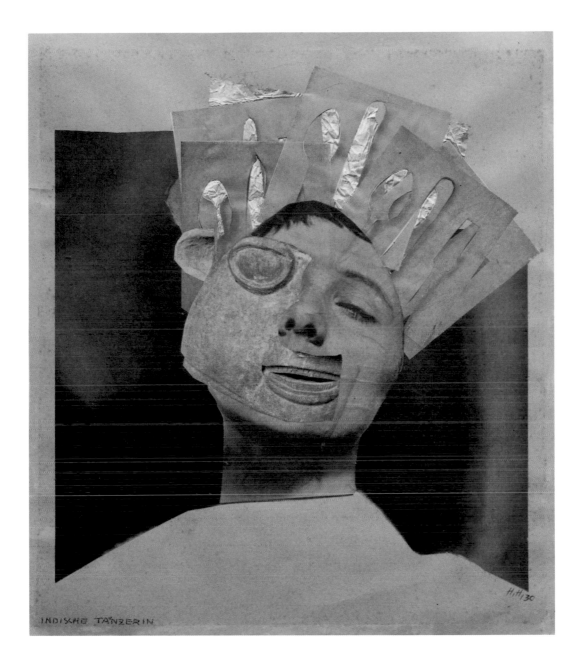

53

INDISCHE TÄNZERIN: AUS EINEM ETHNOGRAPHISCHEN MUSEUM (Indian Dancer. From an Ethnographic Museum) 1930
PHOTOMONTAGE WITH COLLAGE
10 ⅛ X 8 ⅞ IN. (25.7 X 22.4 CM)
COLLECTION THE MUSEUM OF MODERN ART, NEW YORK
FRANCES KEECH FUND

Insofar as Höch used ballpoint pen (a post–World War II invention) to inscribe "30" at the lower right of *Indian Dancer*, the dating of this photomontage is questionable. It may, in fact, date to as early as 1928, the year Carl-Theodor Dreyer released his *Passion of Joan of Arc*, an enormously popular silent film whose star, Renée (Maria) Falconetti, provided Höch with the central image of her photomontage. Although Höch's media source has not yet been located, the photograph used for this collage was a still from the film. The gray tiara, here decorated with knife-and-spoon cut-outs, references a moment in the film when Joan of Arc fashions a crown for herself of plaited straw. Höch superposed a fragment of a photograph of a dance mask from the Bekom tribe of Cameroon atop Falconetti's face. — MM

Der Querschnitt 5, no. 2 (February 1925), between pp. 168 and 169

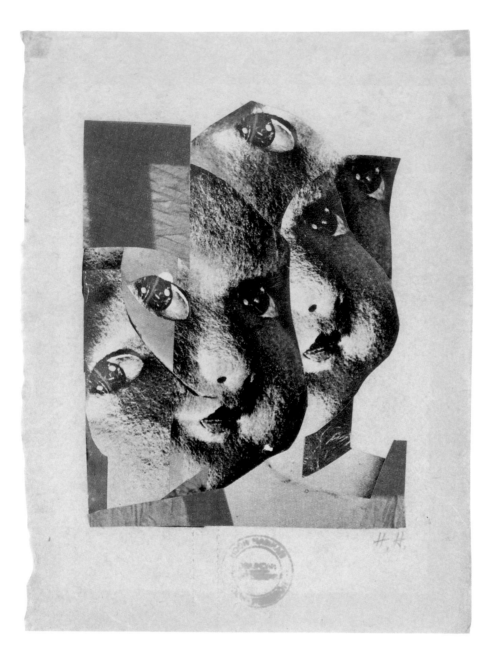

54

ZERBROCHEN (Shattered) 1925
PHOTOMONTAGE ON JAPAN PAPER
8 ½ X 6 ¼ IN. (21.5 X 15.8 CM)
COLLECTION THE MUSEUM OF FINE ARTS, HOUSTON
MUSEUM PURCHASE WITH FUNDS PROVIDED BY THE BROWN FOUNDATION ACCESSIONS ENDOWMENT FUND

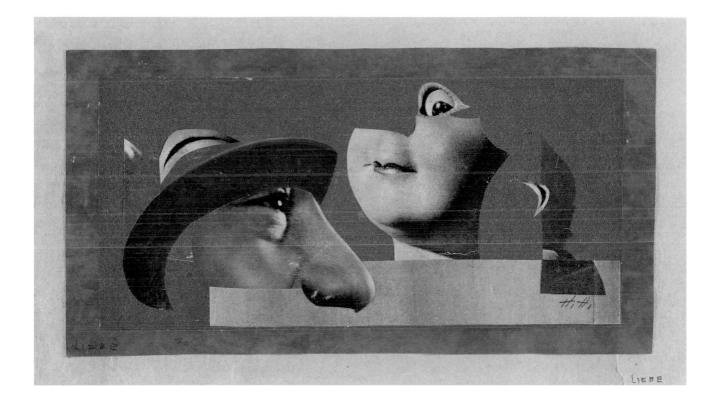

55

LIEBE (Love) C. 1926
PHOTOMONTAGE WITH COLLAGE
5 ⅛ X 10 ⅝ IN. (13 X 27 CM)
COLLECTION INSTITUT FÜR AUSLANDSBEZIEHUNGEN, STUTTGART

The mass-media source for both *Shattered* (pl. 54) and *Liebe* was the periodical *Die Woche*, which, on a single page of its December 1930 issue, reproduced the heads of four dolls and captioned them "Vier Puppen unserer Zeit" (Four dolls of our times). Overlapped five times, the doll's head at the lower left of the page is the source of *Shattered*, while the head at the upper left was a source for *Love* and for another photomontage, *Der Meister* (*The Master*, 1926) (not illustrated). Although usually dated to the mid-1920s, these works almost certainly could not have been made before 1930. — MM

Die Woche 32, no. 49 (December 1930), p.1459

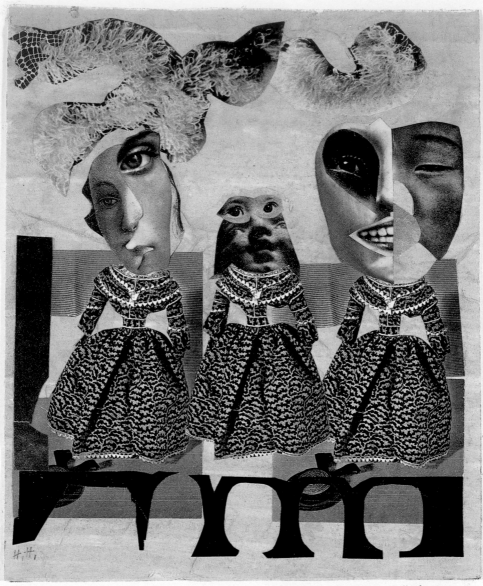

56

MODENSCHAU (Fashion Show) 1925–1935
PHOTOMONTAGE
10 ¹³/₁₆ X 9 ¹/₁₆ IN. (27.5 X 23 CM)
PRIVATE COLLECTION, BERLIN

Höch used a reproduction of Botticelli's *Birth of Venus* for the head of the "model" on the left. For centuries upheld as a classical ideal of female beauty, the Renaissance Venus is here disfigured in part by the eye of a modern woman that Höch collaged onto her face. George Grosz also once defaced a reproduction of a Botticelli painting: to demonstrate his opposition to the notion of "the masterpiece" at the 1920 Dada Fair, he exhibited an illustration of Botticelli's *Primavera* that had been demonstratively crossed out. Höch, by contrast, seems not to be questioning the canon of art history so much as received notions of beauty in this grotesque fashion show of fractured femininity. — MM

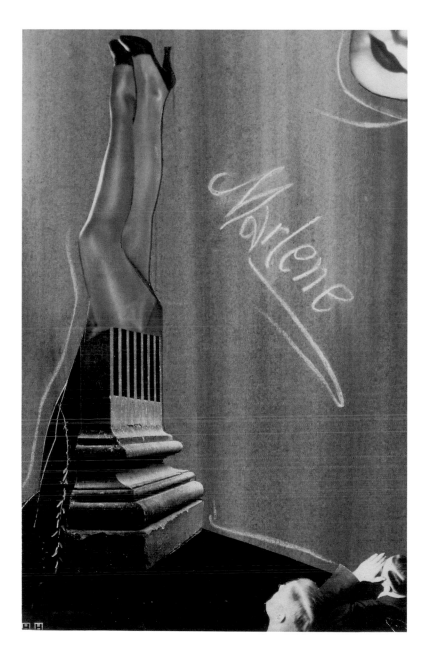

57

MARLENE 1930
PHOTOMONTAGE WITH WATERCOLOR
14 ⁷⁄₁₆ X 9 ½ IN. (36.7 X 24.2 CM)
COLLECTION DAKIS JOANNOU, ATHENS

Together with *The Holy Mountain* (pl. 52) and *Indian Dancer* (pl. 53), *Marlene* belongs to a group of works dating to the late 1920s and early 1930s that reference films or film stars. Höch was especially engaged with the cinema around this time, joining a number of Dutch and German film organizations and even writing essays on film and film censorship. Her allusion here is to Marlene Dietrich, who played the leading female role in Josef von Sternberg's *The Blue Angel* in 1930 and subsequently became an icon of Weimar-era Germany's sexually liberated woman. This photomontage is technically related to at least three other works from the period: *Mother* (pl. 51) and *Love* (pl. 55), both of which include brightly striped papers of coral pink, peach, and gray like that which serves as the background here; and *Keuschheit* (*Modesty*, c. 1930) (not illustrated), which features a photographic fragment of drooping branches like the one beside the pedestal in *Marlene*. — MM

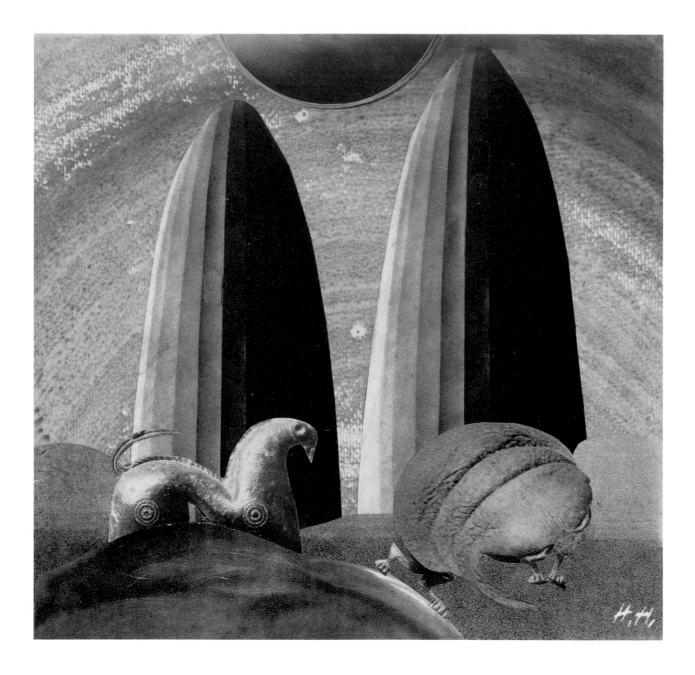

58

IN DER WÜSTE (In the Wilderness) 1927–1929
PHOTOMONTAGE WITH WATERCOLOR
9 ¹³⁄₁₆ X 10 ⅛ IN. (25 X 25.7 CM)
PRIVATE COLLECTION, GERMANY

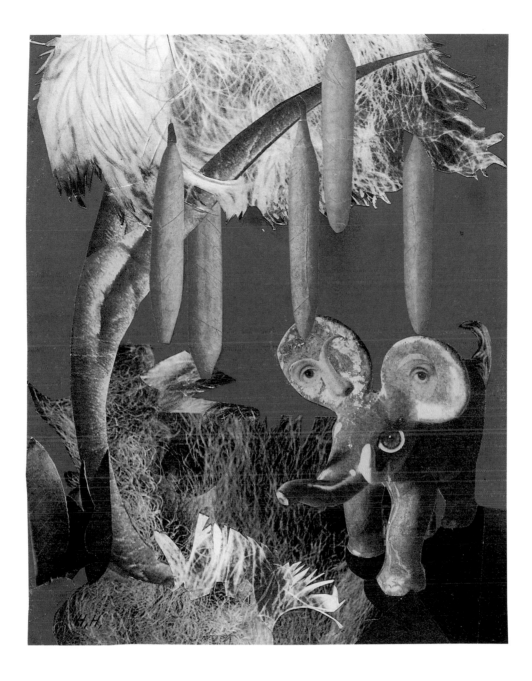

59

WAS MÜSSEN DAS FÜR BÄUME SEIN . . . (What Kind of Trees are These . . .) c. 1930
PHOTOMONTAGE WITH COLLAGE
13 ¹¹/₁₆ X 10 ⅞ IN. (34.8 X 27.6 CM)
COLLECTION STAATLICHE KUNSTHALLE KARLSRUHE

The inscription on the back of this work, "Was müssen das für Bäume sein—wo die grossen—Elefanten spazieren gehen—ohne sich zu stossen" (What kind of trees are these where the great elephants stroll without bumping themselves), is a variation on a phrase used by Höch's former colleague Johannes Baader in his essay "Kritik des Dadaismus" (Critique of Dadaism): "Wie müssen die Bäume sein, auf denen Elefanten spazierengehen?" (What must the trees be like on which the elephants stroll?). The work also contains the inscription "Zigarren—Zigarren" (cigars, cigars) and a dedication to Kurt Schwitters, whose tone poem "Zigarren" (1921) consists of repetitions of that word. The elephant here derives from a photographic reproduction of a toy made of glazed clay, originally illustrated in an article on antique toys. — MM

Die Koralle 6, no. 9 (December 1930), p. 393

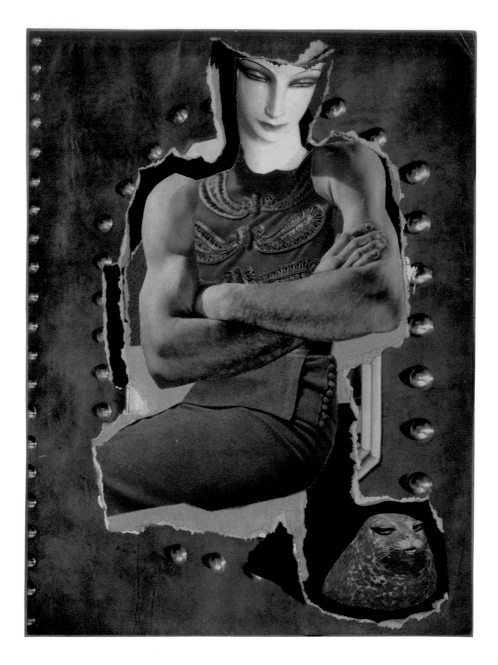

60

DOMPTEUSE (Tamer) c. 1930
PHOTOMONTAGE WITH COLLAGE
14 X 10 ¼ IN. (35.5 X 26 CM)
COLLECTION KUNSTHAUS ZÜRICH

This work may address difficulties Höch experienced in her long-term lesbian relationship with the Dutch poet Til Brugman, which lasted from 1926 to 1935. In later reminiscences, Höch expressed mixed feelings about the couple's time together, recalling it, on the one hand, as the happiest time of her life but also complaining of Brugman's suffocating possessive-ness. The seal under the tamer's watchful gaze may represent Höch, who superimposed a seal's head over her own in her 1972–1973 *Life Portrait* (pages 148–149). — MM

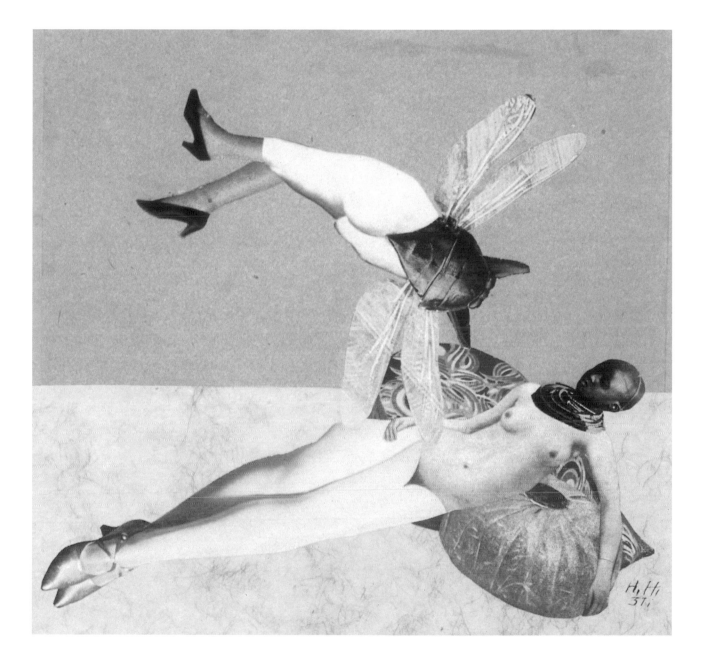

61

LIEBE (Love) 1931
PHOTOMONTAGE
8 ¼ X 8 ⁹⁄₁₆ IN. (21.0 X 21.8 CM)
COLLECTION NATIONAL GALLERY OF AUSTRALIA, CANBERRA

As part of the Love series (see pl. 26), this photomontage focuses on the underbelly of human relationships—in this case, a homosexual liaison. The pair of bug-headed, winged legs that hovers above the drowsy, recumbent female nude imparts an unminstakably ominous tone to the scene. As with *Tamer* (pl. 60), this work may allude to tensions Höch felt in her relationship with Til Brugman. — MM

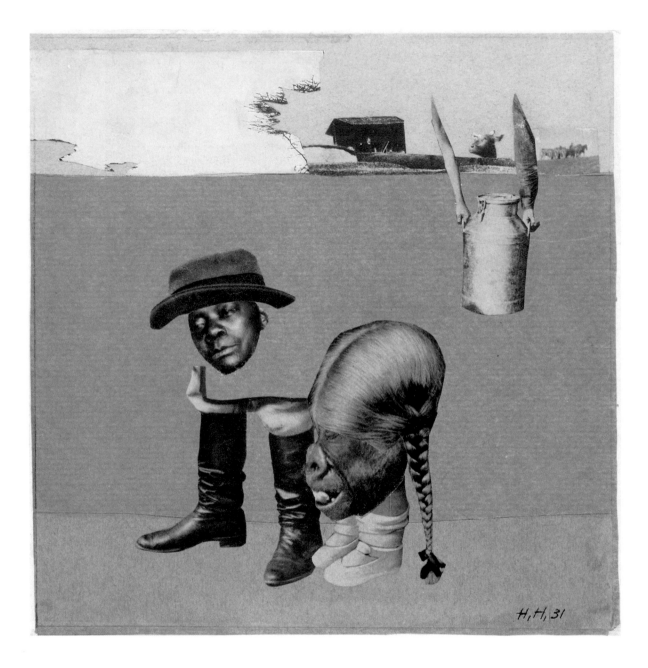

66

BÄUERLICHES BRAUTPAAR (Peasant Wedding Couple) 1931
PHOTOMONTAGE WITH COLLAGE
8 ¼ X 8 ¼ IN. (21 X 21 CM)
COURTESY GALERIE BERINSON, BERLIN

Although Höch never explicitly indicated that this photomontage belonged to the Love series she produced sporadically throughout the Weimar era (see pl. 26), *Ein Liebespaar auf dem Lande* (*A Couple in the Country*), as this work was first known, was listed directly above three other pieces from the series on the checklist to her 1934 Brno exhibition. The subject furthermore fits the profile of other works in the series, which, as a whole, problematizes romance. Here, Höch addresses the relationship of a rural couple of the type valorized by the Nazis: one wears the boots of a storm trooper while the other sports the blond braids then associated with the pervasive *Blut und Boden* (blood and soil) rhetoric of National Socialism. By endowing this stereotypically Aryan wedding couple with the heads of a black man and an ape, Höch ridiculed the racist notion that the Nordic, Aryan race was purest amidst the peasantry of Germany, while simultaneously betraying the extent to which she had internalized it. Indeed, her suggestion here that the German race "degenerates" through the intermarriage of Nazi to Nazi functions only at the expense of people of color. — MM

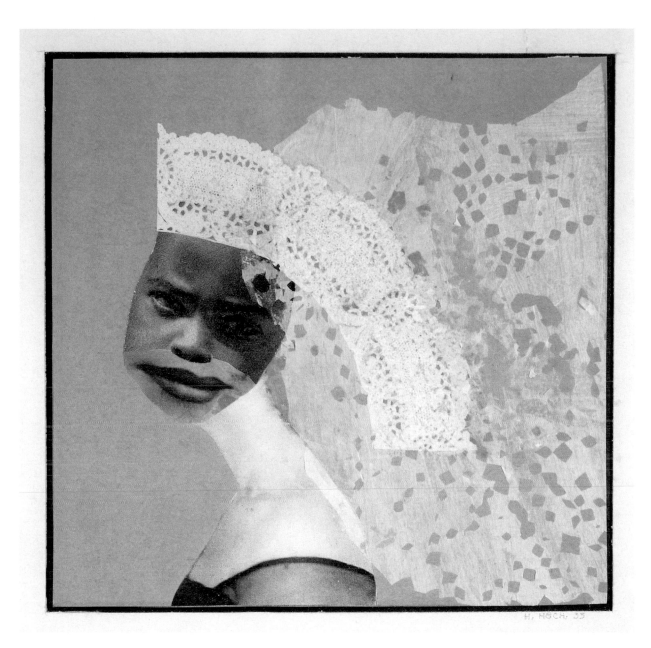

67

DIE BRAUT (The Bride) C. 1933
PHOTOMONTAGE WITH COLLAGE
7 ⅞ X 7 ¾ IN. (20 X 19.7 CM)
COLLECTION THOMAS WALTHER, NEW YORK

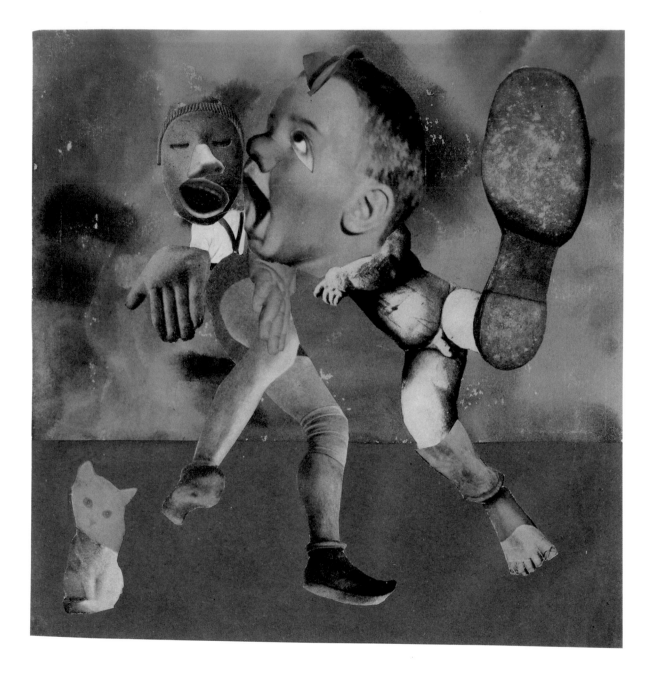

68

DIE EWIGEN SCHUHPLATTLER (The Eternal Folk Dancers) 1933
PHOTOMONTAGE WITH WATERCOLOR
9 ¹⁵⁄₁₆ X 10 ¼ IN. (25.2 X 26 CM)
COLLECTION THOMAS WALTHER, NEW YORK

The "Schuhplattler" is a fast-paced Bavarian folk dance in which thighs, knees, and heels are slapped. It was especially popular during the National Socialist era, when folk traditions of all kinds were celebrated as part of Germany's indigenous national heritage. Insofar as this work dates to 1933, the year of the Nazi assumption to power, it is perhaps not surprising that Höch made these open-mouthed dancers look like ridiculous buffoons, an effect achieved in part by the gross mismatching in color and scale of the figures' various body parts. In this, the work represents a departure from Höch's work of the late Weimar era—in which she constructed figures from similarly-scaled fragments of photographic reproductions—and a return to her aesthetic strategy of the Dada years. — MM

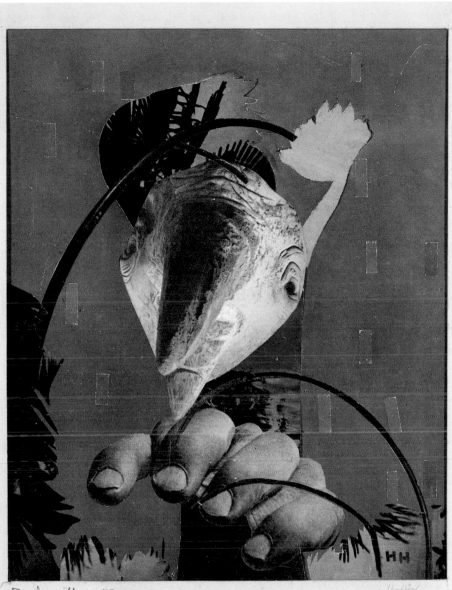

69

RESIGNATION c. 1930
PHOTOMONTAGE
10 ¼ X 8 ¼ IN. (26 X 21 CM)
COLLECTION STAATLICHE MUSEEN ZU BERLIN, KUPFERSTICHKABINETT

In the shaky handwriting of her later years, Höch titled this work and dated it to 1938 on the mat at the lower left. Yet the verso of *Resignation* bears a note in her hand stating that this photomontage was shown at her 1934 Brno exhibition. No work of this title appears on the checklist for that show, but *Resignation* may well have been one of three untitled photo-montages listed there. The melancholic mood of the work derives from its predominant gray-green tonality as well as from its central image of a homely yet remarkably expressive beast (in actuality, a rhinoceros turned on its head) who gazes at us plaintively above the curved fingers of a hand that seems beseeching in its gesture. It is of note that Höch's media source for these fingers may well have been hands folded in prayer. Perhaps the assumption to power of the National Socialists in 1933 motivated the artist to express her sadness about Germany's new politics. She once noted on the back of a photograph of this work that it was one of a pair; its now-lost pendant, fashioned from a photograph of a turtle, was called *Grausamkeit* (*Cruelty*). — MM

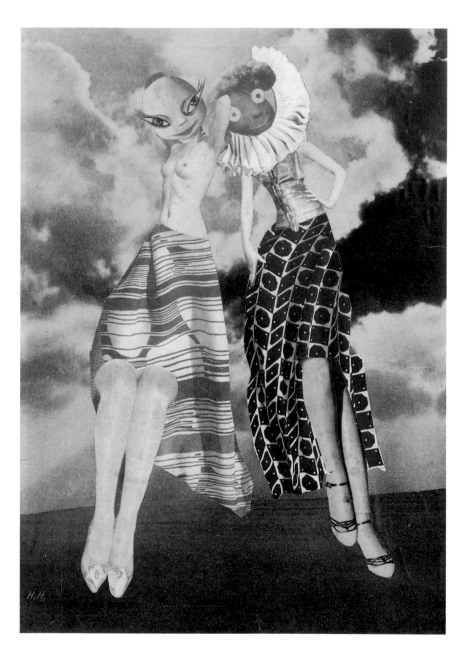

70

AUF DEM WEG ZUM SIEBENDEN HIMMEL (On the Way to Seventh Heaven) 1934
PHOTOMONTAGE
14 ½ X 10 IN. (36.8 X 25.4 CM)
COURTESY BARRY FRIEDMAN LTD., NEW YORK

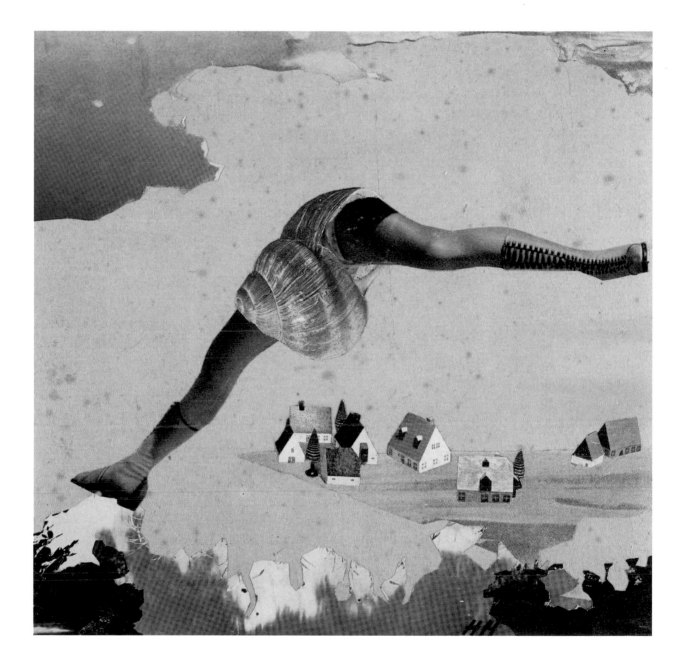

71

SIEBENMEILENSTIEFEL (Seven League Boots) 1934
PHOTOMONTAGE
9 X 12 ¹¹⁄₁₆ IN. (22.9 X 32.2 CM)
COLLECTION HAMBURGER KUNSTHALLE, HAMBURG

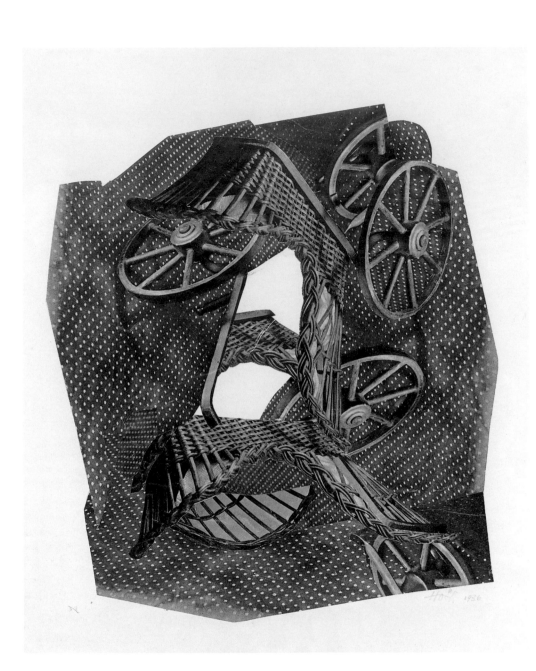

72

DER UNFALL (The Accident) 1936
PHOTOMONTAGE
12 X 10 ½ IN. (30.5 X 26.7 CM)
COLLECTION INSTITUT FÜR AUSLANDSBEZIEHUNGEN, STUTTGART

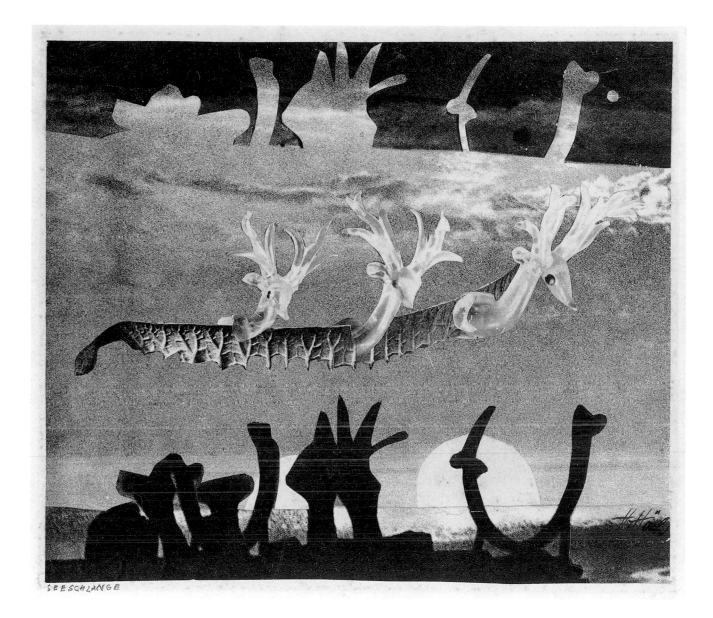

73

SEESCHLANGE (Sea Serpent) 1937
PHOTOMONTAGE
8 ¾ X 10 IN. (22.2 X 25.4 CM)
COLLECTION INSTITUT FÜR AUSLANDSBEZIEHUNGEN, STUTTGART

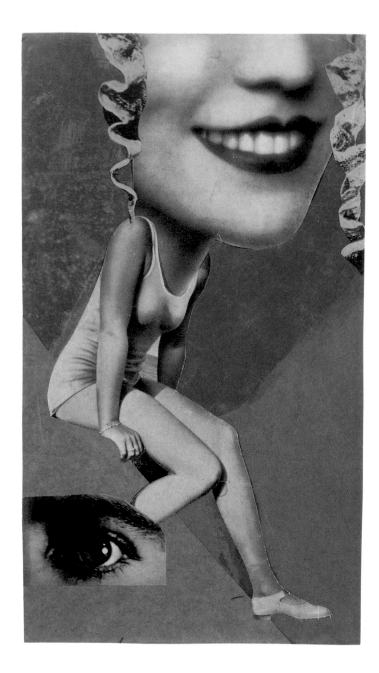

74

FÜR EIN FEST GEMACHT (Made for a Party) 1936
PHOTOMONTAGE
14 ³⁄₁₆ X 7 ¹³⁄₁₆ IN. (36 X 19.8 CM)
COLLECTION INSTITUT FÜR AUSLANDSBEZIEHUNGEN, STUTTGART

THE LATER ADVENTURES OF DADA'S "GOOD GIRL": THE PHOTOMONTAGES OF HANNAH HÖCH AFTER 1933

CAROLYN LANCHNER

HANNAH HÖCH was an active artist from 1915 through the early 1970s; yet, at her death in 1978, she was still best known as the only woman associated with the stridently macho group that was Berlin Dada. Even as the larger body of her work became gradually recognized in post–World War II Germany, the quirky appeal of her image as little Hannah Höch, "ephebic" recruit in Berlin's otherwise all-male Club Dada, tended to push aside the solid, sometimes dazzling accomplishments of her later career.[1]

The boldtype heading of Höch's obituary in the June 9, 1978, issue of Hamburg's newspaper, *Die Zeit*—"Zum Tod von Hanna Höch: Bubikopfmuse im Männerclub" (On the Death of Hannah Höch: Bobhaired Muse of the Men's Club)[2]—perpetuated this misguided identification of the artist, while the article itself attempted to explain and deconstruct the myth. By that time, Hans Richter's distinctly condescending recollection of Höch as Dada's "good girl" had come to define her position within the movement.[3] The author of the obituary, who probably did not know how extremely offensive Höch had found this characterization,[4] duly reminds her readers how Höch had sharply corrected her ex-Dada colleague with respect to his remarks on her role as hostess to the group, asserting with some irony that the appearance of the refreshments she "conjured up" had had less to do with her skills at conjuring or sandwich-making than with the employment that provided her wages.[5] The article is at pains to point out that Höch was not simply the "Bubikopfmuse" but a productive artist in her own right, and concludes (perhaps too definitively) that it was Höch's development and lifelong exploration of the possibilities of photomontage that were, in fact, the most important legacies of Berlin Dada.

Although the demise of Berlin Dada is usually located in about 1922, its spirit and adherents remained integral forces in the life of Berlin until the end of the Weimar Republic in 1933; and Höch's art of the period, despite her absence from Berlin in the late 1920s, shows a keen awareness of its social, political, and cultural dramas. It is thus neither illogical nor surprising that critical and popular reaction to Höch's work has largely annexed the photomontages from the whole of the Weimar period and the two or three years following to their directly antecedent Dada predecessors. This segment of her career has received considerable attention, whereas the entirety of her much varied output during nearly four decades that succeeded has been largely ignored or dismissively referred to as her "late period." This essay will concentrate on this extended late phase of Höch's career in order to examine evolving patterns of change and revision within her practice of photomontage. The principal approach will be through a consideration of the interaction of materials, styles, and procedures in selected works.

PHOTOMONTAGE IN THE POST-WEIMAR YEARS

Höch and her fellow Berlin Dadaists spoke of their works as "photomontages" in part because they liked the anti–fine art connotation the term *montage* derived from the German *montieren*, meaning "to engineer." Although little vestige of such anti-aestheticism clings to our present apprehension of photomontage, the term still defines the medium: *photo*, of course, naming its materials and *montage*, as engineering, specifying the dual process of actual, physical procedure and compositional organization or style. If Höch, as a Dadaist, tacitly endorsed her male colleagues' bellicose program of anti-formalism or anti-style, it was with silent reservation: almost every commentator on her work has observed its careful composition, from the heyday of Dada on, and from the beginning she believed that "photomontage could be used not merely to produce things heavy with political meaning . . . but that one could also regard it as a means of self-expression and eventually arrive at purely aesthetic works."[6]

More than any other medium, photomontage's character and nature depend on the evocative quality of its materials, and these remained constant throughout Höch's career: from first to last, clippings from newspapers, trade journals, fashion and popular magazines, and any other publications that caught her attention. With the exception of the series of montages from the 1920s made from fragments of sewing instructions (pls. 12–15) and the change that widespread color reproduction would bring after World War II, it is less differences in materials that create differences in the moods of Höch's works than the ways in which she uses them. Nonetheless, it is usually the image-content of her chosen material that we notice before style or technique, especially in the montages of the Dada/Weimar period, most of which demand associative readings.

In the mid-1920s, the German art historian Franz Roh put forth an analysis of montage that has been well paraphrased by Christopher Phillips as "a precarious synthesis of the two most important tendencies in modern visual culture . . . the pictorial techniques of modernist abstraction and the realism of the photographic fragment."[7] If, in broad application, this definition seems dated, it is nevertheless helpful to an understanding of Höch's use of the medium throughout her career. In the beginning at least, Höch thought of herself primarily as a painter and only gradually ceded an equal role to photomontage; in variantly evident degree, she drew on her painterly experiences of modernist abstract and semi-abstract styles in ordering her montages. The plethora of material available to her, combined with an ability to recontextualize it both in terms of content and structure, was a lifelong source of exhilaration to her. With El Lissitzky, she recognized that "no kind of representation is as completely comprehensible to all people as photography,"[8] and she delighted in exploiting and problematizing that quality. In general, the more she tampered with the immediately recognizable referential properties of her material, the more a relatively explicit meaning is suggested. When, however, she relied on the photograph's message-triggering properties—as she did more often during the Dada/Weimar period than later—meaning tends to be more densely layered and unstable.

The procedure of cutting and pasting is a constant in Höch's photomontages, but within this basic method she used an extraordinary and subtle variety of techniques. She was a cunning virtuoso with what one commentator called her "holy shears," and she used them both to call attention to their employ and to disguise it.[9] They were instruments of the most delicate, allusive effects, as in *Fata Morgana* (1957) (pl. 92), or again—and often—a blunter tool used to heighten the affective impact of her chosen imagery. In *Resignation* (pl. 69), which despite the prominence of the date 1938 on its mat more likely comes from the early 1930s, she both masks and highlights the results of her cutting and pasting.[10]

It is virtually impossible to look at *Resignation* without immediately registering what I have referred to above as "image-content." Its composition and the methods of its construction contribute equally to the work's startling appearance, but it would be the most unusual viewer whose initial glance were not riveted by the grotesque, even horrifying emergence from a shadowy ground of a wrinkled, wall-eyed creature whose immense nose grows from its forehead and descends over a tiny, pinched mouth. This being extends gross, malformed hands in an incorporeal gesture that is both supplicating and grasping, but access to the viewer, who must be the object of the creature's solicitation, is barred by the three curved arcs rising in front of it.

Höch's first step in the creation of the singular being who peers out at us from *Resignation* was simply to clip reproductions of a black rhinoceros and a worker's clasped, swollen, unkempt hands from the publications in which she found them. Thereafter, it is impossible to second-guess her strategy. Höch regularly clipped illustrations that interested her, using some almost immediately and stockpiling others. Did she know when she cut out the rhinoceros that, with a little fine scissoring around its edges, inverting its head would produce an unnameable but convincing physiognomy? Whatever the answer, the inversion of the head—like the use of an inverted female arm as a leg in the earlier *Denkmal I* (*Monument I*, 1924) (pl. 46)—bears witness to Höch's imaginative play with the givens of her materials.[11]

To turn the rhinoceros head upside down was a simple maneuver. Yet its results are complex, converting as it does the forward-projecting horns into a nose, chin, and mouth enveloped by sinister shadows, which appear to encroach upon the much lighter, almost backlit, plane of the face. Not the least affective result of Höch's strategic inversion is the transformation of a wrinkle on one of the horns into a poignantly expressive mouth, whose shape seems the result of a lifetime's unfulfilled hopes.

Höch's success in transforming a beast's head into a moving face of human despair issues from a game played by variable rules. As Dawn Ades has pointed out, Dada collage can be seen as a "shift . . . from Duchamp's ready-made to the already seen."[12] Throughout the Dada/Weimar era, most of Höch's photomontages were calculated to trigger a viewer's—specifically, on occasion, a German viewer's—instant recognition of their principal component parts. Sometimes emphasis on the immediately familiar depended on the current fame of particular individuals, as in the prominent positioning of the Weimar Republic's President Ebert and Defense Minister Noske in *Dada-Rundschau* (*Dada Panorama*, 1919) (pl. 2); more often, especially in the post-Dada years, focus was on the popular iconography of the worlds of fashion, sport, dance, domesticity, and technology. In displacing and reordering the clichés of mass-media representation, Höch practiced a kind of reverse advertising—an incitement to question received values.

Although Höch never ceased to exploit the recognition quotient of the "already seen," she tended during the mid-1930s to reverse the logic of this property. She had always indulged in some trompe l'oeil play with her scissors, as for instance, in *Dada-Ernst* (1920–1921) (pl. 7), in which the woman at right center is fitted with what has been seen as a "tall, metallic party hat shaped like a dunce cap"[13] but is actually the speaker of a phonograph; or in *Equilbre* (*Balance*, 1925) (pl. 34), where the effect of eyeglasses on the figure to the left derives partly from astute cutting and pasting and partly from the device of leaving an edge around the lower curve of the right eye (probably a cat's). In both these cases, as in almost all Höch's photomontages of the Dada/Weimar period, such visual tricks tend to be incidental within the overall composition. From

the mid-1930s on, however, Höch tended to disguise the recognizable identities of major components of her works. In its prominent juxtaposition of work-worn human hands and the eerie rhinoceros-derived face, *Resignation* conflates Höch's double-edged tactics.

Höch's new treatment of her materials brought another, less substantive, shift to her accustomed processes. Apart from the series Aus einem ethnographischen Museum (From an Ethnographic Museum), she had rarely used titles to suggest that a given image be read as the visualization of a concept; in the mid-1930s, however, her titles began to lose their specificity, enjoining viewers to interpret particular images as symbols of larger notions. In a work of the mid-1920s, for example, in which Höch took for her subject gloom and depression, she contrived for her audience a deeply melancholic face; here, however, she presented it not, as in *Resignation*, to reflect a possible generalized state of the human mind, but as the special property of her fictive personage, *Der Melancholiker* (*The Melancholic*, 1925) (pl. 33). The difference implies, however discreetly, that the despairing creature in *Resignation* is free from a given location in time and place in a way that the other is not.

The question of why Höch began to veil the immediately readable content of her materials and to retreat into more generalized titles probably has several interrelated explanations. If, as remarked above, the exploitation of instantly recognizable imagery in her earlier photomontages amounted to a species of reverse advertising (a critique, in effect, of conventional modes of thinking), then she had considerable reason, despite the fact that her work went unexhibited in Germany until after the war, not to subvert openly the cultural and social standards then advanced in the Nazi-controlled mass media. Materials from the press and magazines were as available to her as they had ever been, but to make use of them as a means of questioning society's norms would now have placed her in the most extreme peril. The urge to work, however, remained constant, and in that kind of double bind, nothing could have been more logical than to shift the thrust of her photomontages from the particular to the general.

For the most part, this turn to the general necessarily carried with it a change of subject matter: although nature and landscape are abundantly represented in Höch's watercolors and paintings throughout her career, they make almost no appearance in the photomontages until the mid-1930s. Their appearance at this point reflects not so much an increased interest in the subject as it does a positive response to the challenge of changing her art without compromising her satisfaction in it. Abhorrent as the Nazi regime was to Höch, it must have been, in all its vast "innocence," at least partially responsible for stimulating her to new creative play with her materials.

The contention here is not that "veiling" the identity of a rhinoceros head, to take an instance, is an act of political concealment, but that outside pressures incited Höch to an experimentation that was temperamentally congenial to her. Before *Resignation*, Höch had rarely placed her figures on grounds that gave any but the most schematic indications of place.[14] When she chose to represent a single head, she usually let it float free on a dark, empty, or muted ground, occasionally, as in *Der kleine P* (*The Small P*, 1931) (pl. 65), anchoring it to absurdly

tiny legs, which in this case rest on a fragment of gravityless earth.[15] The head in *Resignation* may, at first glance, also seem to float free from its gray-green ground, but closer inspection reveals that it is stabilized by a darker vertical shaft cut to the exact width of the left half of the creature's face, from which it extends downwards to the bottom edge of the support. While the ground hardly presents a sense of place with great clarity, it is meticulously worked both for dramatic effect and associative possibilities.

To heighten the impression of the projection of the face toward the viewer, each of the principal background elements that attach to it—the stabilizing vertical, the baroque form showing foliage at the left, and the light green, flowerlike silhouette at the right—conspires to effect a mini-relief. Unquestionably, the flower shape on the left was achieved not by pasting, but by cutting into the ground to reveal a lighter paper beneath. I have been unable to determine, even after examining the work unglazed with a magnifying glass, whether the lower vertical and the element abutting the head at the left also lie beneath the surface; in any case, the illusion that they do (if indeed it is an illusion) is very strong. What Höch has set up here is a micro-theater in which subsidiary figures that are actually or apparently underneath the ground contribute to the central character's effect of forward motion while simultaneously projecting themselves in front of the surface they are actually behind.

If the scene is not explicit, it is nonetheless artfully implied; studded with uneven rows of collaged rectangles, the ground suggests the windowed facade of an urban building observed through twilight shadows. The windowlike aspect of the rows of rectangles was brought into being by a simple yet astute procedure: using the same paper as that of the ground, Höch cut the edges of each rectangle on a bias just sufficient to show the beige of the paper underlying the printed green of its surface. Aligned in irregular bands and seemingly framed in light, the rectangles echo the random order of illumined rooms hidden behind the drawn shades of their inhabitants. The areas of recognizable foliage behind the head and to the left, as well as the jagged-edged strip resembling water at the bottom, further contribute to a sense of the setting as urban landscape.

There is almost no other image in Höch's entire oeuvre quite as grim as *Resignation*. Many, such as *Indische Tänzerin* (*Indian Dancer*, 1930) (pl. 53), are capable of projecting a feeling of discomfort so intense as to be almost palpable. Yet in these other works, some evident admixture of visual punning, like the dancer's cutlery crown, operates to impart a hard edge of irony or satire. Oddly, in *Resignation,* where content and meaning are centrally determined by the visual pun of the rhinoceros head, the ironic, satiric edge is blunted. One critic sensitively described Höch as "skeptical in an almost tender way."[16] In her practice of photomontage, Höch normally held these two impulses in roughly equivalent balance; in *Resignation*, Höch let the scale tip toward tenderness without, as sometimes happened in her work in other mediums, allowing the least residue of sentimentality.

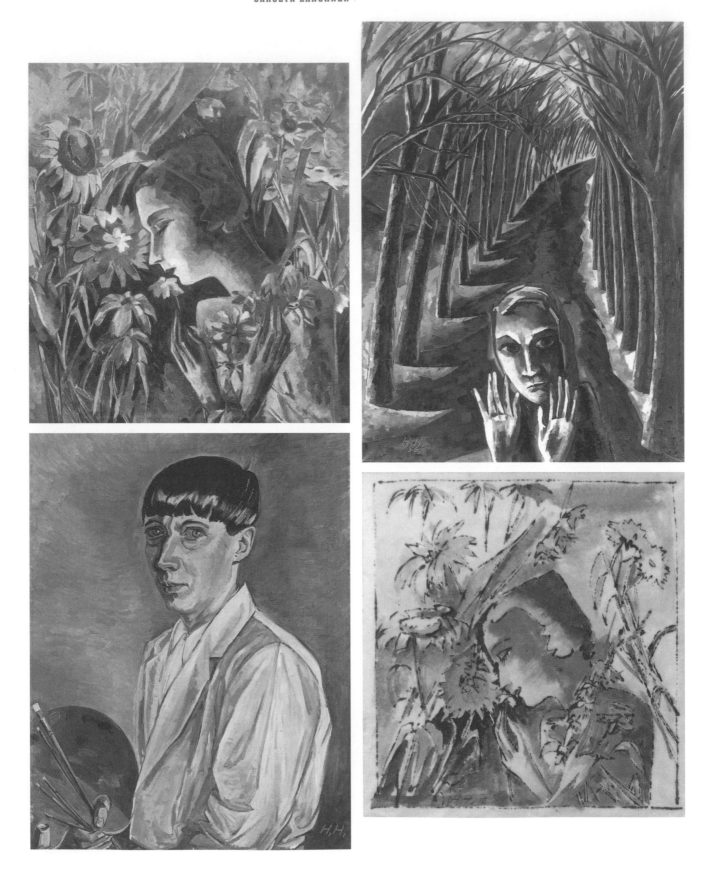

1. (top left) *Duft (Fragrance)*, 1937, oil on canvas. Private collection. **2.** (bottom left) *Selbstbildnis (Self-Portrait)*, 1937, oil on canvas. Private collection.

3. (top right) *Angst (Anxiety)*, 1936, oil on canvas. Germanisches Nationalmuseum (on loan from private collection).

4. (bottom right) *Duft (Fragrance)*, 1916, watercolor. Private collection.

Social Influences of the Nazi Era

The unusual character of *Resignation* is probably not directly attributable to specific events in Höch's life, but the appearance, in the mid-1930s, of a work so marked by empathic identification is not surprising. On every side the artist was uncomfortably aware of the Nazi menace. In 1932, just days before its opening, a planned retrospective of her work at the Dessau Bauhaus was canceled when the school was shut down by the Nazis. In April of the following year, she resigned from the Künstler-Läden (the Artist's Co-op) because new conditions of membership required her to declare allegiance to the Nazi Party and to certify that she had no Jewish blood. During the same year, her friend the writer and artist Otto Nebel fled Germany, and from Hanover came ominous letters from Kurt Schwitters's wife, Helma.[17] Höch's personal life was simultaneously troubled by recurring difficulties in her relationship with the Dutch poet and writer Til Brugman, with whom she had been living since 1926; financial worries were a near constant. By sometime in 1933, Höch and Brugman yielded to the entreaties of many of their friends and left Germany for the Netherlands. They stayed there quite briefly, however, returning to Berlin before the year was over. Although their reasons for returning are unclear, they could well have had to do with Höch's health, which was to take a disastrous turn by the following June.

Seriously ill with Graves' disease, Höch underwent a corrective thyroid operation in July 1935. During the succeeding years of the 1930s her life was so torn by interior and exterior pressures that her sense of self must have been severely shaken. Autobiographical, psychologically revealing content had always tended to be encoded in Höch's photomontages, but in her works in other mediums it is often as overt and recognizable as the familiar images she cut from pages of the popular press. Two oil paintings from 1937, *Duft* (*Fragrance*) (fig. 1) and *Selbstbildnis* (*Self-Portrait*) (fig. 2), together with *Angst* (*Anxiety*) (fig. 3), from 1936, stand as emblems of drives and emotions that Höch could neither control nor reconcile. In these three works, the artist candidly shows us three separate faces of herself during the latter half of the 1930s.

This was a time of significant change in Höch's personal life. Sometime in late 1935 she met Kurt Matthies, a businessman and would-be professional pianist considerably younger than she. By the end of the year, before terminating her ties to Brugman, she had begun what was to be a difficult relationship with Matthies, whom she nonetheless married on September 16, 1938. Despite episodes of bitter quarreling, Höch often felt herself deeply in love. Years before, in 1916, during the second year of her equally stormy seven-year liaison with Raoul Hausmann, she had painted a watercolor wistfully symbolic of the sweetness of untroubled love (fig. 4); its virtually identical reprise, the *Fragrance* of 1937, expresses, as had its model, a yearning for an ideal unattainable on any secure basis.

Security, out of reach in the personal realm, was most conspicuously lacking in the everyday world of Nazi Germany. In the year before Höch's presentation of herself as the romantically beguiled heroine of *Fragrance*, she had envisioned herself in a rather different role—that of the solitary walker in *Anxiety*. Here, the figure of a woman, hands held cautiously before her fear-ridden face, advances nearly out of the picture plane along a sere winter path bordered by leafless, threatening trees. By the time *Anxiety* was painted, Höch had become more fully aware of Nazi depredations and the extent of the regime's threat to all artists it deemed degenerate. *Anxiety* bodies forth not only Höch's increasing fright before the Nazi terror but, also, an augmented loneliness brought about by the emigration of most of her old friends and fellow artists.

If Höch had to contend with problems in her personal life and pervasive fear of a hostile outside authority, she nevertheless had one solid support, her activity as artist. The presence of Matthies in her life curtailed her ability to work in degrees that varied from mild hindrance to aggravated interference; her anxiety about Nazi surveillance and the possibility of denunciation on the basis of her "Bolshevist" Dada past were constants. But they did not diminish her creative drive; in 1937, the year in which she twice visited the infamous *Entartete Kunst* (*Degenerate Art*) exhibition and during the period she would later tell Matthies he had made nearly unendurable, she painted herself—palette in hand, resolutely looking out from the canvas. Over the years Höch made several self-portraits, but in none does she present herself so filled with quiet determination as in this one from the year she was to characterize as the worst in her life.

Höch's daybooks make clear that the extremity of her unhappiness in 1937 was largely the result of problems with Matthies. But she lived, too, with a frustration about her work that had always plagued her and would endure at least until the last two decades of her life. In October of that year, after returning from a long trip with Matthies, she wrote in her diary about retrieving some of her watercolors from a dealer to whom she had apparently consigned them: "Unfortunately, he sold nothing. It would have been so important! Not because at this moment I have nothing to eat, but because even the few people that I still see don't take me seriously because what I do brings in no money." It seems less than realistic for Höch to have expected a responsive market in the cultural atmosphere of Nazi Germany, yet the odd timing of her remarks is itself testimony to the intensity of her ongoing need for professional validation.

Although the latter half of the 1930s brought extreme conflicts to Höch's life, she was by then a veteran in the uses of adversity. Despite the crises—real or perceived—complicating her existence, no overall diminution of her customary artistic productivity is apparent, except in photomontage. The reasons Höch seems to have temporarily neglected this medium are probably at least two-fold. It may be that her efforts to turn the content and character of her photomontages away from specific cultural critique toward more general statements slowed her working process. At the same time, it could have been the nature of the working process itself that encumbered her. Between 1937 and 1940, Höch took numerous trips with Matthies, one in 1937 lasting nearly six months and another in 1939 for nearly the full year. It would have been easy to pack painting materials in their car, or in the trailer they later acquired, and to use them during their many stops; but the logistics of housing a supply of publications and piles of clippings would have been more problematic, and the activity of composition by cutting and pasting, almost never accomplished in one sitting, would have been difficult indeed.

New Forms, New Themes

In 1936, the year before the first of the motor expeditions with Matthies, Höch made two very different photomontages, *Der Unfall* (*The Accident*) (pl. 72) and *Für ein Fest gemacht* (*Made for a Party*) (pl. 74), each of which recalls past practices and forecasts directions that would not fully surface until the 1950s and 1960s. Aside from the physical properties of their construction, these two works have little in common other than their immediately readable imagery. It is a quality, however, that is used to opposed purposes.

In *The Accident*, overturned baby carriages, wheels, and polka-dotted fabric immediately announce themselves visually, while the seemingly tumbled-together arrangement, along with the title, tells us that it is indeed an accident we see. But all clues as to the why or where of the incident, or what the fabric has to do with the carriages, are withheld. The picture shows us everything and tells us nothing. "Irritating the theory of art," Theodor Adorno claims, "is the fact that all art works are riddles." He goes on to counsel that "achieving an adequate interpretive understanding of a work of art means demystifying certain enigmatic dimensions without trying to shed light on its constitutive enigma."[18] Following this precept, I would suggest that certain enigmatic dimensions of our particular riddle—*The Accident*—are somewhat demystified when the aesthetic ruse the picture practices is identified: setting off expectations of realism, it behaves curiously like an abstraction. The eye cannot focus on a single wheel or carriage part without being ineluctably led to the next contiguous one, whereupon the phenomenon repeats itself. This enforced scanning creates a kind of duck/rabbit oscillation between attention directed to content and that directed to structure; the "reference status" of the readable parts is thus compromised by the picture's insistence that each be apprehended not only for what it represents but also for its place within a formal pictorial network.

In no previous photomontage had Höch presented materials as instantly recognizable as those in *The Accident* without an adjunct figure or figures whose presence implied, however ambiguously, agency and narrative content. Devoid of any figure, *The Accident* may not totally discourage musings on the particular nature of the mishap that is alluded to, but it is the total configuration, rather than a specific incident, that most strongly elicits the idea of an accident here. Latent in *The Accident* is a whole series of pictures, such as *Gesprengte Einheit* (*Burst Unity*, 1955) (pl. 89), in which disguised materials are assembled into abstract compositions whose meanings, as their titles suggest, are generic and symbolic.

If *The Accident* looks like no prior photomontage of Höch's that includes instantly recognizable materials, it does look a great deal like a former variety, whose sources would appear abstract to most viewers. My reference here is to the considerable number of collages Höch made in the early to mid-1920s from fragments clipped from sewing, embroidery, and lace-making patterns. Typical of many of these is *Entwurf für das Denkmal eines bedeutenden Spitzenhemdes* (*Design for the Memorial to an Important Lace Shirt*, 1922) (pl. 15), whose largely Futurist-derived structure prefigures that of *The Accident*. In each, the support is used as a neutral surrounding field and again as central negative space defined by a scaffolding of carefully plotted diagonal and lateral rhythms—diagrammed in the earlier work by the hyphenated lines of sewing instructions and in the later by the edges of the things represented. Although the component parts of *Lace Shirt* are held illusionistically flatter than those of *The Accident*, the figuration in each is anchored, about seven-eighths of the way down the sheet, by a flange-like shape patterned to deflect the dominant movement above it. Close in composition, and each equipped with a prescriptive title, both pictures use a disjunctive principle to engage the viewer. In one, an explicitly referential title names an oddly delicate, abstract structure. In the other, competing demands between the formal and the representational code disjunction into the composition itself.

Where *The Accident* actively engages abstraction, *Made for a Party* might be thought of as indulging in a mild flirt. The ground, composed of triangular planes of rose, blue-gray, and silver converging at the lower-left center in a bright-blue irregular rectangle, is classically Constructivist; but far from forcing an awareness of its composition or its structural contribution to the whole, this element functions most immediately to provide a perch for the lovely young woman, whose state of readiness for worldly adventure is apparent even without benefit of the picture's title.

For its affective impact, *Made for a Party* depends almost wholly on the performative efficacy of the "already seen." In this and other ways it resembles the images of young, fashionable, athletic women that pervaded Höch's work of the Dada/Weimar period. When she put one of those figures together, head and body were rarely, if ever, from the same source, and in scale, mood, gender, and species were often uncomfortably incompatible; this strategy, conjoined with a seemingly random display of culturally emblematic paraphernalia, helped to turn popular symbols of the modern and desirable against themselves. Typical are an untitled photomontage from 1921 (pl. 11) and *Das schöne Mädchen* (*The Beautiful Girl*, 1919–1920) (pl. 9). In each, a young, alluring female in a modish bathing suit gestures coquettishly beneath the burden of an oversized head; a deeply contemplative face grotesquely belies the saucy posture of its supporting body in the first, while a light bulb and advertisement take the place of facial features in the other.

In dress and attitude, the young woman Höch shows us as ready for a party in 1936 has much in common with her older sisters of the early 1920s; unlike them, however, she seems not the least encumbered by her overlarge head, and the disembodied eye at bottom left is as capable of catching the attention of other eyes as any her creator might have left in her head. In contrast to the implications of frustration, alienation, and confusion that appear to surround and complicate the existences of her elders, she is serene in an uncluttered, harmonious space; nothing in her glance or smile indicates discomfort. Rather, this is a girl pleased with her ability to attract the desired invitation, untroubled by any conflict between her societally assigned role and her own sense of self.

While *Made for a Party* would certainly have violated the classicizing principles of Nazi artistic ideology, it steers clear of any but the mildest

susceptibility to interpretation as social critique. An aesthetically resolved, successful work, *Made for a Party* should not, on its own merits, have given Höch grounds to give up woman as subject; however, from 1936, the year of its making, until the early 1960s, she makes only sporadic reappearances. Perhaps the artist had become so schooled in the association of the female subject with barbed social commentary that she was psychologically incapable of reinstating that particular theme—on any consistent basis—until circumstances and her own will permitted its customary accompaniment.

Höch's reluctance to inflect her photomontages with the politically provocative during the second half of the 1930s must have prompted the timing of her first uses of the medium to represent landscape. But it was also a period, as she later wrote, when so much travel by car made her feel particularly aware of nature. Although Höch's exact expression was "near to earth," one of her first renditions of nature is closer to a seascape than a landscape. Dated 1937, *Seeschlange* (*Sea Serpent*) (pl. 73) is a fantastic, surrealistic conceit of imaginative and technical ingenuity. Its central drama is the passage of a curious aquatic creature across an expanse of misty green that looks as much like sky as water. Two narrow but conspicuous shore-edge vistas, each equipped with an horizon line—one dark beneath a pale moon, the other illuminated by a setting sun—border the large, ambiguously atmospheric area furnishing the "sea serpent" its ambience.

The air/water section in the work's middle ground was undoubtedly clipped from an illustration showing sky; Höch, however, adjusted it to reinforce its aerial reference and to suggest the illusion of water. The prominent setting sun at the right of the picture, on the lower horizon, is visual inducement to conclude that the creature is airborne; there was, however, no sun in the original illustration, which was, in fact, cut to allow a half oval of the underlying cream-color support to be seen. To create an added effect of light, and perhaps also to provide a sly clue to the high jinks of photomontage, Höch added another smaller and partially obscured setting sun to the left. Above, the cloud forms of the illustration tend to read as rolling waves because they are integral to a mass which, breaking at land's edge, can only be interpreted as water.

Darkly silhouetted against the lower shore are strangely animistic plant shapes that, with only a slight difference in height, are repeated in luminescent outline before the upper horizon line. Höch was an adept of visual rhyme and used it frequently to animate pictorial structures and to parallel the like and unlike. Here, the negative/positive parade of upper and lower figures is surely a means to formal activation of the composition. But it may also be that Höch is coaxing the viewer to play a game with pictorial space whose solution would quite resolve the air/water ambiguity. Subtle and cunningly contrived, *Sea Serpent* nonetheless issues various forthright challenges to interpretive explanation. Foremost among these is the logic of the correspondence between upper and lower plant forms. The former serve a double purpose: cut from the original illustration of sky and set against a dark landscape, they argue against reading the medium in which the creature floats as air; and they offer us a privileged vision of the spectacle that so captures the attention of the eyes of the creature's three little heads. As has been much remarked, a superiority of the pictorial world to that of everyday perception is its ability to render the invisible visible. Here, the upper band of the photomontage reveals a twilight vista of shoreline—exactly as it would appear to the imagined being peering across an expanse of water still illumined by the setting suns at its back.

The War Years

Two years after making *Sea Serpent*, and within days after the outbreak of World War II on September I, 1939, Höch moved from Berlin to a little house in the remote northern suburb of Heiligensee, where she would live until the end of her life. Out of the way, even unknown to some native Berliners, Heiligensee provided a major change from the active urban life that had been Höch's since 1915; as she would explain some two decades later:

> It's actually because this part of Berlin is so quiet and so little known that I moved . . . just before the war. Under the Nazi dictatorship, I was much too conspicuous and well-known to be safe in Friedenau, where I had lived for many years. I knew I was constantly being watched and denounced there by zealous or spiteful neighbors, so I decided . . . to look around for a place in a part of Berlin where nobody would know me by sight or be at all aware of my lurid past as a Dadaist, or . . . Cultural Bolshevist. I bought it at once and moved all my possessions here, and that's also how I managed to save them. If I had stayed in Friedenau, my life's work would have been destroyed in an air raid.[19]

Höch, of course, was unaware of the carpet bombing to come when she moved to Heiligensee; her chief concern at the time was for her own safety. Initially, she felt so secure in the seclusion of her new home that she seems to have had no qualms about decorating its walls with such emblems of officially forbidden art as reliefs by Arp; somewhat later she felt obliged to hide her considerable collection of works by artists she had known (including Arp, Hausmann, Moholy-Nagy, and Schwitters) along with her own.[20] Höch's early days at Heiligensee, however, were relatively unclouded; her relationship with Matthies appears to have become more tranquil and her diary entries and correspondence make clear that she was still very much in love with him. What is most important for present purposes is that the house and the circumstances of her life gave her time and space to return to photomontage.

In her diary of late September 1939, an exasperated entry on the failure of the Western powers to bestir themselves over the fate of Poland is interspersed with remarks on her uninterrupted, daylong bouts of looking through magazines and newspapers for images to cut out. Despite the frequent unreliability of Höch's dates, it would appear that a small flurry of photomontages came into being around 1940. Curiously, most of these, such as *Nur nicht mit beiden Beinen auf der Erde stehen* (*Never Keep Both Feet on the Ground*) (pl. 75) and *Liebe Leute vom Berg* (*Good People of the Mountains*) (pl. 77), seem in important respects to reprise characteristics of her Weimar-period photomontages.

Motifs that recur frequently in works from the mid-1920s through the mid-1930s are brought together in *Never Keep Both Feet on the Ground*: women and dance; flight, as indicated by the beating feathers of birds' wings; and, as in all the many works of the Ethnographic

5. Martin Schongauer, "L'Ascension" (inside right panel from *Retable des Dominicains*), late 1400s. Collection Musée d'Unterlinden, Colmar, France.

Museum series, the annexation of parts of tribal sculpture to distinctly different figures. Paralleling the strategies of many of the earlier photomontages, the work mixes up the banal and the sinister in a tableau that simultaneously begs for and refuses explication. The attitudes of the picture's disembodied legs recall the balletic posture of those of the ascending Christ as sometimes depicted in fifteenth-century German art (fig. 5); but they are so awkward, so strained by earnest endeavor, that a funny vulnerability attends their efforts to propel their owners into a heaven of dubious hospitality.

If *Never Keep Both Feet on the Ground* shares an enigmatic narrative structure with many photomontages from the Weimar period, it is nonetheless much less open than they to interpretation as social commentary. A title of injunctive urgency (insisting that anything is better than the pragmatism of keeping of both feet firmly on the ground) attached to an image that is balanced between humor and threat amounts to a self-directed allegory of nimbleness in art and life. Jula Dech has suggested that this work might stand as a leitmotif for all of Höch's activities, from her early involvement with Dada to such adventures as her 1920 walking trip over the Alps from Munich to Rome.[21] Without taking issue with this view, I would add that, amid the uncertainties of 1940, the creation of *Never Keep Both Feet on the Ground* could have brought Höch a much needed dose of the relief and adrenaline a little manifesto making can induce.

While its stance as personal slogan seems especially appropriate to its time, at least two of the collaged components of *Never Keep Both Feet on the Ground* date to a considerably earlier period. Höch kept files of clippings (some of them in duplicate, triplicate, or sets of even greater number) and used them repeatedly or not at all as the spirit moved her. The impulse behind the inclusion of the African head as an appendage to the bird in the work could have had to do with the prior appearance of a similar head from the same source photograph in a photomontage

from 1930 (fig. 6) that was a part of the Ethnographic Museum series and which also prominently features bodiless legs in athletic extension. In the later work, however, the facial contours of the head have been altered by an operation of Höch's scissors that renders its expression somewhat more malevolent than its mate's in the earlier photomontage. The legs of the dancers derive from an illustration in the January 1932 issue of *Die Dame*, partially captioned "an especially successful sauté."[22] There is no knowing whether Höch considered this editorial judgment in cutting the picture from the magazine. If she did, perhaps it amused her the more as, with deliberation, she shot those legs skyward.

Höch's photomontages abundantly testify to their author's wicked wit and to the pleasure she took in investing them with a language of slippery, allusive meaning. While the setting and action of *Never Keep Both Feet on the Ground* can be connected to nothing observable in the real world, *Good People of the Mountains* discloses, however strangely, characters assuming roles of recognizable function within an identifiable mountain landscape. This sort of rationalization of the fantastic makes the work's interpretive challenge even more tantalizing than that of *Never Keep Both Feet on the Ground*. Both pictures conflate opposing moods and conjoin emblems of alien cultures; but where *Never Keep Both Feet on the Ground* only dabbles in funniness, *Good People of the Mountains* blatantly revels. The estimable people of the title are two stubby beings who resemble boxer dogs suffering from mumps; dressed in baby sweaters and precariously perched, they stretch out their arms with histrionic verve. Their mountain habitat is constructed of largely unidentifiable parts cut to simulate vegetation, craggy rocks, and a towering peak. Eccentrically anthropoid, the rock at the left, in the romantic tradition of the "pathetic fallacy," reverses the roles of man and nature as it actively communes with the good people in a mimetic gesture of rhetorical eloquence. Altogether, the photomontage offers a thoroughly beguiling, if perplexing, scene.

While the picture allows no stable interpretation, it does offer some clues to Höch-watchers and to anyone familiar with German film. These stone lions of Delos done out in baby clothes and identified as estimable mountain people are certainly related to the characters in Höch's earlier *Der heilige Berg (Aus einem ethnographischen Museum XII)* (*The Holy Mountain [From an Ethnographic Museum XII]*, 1927) (pl. 52). There, setting is established by title, which alone suggests that the geometric figuration of the ground be read as earth and mountain. In apparently steady balance atop the lower "earth" element are two oriental stone heads, whose monumental dignity (like that of the Delos lions in the later work) is much compromised by Höch's treatment of them. Using a single image of a bespectacled Caucasian face, Höch contrived that each head wear glasses: the portion of the source face between the tip of the nose and the top of the glasses was cut in half horizontally so that a thin margin of the lower outline of the glasses remained along the top edge of the resulting nose-and-cheek fragment; the stone head at the left was then equipped with the eyes and nearly intact glasses of the source, while the right-hand figure was provided with a nose and cheeks that appear surmounted by spectacles. Although this particular affront was not perpetrated on the Greek lions, their sartorial oddity is prefigured in *The Holy Mountain* by the knitted baby clothes that form a body with outstretched arms beneath the head at the left.

6. Untitled, from the series Aus einem ethnographischen Museum (From an Ethnographic Museum), 1930, photomontage.
Collection Museum für Kunst und Gewerbe, Hamburg.

When Höch made *The Holy Mountain*, its reference to the immensely popular 1926 film of the same name, directed by Arnold Fanck and starring Leni Riefenstahl, would have been unmistakable. There can be little question that Höch, who was an ardent filmgoer, had seen *The Holy Mountain*; to judge by the montage titled after it, her reactions would seem to have been, at the least, ambivalent. Filled with breathtaking alpine scenery, the film unfolds an overwrought tale of triangulated desire: two men are driven by the disruptive effect of their love for the same woman to snowy perdition atop a mountain and a final bonding in death. Reviewing *The Holy Mountain* in March 1927, Siegfried Kracauer described the film's intended audience: "small youth groups which attempt to counter everything that they call mechanization by means of an overrun nature worship, i.e., by means of a panic-stricken flight into the foggy brew of sentimentality."[23]

The Bergfilm (mountain film), as a genre, captured the German imagination throughout the Weimar years and into the Nazi era. Its glorification of the "landscapes of the German fatherland, the characteristic beauty of the homeland"[24] were admired by left and right alike, but their narratives of heroism and self-sacrifice rehearsed, Kracauer claimed, "a mentality kindred to Nazi spirit."[25] Surely Höch's rhetorically gesticulating good people of the mountains, in the guise of stunted lions uniformed in baby clothes, constitute an ironic spoof on the values and actions of the regime whose Führer's favorite retreat was the Berghof.

Höch's stepped-up involvement with photomontage around 1940 certainly owed something to the move to Heiligensee, but it could also have had to do with the character of the war. The false peace of the "phony war," which lasted until April 1941, must have offered Höch a more psychologically propitious environment in which to engage in an activity dependent on mass-media representations than the atmosphere that followed, which was permeated by news of global destruction. As the order of the outside world was collapsing, so too was that of Höch's personal sphere. In late 1942, Matthies left her for a woman who had been her friend for some years, a musician named Nell d'Ebneth; "through her," Höch wrote in her diary, "the pattern of my daily life was destroyed. I stand . . . before ruins." As in the mid-1930s, the unsettling combination of acutely increased inner and outer tensions was accompanied by a decrease in Höch's production of photomontage, a state of affairs that persisted until about 1950.

No doubt prudently, Höch recorded little about the war in her diaries; however, her consciousness of it and perhaps also of the concentration camps is reflected in a series of grim watercolors from 1943 collectively entitled Totentanz (Dance of Death), as well as in a series of watercolors that depict crowds of naked, despairing people wailing and falling to the ground in barren, blurry landscapes.[26] Her relief at the war's end was intense, and her daybook is filled with detailed entries about events surrounding the arrival of Russian troops in Heiligensee. On May 5, 1945, seven days after describing a red sky over Berlin and the "terrible thunder of gunfire," she wrote:

It's quiet here. Over Berlin still have the shots. Took a walk. An unspeakably thankful feeling in my breast. A twelve-year period of suffering, which was forced upon us by a crazy and inhuman, yes, bestial clique, with all the means of evil power, with all the means of the spirit, with all the means of barbarism, that didn't shrink from any crime, is at an end. In my soul is a peace that I haven't felt for years.[27]

7. Kurt Schwitters, Hanover *Merzbau*, as photographed in 1933.

Friedenstaube (*Dove of Peace*) (pl. 83), begun in 1945 and perhaps finished a few years later, is a cool celebration of Höch's newfound sense of peace. In aerial perspective, the montage shows a delicate green dove with pale yellow wings flying tranquilly above a menacing assemblage of polished, high-tech forms and a shallow, round disk that casts its shadow upon the sky. Steel-gray, gunlike cylinders thrusting up from the right appear to support a row of collapsing hollow blocks at the bottom, whose balance seems further endangered by more hollow objects illusionistically poised for a vertical slide down the angled, deep-green plane at the left. Given the evident symbolic intent of the work, perhaps it is not too presumptuous to observe that the open-ended right angles of the forms at the bottom make them look a bit like dismembered swastikas while, at the same time, recalling the appearance of certain photographs of Schwitters's Hanover *Merzbau* (fig. 7), destroyed by bombs during the war.

The Postwar Years and Abstraction

Höch, in common with every other avant-garde artist remaining in Germany, saw the war's end as an encompassing liberation. In 1983, speaking with a group of artists who had variously experienced that turbulent time, the art historian Werner Haftmann captured its flavor: "One was unbelievably curious: what was going on? And naturally colossally happy: now one can finally breathe again, a new beginning is here."[28] In precipitate spirit, parallel to the speed of Germany's "economic miracle," artists regrouped, opened schools, argued, and founded galleries.

By August 2, 1945, Berlin's first private postwar gallery, the Galerie Gerd Rosen, opened under the directorship of the artist Heinz Trökes on the ruined Kurfürstendamm, in a former military supply store.[29] One of its earliest exhibitions, *Fantasten-Ausstellung*, held in February 1946, included several works by Höch; at the end of the year the gallery hosted a group show, *Fotomontage von Dada bis heute*, which Höch organized and participated in.[30] Apart from its evident testimony to her desire to be fully active in a reviving art community, the exhibition is most interesting for the introduction Höch wrote to its catalogue. In many of its essentials, her foreword is a reworking and expansion of an article she had written on the occasion of the 1934 exhibition of her photomontages in Brno, Czechoslovakia. One revision, however, is especially pertinent to the conception of photomontage Höch had been developing since the era of Nazi censorship had begun. In discussing the various types of photomontage in 1934, she had singled out "free-form photomontage" as an area of great potential; in the parallel passage of 1945 she uses instead the phrase "photomontage for its own sake—as a painting or graphic work." This type of photomontage, Höch now claims, allows for "the most imaginative creations of our time," and she attributes its appearance to the Nazi suppression of photomontage that contained any element of caricature or satire.[31]

Höch's enlarged vision of the potential of photomontage guided her working practices in large measure from 1945 until about 1960. During the immediate postwar years her production in the medium remained low, but by 1950 or so it picked up dramatically. From that time until approximately 1960, her work was directed predominantly toward the abstract, as expressed in a variety of modes that range between two main types. In the first, recognizable properties of the "already seen" are preserved, but subverted, in compositions of delicately controlled structural balance and low-key tonal contrasts; in the other, to which many more works belong, the signifying qualities of her materials are subsumed in abstract pictures of apparent gestural freedom and high color. Neither type leaves any room for social commentary, and both push the boundaries of the medium.

The first type had been anticipated already in 1937, in *Sea Serpent*, and later in such works as *Lichtsegel* (*Light Sails*) (pl. 81) and *Traumnacht* (*Dream Night*) (pl. 82), both from 1943–1946; but all of these, to a greater or lesser degree, flaunt the artifice of their construction and materials. The related works of the 1950s, by contrast, are compositionally calmer and do not easily divulge the "real life" identities of their component parts by any immediate visual clues. Were it not for the evident derivation of the dove in *Dove of Peace*, this montage, too, would qualify as an early example of the first type, as exemplified by *Gegensätzliche Formen* (*Opposing Forms*, 1952) (pl. 85). In a manner somewhat parallel to the double address of *The Accident*, *Opposing Forms* is calculated to arouse an oscillation of focus between its totality and its constituent parts. As the title indicates, the work's subject, in a nonmetaphoric sense, is aesthetic order, expressed by means of a composition that is arresting for its exquisite calibration of component elements and sovereign control of tonal harmony. But a fatal indexical trait of "the already seen" ruptures initial attention to the elegancies of the work when its parts ask the "What am I?" question we are programmed to hear when confronted with photographically produced replicas of things in the world. When that question is answered in the looking, as in *Never Keep Both Feet on the Ground*, the effect is to stimulate the viewer's desire to interpret contextual oddity; but when, as in *Opposing Forms*, the question is posed via visual rebus, it drives the viewer to a closer inspection, which cannot be accomplished without a return of attention to the formal qualities of the work's structure.

If the first type of Höch's new way of montaging ingeniously exploits the special properties of photographic reproduction, the second effectively jettisons them. Assessing two typical works of this genre, *Gesprengte Einheit* (*Burst Unity*, 1955) (pl. 89) and *Epos* (*Epic*, 1957) (fig. 8), one critic spoke of "virtuosic abstractions, essays in exuberance and a cunning technique."[32] Here, as in other works of this sort, Höch's scissors provided her with variously formed and colored shapes, which she then assembled into compositions as devoid of reference to anything in the visible world as any painting produced by the then dominant movements of Art Informel or Tachisme. Amazingly, through a process that must have been excruciatingly slow and deliberate, Höch produced pictures that appear, like those of the Informel artists or the gestural side of Abstract Expressionism, predicated on an expansion of the Surrealist notion of *écriture automatique*.

Radical as this new type of montage was, it reprised in vastly accelerated rhythms certain structural tactics evident in those abstractions from the early to mid-1920s Höch had built from fragments of sewing instructions. If, for example, *Schneiderblume* (*Tailor's Flower*, 1920) (pl. 13) is inverted and then compared with *Burst Unity*, it becomes apparent that the two works share some basic strategies; in both, planes and lines radiate centrifugally from a center, defined visually and by title, toward the boundaries of an internal frame which their illusioned momentum breaches. While informed by demonstrably similar pictorial tactics, the affinities between the earlier and later works are all but buried in differences of pace and use of color. *Tailor's Flower* maps out its terrain in the serene, measured step of a diagram, while *Burst Unity* agitates its space with the pyrotechnic energy of a catherine wheel. The earlier montage restricts color to muted tonal modulations set off by areas of white; the later is far bolder in its contrasts of tone, and these are inflected by flashes of brilliant color.

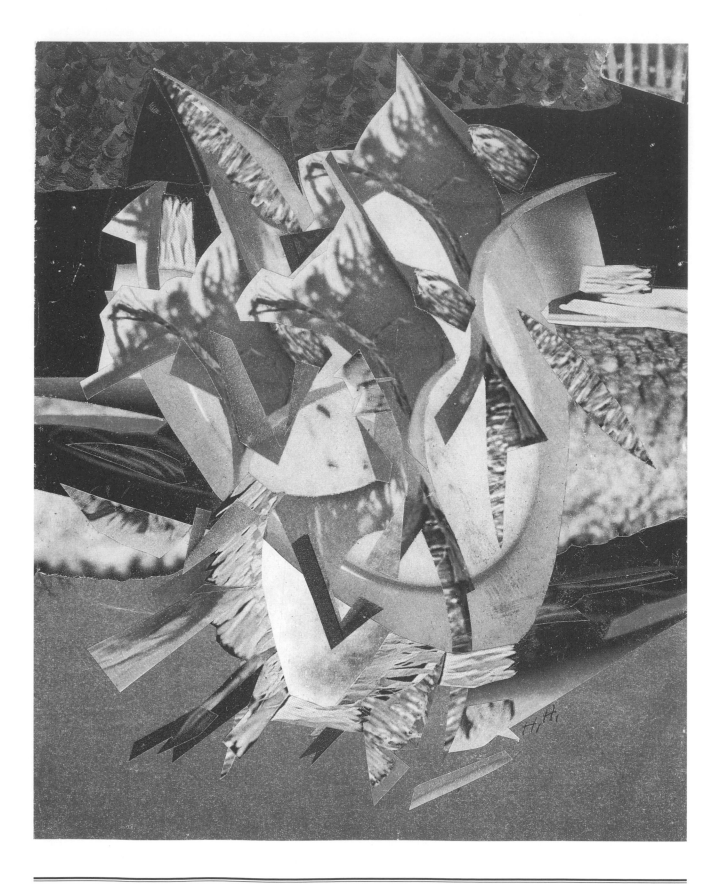

8. *Epos* (*Epic*), 1957, photomontage. Collection Institut für Auslandsbeziehungen, Stuttgart.

Indeed, the hugely increased amount of source material then being printed in high color favored Höch's drive to put photomontage to new uses. Up until about 1950, the magazines and journals from which Höch regularly worked ran few colored reproductions; from that time forward, however, advertising's new enthusiasm for color drove commercial publishing to disseminate a diversity of color illustration rich enough to provide the artist with choices comparable to those offered by tubes of paint.[33]

Höch's decision to force photomontage to speak a language of painterly abstraction could be interpreted as another chapter in the history that regards the medium essentially as a critique of traditional means of art.[34] I do not believe, however, that Höch (except, perhaps, partly during the Dada period) ever saw her own practice of photomontage as an attack on established aesthetic conventions per se; rather, the resources of the medium's "already-seen" dimension offered her unique and irresistible expressive possibilities. When she banished that dimension, she was challenging herself to show that photomontage could rival painting. Although Höch was remarkably successful in that effort, those abstract photomontages in which bits of the recognizable are left intact tend to be stronger.

In collusion with its title, the presence of a pale flower just off center in *Die Bösen im Vordergrund* (*Evil to the Fore*, 1955) (pl. 88) prompts a response of deeper psychological resonance than the wholly abstract technical brilliance of *Burst Unity* can generate. Where the latter restricts its reach to the visualization of a concept, the former invites specific interpretations of the idea suggested by its title. Indeed, *Evil to the Fore* coaxes the viewer to read into its shapes and colors an unfolding tale of poetic allegory. Through the operations of collage, its main character, the delicate pink-and-white bloom, seems simultaneously vulnerable and predatory: at the left, its opened, flesh-colored petals seem to attract the red, liplike slits at the tops of the three black phallic forms that rise from the picture's bottom edge; at the right, the petals—coiled tightly—appear ready to entrap any passing adventurer into their space.

The impetus behind Höch's emphatic redirection of her photomontage work in the 1950s must, in part, have been a reaction to the spirit of the times. Just as her passage through Dada had been a catalyst to the institution of the medium in her artistic praxis and Nazi constraints had been a stimulus to a wider experimentation, so was the particular atmosphere of early postwar Berlin implicated in her turn toward abstraction. With the rise of Tachisme in Europe and Abstract Expressionism in America, abstraction had become the dominant force in Western painting by the early 1950s—a phenomenon that took on a special resonance in Germany, where nonrepresentational art had been outlawed during the years of *entartete Kunst*. Heinz Trökes described reactions to its appearance in the immediate postwar years:

The new art was subject to two completely opposed views. We artists were in a euphoric state of mind; there were, however, people who had never seen anything other than Nazi art. They were completely disconcerted and reacted with the exact words they had been hearing for twelve years: "Cultural-Bolshevism—degenerate—Jewish art." There were intense discussions. In the Galerie Rosen we held regular discussion evenings.[35]

Such early controversy rapidly escalated, in the words of another writer, into "furious debates . . . between the proponents of figurative art and those who pursued abstraction."[36] The disputes acquired a high level of ideological content as abstraction came more and more to symbolize individual and political freedom while representational art became associated with the social realism of the Nazis and—"Cultural-Bolshevism" notwithstanding—the practice officially sanctioned by Soviet authorities. On the least complicated level, one was the flag of democracy, the other of totalitarianism. Nowhere in Germany was this split felt more sharply than in Berlin—divided as it was by four-power rule, geographically isolated from the West, and its very status a major issue of the cold war.

Höch was undoubtedly present during some of the early discussions at the Galerie Rosen and was without question aware of the politicized character her art would seem to have assumed. As is evident from her daybooks, the contemporary cultural scene in Germany and elsewhere interested her greatly, and she kept informed of its developments. Despite exhibiting quite regularly in Berlin during the decade after the war, however, her position was not at all what it had been during that other postwar period some thirty years before. Instead of being at the forefront of avant-garde activity as she had been in her youth, during this second turmoil of recovery she was more an observer and occasional participant. Höch described her situation in a letter to Arp of October 3, 1953, in which she explained her failure to respond to his last letter:

It's my work (I have so much to catch up on and it's the only important thing left) and also my beloved garden that takes up so much time and energy. And . . . everyday survival in Berlin is still dreadfully hard. I live all alone in a very romantic little house. . . . I see few people and am focused on my work. I read a lot also—there are an infinite amount of things that have happened . . . and now again stream in from the wide world. . . . Slowly, intellectual life is returning to this so-long-godforsaken Berlin. . . . Just getting up again causes convulsive strains. Not uninteresting.[37]

Höch was not exaggerating when she told Arp that she was focusing on her work. During the 1950s her production of photomontages alone rivaled her most prolific periods of the 1920s. In 1957, and again in 1959, exhibitions of her recent photomontages were mounted at the Galerie Rosen: the first contained twenty-six works, all from the early years of the decade, and the latter presented thirty-five from the years between 1956 and 1959. *Das Kunstwerk*'s review of the 1959 exhibition began by reminding its readers that Höch had been the only woman in Berlin's Dada group and pointed out that, among its members, she was the only one to have remained faithful to the city. It also remarked on the collage technique in the new work, which it found to be "still fresh and full of life," its old "readiness to attack" now replaced by a softer

irony. Judiciously, the review pronounced the montages that avoid "glaring color" to be the more successful.[38] One cannot know exactly how the reviewer wanted this last statement applied, but a work such as *Fata Morgana* (1957) (pl. 92), which emphatically eschews any such disturbing qualities, would presumably have secured a place on the positive side of the magazine's evaluation.

Titled after the legendary enchantress, famous for her magic powers of mutability, *Fata Morgana* is an ethereally beautiful picture, a shutter-quick glimpse of its namesake caught in the act of transfiguration. If we allow ourselves only a modicum of suspended belief, *Fata Morgana* actually can look like a miraculous happening caught by the camera's lens; in the same way that a photograph of a body in mid-action neces-sarily implies that action's completion in the next instant, *Fata Morgana* wants to document the moment before the whorl of filmy pink skirt, pearls, and tree branch will have resolved themselves into the sorcer-ess's new identity. To create this effect Höch cheated a little. The natu-ral settings of earlier montages such as *Sea Serpent*, *Dream Night*, or *Light Sails* make their fictive character immediately and wholly obvious; but the definitive deterrent to reading any of them as photographic "miniatures of reality"[39] is the more or less openly declared disguise of their "real-life" sources. In *Light Sails*, an obviously collaged, volumi-nously pleated skirt pretends to be a flower; in *Fata Morgana*, on the other hand, the discreetly affixed skirt baldly declares itself as a swath of fabric—however oddly deployed it is in the moment we see it. Once more, Höch capitalizes on what Roland Barthes calls "photography's inimitable feature . . . someone has seen the referent."[40] Dynamically integrated with a frothy sky and water, the recognizable elements con-fer their photographic legitimacy on what would otherwise be a roman-tic, painterly seascape—indeed, is, in large part, a painterly seascape. While a considerable admixture of collage contributes to the appear-ance of sky and water, the most delicate and contextually realist effects, as in the entire upper portion and again at the bottom, issued from Höch's brush.

Höch had combined painting and photomontage before, but never, as in *Fata Morgana*, to heighten effects of illusionism; Höch, who had the most sensitive understanding of the medium's temperament, had not tried to bend it to such hostile service. The closest she came to forc-ing photomontage to unnatural duty was her use of it in the gestural abstractions of the 1950s. While *Fata Morgana* is an inspired work, it must, to some degree, represent Höch's acknowledgment that she was pushing boundaries perhaps better left undisturbed. After *Fata Mor-gana*, Höch went on making abstract pictures through the process of photomontage, but less frequently; and, increasingly, as in *Geordnetes Farbspiel* (*Ordered Color Play*, 1962) (pl. 94), the collaged parts were arranged along an implied grid.

Given that the practice of photomontage is all about the altering and assuming of identities, Höch's attraction to the fabulous Fata Morgana (whose skills in the art of changing shapes were so great that mirage itself was her invention) must have been on the order of magical self-definition. Although very different in style from *Fata Morgana* and far more overt, Höch again equated her persona with a mythological figure in a collaged self-portrait entitled *Hekate* (*Hecate*, 1965), after the god-dess of ghosts and witchcraft. This tendency to symbolic identification is not frequently evident in her photomontages, but it often surfaces in her work in other mediums and in the poetry and short stories she wrote off and on throughout her life.

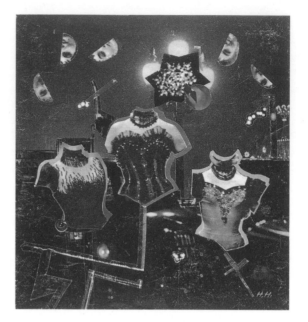

THE FINAL DECADE

Among the photomontages shown with *Fata Morgana* at the 1959 Galerie Rosen exhibition was *Toulouse-Lautrec zugeeignet* (*Dedicated to Toulouse-Lautrec*, 1957) (fig. 9), which may well have been one of those works *Das Kunstwerk*'s reviewer found disturbing for its "glaring" qualities. Although not one of Höch's most inspired pieces, its satirical treatment of the female figure signals the beginning of the thematic and stylistic freedom that came to characterize the last decade of her active engagement with photomontage. She had never programmatically excluded particular subjects or modes from her montages of any given period; but her tendency (with the possible exception of the very early Dada years) had been to privilege certain ways of working over others during particular spans of time. In the 1960s, however, with years of experimentation to draw on, Höch's fancy played equally over the gamut of the medium's possibilities—happily, one assumes, producing such varied works as *Loch im Himmel* (*Hole in the Sky*) (fig. 10), *Komposition in Grau* (*Composition in Gray*) (fig. 11), and *Das Fest kann beginnen* (*On with the Party*) (pl. 97) within a single year, 1965.

Secluded as she was in Heiligensee, Höch was nonetheless avidly interested in the events of the world and seems to have had ambitions to undertake a collage that would surpass in size and scope the largest, most encyclopedic, and best known photomontage of her career,

9. *Toulouse-Lautrec zugeeignet* (*Dedicated to Toulouse-Lautrec*), 1957, photomontage. Collection Peter Carlberg, Hofheim, Germany.

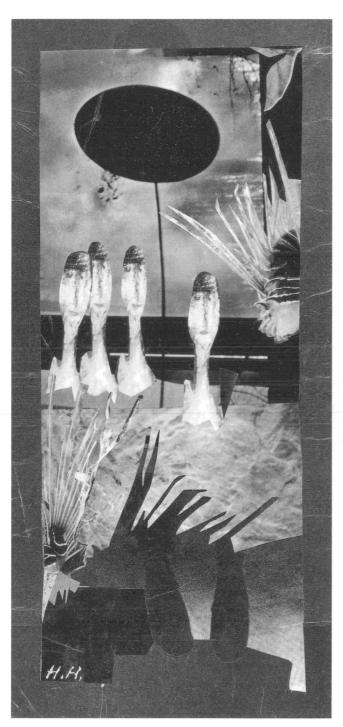

10. *Loch im Himmel* (*Hole in the Sky*), 1965, photomontage.
Collection Landesbank Berlin.
11. *Komposition in Grau* (*Composition in Gray*), 1965, photomontage.
Collection Institut für Auslandsbeziehungen, Stuttgart.

Schnitt mit dem Küchenmesser (*Cut with the Kitchen Knife*, 1919–1920) (pl. 1). On a paper found in her estate and filed in the July 18, 1960, issue of *Life International*, she had made the notation "Preparations for a new large collage," specified dimensions of the work as "120 x 160 cm," and listed its themes:

Fabulous beasts; fantastic plants; pretty, alienated girls; machines; old art; new art; . . . cats; space flight; soil from the moon; sex; screaming; resigned old people (without eyes); philosopher (put together from all the best); "freed" countries (blacks killing each other and starving); markets; beautiful large flowers; newborn babies in starlike arrangement; drugged creatures; a large head, made from all the astronauts.

Höch's aspiration would seem to have exceeded her reach, for the protean collage was never realized—perhaps because of its daunting scope or (more fundamentally for Höch, whose genius was always for the small) because of its size.

Höch, in fact, did make individual photomontages on several of the themes she had listed; however, neither these nor any others are invested with the mordant satire typical of the Dada/Weimar years. Where, for instance, Höch had held up the promises of the new technology of the 1920s to witty pictorial questioning in the earlier phase, the space age became cause for uncritical celebration in her later years, as in her 1969 montage *Den Männern gewidmet, die den Mond eroberten* (*Dedicated to the Men Who Conquered the Moon*) (pl. 103), which celebrates the American astronauts who that year had achieved the first moon landing. Indeed, the biting, sometimes nasty wit of the 1920s and early 1930s is almost entirely avoided in Höch's work of the 1960s, surfacing only in montages that focus on the female figure.

Although the old parodic impulse is resurrected with the reappearance of woman as subject, its expression is now cleaner, less charged with dense layers of meaning than formerly. These differences probably owe to the nature of the respective times and to Höch's own feelings of involvement with them. During the earlier period, Höch was herself an example of the New Woman—that contradictory creature who was the cynosure of an entire culture. Maud Lavin has noted succinctly that "within Höch's avant-garde circle and throughout Weimar Germany, the images and attitudes of modernity were consistently projected onto women."[41] As part of that generation of women forced "to assume the threatening promises of the modern,"[42] Höch would necessarily have seen the female as subject in a more complex way in Weimar Berlin than from her later vantage point in Heiligensee.

However her perspective may have changed, Höch seems to have understood the feminine from first to last as a cultural construct. Chances are great that she would have found Simone de Beauvoir's dictum "One is not born a woman, but rather becomes one" improved in Judith Butler's paraphrase: "No one is born with a gender—gender is always acquired."[43] In the photomontages of the Weimar era, as in

those of the 1960s, Höch doubly caricatures mass-media representations of women and their own complaisance in the masquerade that produces identity. In both periods, Höch's women must cope with fragmentary, hybrid, unstable, sometimes androgynous bodies—conditions that encumber their efforts to perform expected gender roles far more in the earlier montages than in the later. Thus where *Fata Morgana* pictures a magic instant of transformation, Höch's Weimar montages often portray women arrested in insoluble Kafkaesque transition. The titled figure of *Die Süße* (*The Sweet One*, 1926) (pl. 50) appears dubious, even worried about her ability to charm, while that of *Die Sängerin* (*The Singer*) (pl. 35), from the same year, looks as if her male head is giving her active pain; funny as these images are, they are also poignant commentaries on the strains and confusions caused by culturally exacted gender performance. By contrast, the voluptuous white body separating the Audrey Hepburn–like head from its legs in *Hommage à Riza Abasi* (*Homage to Riza Abasi*, 1963) (pl. 96) seems to be suffering no discomfort, nor giving any to her appended parts. The incongruity between the slender, well-mannered head and legs and the heavy bellydancer's body is used in zestful, mocking celebration of the rituals of dressing for the occasion.

If, as is more than likely, Höch had seen the first postwar issue of *B.Z.* ten years earlier, she would have seen on its front page the headline "What would you say if someone exchanged your head?" set between an illustration of Audrey Hepburn's head and a curvaceous, bikini-clad body (fig. 12). The article to which these elements were attached recounts the star's extreme displeasure that the two images had been conjoined to advertise her film *Roman Holiday,* while noting the pragmatic response of the body's owner: "Advertising must be."[44] One has to think that in *Riza Abasi* Höch may have found special relish in constructing this particular send-up of female vanity and acquired notions of the vulgar and genteel.

Höch's woman-centered photomontages of the 1960s more consistently and more obviously target the female's acculturated strategies of seductiveness than do their earlier counterparts. With rare exceptions, such as *Grotesk* (*Grotesque*, 1963) (pl. 98), they feature a single figure conspicuously in pursuit of sexual attention. In *On with the Party* and *Entartet* (*Degenerate*, 1969) (pl. 105), the female persona is subject to a bodily alteration so ludicrous and an accessorization so extreme that her satiric allure encompasses the acquired mannerisms of the male response as much as those of the siren come-on. Entering stage right, the heroine of *On with the Party* fixes the spectator with a worldly eye as her large, glistening red lips smile with enigmatic promise; an equally red nipple protruding, prowlike, from a suspiciously androgynous body projects her into a glitzy pictorial space.[45] The tightly corseted body in *Degenerate* gestures so daintily with its disembodied, pink-gloved hands and invites such prospects of bliss through its pointy, pastry-tube breasts that it has no need of a head. The excessive, high-camp femaleness of these two figures comes very close to drag, which, as Höch was well aware, virtually defines gender as performance.

12. Cover of *B.Z.*, November 19, 1953.

10 Pf

Nr. 1 • 77. Jahr
Donnerstag,
19. Nov. 1953

B.Z.

Einer Mutter Gebet enthüllt Geheimnis

B.Z.-Reporter N. Hameln, 19. Nov.

Fahrgäste auf dem Bahnhof in Hameln wurden Zeugen einer ergreifenden Szene: ein 70jähriges Mütterchen legte am Ende des Bahnhofstunnels einen Blumenstrauß nieder und verharrte in stillem Gebet. So kam man einem erschütternden Geheimnis auf die Spur: unter den Gleisen des nach dem Kriege zerstörten Bahnhofs befindet sich ein bisher unbekanntes Massengrab.

Jedes Jahr seit 1945 war die Greisin aus dem Ruhrgebiet gekommen, um am Geburtstag ihres toten Sohnes einen Strauß an die Stelle niederzulegen, wo sie ihn nach Aussagen seiner ehemaligen Kameraden vermutete. Nie in den vergangenen acht Jahren ist die verhärmte Frau Fahrgästen aufgefallen. Diesmal wurde man auf sie aufmerksam. Auf teilnahmsvolle Fragen erklärte sie weinend, daß ihr Sohn unter den Trümmern des Bahnhofs verschüttet sei. Die Polizei hat sofort Nachforschungen angestellt und die Vermutung bestätigt gefunden, daß unter den Bahnhofstrümmern im März 1945 verschüttete Tote liegen. Die Gleise werden aufgerissen und umgelegt, damit sobald wie möglich die toten Soldaten des letzten Weltkrieges eine würdige Grabstätte erhalten.

Ein merkwürdiger Zufall will, daß sich in der gleichen Gegend die erschütternde Tragödie einer anderen Mutter zugetragen hat. Siehe Seite 5.

Mit 4:0 gewann London im Olympiastadion den Fußballstädtekampf

Siehe Bericht und sämtliche Sportergebnisse von gestern auf Seite 14 und 15

Nur einer kam davon

Zufall bewahrte einen Arbeiter vor dem Tode

B.Z.-Reporter —g. Paris, 19. Nov.

Nur einen von sieben Arbeitern bewahrte das Schicksal vor dem Tode, als auf Fort Foch bei Straßburg Hunderte von Tonnen Munition mit atomarer Gewalt in die Luft flogen. Der Mann war das Essen für sich und seine Kameraden holen gegangen. Als der Essenträger zurückkehrte, wurde er 200 Meter vor dem Fort von dem gewaltigen Luftdruck zu Boden geschleudert.

Letzte Meldung:

Von sofort an benötigen Bewohner der Bundesrepublik und Westberlins auch für Luftreisen wieder Interzonenpässe. Mit dieser gestern mittag von der alliierten Oberkommission in Bonn bekanntgegebenen neuen Anweisung wird die Mitteilung vom Vortage widerrufen, nach der lediglich Westberliner für Luftreisen Interzonenpässe benötigen. Bewohner Ostberlins und der Sowjetzone sollen jedoch auch künftig ohne Interzonenpaß fliegen können.

Was würden Sie dazu sagen, wenn man Ihren Kopf aus- wechselte?

TÖDLICH BELEIDIGT war Audrey Hepburn, ein junger britischer Hollywoodstar, weil ein Lichtspieltheater bei der Werbung für ihren preisgekrönten Film „Roman Holiday" Audreys zarten mädchenhaften Kopf auf den kurvenreichen Körper der Schauspielerin Terry Moore montiert hatte. Die Werbung erwies sich als äußerst schlagkräftig. Audreys Protest ebenfalls. Terry Moore, die Besitzerin des Körpers, war nicht entrüstet. „Reklame muß sein", meinte sie.

Deutsche Dackel für Prinz Charles

KÖNIGLICHE SPIELGEFÄHRTEN. Weil Dackelkinder so niedlich sind, hat die englische Königin für Prinz Charles und Prinzessin Anne in Gergweis (Niederbayern) zwei kleine Krummbeiner gekauft. Diese stammen von dem gleichen Wurf.

13. "Dank für die Zeitschriften/Hannah Höch," 1969, drawing from notebooks entitled "Weggebene Arbeiten" (1969–1978).
Collection Berlinische Galerie, Landesmuseum für Moderne Kunst, Photographie und Architektur, Berlin.

On with the Party and *Degenerate* share with their Weimar counterparts an indefinite setting, although set forth very differently. Figures in the early works were presented variously: against an accumulation of objects, each of which acted as a sign for a recognizable function; before a blank or atmospheric void; or in contrast with Constructivist, abstract props. In the grounds of *On with the Party* and *Degenerate*, on the other hand, Höch is once more playing her game of "already seen, but can you name it?" More closely related to the mise-en-scène of the Weimar works is *Fremde Schönheit II* (*Strange Beauty* II, 1966) (pl. 101), which is, in fact, a variant on a work of the same title from 1929 (pl. 47). Where the earlier beauty is costumed in her nakedness, the second appears in a stately but tampered-with gown; each wears a rather horrifying "primitive" head—perhaps, in each case, to point at the artificiality of our acquired notions of the acceptable and the fetishistic nature of our own tribal customs.

Of the above montages, *Degenerate* may have held a more specialized significance for Höch. On a page in one of the notebooks she used between 1969 and 1978 is a drawing she made of popular magazines suspended from clips, as if being displayed by a vendor (fig. 13). Some of their titles are clearly legible, including *Magnum*, *Life*, and *Du*; others are only partially given, such as *Aujourd*, *Learn*, and *Art*. At the bottom of the page is an inscription: "Dank für die Zeitschriften [Thanks for the

magazines]/Hannah Höch." As the notebook was for personal purposes only, the drawing must express the deep private pleasure Höch took in the multitude and range of materials available to her. The bridge between this drawing and *Degenerate* rests on comparing the forms of the clips holding the magazines with the bowlike objects suspended above the montage's figure and repeated in negative reverse along the bottom; although the "bows" are evidently not photographs of magazine clips, the similarity of their shape and placement to these objects is too great to be coincidental, especially given Höch's acute eye for morphological rhyme. The imagery of the photomontage thus becomes Höch's high-spirited homage to her sources, and its title, so obviously evoking the era of *entartete Kunst*, a gleeful appreciation of their openness.

Seven years after the execution of *Degenerate*, the Musée d'Art Moderne de la Ville de Paris and Berlin's Nationalgalerie jointly organized one of the most important exhibitions of Höch's works to be held during her lifetime. In an interview for its catalogue, Höch credited the widespread development of photomontage after World War I to the technical advances that had been made by photography around that time, adding that the inexhaustible supply of material that resulted

remained a wonderful gift to her.[46] Implicitly, these remarks allude to commercial photography's second great gift to her, the introduction of color illustration after World War II and its ubiquitous availability during the years that followed. Höch had always very sensitively balanced the variant tonalities of her materials and sometimes added color by hand or through the use of colored papers, but her maneuvering ground was limited. Color reproduction became a principal tool in her career-long program to open up the aesthetic possibilities of photomontage; it allowed her to experiment with abstraction, to endow such works as *Degenerate* with the contemporary zest of Pop art, and to enrich the range of her expression.

Such extraordinarily idiosyncratic works as *Um einen roten Mund* (*About a Red Mouth*, c. 1967) (pl. 104) and *Der Baumzingel* (*The Tree Girdler*, 1966) (pl. 106) would have been unthinkable without strong color. Of all Höch's many photomontages that circle around the themes of woman and sex, *About a Red Mouth* is perhaps the most directly provocative. Glistening red lips, curved into a smile that is both civil and secret, preside over an illusionistically undulating realm of frothy fabric and cross sections of the rose-colored mineral rhodochrosite. While the picture's implied movement might be generated by pictorial vector alone, its psychological resonance depends on rhymes of color and form that echo among the lips, swelling waves of fuchsia ruffles, and pink curvatures of rhodochrosite. Although not explicit, the sexual connotations of this constellation of images are unavoidable: one critic has justifiably observed that the "innermost ovoids . . . repeated by encircling rims of pale flesh tones . . . of the pinkish rock become . . . animate. . . suggesting female genitalia."[47] Part abstract and part reliant on the message-triggering properties of the "already seen," *About a Red Mouth* might be understood as an updated version of *Marlene* (1930) (pl. 57). In the earlier photomontage, the possessor of red lips, perched in the upper-right corner, seems to have a privileged, and therefore controlling, view of both the female body and its male admirers below;[48] in the later work, the red mouth metonymically signifies woman's role as "keeper of the temple"—its slight smile suggesting either the courtesy reserved for polite society or an invitation to more intimate conversation.

Like *About a Red Mouth*, *The Tree Girdler* owes a debt to such earlier forays into abstraction as *Evil to the Fore*, in which the recognizable and the unrecognizable are combined. *The Tree Girdler*, however, takes the medium to a new expressive level. The fabulous creature of the work, which is larger than most of Höch's photomontages, is brought into being by a technique of cunning sophistication. The striations of the tree trunk, which reads as the creature's body, are set against a rich purple ground and mimic the layering of orange-red stripes that are intermittently collaged across the creature's bluish to yellow-white face. The real tactility of such elements as the stripe that curves upward to the right (demarcating the creature's chin and its protruding tongue) is thus confused with the imaged tactility of bark. While Höch makes strategic use of ready-made imagery here, she does not, as in the past, play with or rely on the "already-seen" property of her materials. The montage does not solicit the viewer to name its sources (as *Opposing Forms*, for instance, had done); nor is there any vestige of narrative structure. There is no invitation, as in *Resignation,* to explicate its imagery; nor is there the inducement to allegorical reading of *Evil to the Fore* or *About a Red Mouth*. As in most of Höch's other photomontages, what we notice first in *The Tree Girdler* is image-content, but it is content that is virtually independent of photography's insistence on

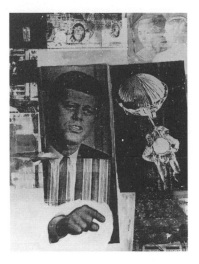

14. Robert Rauschenberg, *Retroactive II*, 1964, oil and silkscreen ink on canvas. Collection Stephan T. Edlis. ©1996 Robert Rauschenberg/Licensed by VAGA, New York, N.Y.

being seen as the record of something in the real world. Around the time Höch made this piece, she remarked that "to use my materials to make a clear, aesthetically resolved statement unfailingly brings me great pleasure";[49] one may reasonably assume that she felt well compensated by *The Tree Girdler*.

Although Höch was bothered by ill health throughout the 1960s, she maintained a high level of creative activity and an energetic involvement with outside events. Exhibition openings, lectures, films, theater, and occasional travel all furnished frequent reasons for expeditions from Heiligensee. After one such excursion in January 1965, she wrote in her daybook about a Rauschenberg exhibition she had just seen: "Huge collages à la DADA." The observation undoubtedly bespeaks Höch's awareness of the extraordinary importance Rauschenberg's art (fig.14) held for young Berlin artists of the time. His significance and Höch's historical role in preparing it was to be underscored more than a decade later by Heinz Ohff in the catalogue for the 1977 exhibition *Berlin Now*, which, aside from a large, special section of Höch's photomontages, included only the art of younger contemporary artists. "Rauschenberg's influence on Berlin in the sixties cannot be overstated," Ohff wrote, claiming the American's art to be reminiscent of photomontage as "baptized . . . by Berlin's dadaists." In his partial listing of the group's members, Höch's name is first.[50] Höch's own judgment appears in some notes she made to herself in 1968: "Collage, as we comprehensively say today . . . has spread throughout the world to become the medium for the most subtle of creations. . . . Our little sheets from long ago have brought a powerful following—giant printing machines produce proofs several meters long (Rauschenberg). The color photo released an endlessly fascinating material—without any boundaries." Höch's initial remarks on seeing Rauschenberg's work in 1965 and her later ruminations on the expansion of photomontage clearly show her to have regarded at least one branch of Pop art as the technologically enhanced beneficiary of Dada's initiatives.

By the beginning of the 1970s, Höch's own ability to profit from the printing miracles of a new age had become severely limited. Her health and, in particular, her eyesight were making it more and more difficult to work. This last, not quite full, decade of her life did, however, bring her considerably increased recognition, beginning with a large retrospective of her collages at Berlin's Akademie der Künste and later including shows in Kyoto and Paris and at the Nationalgalerie in Berlin, as well as prominent representation in various international group exhibitions. But Dada still haunted her; in an interview coinciding with her 1976 Paris and Berlin shows she complained: "I'm sick and tired of Dada; slowly it's becoming played out. Everything else that has developed goes unnoticed."[51]

If Höch remained irritated to the last by the way her interesting role as Dada's only girl seemed to overshadow her own persona and accomplishments, she was, on a deeper level, satisfied with her life's work. After a meeting with her old Dada colleague Walter Mehring, Höch wrote in her daybook that it had been, "disappointing, but was strengthening, specifically in its affirmation of the course of my own life, of which I am once more so conscious."[52] In this clarity of spirit she undertook *Lebensbild* (*Life Portrait*, 1972–1973) (fig. 15), her last significant—and her final woman-centered—photomontage.

By far the largest collage of her career and assembled entirely from black-and-white photographs laid out in rectangular blocks, *Life Portrait* is, without other pretension, both a summation of Höch's life and a celebration of her work with photomontage.[53] Dead center, presiding over the world she has known, the eighty-three-year-old Höch, her white hair still bobbed, poses in symbolic contemplation of her hands; most closely surrounding her are photographs of people who had been close to her: her father, Raoul Hausmann, Kurt Schwitters, Hans Arp, and Til Brugman, among others. In the upper-left quadrant, photomontages from every period of her career represent her art.[54] Elsewhere, *Life Portrait* shows us the many identities of Hannah Höch—*inter alios*, the baby peering curiously at the world, Dada's girlishly graceful young woman, the new proprietor of Heiligensee, the little old lady tending her garden, the same returning from the ceremony that had installed her as Professor at the Akademie. But *Life Portrait* is not a solemn summation. The wit and humor that were always Höch's are here too: in the juxtaposition of baby "Hanna" and the parental telephone; in an image of the elderly artist, picture in hand, wearing a ridiculously snooty looking seal's head; or, not least, in the center photograph of Höch, where cartoonlike birds encroach on her otherwise magisterial presence.

For all the frustrations of a long career, *Life Portrait* speaks clearly of Höch's own faith in herself and her lifelong involvement with the medium of photomontage. She had been "odd woman out" in a group that pioneered photomontage, but, unlike her early comrades, her pioneering lasted a lifetime. *Life Portrait* is a valedictory salute to the adventures of nearly six decades. "Here," Höch said, "is simply Höch the individual with collage."[55]

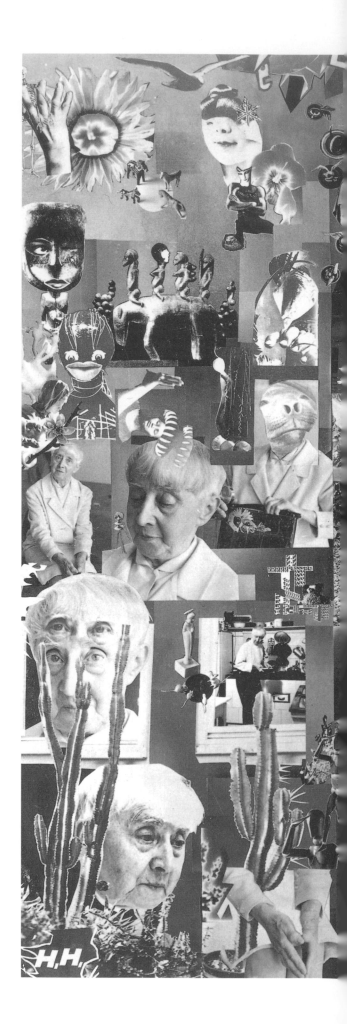

15. *Lebensbild* (*Life Portrait*), 1972–1973,
collage with original photographs by Liselotte and Armin Orgel-Köhne
Collection Liselotte and Armin Orgel-Köhne, Berlin.

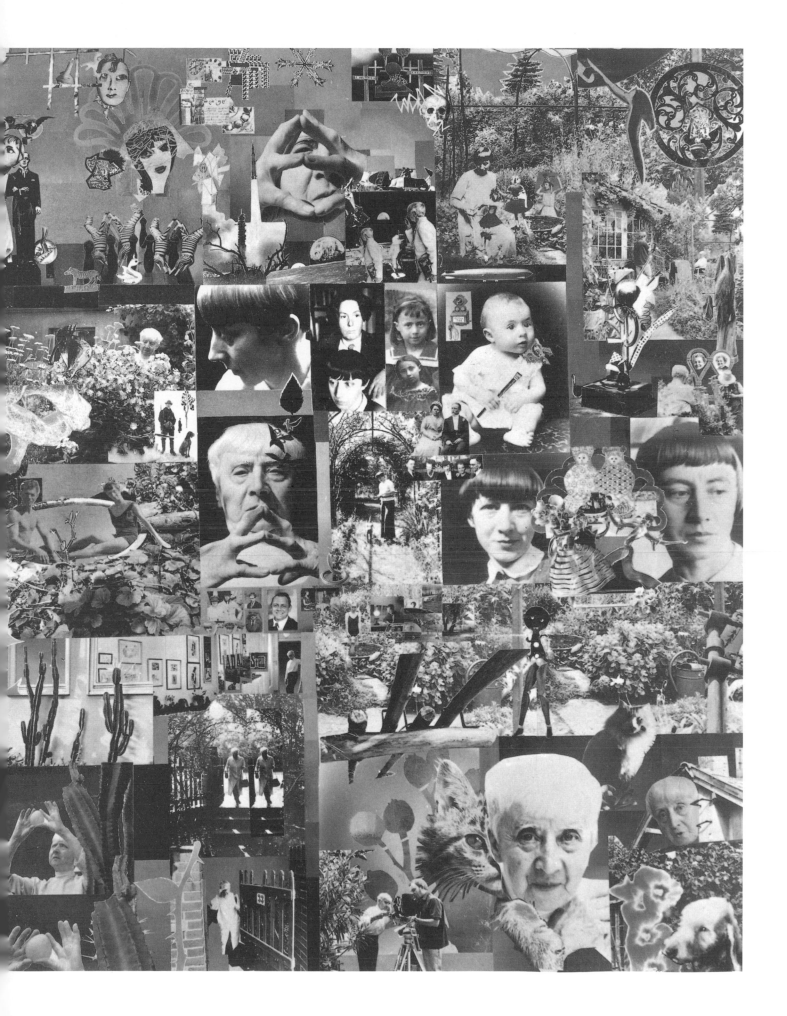

1 Walter Mehring described the young Höch as "ephebische" in his *Berlin Dada* (Zurich: Verlag der Arche, 1959), p. 43. The term is a reference to a young man of ancient Greece in training for citizenship.

2 On the addition of the final *h* to Höch's nickname, see Maria Makela's essay in this volume, p. 74 n2.

3 Seemingly a bit bemused by his memories, Richter had written in 1964: "How did Hannah Hoech, a quiet girl from the little town of Gotha . . . come to be involved in the decidedly *un*quiet Berlin Dada movement? At the first Dada shows in Berlin she only contributed collages. Her tiny voice would only have been drowned by the roars of her masculine colleagues. But when she came to preside over gatherings in Hausmann's studio she quickly made herself indispensable, both for the sharp contrast between her slightly nun-like grace and the heavyweight challenge presented by her mentor, and for the sandwiches, beer and coffee she managed somehow to conjure up despite the shortage of money. On such evenings she was able to make her small, precise voice heard. When Hausmann proclaimed the doctrine of anti-art she spoke up for art and for Hannah Hoech. A good girl." Hans Richter, *Dada: Art and Anti-Art*, trans. David Britt (London: Thames and Hudson, 1966; reprint, New York and Toronto: Oxford University Press, 1978), p. 132. First published in German in 1964 by DuMont Schauberg, Cologne.

4 In a copy of a letter to Richter, 13 December 1965 (now in the Hannah Höch Archive, Berlinische Galerie, Berlin) Höch wrote: "Your declaration of my persona as 'good girl' [tüchtiges Mädchen] compels me to doubt the continued existence of your friendship to me." As Höch crossed out this sentence, it may not have appeared in the letter actually sent to Richter; however, her irritation is apparent in the letter's closing: "The so-called 'good girl,' HH." All translations from the German are, unless otherwise noted, mine and Susan Richmond's.

5 The employment to which the author, Katrin Sello, refers was Höch's job at the Ullstein publishing house, where she worked from 1916 to 1926 making handicraft and sewing patterns for women's magazines.

6 Letter from Höch to Walter Mehring, April 1959, cited in Mehring, supra, note 1, p. 91.

7 Christopher Phillips, "Introduction," in *Montage and Modern Life 1919–1942*, exh. cat. (Boston: Institute of Contemporary Art, 1992), p. 26. Phillips's paraphrase is of Franz Roh, *Nachexpressionismus* (Leipzig: Klinckhardt und Biermann, 1925), pp. 45–46.

8 Cited in Dawn Ades, *Photomontage* (New York: Pantheon, 1976), p. I6.

9 Peter Krieger, "An der Wildbahn 33, Heiligensee: Erinnerungen an Hannah Höch," in *Hannah Höch: Fotomontagen, Gemälde, Aquarelle*, ed. Götz Adriani, exh. cat. (Cologne: DuMont Buchverlag, 1980), p. 97.

10 The inscription of title and date on the mat of *Resignation* is in the shaky handwriting Höch typically displayed during the last decade of her life. The back of the montage is inscribed in a firmer hand: "Höch/um 1930/War in Höch Ausst. - Brünn 1934/War in Gal. Franz—Höch Ausst. 1949/War im Museum of Modern Art, New York 1948." Since the German "um 1930" translates "around 1930," it can be assumed that the montage was made after that date and must have been completed by 1934, since Höch alludes to its inclusion in her exhibition of that year in Brno, Czechoslovakia. The only existing checklist of the 1934 exhibition is in Höch's hand; although it does not include *Resignation*, there are several unidentified items (each listed as "Blatt"), and it could have been one of these.

11 The collaged arm is a single, intact piece, but Maud Lavin, in *Cut with the Kitchen Knife: The Weimar Photomontages of Hannah Höch* (New Haven and London: Yale University Press, 1993), p. 173, reads it as double, the arm from elbow to hand being "unidentifiable as human" and from elbow to shoulder appearing "to be a trousered leg."

12 Ades, supra, note 8, p. 8.

13 Lavin, supra, note 11, p. 8.

14 Among the few montages of the Weimar period to place their figures against defined settings are *Gespräch* (*Conversation*, 1929) and *Vagabunden* (*Vagabonds*, 1926) (page 67).

15 Maria Makela has pointed out that Höch prudently altered the title of this montage sometime after its execution. Originally it had been *Der kleine Pg*, for *Parteigenosse*, which would have been understood by any German as "small member of the (Nazi) party."

16 Jürgen Schmidt, "Sanfte Frauen aus Buntpapier: Die Hamburger Galeristin Elke Dröscher stellt Collagen von Hannah Höch aus," *Stuttgarter Zeitung*, 13 January 1975.

17 Details concerning events in Höch's life all come from her correspondence, daybooks, and other documentation, now in the Hannah Höch Archive of the Berlinische Galerie, Berlin; this is the source of all such information appearing without a note. Documents from the years 1889–1945 have been collected in the two volumes of *Hannah Höch: Eine Lebenscollage*: vol. 1 (1889–1920), ed. Cornelia Thater-Schulz (Berlin: Berlinische Galerie and Argon, 1989); vol. 2 (1921–1945) (Berlin: Berlinische Galerie and Hatje, 1995).

18 T. W. Adorno, *Aesthetic Theory*, trans. C. Lenhardt from the second German edition of 1972 (London: Routledge and Kegan Paul, 1984), pp. 176, 177. First published in German in 1970 by Suhrkamp Verlag, Frankfurt am Main.

19 Interview with Edouard Roditi (1959), in *More Dialogues on Art* (Santa Barbara, California: Ross-Erikson, 1984), p. 96; reprinted from "Interview with Hannah Höch," *Arts* 34, no. 3 (December 1959), p. 24.

20 Stories have long circulated that Höch buried her art collection and Dada mementos in her garden. Eva-Maria Rössner, Höch's niece, and her husband, Heinrich Rössner, however, told Maria Makela that Höch kept them behind a wooden partition in her attic and did not actually bury any until the Russians were advancing on Berlin in 1945.

21 Jula Dech, "Marionette und Modepuppe, Maske und Maquillage: Beobachtungen am Frauenbild von Hannah Höch," in *Hannah Höch*, supra, note 9, p. 92.

22 I am grateful to Maria Makela for pointing out the illustration in *Die Dame* to me.

23 Cited by Eric Rentschler, "Mountains and Modernity: Relocating the Bergfilm," *New German Critique*, no. 51 (Fall 1990), p. 139 n4, which gives the source of Kracauer's remarks as the 4 March 1927 edition of the *Frankfurter Zeitung* and indicates they were reprinted in Kracauer's *Von Caligari zu Hitler* (Frankfurt am Main: Suhrkamp, 1979), p. 400.

24 Wilhelm Spickernagel, cited in ibid., p. 141, from Spickernagel's "Der Kinematograph im Dienst der Heimatkunst," *Hannoverland* 6 (1912), p. 234.

25 Kracauer, cited in ibid., p. 140, from his *From Caligari to Hitler: A Psychological History of the German Film* (Princeton: Princeton University Press, 1947), p. 112. The above paraphrases Rentschler's remarks.

34 See, for example, Erika Billeter, "Malerei und Photographie: Begegnung zweier Medien," *Du* (Zurich), no. 10 (1980), pp. 52–54.

35 Trökes, in *Grauzonen Kunst*, supra, note 28, p. 282.

36 Eberhard Roters, "Art in Berlin from 1945 to the Present," in *Art in Berlin* (Seattle and London: University of Washington Press, 1989), p. 103. This book was published on the occasion of an exhibition of the same title at the High Museum of Art, Atlanta, 1990.

37 Letter in the files of the Stiftung Hans Arp und Sophie Taeuber-Arp e.V., Bahnhof Rolandseck, Rolandseck, Germany. I am grateful to Kristin Makholm for sharing her research at the Foundation with me.

38 Heinrich ten Losen, "Ausstellungen," *Das Kunstwerk* (Baden-Baden and Krefeld) 13, nos. 2–3 (August–September 1959), p. 66.

39 The phrase is used by Susan Sontag in her *On Photography* (New York: Farrar, Straus and Giroux, 1973), p. 4.

40 Roland Barthes, *Camera Lucida: Reflections on Photography*, trans. Richard Howard (New York: Hill and Wang, 1981), p. 79.

41 Lavin, supra, note 11, p. 205.

42 Greil Marcus, review of Lavin's *Cut with the Kitchen Knife*, *Artforum* 32, no. 4 (December 1993), p. 89.

43 Judith Butler, *Gender Trouble: Feminism and the Subversion of Identity* (New York: Routledge, 1990), p. 111.

44 *B.Z.* (Berlin), 19 November 1953. The page is reproduced in *Hundert Jahre Ullstein 1877–1977*, ed. W. Joachim Freyburg and Hans Wallenberg (Frankfurt am Main, Berlin, Vienna: Ullstein Verlag, 1977), p. 80.

45 For an interpretation of the figure in *On with the Party* as threatened, see Lora Rempel, "The Anti-Body in Photomontage: Hannah Höch's Woman without Wholeness," in *Sexual Artifice: Person, Images, Politics*, Genders 19 (New York and London: New York University Press, 1994), p. 161.

46 Suzanne Pagé, "Interview avec/mit Hannah Höch" in *Hannah Höch: Collages, Peintures, Aquarelles, Gouaches, Dessins/Collagen, Gemälde, Aquarelle, Gouachen, Zeichnungen* (Paris and Berlin: Musée d'Art Moderne de la Ville de Paris and Nationalgalerie, Staatliche Museen Preußischer Kulturbesitz, 1976), p. 32.

47 Rempel, supra, note 45, p. 150.

48 This reading is based on that of Amelia Arenas in her excellent paper, "Soliloquies of a Paper Doll: Text, Image and Autobiography in Hannah Höch," unpublished at this writing.

49 From a 1965 interview with Höch made for a film on the artist by the Kulturfilm-Institut, Berlin. A copy, obtained from the Hannah Höch Archive of the Berlinische Galerie, is in the Dada Archive, Iowa City, Iowa, and is catalogued as Reel 2, Frames 543–53. The bibliographer of the Dada Archive, Timothy Shipe, kindly made this material available to me.

50 "Art in Berlin since 1945," in *Berlin Now: Contemporary Art 1977*, exh. cat. (New York: Goethe House, 1977), p. 17. The tripartite New York exhibition included the shows "Hannah Höch Collages and Photomontages" at the Goethe House; "Realistic Tendencies" at the New School Art Center; and "Abstraction, Conception, Performance," at the Downtown Loft of Denise René Galerie.

51 "Ein Leben lang im Gartenhaus: Heiko Gebhardt und Stefan Moses besuchen Hannah Höch, die große alte Dame der einstigen Protest-Kunst Dada," *Stern*, 22 April 1976, p. 103.

26 Photographs of these works are in the Hannah Höch Archive, Berlinische Galerie, Berlin.

27 This passage was translated by Maria Makela in notes she took from Höch's daybooks at the Höch Archive, Berlinische Galerie, Berlin.

28 "Zur Entwicklung der Kunst in den Westzonen und Berlin nach 1945: Eine kommentierte Interviewmontage aus Gesprächen mit Rupprecht Geiger, Werner Haftmann, Heinz Trökes, Thomas Grochowiak, Bernard Schultze, Hann Trier, Bernhard Heiliger und Manfred Bluth," in *Grauzonen Kunst und Zeitbilder Farbwelten 1945–1955*, ed. Bernhard Schulz (Berlin and Vienna: Medusa Verlagsgesellschaft mbH, 1983), p. 249. This book served as the catalogue for the *Ausstellung der neuen Gesellschaft für Bildende Kunst* held at the Akademie der Künste, Berlin, 20 February– 27 March 1983.

29 See Heinz Trökes in ibid., p. 256.

30 Ibid., p. 266.

31 The Brno article is reprinted in Lavin, supra, note 11, pp. 219–220. That of 1945 is in *Fotomontage von Dada bis heute*, exh. cat. (Berlin: Galerie Gerd Rosen, 1946). A letter from H. Uhlmann to Höch, 12 December 1946, now in the Höch Archive, Berlinische Galerie, makes it appear that the exhibition's opening was delayed until at least the latter half of December. I am grateful to Ralf Baumeister of the Berlinische Galerie for making this material available to me.

32 John Berryman, "London Review: *Hannah Höch: Collages*," *Arts Review* (London) 39, no. 11 (5 June 1987), p. 379.

33 I am grateful to Richard Benson, Adjunct Professor, School of Art, Yale University, for clarifying this point; according to Benson, it was not the introduction of new color printing processes after World War II that led to the wide dissemination of commercial color illustration, but the advertising industry's belief that color was more attractive to the consumer.

52 Note, 25 February 1967, Hannah Höch Archive, Berlinische Galerie, Berlin.

53 The immediate impetus behind the beginning of *Lebensbild* was the urging of the Berlin photographers Liselotte and Armin Orgel-Köhne, who had remarked to Höch that they had missed seeing a collaged self-portrait in Höch's 1971 Akademie der Künste exhibition. The Orgel-Köhnes encouraged Höch throughout the process of making the work and materially assisted in its realization by supplying her with photographs. In gratitude for their part in its making, Höch gave them the picture at its completion.

54 All the two-dimensional works represented in *Life Portrait* are photomontages, with the exception of the oil painting *Die Braut* (*The Bride*, 1927) (page 14). In a brochure for the exhibition *Hannah Höch: Gotha 1889–1978 Berlin* (Gotha: Museen der Stadt Gotha, 1994), there is a statement by Höch in which she discounts any special status for the presence of *The Bride* in this picture on the grounds that the painting is one of those she had made based on the principles of photomontage.

55 Ibid.

exhibition plates

75-109

wOrld war II

and bOdy and

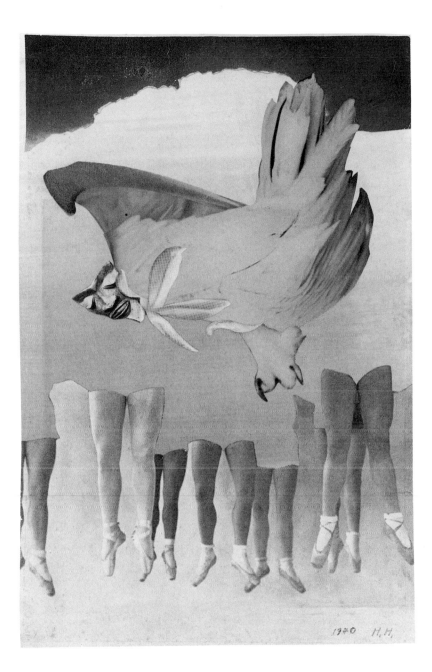

75

NUR NICHT MIT BEIDEN BEINEN AUF DER ERDE STEHEN (Never Keep Both Feet on the Ground) 1940
PHOTOMONTAGE
12 ¹¹⁄₁₆ X 8 ³⁄₁₆ IN. (32.3 X 20.8 CM)
COLLECTION INSTITUT FÜR AUSLANDSBEZIEHUNGEN, STUTTGART

While the original photograph of ten ballerinas Höch appropriated for this photomontage highlighted the dancers' vitality and strength, here, the disembodied legs seem curiously lifeless as they dangle limply from a "cloud" in the blue sky. Perhaps it is the threatening "bird" hovering above that renders them inert. Its head derives from a photograph in *Der Querschnitt* of three carved-ivory sculpture heads from the former Congo that Höch evidently had saved for nearly fifteen years; she used the left head here, and the middle and right heads in two works from the Ethnographic Museum series (see *Sadness* [pl. 44]). If the date inscribed at the lower right of this photomontage is correct, the work may be an oblique commentary on those Germans whose heads were "in the clouds" during the Nazi era. It is perhaps no coincidence that the opening sequence of Leni Riefenstahl's 1935 *Triumph of the Will* shows Hitler descending through the clouds in an airplane. — MM

Der Querschnitt 5, no. 1 (January 1925), between pp. 40 and 41
Die Dame 59, no. 9 (January 1932), p. 9

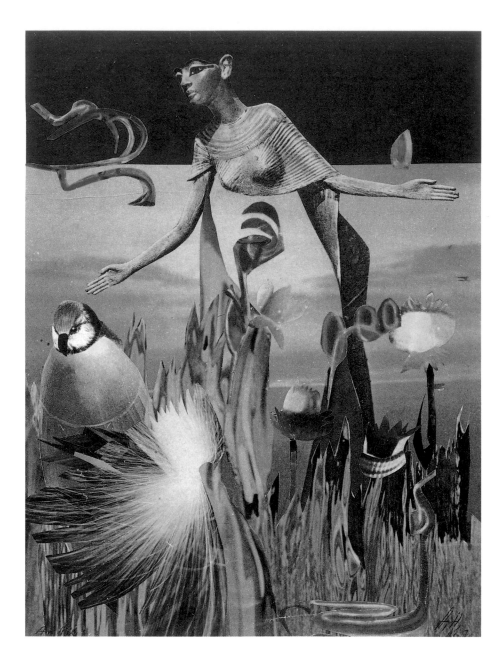

76

AM NIL II (On the Nile II) c. 1940
PHOTOMONTAGE
10 ¹³⁄₁₆ X 9 ³⁄₁₆ IN. (27.5 X 23.4 CM)
COLLECTION PETER CARLBERG, HOFHEIM, GERMANY

The statue of Isis from the grave of Tutankhamen that Höch used here was reproduced in at least two Ullstein periodicals in the early 1930s as an advertisement for the first volume of Propyläen Press's *Welt-Geschichte* (*World History*), published in 1931. Höch's photomontage is not inscribed with a date, but "c. 1940" is the one usually assigned it in the literature. By this time the artist had abandoned explicit socio-political imagery in favor of a biomorphic surrealism less likely to fall afoul of the Nazis and inspired in part by her encounters with the German countryside on the many road trips she made in the late 1930s and early 1940s with her husband, Heinz Kurt Matthies. Here, a fragment of the Isis figure from a 1934 issue of *Die Koralle* presides regally over a magical dreamscape filled with floating objects of ambiguous origin. Only the "bird," with its zeppelin body, and the "grass," fashioned from a photograph of rippling water turned on its side, are clearly identifiable in this otherwise strange and exotic world. — MM

Die Koralle 2 (new series), no. 28 (19 July 1934), back cover

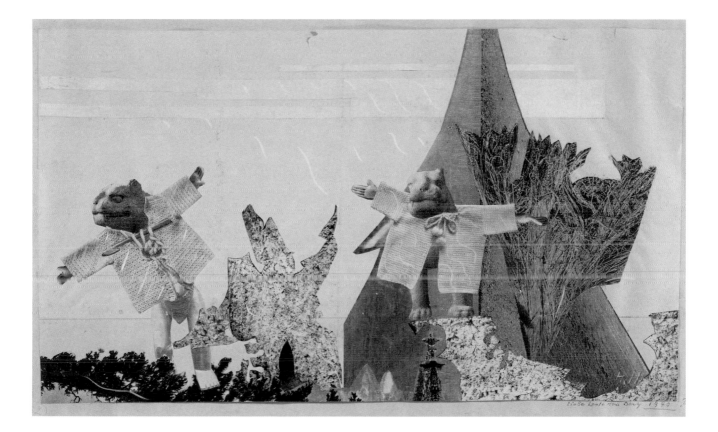

77

LIEBE LEUTE VOM BERG (*Good People of the Mountains*) 1940
PHOTOMONTAGE
15 ¾ X 22 ⁷⁄₁₆ IN. (40 X 57 CM)
COLLECTION LANDESBANK BERLIN

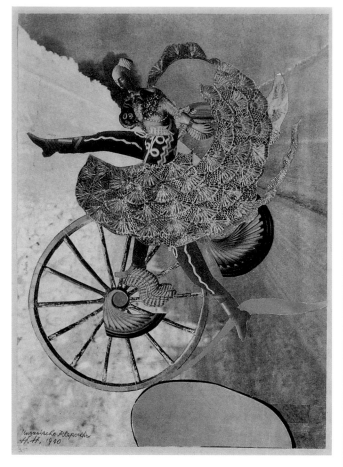

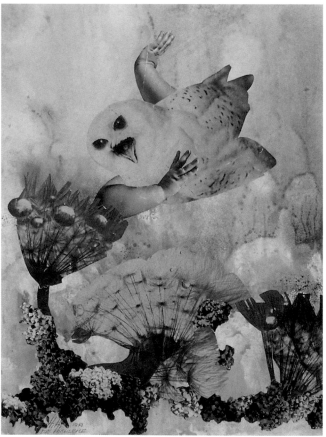

78
———

UNGARISCHE RHAPSODIE (Hungarian Rhapsody) 1940
PHOTOMONTAGE
14 X 10 1/16 IN. (35.5 X 25.5 CM)
COLLECTION INSTITUT FÜR AUSLANDSBEZIEHUNGEN, STUTTGART

79
———

DIE FRÖLICHE (The Merry One) 1943
PHOTOMONTAGE WITH WATERCOLOR
13 3/4 X 10 1/4 IN. (35 X 26 CM)
GERMANISCHES NATIONALMUSEUM, NUREMBERG (ON LOAN FROM PRIVATE COLLECTION)

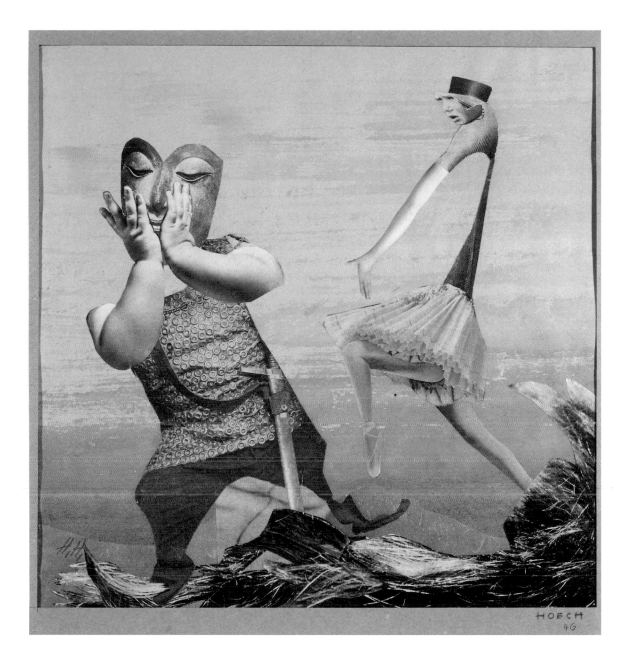

80

STREIT (Quarrel) c. 1940
PHOTOMONTAGE
11 ⅛ X 11 ⅛ IN. (28.3 X 28.3 CM)
COURTESY BARRY FRIEDMAN LTD., NEW YORK

Streit was one of a group of photomontages by Höch shown in the exhibition *Photomontage from Dada to Today*, which she organized at the Galerie Gerd Rosen in Berlin in December 1946. The name and date inscribed in the lower-right margin—HOECH 46—is not in the artist's own hand and was probably added at the time of the Rosen exhibition. The work may date from the early 1940s, as it is related to several pieces attributed to those years, including *Good People of the Mountains* (pl. 77) and *The Merry One* (pl. 79), the latter of which features the identical set of child's arms used in the left-hand figure here. — KM

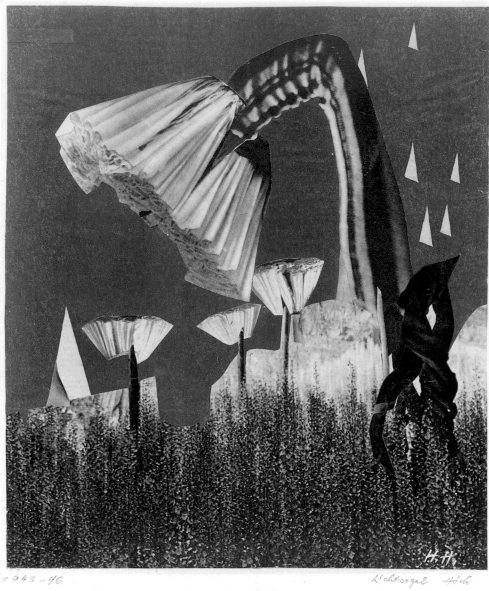

81

LICHTSEGEL (Light Sails) 1943–1946
PHOTOMONTAGE
12 X 10 ⅜ IN. (30.5 X 26.3 CM)
COLLECTION INSTITUT FÜR AUSLANDSBEZIEHUNGEN, STUTTGART

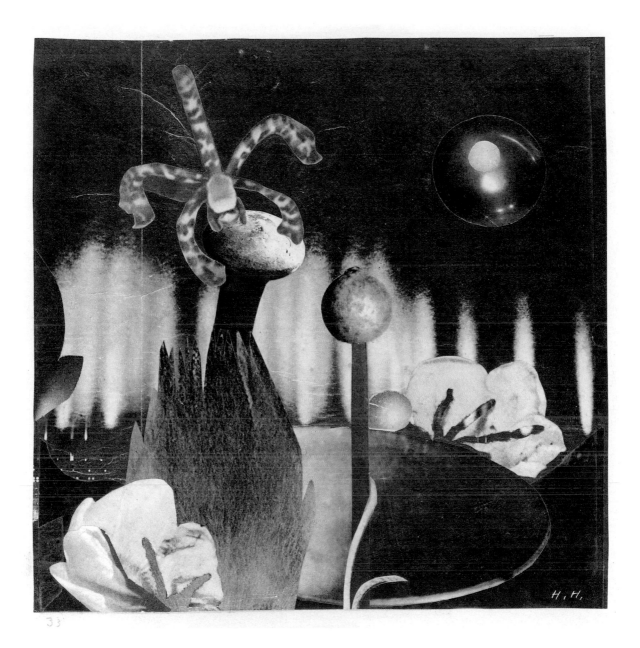

82

TRAUMNACHT (Dream Night) 1943–1946
PHOTOMONTAGE
10 ½ X 10 9⁄16 IN. (26.6 X 26.8 CM)
COLLECTION INSTITUT FÜR AUSLANDSBEZIEHUNGEN, STUTTGART

During the post-Weimar era, Höch frequently used images that had been clipped from media sources years earlier. The spiderlike form at the upper left of this work is from a picture captioned "Orchid as headdress" in a 1925 issue of the Ullstein periodical *Uhu*. Höch had included the same image in her scrapbook (c.1933), on a page devoted to head ornaments and hairstyles of non-Western peoples. By the time she incorporated the orchid into *Dream Night*, her original ethnographic interest had given way to an emphasis on the fantastic form of the orchid itself. — PB

Uhu, no. 9 (June 1925), p. 59

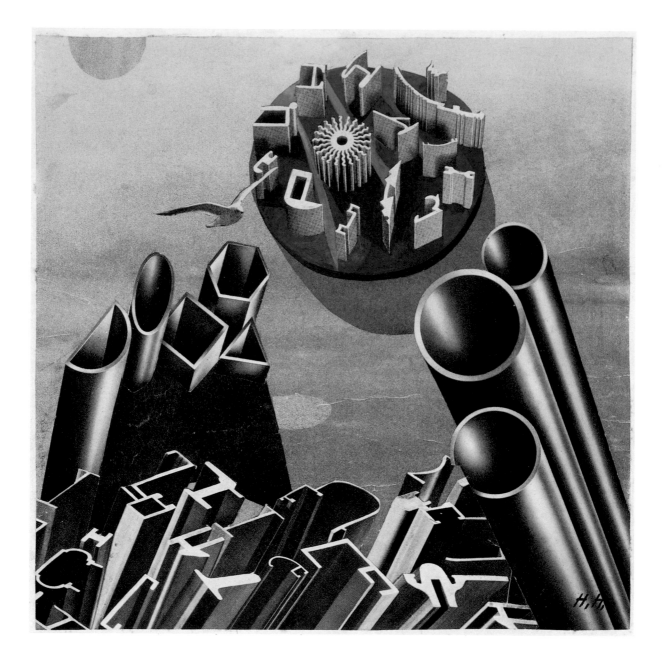

83

FRIEDENSTAUBE (Dove of Peace) 1945
PHOTOMONTAGE
8 ⅞ X 9 IN. (22.5 X 22.8 CM)
COLLECTION STAATLICHE MUSEEN ZU BERLIN, KUPFERSTICHKABINETT

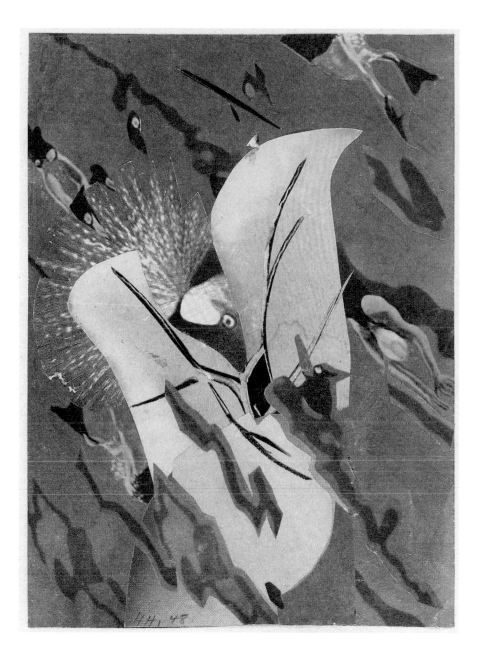

84

SEIDENSCHWANZ (Silk Tail) c. 1948
PHOTOMONTAGE
7 11/16 X 5 1/2 IN. (19.5 X 14 CM)
COLLECTION INSTITUT FÜR AUSLANDSBEZIEHUNGEN, STUTTGART

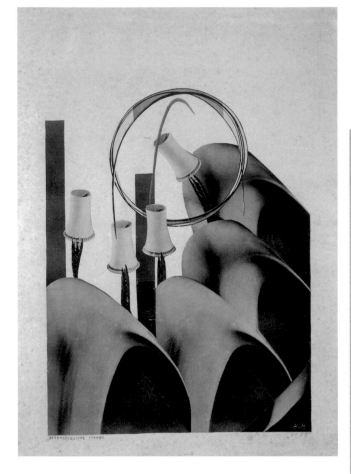

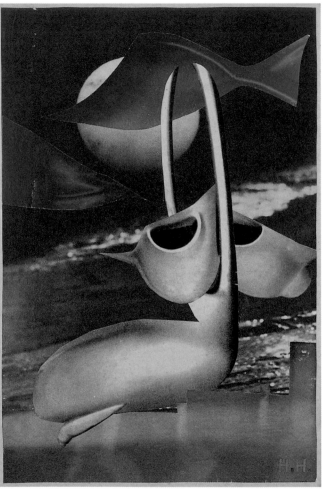

85

GEGENSÄTZLICHE FORMEN (Opposing Forms) 1952
PHOTOMONTAGE ON JAPAN PAPER
14 ⁹⁄₁₆ X 11 IN. (37 X 28 CM)
COLLECTION BERLINISCHE GALERIE, LANDESMUSEUM FÜR MODERNE KUNST, PHOTOGRAPHIE UND ARCHITEKTUR, BERLIN

86

MONDFISCHE (Moonfish) 1956
PHOTOMONTAGE ON CARDBOARD
11 ⁵⁄₁₆ X 7 ¹³⁄₁₆ IN. (28.8 X 19.8 CM)
COLLECTION BERLINISCHE GALERIE, LANDESMUSEUM FÜR MODERNE KUNST, PHOTOGRAPHIE UND ARCHITEKTUR, BERLIN

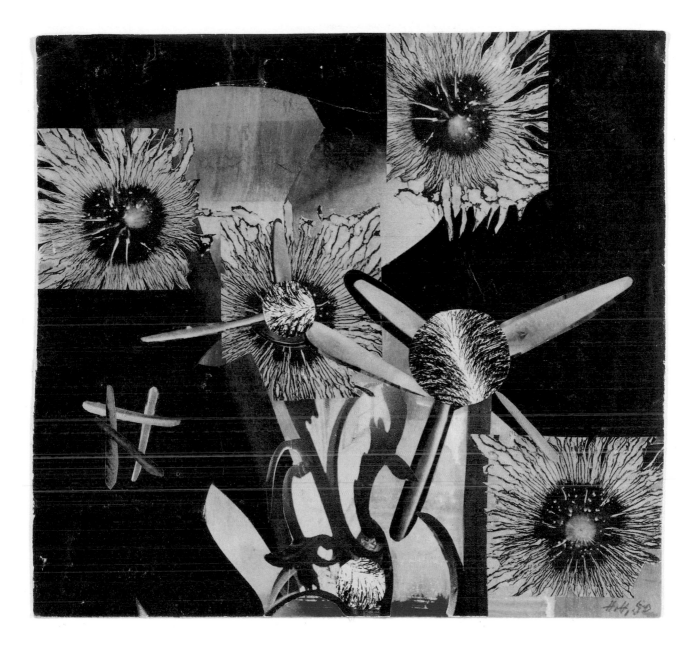

87

SYNTHETISCHE BLUMEN (PROPELLERDISTELN) (Synthetic Flowers [Propeller Thistles]) 1952
PHOTOMONTAGE
9 X 9 ⅝ IN. (22.8 X 24.5 CM)
COLLECTION LANDESBANK BERLIN

Here Höch includes several examples of microscopic imagery, including what appear to be extreme close-ups of the part in someone's hair. Höch was an avid reader of science magazines and, around this time, took many of the source photographs for her photomontages from articles on microscopic photography, physics, and space exploration. With propellers for petals and ornamental ironwork suggesting stem and leaves, her "flowers" are a hybrid concoction of nature, science, technology, and art. In the debates that took place about contemporary German art in the early 1950s, abstraction and surrealism came to be regarded by some as symbols of democracy and freedom in the new Germany, while realism, promoted by East German and Communist ideologues, seemed too closely allied with the recent Nazi art policies. Höch's fanciful use of technological imagery firmly aligned her with the proponents of modernism. — KM

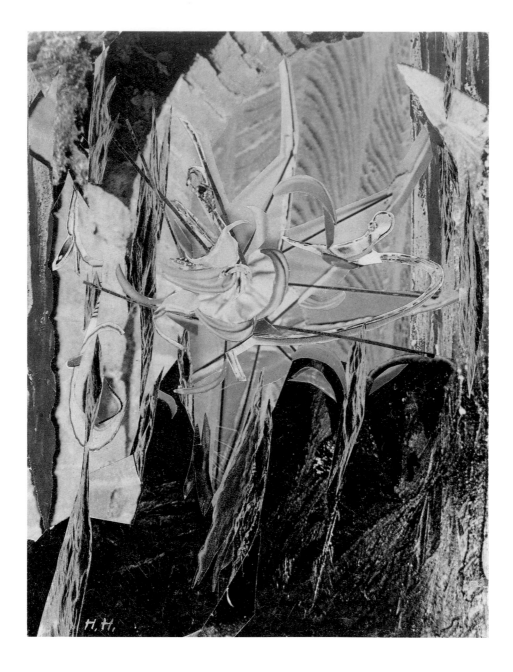

88

DIE BÖSEN IM VORDERGRUND (Evil to the Fore) 1955
PHOTOMONTAGE
9 ¹³⁄₁₆ X 7 ⅜ IN. (25 X 18.8 CM)
COLLECTION INSTITUT FÜR AUSLANDSBEZIEHUNGEN, STUTTGART

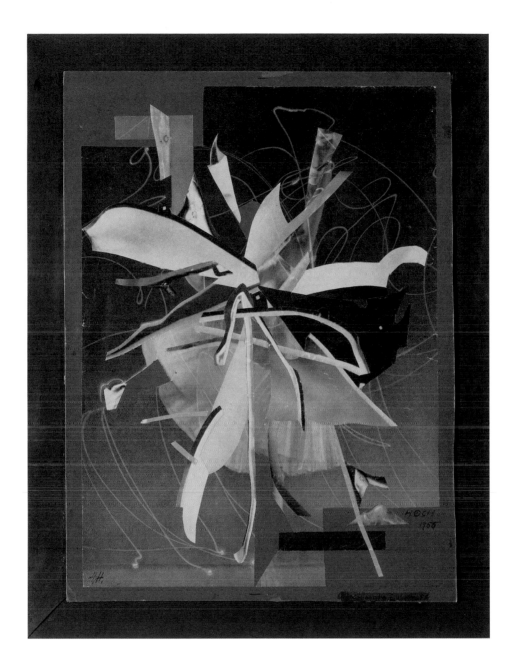

89

GESPRENGTE EINHEIT (Burst Unity) 1955
PHOTOMONTAGE
15 ¾ X 11 ⅝ IN. (40 X 29.5 CM)
COLLECTION INSTITUT FÜR AUSLANDSBEZIEHUNGEN, STUTTGART

Although one of Höch's more remarkable forays into abstraction, the title of this work encourages a metaphoric reading. On one level, it suggests (together with the imagery) the energy unleashed by the splitting of the atom. But, if the date inscribed in the gray area at the lower right is correct, it may equally refer to the division of Germany into East and West. In 1955, West Germany was granted autonomy by the Allied powers and accepted into the NATO alliance, while East Germany became a Warsaw Pact nation, thereby putting to rest any hopes for a reunification of the nation in the near future. This work may encapsulate the sense of threat and fracture Höch felt as a result of the cold war. — PB

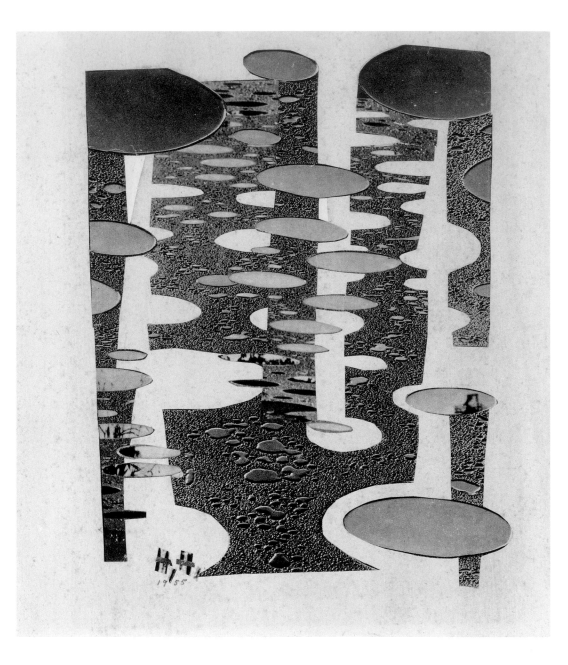

90

KLEBEZEICHNUNG II (Glued Drawing II) 1955
PHOTOMONTAGE
14 X 9 ¹³⁄₁₆ IN. (35.5 X 25 CM)
COURTESY GALERIE ALVENSLEBEN, MUNICH

Klebezeichnung II is unique among Höch's abstract photomontages from the 1950s in that it utilizes a single photograph for its source—here, a close, oblique shot of the circular designs in the surface of an urban oil swamp that is a typical example of New Vision photography from the 1920s. The caption to the original photograph stressed the "wonderful natural ornament" created by the oil patches. Twenty-seven years later, Höch transformed these patterns into a complex constellation of shifting disks, now cut and recast into a thoroughly "artistic" ornament of her own invention. The title recalls the early days of Dada, when collages and photomontages were frequently referred to as "Klebezeichnungen" (glued drawings) or "Klebebilder" (glued pictures). — KM

Die Koralle 3, no. 10 (January 1928), p. 545

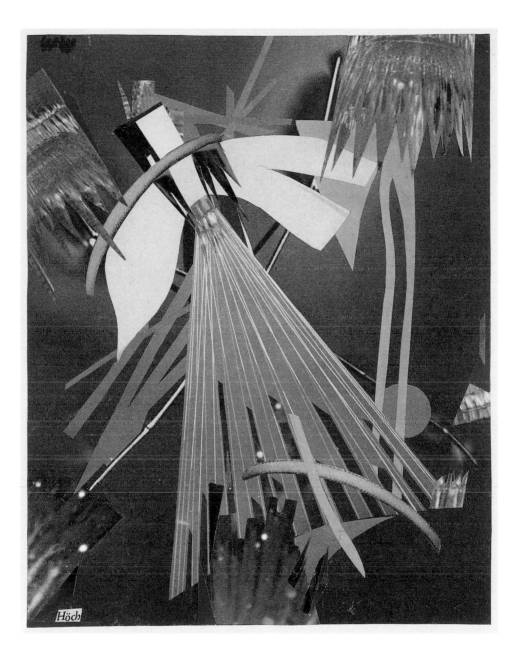

91

FRIEDENSENGEL (Angel of Peace) c. 1958
PHOTOMONTAGE ON CARDBOARD
8 ¹¹/₁₆ X 6 ⅞ IN. (22 X 17.5 CM)
COLLECTION BERLINISCHE GALERIE, LANDESMUSEUM FÜR MODERNE KUNST, PHOTOGRAPHIE UND ARCHITEKTUR, BERLIN

During the 1950s, color photography became a rich mine of source material for Höch's photomontages. Featured in popular magazines in special photographic layouts and cover stories, this burst of color became an added attraction to readers in an increasingly competetive media market. From the beginning it was advertising that most flaunted the new technology, using color to render products more attractive and desirable. Höch recounted to Heinz Ohff, in his 1968 monograph (p. 30), how she sought out the banal rather than the arresting in these images: "Somewhere, I find something that is unimportant (the more unimportant the better)—something insignificant but which suddenly stimulates my fantasy, which compels me to say something. This statement is then systematically worked out. That is, from then on, nothing accidental may even begin to intrude, either in the composition, or in the color, or in the content, insofar as a content is sought." Here, glasses from a liquor advertisement and a span from a suspension bridge combine to suggest a heavenly being. — KM

Life International, recurring advertisement for Ballantine scotch; earliest example located 7 December 1959, p. 99

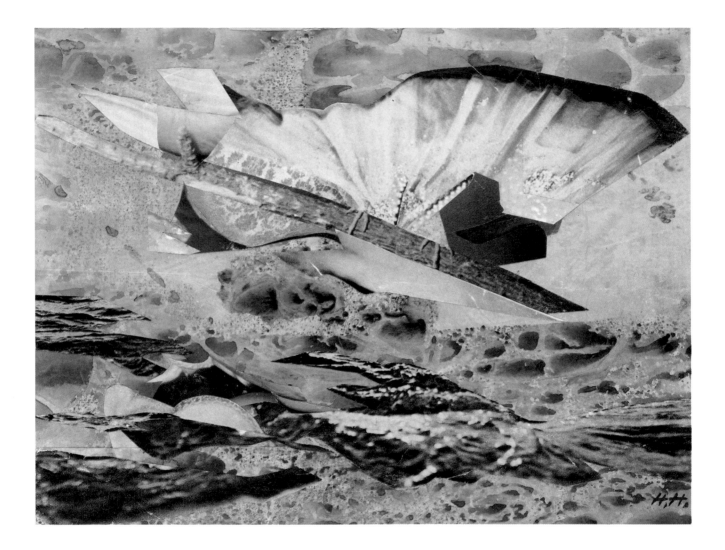

92

FATA MORGANA 1957
PHOTOMONTAGE WITH WATERCOLOR
8 ⅜ X 11 ⅛ IN. (21.2 X 28.2 CM)
COURTESY GALERIE REMMERT UND BARTH, DÜSSELDORF

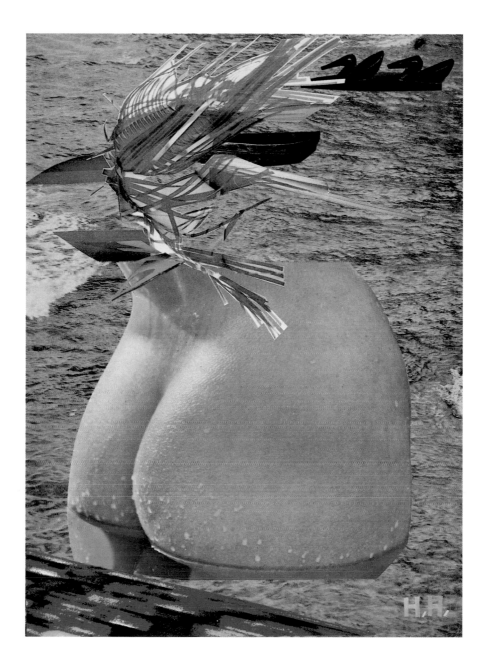

93

DER SCHÖNE PO (The Beautiful Po) c. 1959
PHOTOMONTAGE
19 ⅝ X 15 ¹³⁄₁₆ IN. (49.8 X 40.2 CM)
COLLECTION DR. PETER J. HEINDLMEYER, BERLIN

The title of this work is a play on words. It refers simultaneously to the Po River in northern Italy and to the German colloquialism for the word *fanny* (*Po*, the shortened version of *Popo*). — PB

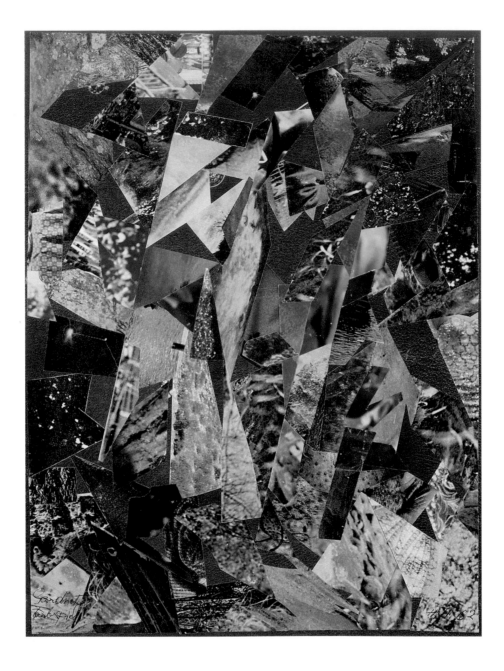

94

GEORDNETES FARBSPIEL (Ordered Color Play) 1962
PHOTOMONTAGE
13 ⅞ X 10 ⁷⁄₁₆ IN. (35.2 X 26.5 CM)
PRIVATE COLLECTION, DÜSSELDORF

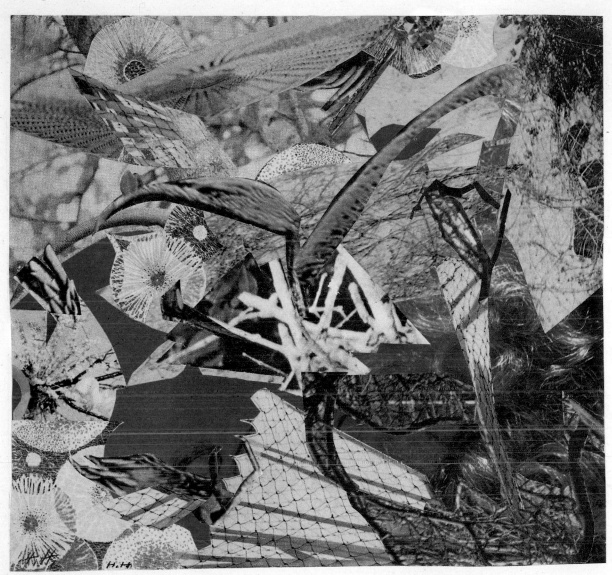

95

WENN DIE DÜFTE BLÜHEN (When the Fragrances Bloom) 1962
PHOTOMONTAGE ON CARDBOARD
8 ¼ X 8 ⅞ IN. (21 X 22.5 CM)
COLLECTION BERLINISCHE GALERIE, LANDESMUSEUM FÜR MODERNE KUNST, PHOTOGRAPHIE UND ARCHITEKTUR, BERLIN

Here, as in _Ordered Color Play_ (pl. 94), Höch created an entirely nonrepresentational photomontage that is dense with lush, high-contrast color. For both works, she sliced and shredded her source material so extensively that the original imagery is all but obliterated; photographs are exploited for their formal rather than representational properties—line, color, and texture. The works must be considered within the context of such contemporary practices as Abstract Expressionism and Art Informel, although Höch maintained an intimacy of scale and achieved a sense of energy through meticulous composition rather than the appearance of spontaneity. — PB

Life International, recurring advertisement for Martini vermouth, earliest example located 6 July 1959, p. 49

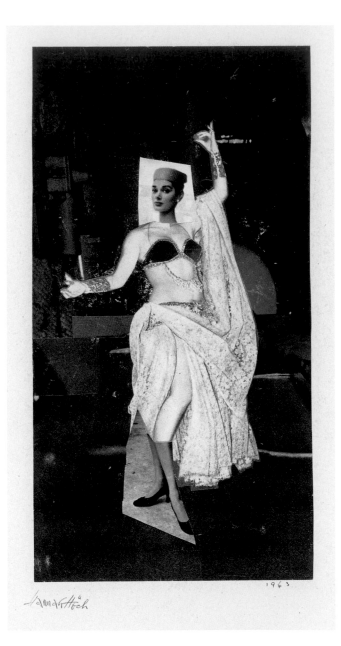

96

HOMMAGE À RIZA ABASI (Homage to Riza Abasi) 1963
PHOTOMONTAGE
13 ⅞ X 7 3/16 IN. (35.2 X 18.3 CM)
COLLECTION INSTITUT FÜR AUSLANDSBEZIEHUNGEN, STUTTGART

Höch returned to the image of the modern woman in the mid-1960s, after a prolonged period of experimentation with surrealist and formalist abstraction. This image is closely related to a photographic layout that appeared on the front page of the November 19, 1953, issue of *B.Z.* (see illustration, page 145) in which Audrey Hepburn's head was displayed in conjunction with a bikini-clad body. According to the article, Hepburn had been dismayed when another woman's body had been substituted for her own in a magazine spread on her film *Roman Holiday*. In *Riza Abasi*, a fashion model—the ubiquitous icon of feminine glamor in the popular press (and, here, an uncanny Hepburn look-alike)—sports the hyper-sexualized body of a belly dancer. Both of these exhibitionist media constructs are caricatured in this ironic "homage" to modern femininity. The Riza Abasi of the title possibly refers to the celebrated seventeenth-century Persian miniaturist, Riza-i-Abbasi (also known as Aqa-Riza), renowned for his portrayal of single figures. The work has sometimes been known by the title *Exzentrische Dame (Eccentric Lady)*. — KM

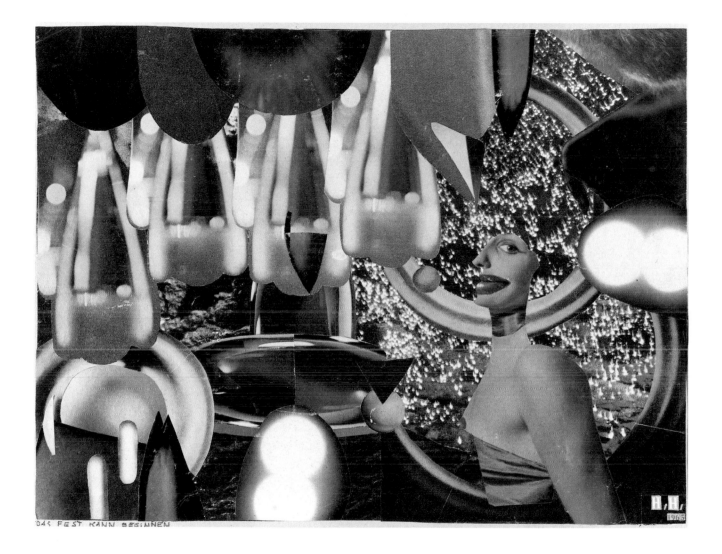

97

DAS FEST KANN BEGINNEN (On with the Party) 1965
PHOTOMONTAGE
10 ⁷⁄₁₆ X 13 ¾ IN. (26.5 X 35 CM)
COLLECTION INSTITUT FÜR AUSLANDSBEZIEHUNGEN, STUTTGART

The title of this work harks back to Höch's 1936 photomontage *Made for a Party* (pl. 74). As yet, the only source image that has been identified is of a cavern illuminated by thousands of glow worms, used as a backdrop for the female figure. The incongruity of this image underscores the fact that, at this point in her experimentation with the medium, fantasy and visual effect were more important to Höch than the original meaning of her sources. — PB

Life International, 11 April 1960, p. 51

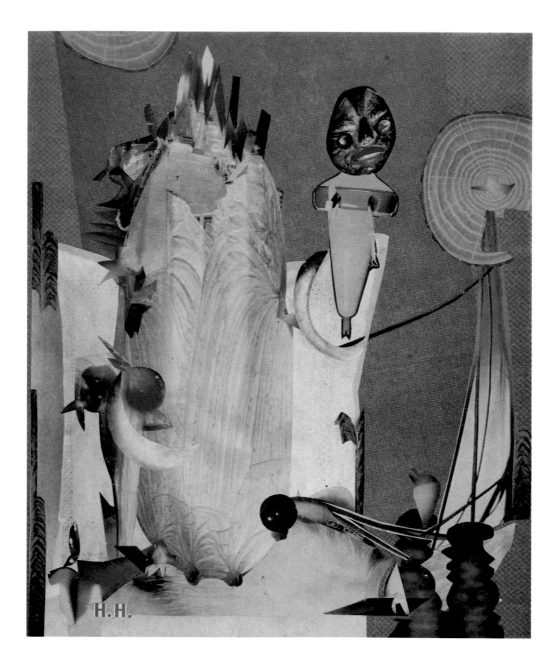

100

MAGIE (Magic) 1966
PHOTOMONTAGE ON CARDBOARD
14 ¹⁵/₁₆ X 12 ⅝ IN. (38 X 32 CM)
COLLECTION BERLINISCHE GALERIE, LANDESMUSEUM FÜR MODERNE KUNST, PHOTOGRAPHIE UND ARCHITEKTUR, BERLIN

One of the identifiable sources in *Magic* is a cascading piece of drapery from an advertisement for Dralon fabrics, found in *Hör zu* (Listen), the *T.V. Guide*–like magazine Höch often purchased during these years. Excised from its original context and turned upside down, it is combined with other decontextualized images to form a magical landscape that traverses the real and the everyday. The same image of a Peruvian trophy head that appears in *Strange Beauty II* (pl. 101) is here perched atop the body of an electric mixer, creating a hybrid creature who seems to balance between the worlds of technology and the primitive as if on a tightrope. — KM

Hör zu, 4–10 April 1965, p. 21

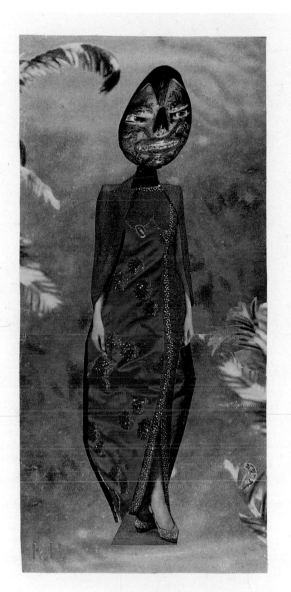

FREMDE SCHØNHEIT II

101

FREMDE SCHÖNHEIT II (Strange Beauty II) 1966
PHOTOMONTAGE
12 ¹³⁄₁₆ X 5 ⅞ IN. (32.5 X 15 CM)
COLLECTION INSTITUT FÜR AUSLANDSBEZIEHUNGEN, STUTTGART

This work reprises the theme of "strange beauty" Höch introduced in her 1929 photomontage of the same title (pl. 47), a part of the Ethnographic Museum series. The earlier work distanced the viewer from idealizations of feminine beauty by superimposing a shrunken head atop a langorous nude odalisque; here, a runway model grins out at her imagined audience through the features of a Peruvian terra cotta trophy head (also used in *Magic* [pl. 100]). By this time, color fashion spreads were a regular feature in popular magazines and increasingly defined the visual standard of the modern woman. For the background, Höch inverted two fragments of the blurred background from a photograph of a featherstar, a marine animal found in coral reefs. — KM

Life International, 17 August 1959, p. 45

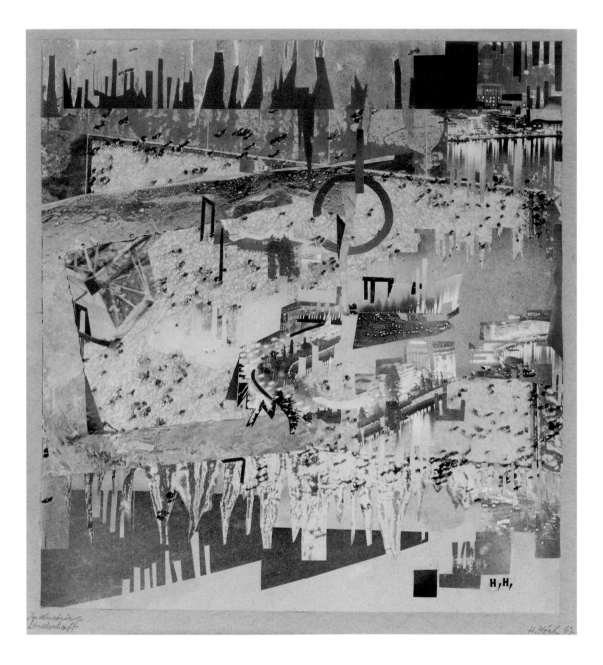

102

INDUSTRIELANDSCHAFT (Industrial Landscape) 1967
PHOTOMONTAGE
11 7/16 X 10 1/4 IN. (29 X 26 CM)
COLLECTION LANDESBANK BERLIN

At first glance, this crowded composition seems to be filled with such industrial forms as towers, smokestacks, and buildings, a reference further maintained by the title. Yet upon close scrutiny, one notices that the "industrial" forms are all cutouts: positive and negative outlines, snipped by Höch, that merely suggest a crowded skyline. The color photographs used in the composition were, in fact, decidedly nonindustrial: a night view of the Swiss resort town of Lugano and a bird's-eye view of a swimming pool teeming with people. The pool photograph, in particular, recalls the oblique New Vision photography of the 1920s and 1930s, with its severe manipulation of space and distortion of the human form. — KM

Life International, 1 February 1960, p.100
Life International, recurring advertisement for Canadian Club whiskey, earliest example located 29 February 1960

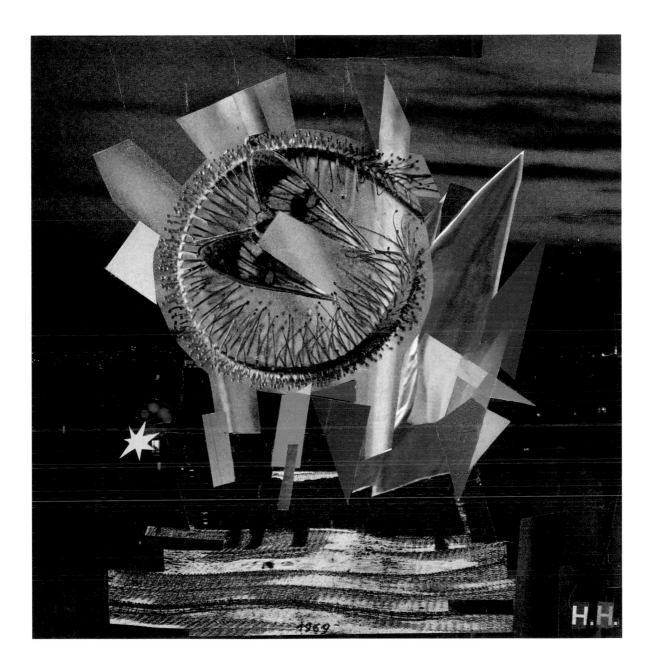

103

DEN MÄNNERN GEWIDMET, DIE DEN MOND EROBERTEN (Dedicated to the Men Who Conquered the Moon) 1969
PHOTOMONTAGE
10 ⅛ X 10 ⅜ IN. (25.7 X 26.4 CM)
COLLECTION PETER CARLBERG, HOFHEIM, GERMANY

Höch became fascinated with the exploration of space as early as the launching of Sputnik in October 1957 and clipped articles about space flight from journals such as *BZ am Abend*, *Life International*, and *Die Welt* from the late 1950s into the 1970s. She watched the first moon landing on television, along with millions of other viewers, and subsequently painted a sign reading "Man has landed on the moon" on the housing of an electrical unit in her backyard. Since two of the source images for this work, of a sundew plant and a syntomid moth (from *Life International*, 21 July 1958 and 24 November 1958) are from a series on Darwinian evolution, Höch may have conceived of the moon landing as a signal moment in human evolution. — KM

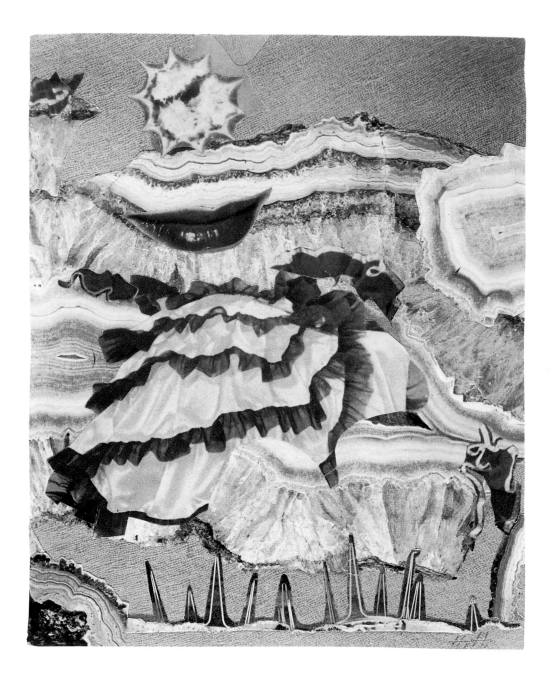

104

UM EINEN ROTEN MUND (About a Red Mouth) C. 1967
PHOTOMONTAGE
8 1/16 X 6 1/2 IN. (20.5 X 16.5 CM)
COLLECTION INSTITUT FÜR AUSLANDSBEZIEHUNGEN, STUTTGART

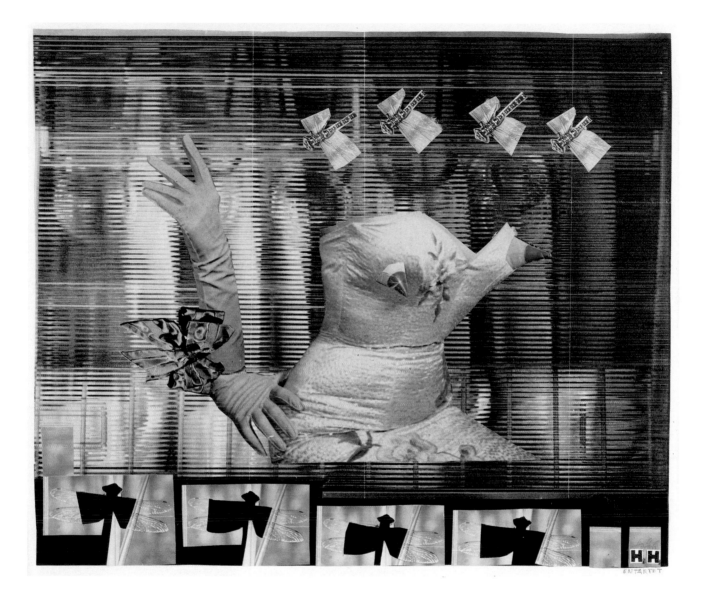

105

ENTARTET (Degenerate) 1969
PHOTOMONTAGE
13 ½ X 16 IN. (34.3 X 40.6 CM)
COLLECTION LANDESBANK BERLIN

Like *The Eternal Feminine II* (pl. 99), *Degenerate* presents fragmented attributes of female glamor. But where the arresting eyes, silken hair, parted lips, and fashion accoutrements of the earlier work suggest a seductive sensuality, here the elements create a more sinister image. The figure is mostly torso, tightly corseted into a white satin dress; her elegant, gloved arms are hinged delicately to her right hip in a gesture of mock affectation and poise. Most threatening are the clipped, conical "nipples" that protrude, missile-like, from the bodice of the dress. Höch adds to the sense of sexual menace through the repeated image of a dragonfly clipped of its wings, which oddly resembles diamond jewelry. What might have been alluring in *The Eternal Feminine II* here has become "degenerate." The title also plays off the term the Nazis used to characterize Höch's artistic compatriots in the notorious *Degenerate Art* exhibition of 1937. — KM

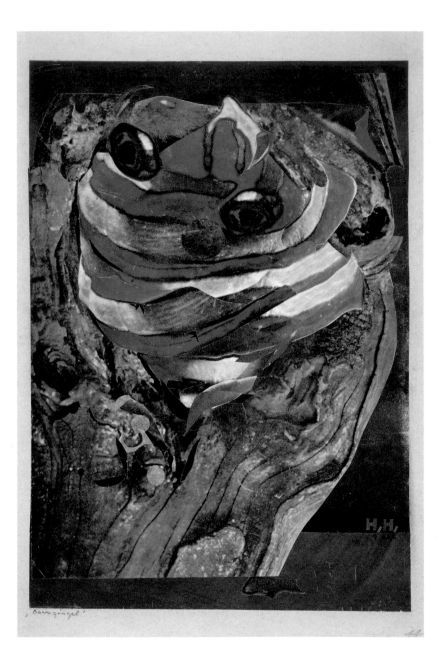

106

DER BAUMZINGEL (The Tree Girdler) 1966
PHOTOMONTAGE ON CARDBOARD
14 ⁹⁄₁₆ X 9 ¹³⁄₁₆ IN. (37 X 25 CM)
COLLECTION BERLINISCHE GALERIE, LANDESMUSEUM FÜR MODERNE KUNST, PHOTOGRAPHIE UND ARCHITEKTUR, BERLIN

 In the mid-1960s, Höch began making a series of bizarre, Surrealist-inspired "portraits," composed primarily from images of creatures in nature. For *The Tree Girdler*, Höch sliced up at least two copies of an image of a tropical fish (a wrasse) from the cover of a *Life International* magazine. So deftly did she shred and reassemble her sources that the identity of the original image is almost totally subsumed by that of its constructed alter ego. — PB

Life International, 17 August 1959, cover
Life International, 20 June 1960, p. 5

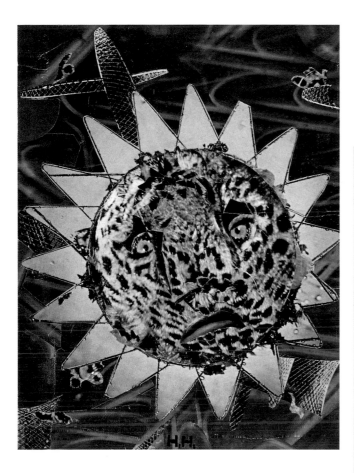

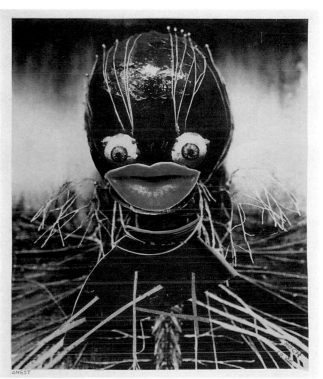

107

TRAUER II (Sadness II) 1967
PHOTOMONTAGE
13 ¹¹⁄₁₆ X 10 ¼ IN. (34.7 X 26 CM)
COLLECTION HANS-JOACHIM HAHN, BERLIN

This work is a succinct restatement of Höch's earlier *Sadness*, a 1925 work from her Ethnographic Museum series (pl. 44). She achieves the expression of sorrow here by cutting and inverting parts of a jaguar's head that was pictured on a *Life International* cover, then pasting on an upside-down smile. — PB

Life International, 13 April 1959, cover

108

ANGST (Anxiety) 1970
PHOTOMONTAGE
10 ⁷⁄₁₆ X 8 ¾ IN. (26.5 X 22.3 CM)
GERMANISCHES NATIONALMUSEUM, NUREMBERG (ON LOAN FROM PRIVATE COLLECTION)

The primary source image for *Anxiety* is a rather macabre photograph of a scientific model, made from a mannequin over which an actual human nervous system had been draped. This work is somewhat unusual in that Höch made only a relatively modest intervention to the source image, which is confined to the mouth and throat and a few shreds of paper that mimic the tendril-like nerves. Clearly the exposed sensory system and the mannequin's pop-eyed stare were the source of inspiration for Höch's title. — PB

Life International, 28 March 1960, p. 69

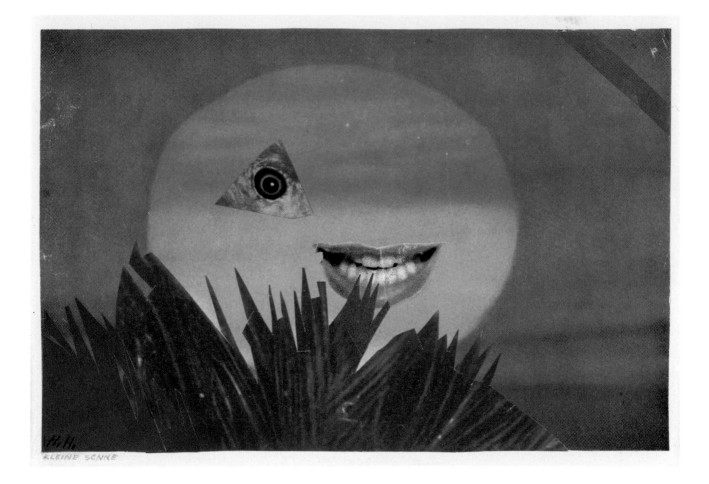

109

KLEINE SONNE (Little Sun) 1969
PHOTOMONTAGE
6 ⁵⁄₁₆ X 9 ⁷⁄₁₆ IN. (16 X 24 CM)
COLLECTION LANDESBANK BERLIN

The two identifed sources for this work are photographic reproductions of a setting sun from an advertisement for DC-8 aircraft, and of Marilyn Monroe on a 1959 cover of *Life International*, from which Höch excised the actress's lips. Monroe's likeness was exploited by many artists during the 1960s—most notably by Andy Warhol, who even made silkscreened paintings of her lips alone. In this work, however, there is no indication that Höch was interested in the recognizability of Monroe's famous lips; they were, most likely, just the right size and fit. — PB

Life International, recurring advertisement for DC-8 aircraft, earliest example located 16 March 1959, p. 35
Life International, 25 May 1959, cover

CHRONOLOGY

KRISTIN MAKHOLM

1889

Adolf Hitler born.
Gustave Eiffel designs tower for
Paris World Exhibition.
First May Day celebrated in Paris.

Born Anna Therese Johanne Höch on November 1, in the
Thuringian city of Gotha, to Friedrich Höch, senior employee in an
insurance agency, and Rosa Höch (née Sachs), formerly a reader
and housekeeper for two women of nobility.[1] The parents are
evangelical and maintain an orderly, bourgeois existence for
Anna and her four younger siblings: Friedrich (Danilo), Walter,
Margarete (Grete), and Marianne (Nitte).

1904

Russo-Japanese War breaks out,
resulting in humiliating defeat for Russia.
Marlene Dietrich born.

Leaves the Höhere Töchterschule (Girls' High School) in Gotha to
care for her infant sister, Marianne, thereby postponing her plans
to study painting. Her father nevertheless encourages her to draw
from nature, and she creates pencil and watercolor drawings of
Gotha landscapes, still lifes, and family members.

1907

Picasso paints
Les Demoiselles d'Avignon.

Makes her first collage, *Nitte unterm Baum* (*Nitte under a Tree*)
(page 58), from cut-and-torn colored papers.

1912

Gerhart Hauptmann wins Nobel Prize
for Literature.
SS *Titanic* strikes iceberg and sinks
on its maiden voyage.

Enters the Kunstgewerbeschule (School of Applied Arts) in the
Berlin suburb of Charlottenburg, where she studies with Harold
Bengen in his glass-design class and creates drawings and
designs for glass, wallpaper, official documents, and embroidery.
Also studies calligraphy with Ludwig Sütterlin.

1914

World War I breaks out following
assassination of Austrian Archduke
Franz Ferdinand in Sarajevo.
Battle of the Marne halts
German advance into France.

Receives a travel award from the School of Applied Arts to visit
the Werkbund show in Cologne, an international exhibition of
architecture, furniture, applied art, and industrial objects. She and
five other students on the trip are stopped at the Rhine River by
the outbreak of World War I.[2] Returns to Gotha to work for the
Red Cross after the School of Applied Arts is closed.

*Just as I was emerging from
the dreamy years of youth
and becoming ardently
involved with my studies,
this catastrophe shattered
my world. Surveying the
consequences for humanity
and for myself, I suffered
greatly under my world's
violent collapse.*

*— Hannah Höch on the outbreak of
World War I, "Lebensüberblick," 1958*

185

1. Höch family house in Gotha, Kaiserstraße 28. **2.** Harold Bengen's class at the School of Applied Arts, Berlin-Charlottenburg, c. 1913 (Höch marked no.15).

We were both in those days enthusiastic admirers of Herwarth Walden's 'Der Sturm' Gallery. But Hausmann remained until 1916 a figurative expressionist, a close friend and disciple of [Erich] Haeckel and at the same time an admirer of [Robert] Delaunay and of Franz Marc, whereas I had already begun in 1915 to design and paint abstract compositions in the same general tradition as those that [Wassily] Kandinsky had first exhibited a couple of years earlier in Munich.

— Hannah Höch, in an interview
with Edouard Roditi, 1959

1915

Enrolls in January at the Unterrichtsanstalt des königlichen Kunstgewerbemuseums (School of the Royal Museum of Applied Arts, later known as the State Museum of Applied Arts) in Berlin, which combines the rigorous instruction of an art academy with courses in all aspects of the applied arts.[3] Here she enters the graphic- and book-arts program headed by Emil Orlik, a well-known Jugendstil artist whose work is inspired by Japanese woodblock prints. She supplements her day courses with six nights of classes in calligraphy and figure drawing.[4] Typical assignments for school competitions include designing a title page for an auction catalogue, posters for the war effort, and pictures for the wounded and recovering soldiers in the hospital. George Grosz is in the same class from 1915 to 1917 and participates in many of the same assignments and competitions.[5] Höch remains enrolled at the school through March 1920.[6]

Meets the Austrian-born painter Raoul Hausmann in late April, probably at Herwarth Walden's avant-garde gallery, Der Sturm. Maria Uhden, a childhood friend from Gotha, is exhibiting at the gallery and possibly brings Höch there for the first time.[7] Uhden is involved with the artist Georg Schrimpf (her future husband), who, along with Hausmann, is part of the circle around the psycho-analyst Otto Gross and the writer Franz Jung. The relationship between Höch and Hausmann (who is married to Elfriede Schaeffer, and has a daughter, Vera) becomes intense as early as July. Through Hausmann, Höch meets Johannes Baader, the former tomb architect and future *Oberdada*, and Salomo Friedlaender ("Mynona"), the writer whose philosophy of "creative indifference" will fuel early Dadaist ideas.

Poison gas used for first time by German armed forces in Battle of Ypres, Belgium. German U-boat sinks British ocean liner *Lusitania* as part of blockade of England. Albert Einstein presents his General Theory of Relativity.
D. W. Griffith directs *Birth of a Nation*.

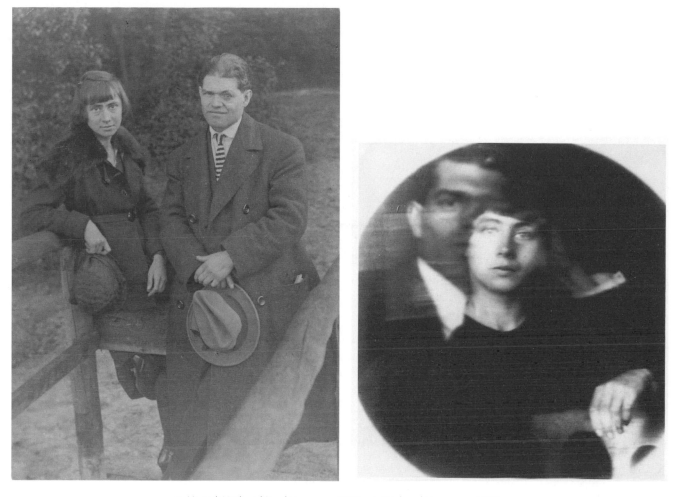

3. Hannah Höch and Raoul Hausmann, 1918. **4.** Höch and Hausmann, 1919.

Battle of Verdun.
Hindenburg appointed head of
German armed forces.
Food rationing instituted in Germany.
Dada movement founded by Hugo Ball,
Tristan Tzara, Hans Arp, and others
in Zurich.
Assassination of Rasputin in Russia.
Wilson reelected president in U.S.
by a slim margin.
Kafka publishes *The Metamorphosis.*

1916

At the first of the year, begins working three days a week in the
handiwork division of the Ullstein Press, where she makes
embroidery and lace designs for publications such as *Die Dame*
(The Lady) and dress designs for *Die praktische Berlinerin* (The
Practical Berlin Woman), two of the company's most successful
women's magazines.[8] Also begins to publish embroidery designs
in a non-Ullstein publication, *Stickerei- und Spitzen-Rundschau*
(Embroidery and Lace Review).[9] The job (which she continues to
hold until her move to the Netherlands in 1926) requires that she
work with delicate paper patterns, many of which appear in her
collages of the 1920s. It also provides her access to multiple
copies of such Ullstein publications as *BIZ*, *Der Querschnitt*, and
Uhu, which she will mine for photographic reproductions to use
in her photomontages.

Obtains the first of two abortions on May 16.[10] Although she
desires children, she refuses to give birth to a child while
Hausmann is still married to his wife.

Professor Orlik engages her as a woodcutter for his woodblock
designs in November,[11] and she creates her first abstract wood-
cut collages. Also produces her first oil painting.[12]

1917

Höch's facsimile print of a woodcut of the prophet Matthew (from
a fifteenth-century *Ars Memorandi* in the Ducal Library in Gotha)
is published in the luxury edition of *Das Kunstblatt* (The Art Page),
one of the leading German Expressionist periodicals.[13]

Hausmann moves in with Höch to her studio in the Büsingstraße,
in the Friedenau district of Berlin.

U.S. enters World War I, declaring
war on Germany.
October Revolution installs Lenin as
Chief Commissar in Russia; Russia and
Germany sign armistice at Brest-Litovsk.
Bobbed hair becomes a fashion craze.

I was somewhat timid at this debut. I gladly would have gotten out of it, since I was never in my life fond of noise. But I also didn't want to appear cowardly, so I threw myself with resignation into what the thing—the tin thing—really needed, because it was my job.

— *Hannah Höch on her participation in the 1919 Dada Soirée, "Erinnerungen an DADA," lecture delivered in Düsseldorf, 1966*

1918

Obtains the second of her two abortions on January 18.

The first Berlin Dada-Soirée takes place on April 12 in the rooms of the Berlin Secession on the Kurfürstendamm. Richard Huelsenbeck, who had brought Dada ideas from Zurich to Berlin a year earlier, reads from his Dada Manifesto; Hausmann reads from his essay "The New Material in Painting"; and Grosz sings and bounces soccer balls off the heads of the audience.[14] Due to a major falling-out with Hausmann, which almost leads to the breakup of their relationship, Höch does not participate in this evening program. It is only through Hausmann's promise to leave his wife, which he later rescinds, that the couple reunites.[15]

Travels with Hausmann in August to Heidebrink, an island fishing village on the Baltic Sea, where they encounter a type of commemorative military picture with the heads of various soldiers pasted in. These mementos reputedly give them the idea for photomontage. On their return to Berlin, they create the first Dada photomontages.

Makes the acquaintance of the artists Kurt Schwitters and Hans Arp.[16]

Publishes several articles in *Stickerei- und Spitzen-Rundschau* that argue for a revolution in embroidery design and emphasize the painterly and abstract possibilities of what she considers a legitimate artistic medium.[17]

Takes part in December in the first meetings of the November-gruppe, the revolutionary artists' organization formed in the wake of the November Revolution that had recently ousted the Kaiser and accompanied the end of World War I. The group's goals are to bring art to the people and to serve the socialist revolution through arts legislation and the reform of institutions such as art schools and museums. Höch becomes a member, sporadically contributing to the group's annual exhibitions from 1920 through 1931, and through it meets artists such as Arthur Segal, Otto Freundlich, and Thomas Ring, as well as the writer and critic Adolf Behne, who will later become friends.

1919

Participates in the First Berlin Dada Exhibition at the print cabinet of I. B. Neumann on April 28–30, which includes works by Hausmann, Grosz, Walter Mehring, Jefim Golyscheff, Fritz Stuckenberg, Erica Deetjen, and Arnold Topp. Höch exhibits some of her abstract watercolors and participates for the first time in a Dada event, the Dada-Soirée on the final day of the exhibition, for which she plays pot lids and a child's rattle in an anti-symphony composed by Golyscheff.[18] Later in the year, on November 30 and December 7, she participates in a "simultaneous poem" by Richard Huelsenbeck in the Dada-Matinée at the newly founded avant-garde theater "Die Tribüne," where, for the first time, all the Berlin Dadaists perform together.[19]

Publishes an embroidery design in the April issue of *Stickerei- und Spitzen-Rundschau* as well as an article and a short story in its October–November issue.[20] In December, one of her woodcuts is reproduced in an advertisement for "dadaco" in the second number of the periodical *Der Dada*, where she is mistakenly identified as "M. Höch."[21]

1920

Two of Höch's Dada dolls appear in April on the cover and within the body of the periodical *Schall und Rauch* (Noise and Smoke), a magazine founded by the theater director Max Reinhardt in conjunction with his cabaret of the same name. Both the cabaret and periodical become outlets for Dadaist wit and satire. After Hans Hoffmann, press officer for the Munich Expressionist Workshop, sees the dolls on the cover, he invites Höch to submit them to the group's first exhibition, to be mounted in Chicago. She perhaps also sends some embroidered pillows to this exhibition, but it is unclear whether the show actually takes place. The dolls are ostensibly purchased by a Chicago painter named Carl Sachs.[22]

November Revolution in Germany results in abdication of Kaiser Wilhelm II; Friedrich Ebert named Chancellor. Armistice signed between Allies and Germany brings World War I to a close. Czar Nicholas II and family executed in Russia.

German Communist Party founded by Spartacist leaders Rosa Luxemburg and Karl Liebknecht; Spartacist revolt in Berlin; Luxemburg and Liebknecht murdered by counterrevolutionary Freikorps irregulars.
National Assembly meets in Weimar, elects Ebert president and ratifies new constitution, which includes provision giving women the right to vote.
Peace treaty signed in Versailles, imposing harsh war reparations on Germany.
Benito Mussolini founds Italian Fascist party.
Bauhaus founded by Walter Gropius.

National Socialist (Nazi) Party, led by Adolf Hitler, founded in Munich. Monarchist coup put down in Berlin. Communist uprising suppressed in Ruhr. Right wing parties gain in Reichstag elections.
U.S. Senate votes against membership in League of Nations.
18th Amendment institutes Prohibition in U.S.; 19th Amendment passed, giving women right to vote.

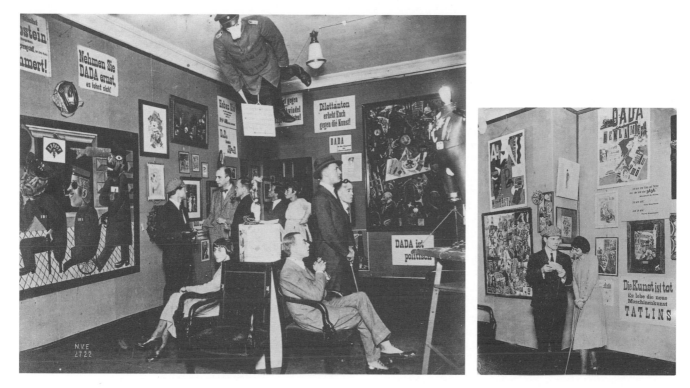

5. View of the First International Dada Fair, Berlin, 1920 (Höch at left). **6.** Raoul Hausmann and Hannah Höch with their work at the First International Dada Fair.

Participates in the First International Dada Fair, the largest and most comprehensive of the Dada exhibitions, held at the gallery of Dr. Otto Burchard in Berlin from June 30 to August 25. The show contains 174 Dada works—including paintings, prints, sculptures, objects, pamphlets, ephemera, and posters—by more than twenty-five artists, including such non–Berlin Dadaists as Max Ernst, Francis Picabia, and Hans Arp. Höch's participation is opposed by Grosz and John Heartfield, and she is included only through the intercession of Hausmann, who threatens to withdraw.[23] She is represented with at least eight works, including her Dada dolls, *Dada-Rundschau* (*Dada Panorama*, 1919) (pl. 2), and the monumental photomontage *Schnitt mit dem Küchenmesser Dada durch die letzte weimarer Bierbauchkultur-epoche Deutschlands* (*Cut with the Kitchen Knife Dada through the Last Weimar Beer-Belly Cultural Epoch of Germany*, 1919–1920) (pl. 1). The exhibition receives a rash of reviews, including one by Adolf Behne in *Die Freiheit* (The Freedom) that praises Höch's "splendid collages."[24]

Attends Monday soirées at the studio of Arthur Segal, which become a monthly fixture of Berlin intellectual life for many years. Here, she converses with artists, philosophers, and writers such as Mynona, Ernst Simmel, Erich Buchholz, and Alfred Döblin.[25]

Stickerei- und Spitzen-Rundschau publishes an enthusiastic review of Höch's designs for printed fabric in its September issue. Executives from the Alexander Koch Verlag in Darmstadt suggest factories that might put her extraordinary designs into production.[26]

Travels from Munich to Italy in October and November with her sister Grete and the Swiss poet Regina Ullmann in order to distance herself from Hausmann. Her friend the architect Ludwig Mies van der Rohe, who has connections to the Pope in Rome, arranges for the visa, and much of the trip is accomplished on foot. Ullmann leaves the party at Venice; Grete departs at Bologna; and Höch continues alone to Florence and Rome, where the Italian Dadaist Enrico Prampolini gives her a copy of the Futurist Manifesto.[27] Upon her return to Germany, she reestablishes her connection with Hausmann.

1921

Attends the Faschings-Dada-Ball, organized by Baader in January, one of a rash of artists' costume parties she will attend through 1926.

Publishes several designs in *Stickerei- und Spitzen-Rundschau*;[28] a cover illustration for the March–April issue of *Die Kornscheuer* (The Corncrib), a monthly publication dedicated to the arts; an April Fools'–joke photomontage in the *Berliner Illustrirte Zeitung* (*BIZ*) entitled "The Botanical Garden's Interesting New Acquisitions," depicting a carnivorous plant seated at a table and eating off a plate; and a watercolor illustration in Hans Arp's volume of poetry, *Der Vogel selbdritt*.

Along with Hausmann, Grosz, Otto Dix, Thomas Ring, and Rudolf Schlichter, signs the "Open Letter to the Novembergruppe," which is published in *Der Gegner* (The Adversary), one of the revolutionary periodicals put out by Wieland Herzfelde's Malik Verlag. Although the letter publicly criticizes the Novembergruppe's retreat from politics and its increasingly bourgeois activities, Höch continues to show watercolors and paintings in the group's annual exhibitions.

Participates with Hausmann and Mynona on February 8 at the Berlin Secession in an evening of readings of "grotesques" (short, satirical essays or stories, often combining humor with the shocking, the bizarre, and the parodistic). Höch's reading from an essay entitled "Journey to Italy," about her experiences on her 1920 trip, is cited by one reviewer as the best of the three performances.[29] The essay is published in May in the first and only number of the official Novembergruppe periodical, *NG*, which also reproduces one of her relief prints on its cover (page 53).[30]

With Helma Schwitters, accompanies Hausmann and Kurt Schwitters on their "Anti-Dada Merz-Tournée" to Prague. During two Dada performance evenings (September 6 and 7), the two women sit in the audience as the men try to outdo each other in a noise fest, reciting Dada "sound poems" and trying to antagonize the generally amused crowd. This is the first of her many trips with Helma and the "unfathomable" Kurt Schwitters.[31]

1922

Publishes a design for a pillow in the February issue of *Die Dame*[32] and exhibits in a design and pattern fair in Leipzig.[33]

Is invited to participate in late September at the International Dada and Constructivist Congress in Weimar, a conference that attracts artists from all over Europe, including El Lissitzky, Theo and Petra (Nelly) van Doesburg, Cornelis van Eesteren, László Moholy-Nagy, Tristan Tzara, Hans Arp, and Sophie Taeuber-Arp. Because she is traveling in southern Germany when the invitation is sent, she does not participate, but does attend a restaging of Schwitters's "Dadarevon" at the Garvens Gallery in Hanover with many of the Congress members on September 30.[34]

Separates from Hausmann by the middle of the year.

1923

Schwitters reproduces one of Höch's drawings in the first issue of his periodical *Merz*, devoted to Holland Dada, and Höch helps to locate subscribers for the magazine in Berlin.[35] She also creates the first of two grottoes for Schwitters's *Merzbau*, the organic architectural structure the artist is building at his house in Hanover, which will be destroyed by an air bomb in 1944. Entitled "Bordello," Höch's grotto consists mainly of photographs and small collaged additions and depicts a prostitute with three legs.[36] Her second contribution, produced a few years later as part of the column called the "Cathedral of Erotic Misery," refers to the German writer and philosopher Johann Wolfgang von Goethe.[37] A strong friendship develops between Höch and Schwitters, who often stays at her Büsingstraße studio when he visits Berlin and even stashes a hoard of Merz material in a crawl space there.[38] Schwitters also asks her to lodge other visiting artists, such as Vilmos Huszár, which she does frequently.

German war reparations fixed at $33,250,000,000; German mark begins rapid fall, initiating period of extreme inflation.
Finance Minister Matthias Erzberger assassinated by right-wing extremists who hold him responsible for terms of Treaty of Versailles.
Nazis establish SA (Sturmabteilung) Brown Shirts.

Mussolini marches on Rome and assumes power in Italy.
German foreign minister Walther Rathenau negotiates Treaty of Rapallo with U.S.S.R., cancelling war debts and establishing diplomatic relations; Rathenau subsequently assassinated by right-wing extremists.
American "cocktails" become fashionable in Europe.

French and Belgian forces, including colonial troops, occupy the Ruhr to ensure Germany's acquiescence to reparations payments.
Skyrocketing inflation drops value of the mark to 4 million to the dollar; new currency, "Rentenmark," established to end inflation.
"Beer Hall Putsch" fails in Munich; Hitler placed under arrest.
German Communist Party banned.
Italy dissolves all non-fascist political parties.

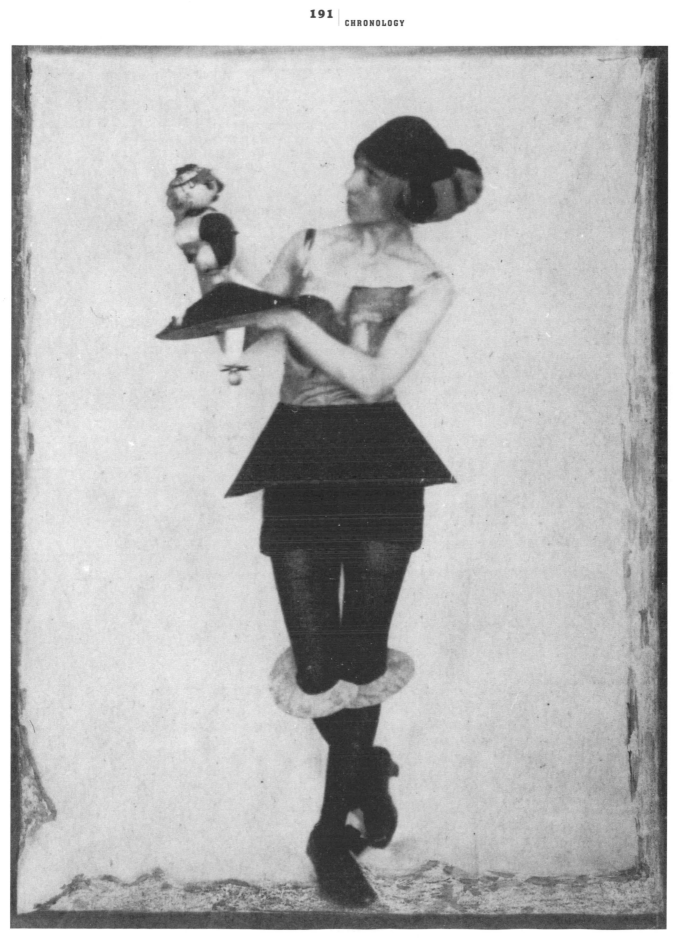

7. Höch with one of her Dada dolls, c. 1925.

Höch's father dies in Gotha on February 22.

Designs for embroidery are published in the March, May, and June issues of *Die Dame*.[39]

Visits László Moholy-Nagy and his wife, Lucia Moholy, in late May at the Bauhaus in Weimar. In the coming years, Höch will attend a variety of entertainments with the Hungarian Constructivist, including films (both popular and avant-garde), cabaret and jazz performances, and even her one-and-only soccer game.[40] After Weimar, she continues on to Dresden to meet the Schwitterses for a private demonstration of Kurt's tone poem *Ursonate*.[41]

Vacations in Sellin, on the island of Rügen, with the Schwitterses and Arps in August, and makes objects and sculptures from the driftwood on the beach. Upon their return to Berlin, the Arps stay with her in her Büsingstraße studio, where they hold evening readings of poetry and create colored reliefs from wood fragments. Höch's close friendship with both Sophie Taeuber and Hans Arp originates during this period. She also frequently attends evening get-togethers at the home of Adolf and Elfriede Behne, where she is enchanted by the stories of the Berlin artist and photographer Heinrich (Papa) Zille.[42]

1924

Schwitters reproduces Höch's collage *Astronomie* (*Astronomy*, 1922) (pl. 20) in the seventh number of his *Merz* magazine; she publishes the same image as a postcard. *Die Dame* publishes more embroidery designs in its February, November, and December issues.[43]

In April, makes her first trip to Paris, where she develops a friendship with the Dutch De Stijl artist Theo van Doesburg and his wife, Nelly. Meets Piet Mondrian at the van Doesburgs' studio in Clamart and is often engaged with Tristan Tzara, to whom she gives several of her collages and photomontages and whom she accompanies to the Théâtre du Champs-Elysées to see Stravinsky conduct his *L'Histoire du soldat*.[44] Höch's travel diary mentions engagements with many artists, including Ivan and Xana Puni, Man Ray, Constantin Brancusi, Fernand Léger, and Sonia Delaunay (with whom she exchanges pattern designs and discusses painting on fabric).[45] She also attends a meeting of the French Surrealists that includes Tzara, Pierre Soupault, Paul Eluard, Erik Satie, and Marcel Duchamp;[46] and goes to the Jockey jazz bar with Mme. Puni and members of the Synthetic Cubist group the Section d'Or, which includes Jacques Lipschitz and Amédée Ozenfant.[47] Höch becomes especially enamored of Parisian street life and popular culture, including the Folies-Bergères, the Marché aux Puces, and other tourist destinations.

Allows Schwitters to host a soirée in her studio in August, one of many times during these years that she opens her home to Schwitters, Arp, and others for their readings of experimental poetry and prose. In September, she becomes van Doesburg's intermediary in Berlin for the dissemination of his periodical *De Stijl* through the publisher Wasmuth.[48]

Participates with two paintings in the *Erste Allgemeine Deutsche Kunstausstellung in Sowjet-Rußland* (*First Comprehensive German Art Exhibition in Soviet Russia*) in Moscow, organized by the artistic wing of the International Worker's Aid (IAH), a pro-Soviet German support group under the leadership of Otto Nagel and Eric Johansson. The exhibition presents 501 postwar works by 126 German artists belonging to thirteen different artists' organizations; Höch shows under the aegis of the Novembergruppe.

1925

Höch's painting *Die Etiketten wollen sich hervortun* (*The Tags Want to Distinguish Themselves*, 1922) is reproduced in Arp and Lissitzky's *Die Kunstismen* (*The Isms of Art*), a book that traces the development of art from Viking Eggeling's contemporary experimental films back to Expressionist painting of 1914. Her photomontage *Hochfinanz* (*High Finance*, 1923) (pl. 10) is published in Moholy-Nagy's Bauhaus book *Malerei, Fotographie,*

Hans Arp and Kurt Schwitters, in my experience, were rare examples of the kind of artist who can really treat a woman as a colleague.

— *Hannah Höch, in an interview with Edouard Roditi, 1959*

Lenin dies in Moscow.
Hitler, sentenced to five years' imprisonment, is released after eight months.
Dawes Plan adopted, reducing German reparations and calling for Allied withdrawal from the Ruhr.
André Breton publishes *Surrealist Manifesto*.
Bauhaus closes in Weimar.

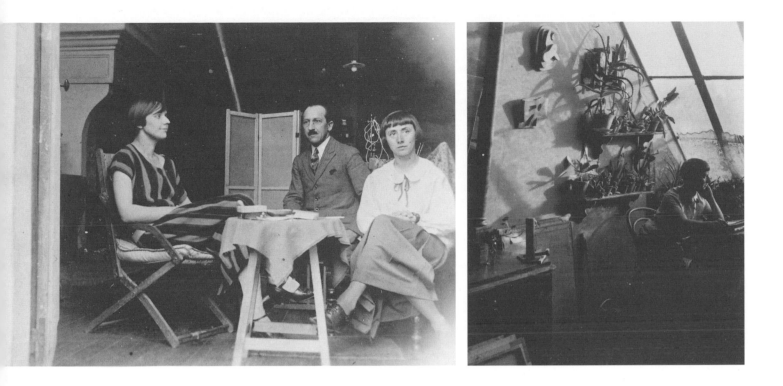

8. Nelly van Doesburg, Piet Mondrian, and Höch in Theo and Nelly van Doesburg's Clamart studio, 1924. **9.** Höch's Büsingstraße studio, Berlin-Friedenau, c. 1925.

Hindenburg, leader of German armed forces in WWI, elected president.
Hitler publishes *Mein Kampf.*
Nazi SS (Schutzstaffel) Black Shirts formed.
Treaty of Locarno establishes western border of Germany; British withdraw from Cologne.
Bauhaus reopens in Dessau.
First Surrealist exhibition in Paris.
Eisenstein's *Battleship Potemkin* screened in Moscow.

Film (*Painting, Photography, Film*), along with a photographic self portrait. She again publishes embroidery designs in *Die Dame*.[49]

Travels in July to London, the Isle of Wight, and Belle Isle, off the coast of Brittany, where she meets the van Doesburgs at their summer residence. Upon returning to Paris for a few days she visits the *Exposition internationale des arts décoratifs et industriels modernes*, the largest exhibition of applied arts, industrial design, and architecture since before World War I, where she is especially interested in the textile division. Expands her connections with artists and architects from Italy and the Soviet Union and makes the acquaintance of Jane Heap, editor of New York's avant-garde literary and arts magazine *The Little Review,* who displays works by Höch, on loan from Tzara, in the Little Review Galleries in New York.[50]

Makes paintings based on principles of photomontage, including *Roma* (*Rome*, 1925), *Journalisten* (*Journalists*, 1925), and *Die Braut* (*The Bride*, 1927) (pages 13–14). The first two are exhibited in June in the annual exhibition of the Novembergruppe in Berlin; Mies van der Rohe, current chairman of the group, recommends that the city buy Höch's pictures in an effort to attain municipal support for its artist members, but the reigning official on the city committee, the artist Hans Baluschek, declines to purchase them.[51]

With Kurt Schwitters, begins plans for an "anti-Revue" entitled *Schlechter und besser* (*Worse and Better*), a Merz performance parodying the extravagant and popular revues of the 1910s and 1920s. Schwitters plans to direct the piece and create the story, while Höch is slated to design the sets and costumes, and Hans Heinz Stuckenschmidt, a composer associated with the Novembergruppe, is enlisted to compose the music. While the plans are never realized, Höch does design several stage sets and costumes, including those for the characters Mr. and Mrs. Warm Oven and a girl whose head emits smoke.[52]

1926

Publishes a woodcut as illustration to Ernest Hemingway's "Banal Story" in the Spring–Summer issue of *The Little Review*.

Spends a few weeks during July with the Schwitterses in Kijkduin, near Schevenigen, the Netherlands, at the home of the Hungarian painter Lajos d'Ebneth and his wife, Nell. Evening get-togethers are attended by many painters, writers, and architects, including van Eesteren, Huszár, Ida Bienert, Siegfried and Carola Giedion, J. J. P. Oud, and Gerrit Rietveld. During the days, Höch, Schwitters, and d'Ebneth create small reliefs and sculptures from the drift-wood and detritus on the beach. Two of these by Schwitters, *Die breite Schmurchel* (*The Wide Schmurchel*, 1923) and *Kathedrale* (*Cathedral*, 1926), become part of Höch's extensive collection of art (now in the collection of the Neue Nationalgalerie in Berlin).[53] Takes day trips throughout the Netherlands with Schwitters, including a visit to the Ethnographic Museum in Leiden.

During her stay at the home of d'Ebneth, meets the poet Til Brugman, the Dutch contact for Schwitters's *Merz* periodical and author of poems, grotesques, and prose pieces for *Merz* and *De Stijl*. The two women travel to Paris and Grenoble in late July and August. Höch rents out her studio and apartment in Berlin and quits her job at Ullstein, and by October moves to The Hague to live with Brugman, whose apartment is designed by Huszár with De Stijl furniture by Rietveld. Höch receives financial support from the Novembergruppe, which has extra funds available for artists in need.[54]

1927

Travels with Brugman throughout Belgium in April and, to recuperate from a summer illness, to Italy and Switzerland during August. During this latter trip, she probably visits the spa at Monte Verita, a famed artists' retreat near Ascona, on the Italian-Swiss border, owned by the German financier and collector Eduard van der Heydt, whose renowned collection of ethnographic art is partially installed in the hotel corridors.[55] Returns to the Netherlands via Paris in early September.

1928

Joins a film league in the Netherlands, a forerunner of the International League for Independent Film, that screens avant-garde and controversial films (which she attends with Brugman) and opposes film censorship. Exhibits paintings at the Stedelijk Museum in Amsterdam in March and November with the Dutch artists' group "De Onafhankelijken" (The Independents) and contributes to their exhibitions of Dutch and foreign contemporary art in 1929.

Travels with Brugman in the summer to Norway and is so impressed by the Nordic country that she recommends it to Schwitters, who visits there in 1929 and makes it his residence in exile from 1937 to 1940.[56]

1929

Receives her first one-person exhibition, organized by the architect Jan Buijs, at the Kunstzaal De Bron in The Hague, which consists of approximately fifty paintings, watercolors, and drawings but no photomontages. Höch publishes her artistic credo in the catalogue, which calls for the effacement of all boundaries between styles and artistic points of view, between the real and the fantastic, between the admissable and the inadmissible in art.

Exhibits in the mammoth international *Film und Foto* exhibition in Stuttgart, organized by the Württemberg office of the German Werkbund, which highlights the latest innovations by 191 artists in film, photography, photomontage, and commercial photography and which travels internationally to several cities through 1931. Höch is represented with at least eighteen photomontages (the first she has shown since the 1920 Dada Fair), including *Die Kokette I* (*The Coquette I*, 1923–1925) (pl. 26) and *Russische Tänzerin (Mein Double)* (*Russian Dancer [My Double]*, 1928) (pl. 40). In one review her work is singled out, along with that of

I would like to do away with the firm boundaries that we human beings so self-assuredly are inclined to erect around everything that is accessible to us....Most of all I would like to depict the world as a bee sees it, then tomorrow as the moon sees it, and then, as many other creatures may see it. I am, however, a human being, and can use my fantasy, bound as I am, as a bridge.

— Hannah Höch, foreword to the catalogue for her solo exhibition at the Kunstzaal De Bron, The Hague, 1929

Germany admitted to League of Nations.
Hitler Youth founded.
Invention of the permanent wave.

End of Allied control of Germany.
Trotsky expelled from Communist Party.
Execution of Sacco and Vanzetti in U.S.
Al Jolson stars in *The Jazz Singer*.

Chiang Kai-shek elected
President of China.
D. H. Lawrence publishes
Lady Chatterly's Lover.
Falconetti stars in Carl Dreyer's
The Passion of Joan of Arc.

"Black Friday" Wall Street crash
touches off worldwide economic crisis.
Erich Maria Remarque's *All Quiet on the Western Front* is best-seller in Germany.
August Sander publishes his
compendium of photo portraits,
The Face of Our Time.
Brecht and Weill's *Threepenny Opera* produced.
Graf Zeppelin airship flies around
the world.
"Talkies" bring an end to silent film era.
Museum of Modern Art opens
in New York.

10. Card announcing Höch's return to Berlin with Til Brugman, 1929. **11.** Höch and Brugman, c. 1930.

Moholy-Nagy and Man Ray, as being especially noteworthy.[57] Franz Roh and Jan Tschichold publish her photomontage *Von Oben* (*From Above*, 1926–1927) (pl. 38) in their book *foto-auge* (*photo-eye*), one of the catalogues to come out of the exhibition. After seeing her work at the Berlin venue of the exhibition, Josef Albers, instructor at the Bauhaus in Dessau, asks to exchange one of his glass paintings for one of her photomontages.

Moves with Brugman on November 1 back to her Büsingstraße apartment in Berlin. Höch feels increasingly distanced from the Berlin art scene and hopes for renewed contact with colleagues and greater opportunities for work and commissions.

1930
Höch's mother dies on April 10.

Reconnects with many of her friends and colleagues in Berlin, including Mynona, Adolf Behne, and Georg Muche and his wife, who take French lessons from Brugman.

1931
Reinitiates a friendship with Raoul Hausmann, who has since turned to photography as his primary artistic medium. Theo van Doesburg dies of a heart attack on March 7, at the age of forty-seven, in Davos, Switzerland.

Participates in April and May in the exhibition *Fotomontage*, at the former Applied Art Museum in Berlin, with works from the Love and Ethnographic Museum series. Two untitled works from the latter series are purchased by Baron von der Heydt, presumably because they employ reproductions of sculptural objects from his own extensive collection of ethnographic art.

Participates in October in the international exhibition *Frauen in Not* (*Women in Distress*), at the Haus der Juryfreien in Berlin, with works on the subject of women and children. The exhibition is connected with controversies over Article 218 of the constitutional code, which has imposed strict laws against abortion.

Joins the Reichsverband bildender Künstler Deutschlands (National Federation of Visual Artists of Germany)[58] and the Deutsche Liga für unabhängigen Film Ortsgruppe Berlin (German League for Independent Film, Berlin Division).

Nazi Wilhelm Frick, Minister of Education in Thuringia, issues "Ordinance against Negro Culture."
National Socialist party becomes second largest party in Reichstag.

Five million unemployed in Germany.
Dresdener Bank collapses, leading to month-long government closure of all German banks.
'Harzburg Front' against Bolshevism unites National Socialists with leading financiers.
Empire State Building is completed in New York City.
Charlie Chaplin stars in *City Lights*.
Hattie Carraway (D-Ark.) first woman elected to U.S. Senate.

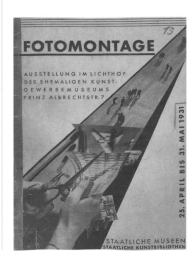

1932

Early in the year, a break-in occurs in Höch and Brugman's apartment in the Büsingstraße, which letters from friends suggest may be politically motivated.[59] Problems apparently begin to arise in the relationship between Höch and Brugman.[60]

Exhibition of forty photomontages and watercolors by Höch, planned for May 29 to June 10 at the Bauhaus in Dessau, is canceled when the Nazis close the school. Exhibits photomontages from the Love and Ethnographic Museum series in an international exhibition of photography in July at the Palais des Beaux-Arts in Brussels.

Writes comments on film censorship, which she characterizes as an attack against the basic human rights of freedom and creativity, in response to questions posed to her through the mail by the Czech magazine editor František Kalivoda.[61] These appear in the November issue of Kalivoda's *Index*, a periodical devoted to film and culture published in Brno, Czechoslovakia.

Creates first book covers for "Dreigroschenromane," or three-penny novels, published by the Antony Bakels publishing house in Berlin. Financial hardships force Höch to take on such assignments, which she continues into the 1940s.

1933

Moves with Brugman to a new apartment in the Friedenau district of Berlin, at Rubensstraße 66. Receives a letter on April 28 from the Künstler-Läden, an artist's cooperative in Berlin, asking her to affirm her support for National Socialism and to deny that she is of Jewish descent. Höch writes "nein" on the letter and promptly resigns from the organization that had been selling her works on commission since 1932. All works loaned to the shop are returned to Höch.

Exhibits eight photomontages at the *Deuxième exposition internationale de la photographie et du cinéma* in Brussels in June and July.

Travels to the Netherlands with Brugman from July to September (perhaps, as letters from friends intimate, to flee Germany for Holland or Paris) but returns to Berlin at the beginning of October. Their return after three months seems to surprise friends such as Thomas Ring and Otto Nebel.[62] Paints *Wilder Aufbruch* (*Savage Outbreak*) (page 17) in response to the seizure of power by Hitler and the National Socialists, wishing to illustrate the rupture that is occurring between the "Welteroberungswahn" (madness of world conquest) of men and the sorrowful resignation of women.[63]

1934

Exhibition of forty-two photomontages at the Masaryk student residence in Brno, Czechoslovakia, from late February to early March. Kalivoda, who organizes the exhibition, again asks Höch to submit an article on film censorship, this time for his literary journal *Středisko*. Claiming unfamiliarity with the present film scene, Höch submits instead an article on photomontage, which appears in the April issue of the magazine.[64]

Travels again with Brugman to the Netherlands in April, but the two return to Berlin in early May. A month later, Höch becomes very sick with Graves' disease, a serious inflammation of the thyroid gland. She has the goiter removed in an operation and remains in the hospital through July. While recovering from her operation, agrees to act as a consultant to Kalivoda's new magazine, *Ekran* (Screen), a periodical devoted to the latest international achievements in film, photography, and painting. Kalivoda's plans to produce a special issue devoted to Höch's work in all media and a corresponding exhibition do not materialize.[65] Convalesces at the mountain spa in Johannisbad in October.

1935

Creates the illustrations for *Scheingehacktes* (*Mock Mincemeat*), Brugman's first German-language book of grotesques.

The peculiar characteristics of photography and its approaches have opened up a new and immensely fantastic field for a creative human being: a new, magical territory for the discovery of which freedom is the first prerequisite. But not lack of discipline, however.

— Hannah Höch, "A Few Words on Photomontage," 1934

Nazi-dominated Dessau City Council closes Bauhaus.
Hindenburg wins German presidential elections; Hitler is second.
Nazi party gains largest representation in Reichstag; Hitler demands to be named chancellor but is rebuffed.
Franklin Roosevelt coins phrase "New Deal"; wins U.S. presidential election in landslide victory.
Greta Garbo stars in *Grand Hotel*.

Hindenburg names Hitler chancellor.
Reichstag building destroyed in fire; Hitler blames Communists, outlaws German Communist Party.
Exodus of German artists and intellectuals begins; will reach 60,000 by 1939.
Dachau concentration camp opens; boycott of Jewish businesses initiated.
Roosevelt launches New Deal, including National Industrial Recovery Act, Public Works Administration, and Tennessee Valley Authority.
Prohibition repealed in U.S.
U.S. recognizes U.S.S.R. and re-establishes trade relations.
Japan withdraws from League of Nations.

Hindenburg dies; Hitler named Führer.
Stalin begins purges of Communist Party in U.S.S.R., resulting in deaths of millions.
Socialist Realism declared only acceptable art form in U.S.S.R.
Three-year "Dust Bowl" drought begins in American midwest.

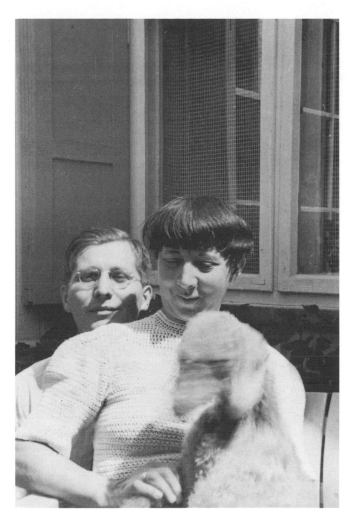

12. Höch and Heinz Kurt Matthies, 1940.

During a hiking trip in the Dolomite Alps, meets Heinz Kurt Matthies, a businessman, mountain climber, and amateur pianist twenty one years younger than she. An active correspondence ensues, and near the end of the year Höch breaks off her nine-year relationship with Brugman, which she will later describe as some of the most enjoyable years of her life.[66]

Last exhibition of Höch's work until after World War II is held at the Galerie d'Audretsch in The Hague. She shows watercolors and photomontages, partly because these works can be transported more easily and safely than paintings.

1937
From June to November, takes a long road trip through southern Germany with Matthies in his trailer and produces many naturalistic watercolors of flowers and landscapes along the way, which she tries to sell in Erfurth. Several events mar the vacation, including an accident involving a small child and what Höch describes as a small heart attack she experiences outside of Mainz in June. On the road to Bayreuth and Nuremberg in November, Höch and Matthies engage in heated arguments, which temporarily cause them to separate.[67]

On September 11 and 16, visits the *Entartete Kunst* (*Degenerate Art*) exhibition in Munich, the mammoth showcase of 730 works considered degenerate by Hitler and the National Socialists. In Wolfgang Willrich's book *Die Säuberung des Kunsttempels* (*The Cleansing of the Temple of Art*), an inflammatory tract devoted to the artistic and cultural enemies of the Third Reich, Höch is identified as an affiliate of the "Bolshevist" Novembergruppe and signatory of the 1921 "Open Letter"; her painting *Journalists* is reproduced in a montage of artists associated with the organization.

The most important works of the post-World War I period are represented here. All museums and public collections are represented here. After the public outcry, it is astonishing how well-behaved the public is. Many faces are closed and also quite a lot of opposition can be detected. Scarcely a word is spoken.

— Hannah Höch on the "Degenerate Art" exhibition, journal entry from September 11, 1937

Takes eleven of her art works in December to the "Luftfahrtminis-terium," the ministry of civil aviation in Berlin.[68] It is possible that Höch has received a commission to provide artworks for this building, which is completed around this time, since the Nazi regime stipulates that a certain percentage of construction costs for public buildings be used for art.[69]

1938

Matthies is hospitalized from January through April after a nervous breakdown and possible suicide attempt, and Höch sacrifices much of her time and energy helping him recuperate.[70] She rents out the room he has occupied in her apartment since Brugman's departure in early 1936 and continues to produce book jackets for the Antony Bakels publishing house in order to pay off the debts from her 1934 thyroid operation. Ultimately, the couple marries on September 16.

Visits the *Entartete Kunst* exhibition for a third time in March in its Berlin installation, and for the fourth time in November, when she travels with Matthies to Hamburg (where she feels the exhibi-tion is better installed and includes more distinguished works). This trip is the first that Höch and Matthies take with their new furnished trailer. Höch loves the freedom and comfort of this life on the road with Matthies, as suggested by several paintings from this year, including *Paradies* (*Paradise*) and *Die Freiheit* (*Freedom*).

Becomes aware of the pogroms against Jews in Germany. In her journal, she writes of the burning of the synagogues on November 11 and of the plight of many of her Jewish friends, including the composer Walter Hirschberg, who was interned in a concentration camp and then forced to flee Germany. Her fear of the Nazis escalates during this period, and she appears to tear many pages from her private journals.

1939

Spends much of the year traveling throughout Germany and the Netherlands in the trailer with Matthies, who has been selling welding materials during the Nazi period and thus appears to be less restricted than most in his travels. The couple visits many friends, including Jan Buijs in the Netherlands, and Willi Baumeister, Hans Hildebrandt, and Til Brugman in Germany. They return to Berlin in late August, just before the outbreak of World War II on September 1.

Purchases a small home (a former guardhouse at the entrance to an airfield from World War I) in Heiligensee, a town on the northwest outskirts of Berlin. Later, she will recall how she moved her "very questionable" possessions here, thereby saving them from probable destruction in an air raid.[71] Spends many days here clipping photographs from periodicals for her photomontage files.[72]

1940

Continues to travel throughout Germany with Matthies during the summer, and in August and September travels to Italy. Maintains little contact with friends and colleagues, many of whom have gone into exile. Outside of her family, the Behnes and the Rings are the primary friends with whom she has contact during the war years.

1941

Produces two series of watercolors: Notzeit (Time of Suffering), probably begun in this year and completed over the next few years, and Totentanz (Dance of Death), completed in 1943.

1942

Applies to the Reichskammer der bildende Kunst (National Agency for Visual Art) in February for painting materials, which she receives.[73] On the application, Höch specifies that she is a member of the NSV, the Nationalsozialistische Volkswohlfahrt, an organization that administers officially approved charitable activi-ties. It has been suggested that dissenters of the Nazi regime often used membership in the NSV to protect themselves.[74]

Jammer! KRIEG!!! Jammer!
(Misery! WAR!!! Misery!)

— *Hannah Höch, journal entry from*
August 31 to September 2, 1939

Germany invades Austria; Germany and France mobilize armed forces; British issue gas masks to civilians.
Munich Agreement cedes Czechoslovak Sudetenland to Germany.
Leading figures in British government resign in protest to Prime Minister Neville Chamberlain's policy of appeasement toward Germany.
Anti-Jewish "Kristallnacht" pogroms in Germany.
Orson Welles's "War of the Worlds" radio broadcast causes panic in U.S.

Spanish Civil War, begun in 1936, comes to close as major powers recognize Franco government.
Stalin and Hitler sign non-aggression pact, opening door for mutual invasion of Poland.
Germany invades Poland; England and France declare war on Germany; U.S.S.R. invades Poland from east.
James Joyce publishes *Finnegan's Wake*.
Vivian Leigh stars in *Gone With the Wind*.

Germany invades Denmark and Norway, then Holland, Belgium, Luxembourg and France.
Winston Churchill succeeds Chamberlain as British prime minister.

Germany invades Russia; Japanese bomb Pearl Harbor; U.S. enters World War II.

German siege of Stalingrad begins.
British and American forces drive back Germans in North Africa.
Systematic gassing of Jews in concentration camps begun by Germans.
U.S. interns more than 100,000 Japanese-Americans in camps.

Separates in early November from Matthies, who leaves her for the violinist Nell d'Ebneth, her Dutch friend. Matthies and d'Ebneth plan to travel throughout Europe playing chamber music together. Höch is distraught by this sudden departure and retreats even more deeply into her solitary existence.

1944

2,000 tons of bombs dropped on Berlin.
Allies invade Normandy, liberate Paris, and push past German border.
First V-1 and V-2 rockets dropped on London.
Assassination attempt on Hitler by German officers fails.

As the struggle for survival wages on in war-torn Berlin, Höch resorts to raising chickens in a coop in her backyard and continues to grow crops in her vegetable garden to supplement the meager war rations. Shortages of electricity and water and lack of provisions continue to escalate until the end of the war. Höch, however, continues to receive newspapers and to listen in the evenings to the news on Radio London.

The divorce from Matthies is made official in November.

1945

Franklin Roosevelt dies and is succeeded as U.S. president by Harry S. Truman.
Russians enter Berlin; Hitler commits suicide.
Germany capitulates to Allies and is divided into four sectors controlled by Britain, France, U.S., and U.S.S.R.
Japan surrenders after U.S. drops atomic bombs on Hiroshima and Nagasaki.

Experiences the final battle for Berlin. Writes extensively in her journal about the arrival of the Russian army in Heiligensee beginning on April 22. While the Russians occupy many of the houses in the neighborhood and pay many "visits" to the female residents (an allusion to the widespread rape of German women by occupying troops), Höch maintains that she has not been harmed by the Russians and that all they have taken are a flashlight and some garden hoses. At one point, she buries some of her Dada art works in trunks underneath her garden to hide them from the Russians.[75]

Shows her works for the first time since before the war in a December exhibition devoted to artists living in Reinickendorf (the northern Berlin district that oversees the village of Heiligensee). The show is organized by the Kulturbund zur demokratischen Erneuerung Deutschlands (Cultural Federation for the Democratic Renewal of Germany), a pro-Soviet organization founded in July 1945 to promote local and regional artists which is prohibited in November 1947 because of its Communist tendencies.[76]

1946

Churchill gives "Iron Curtain" speech in Fulton, Missouri.
Goering and eleven others sentenced to death by Nuremberg Tribunal; Goering commits suicide.

Participates as one of five artists associated with so-called postwar Berlin Surrealism in the exhibition *Fantasten-Ausstellung* at the Galerie Gerd Rosen, the first private gallery to open in Berlin after the war and one of the leading representatives of abstract and surrealist art in Germany. Höch's catalogue essay, entitled "Fantastic Art," addresses the imperfection of images of the visible world and advocates entering the purer realm of the supra-real, the fantastic, and the intangible.[77]

After the editors of *Ulenspiegel* see her watercolors in an exhibition in Steglitz,[78] Höch begins to publish works in this left-wing, anti-fascist journal of literature, art, and satire, similar to the prewar Munich journal *Simplicissimus*. Founded in 1945 by the graphic artist Herbert Sandberg and the writer Günther Weisenborn, the journal is soon sanctioned by the Allies for its pro-Communist tendencies but continues publication in the Eastern Zone until 1948.[79] Höch's first contribution, to the June 1946 issue, is the photomontage *Siebenmeilenstiefel* (*Seven-League Boots*, 1934) (pl. 71); she continues to publish photomontages and watercolors in the journal throughout 1947 and into 1948.

Renews contact with friends and colleagues, including Kurt Schwitters, now living in England, with whom Höch has not been in touch since before the war. Joins the Schutzverband bildender Künstler (Protective League for Visual Artists), an organization founded in 1945 to support artists through exhibitions, stipends, and supplies; exhibits with the group in November 1946 in Leipzig and continues to attend its meetings through 1948.

Organizes the exhibition *Fotomontage von Dada bis heute* (*Photomontage from Dada to Today*) in December at the Galerie Gerd Rosen, which features photomontages by Höch, Hausmann, and Juro Kubicek, as well as two of Höch's illustrations for *Ulenspiegel* and a catalogue essay on photomontage, similar to the one she had written for the 1934 Brno exhibition.

I don't have any illusions and I know that many awful things will now happen to me, and yet, this basic feeling of peace is there, and is unspeakably wonderful.

— *Hannah Hoch, journal entry, May 1, 1945*

It was in the first frigid winter of hunger when absolute chaos still reigned. There was absolutely no echo for this sort of thing and only a few people saw this small show in its temporarily installed rooms.

— *Hannah Höch on the reception of her exhibition "Photomontage from Dada to Today," in a letter to Raoul Hausmann, March 1950*

1947

Sends watercolors to the Freunde der bildenden Kunst (Friends of Fine Art), a Berlin organization that sells artists' works on commission. The group has no exhibition space but plans to send her works to Munich and Karlsruhe for greater exposure; they ask specifically for works with flower themes.[80] Later in the year, exhibits eight fantastic watercolors in *Maler sehen die Frau* (*Painters View the Woman*), an exhibition of women artists sponsored by the women's group of Berlin-Zehlendorf.

Receives a ration card from the Volkskunstamt (People's Office for Art) in Reinickendorf. The "Lebensmittelkarte 1" is the same type of support received by the manual laborers and construction workers rebuilding the city of Berlin and its infrastructure. This testifies to the importance the Occupation forces accord Berlin artists.[81]

1948

Officially takes back her maiden name and drops that of Matthies.

Kurt Schwitters dies in England on January 8; Adolf Behne dies of tuberculosis in Berlin on August 22. Develops friendships with several other Berlin artists, including Heinz Fuchs and Ernst Fritsch, two professors at the newly reorganized Hochschule für bildende Kunst (College of Fine Arts) in Berlin.

Contributes throughout the year to the art exhibition and education programs of the Reinickendorf Kunstamt (Office for Art), delivering lectures at various sites in her district on topics such as "Woman and Art" and "On Regarding an Artwork without Bias: Why? How? For What Purpose?" Continues to exhibit primarily naturalistic paintings and watercolors in local exhibitions but is represented with three pre–World War II photomontages—*Resignation* (c. 1930) (pl. 69), *Liebe im Busch* (*Love in the Bush*, 1925) (pl. 30), and an untitled work from 1919—in an exhibition of collage at the Museum of Modern Art, New York.

1949

Drops out of the Schutzverband because, due to the currency reform, she can't afford the annual fee.[82] She may also be influenced by circulating letters that condemn the organization for becoming too Communist.[83]

First major exhibition after the war, *Hannah Höch und Dada*, at the left-wing Galerie Franz in Berlin.[84] The exhibition includes nineteen paintings by Höch; a number of her watercolors, drawings, and photomontages; and works by Arp, Freundlich, Hausmann, and Schwitters. Richard Huelsenbeck and J. J. P. Oud send letters of congratulations.

1950

Becomes a founding member of the Berufsverband bildender Künstler Berlins (Professional Association of Visual Artists in Berlin), an organization devoted to the unbiased, party-free representation of artists.[85] Participates with two watercolors in a memorial exhibition on the occasion of the thirtieth anniversary of the founding of the Novembergruppe.[86]

1951

One of twenty-two original members invited by Walter Wellenstein to become part of Der RING bildender Künstler Deutschlands (The RING of Visual Artists of Germany), an organization devoted to jury-free exhibitions, democratic selection processes, and support of artist members; contributes to their first exhibition at the Haus am Waldsee. Receives financial awards from the Berufsverband and the Berliner Notstandsaktion (Berlin Emergency Action), which favor artists who paint scenes of Berlin.[87]

Visits an exhibition at the Haus am Waldsee of works by Max Ernst, whom she considers her closest artistic compatriot.

Scratches her cornea in an accident in a friend's garden. The severe eye problems that result will hinder her reading and art-making into 1952.[88]

Through all phases of development, he [Ernst] has been my closest relative. It began with Dada.

— Hannah Höch, journal entry, December 1951

U.S. Secretary of State George Marshall calls for European Recovery Program (Marshall Plan).
Dead Sea Scrolls discovered in Palestine.
U.S. "G.I. Bill of Rights" allows more than one million war veterans to enroll in colleges.

U.S.S.R. initiates ground blockade of West Berlin; Allies airlift supplies to beleaguered city.
Israel founded, with David Ben-Gurion as Prime Minister.
Mahatma Gandhi assassinated in India.
Jackson Pollock paints first drip paintings.

Germany officially divided into German Federal Republic (West Germany) and German Democratic Republic (East Germany); Berlin Blockade lifted.
U.S.S.R. develops atomic bomb.
NATO founded.
Communist People's Republic of China established; Republic of China established on Formosa.

North Korean forces invade South Korea; U.N. forces and Chinese enter conflict.
U.S. Senator Joseph McCarthy claims State Department riddled with Communists and sympathizers.

Douglas MacArthur relieved of command in Korea by Truman.
British spies Burgess and MacLean escape to U.S.S.R.
Julius and Ethel Rosenberg sentenced to death in U.S. for espionage.

1952

An active participant in Berlin cultural life, she sees exhibitions of Georg Muche and Alexander Calder at Galerie Springer, also known as the Maison de France; attends lectures at the Haus am Waldsee, including one on De Chirico and Dali; and goes to readings by her friend the writer Karl Friedrich Borée at the Maison de France.[89]

Exhibits two paintings in *Eisen und Stahl* (*Iron and Steel*), a Düsseldorf exhibition that deals with technological imagery since the Middle Ages.

Through correspondence from Hannah Kosnick-Kloss-Freundlich, the widow of Otto Freundlich, learns that Nelly van Doesburg and Til Brugman are currently living in Paris, and that Otto Freundlich died in a concentration camp in 1938.

1953

Receives financial support from the Reinickendorf Bureau for Art. Since work must be shown periodically in local exhibitions, Höch promises that she will undertake a series of Reinickendorf landscapes in watercolor.[90] Contracts hepatitis and works very little during the spring months.

Exhibits five works in the exhibition *Dada 1916–1923* at the Sidney Janis Gallery in New York. Begins to show her paintings in the annual jury-free art exhibitions in the exhibit halls of the Berlin radio tower, to which she submits through 1955 and again in the early 1960s.

Renews her correspondence with Hans Arp, who lives in Meudon, outside of Paris. Höch is very enthusiastic about his poems, which she has read in the journal *Die literarische Welt* (The Literary World), as well as poems by Richard Huelsenbeck, the "New York Cantatas."[91]

1954

Regularly reads the literary journals *Merkur* (Mercury) and *Der Monat* (The Month).[92] Begins to receive a small monthly pension from the Hauptkunstamt (Main Bureau for Art) in Berlin on the occasion of her sixty-fifth birthday, for which Hans Arp has written a letter of recommendation.[93]

Richard Huelsenbeck offers to purchase several of the Dada works in Höch's collection, including some of her own and Hausmann's early pieces. Höch is unwilling to sell any of the collection at this time, despite the fact that she had given away several works immediately after the war to safeguard them from enemy hands.[94]

1955

Travels with her brother Walter and his family to Essen, Duisberg, and Cologne, where she visits family, friends (such as Georg Muche), and museums; shows her photomontages and watercolors to the curators at the Folkwang Museum in Essen and the museum in Duisberg.[95]

1956

Travels for first time by airplane to the large Schwitters retrospective in Hanover, accompanied by gallery director Rudolf Springer and his wife. Renews contact with many artists and meets dealers, art historians, and museum professionals, including Werner Schmalenbach, Carola Giedion-Welcker, and Hans Bolliger, who will begin to sell Höch's work through his Swiss gallery, Kornfeld und Klipstein. Later that fall, she travels to his gallery in Bern to see an exhibition that contains some of her works; while there she attends exhibitions of the work of Paul Klee, Egon Schiele, and Marc Chagall and visits the artists Otto Nebel and Gertrud Koref-Stemmler.

Exhibits a small number of photomontages in a collage exhibition at the Rose Fried Gallery in New York. Fried gives one work, *Auf Tüllgrund (On a Tulle Net Ground,* 1921) (pl. 14) to the Busch-Reisinger Museum in Boston, and in 1963, three more to the Museum of Modern Art in New York.[96]

U.S. detonates first hydrogen bomb. After his release from prison, Malcolm X joins U.S. Black Muslim leader Elijah Mohammed. Willem de Kooning paints *Woman I.*

Death of Stalin. Rosenbergs executed. Korean armistice signed, bringing the war to an end.

Four Powers Conference on German reunification fails. French forces in Vietnam defeated at Dien Bien Phu.

U.S.S.R. ends state of war with West Germany; West Germany joins NATO. Bus boycott by blacks in Montgomery, Alabama.

Soviet troops enter Hungary and crush popular rebellion. Communist Party banned in West Germany. War breaks out between Israel and Egypt; Egypt wrests control of Suez Canal from England and France. Fidel Castro launches Cuban Revolution.

Slowly intellectual life is returning to this so-long-godforsaken Berlin.

— *Hannah Höch, letter to Hans Arp, October 3, 1953*

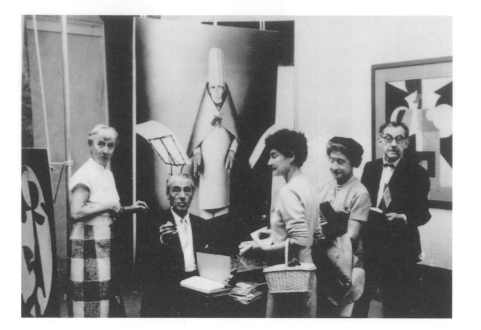

13. (left to right) Hannah Höch, Hans Richter, Juliet Man Ray, Frida Richter, and Man Ray at the exhibition *Dada: Documents of a Movement*, Düsseldorf, 1958.

Exhibits in the *Große Berliner Kunstausstellung* for the first time since the early 1930s, participating as a member of the RING. She will continue through the 1950s to show in this annual exhibition, exclusively with paintings and watercolors.

1957

Solo exhibition at the Galerie Gerd Rosen with twenty-six collages and photomontages from the 1950s.

Begins to show with the Deutscher Künstlerbund (German Artists' League), an umbrella organization that attempts to showcase Germany on the international art scene.[97] She will become a member in August 1959 and submit works (paintings and drawings only) to this juried exhibition through the 1960s.[98]

Takes a great interest in the October launching of Sputnik, the first space capsule sent into orbit around the earth. Cuts out and collects many articles and images about this watershed event, many from the newspaper *BZ am Abend*. This marks the beginning of her avid interest in space exploration during the late 1950s and 1960s, which she will often write about in her journals.[99]

1958

Writes her "Lebensüberblick" (Life Overview), an autobiographical text requested by Richard Huelsenbeck for his forthcoming book on Dada. The request comes only after Höch has complained of her omission from his earlier Dada account, *Mit Witz, Licht und Grütze* (1957).[100]

Til Brugman dies in Gouda, the Netherlands, on July 24; Hoch's brother Walter dies from cancer in Essen on November 25.

Exhibits approximately twenty Dada works, including watercolors, collages, and photomontages, in the first large retrospective of Dada after the war, *Dada: Dokumente einer Bewegung* (*Dada: Documents of a Movement*), mounted at the Düsseldorf Kunstverein. Höch attends the opening of the exhibition on September 5, where she sees Man Ray, Hans Richter, Werner Graeff, and Dr. Ewald Rathke, the curator of the exhibition. Publishes an account of one of her trips with Schwitters in the catalogue.[101]

1959

Her exhibition of thirty-five photomontages from 1956 to 1959 at the Galerie Rosen is well received by the German press, with one reviewer praising the subtle irony that has come to replace the socio-critical aggressivity of the Dada period in her work.[102]

I have always tried to exploit the photograph. I use it like color, or as the poet uses the word.

— *Hannah Höch, letter to Walter Mehring, April 1959*

First steps toward European Common Market taken in Italy.
Soviet satellite Sputnik launched, inaugurating the Space Age.
Eisenhower sends U.S. paratroopers to Little Rock, Arkansas, to ensure desegregation of public schools.

European Common Market established.
De Gaulle elected president of France.
Robert Rauschenberg exhibition inaugurates Castelli Gallery, New York.

Castro assumes power in Cuba.
George Grosz dies shortly after returning to Germany.
Gunther Grass publishes *The Tin Drum*.

Subscribes to the photography-based magazines *Life* and *Magnum*.[103] Interview with Höch by the writer Edouard Roditi appears in *Der Monat*, in which she describes the formation of Berlin Dada as well as the general environment of modern art in the late 1910s and 1920s.[104] Although after its publication Höch will maintain that key comments about Richard Huelsenbeck's involvement in the formation of Dada were edited out, there is a public outcry from Huelsenbeck and others regarding Höch's misconstruction of Dada.[105] Höch attempts unsuccessfully to change the text before its planned republication in Roditi's *Dialogues on Art*.[106] These unpleasant exchanges will color her relationship to Huelsenbeck for the rest of her life.

Accompanies Rudolf Springer on a trip to Paris in late November and early December, where she visits César Domela Nieuwenhuis, Hans Arp and Marguerite Hagenbach-Arp, and Nelly van Doesburg but just misses the opening of the International Exposition of Surrealism at the Galerie Daniel Cordier, in which two of her paintings from the 1920s are exhibited.

1960

Hans Arp advises Höch to correct the still-festering problem with Richard Huelsenbeck concerning the Roditi interview of 1959 and agrees to purchase two of Höch's works from the early 1920s that she has offered to sell to him, *Huldigung an Arp* (*Hommage to Arp*, 1923) and *Schnurenbild* (*String Picture*, 1923–1924).[107]

Exhibition of the RING at the Haus am Waldsee includes a section devoted to Höch's works from Dada to the present, in honor of her seventieth birthday.

Begins to receive financial support (which will continue for the rest of her life) through the Deutsche Künstlerhilfe (German Artist's Aid), a fund financed through subsidies from the Federal Ministry and the broadcasting institutions.[108]

1961

Honored guest from January through early April at the Villa Massimo, an artist's retreat in Rome overseen by the Preußischer Kulturbesitz. Höch produces many drawings, some large woodcuts, and several poems and aphorisms which she inscribes on small pieces of paper. The final three weeks are spent at the Casa Boldi near Olevano, a retreat she visited first on her trip to Rome in 1920. In the train on the way home, a collapsible couchet bed falls on her head, which sends her to the hospital in Berlin. While there is no official skull fracture, she experiences pain and bouts of disorientation throughout the coming weeks.[109]

Her one-person retrospective exhibition at the Galerie Nierendorf in Berlin includes seven paintings, forty-five photomontages, and thirty-three watercolors. From this point on, Galerie Nierendorf becomes Höch's primary Berlin dealer and its directors, Florian and Inge Karsch, become lasting supporters and friends. The Nationalgalerie in Berlin purchases *Cut with the Kitchen Knife* for its permanent collection.

1962

As more books are published by former members of the Club Dada (including Huelsenbeck, Hausmann, and, later, Hans Richter), Höch is beset with requests to open up her extensive holdings of Dada memorabilia and materials for perusal. Hausmann, especially, berates Höch for what he considers her less than adequate curatorship of his works in her possession.[110]

1963

Retrospective exhibition of Höch's work, organized by Florian and Inge Karsch, opens at the Galleria del Levante in Milan with fifty-three photomontages, watercolors, and paintings from the period from 1916–1961.

Travels to Stuttgart to attend the opening of the Deutscher Künstlerbund exhibition, in which she has two paintings. Afterward, travels to Paris and Meudon, where she visits the Arps and Nelly van Doesburg.

Sidebar (chronology of world events):

American U-2 spy plane shot down over U.S.S.R.
Former Gestapo chief Adolf Eichmann arrested in Argentina and deported to Israel.
Neo-Nazi political groups banned in Germany.
Kennedy elected U.S. President.
"The Pill," oral contraceptive, becomes available in U.S.

Berlin Wall divides East and West Berlin.
Russian cosmonaut Yuri Gagarin orbits earth, becoming first man in space.
U.S.-backed "Bay of Pigs" invasion by anti-Castro Cubans fails.
U.N. Secretary General Dag Hammarskjöld dies in air crash.
Eichmann found guilty in Jerusalem trial and subsequently hanged.
"Freedom Riders" attacked by white mobs in Alabama.
First publication in U.S. of Henry Miller's previously banned 1942 *Tropic of Cancer*.

Cuban Missile Crisis poises U.S. and U.S.S.R. on verge of nuclear war.
Andy Warhol exhibits first Campbell's Soup-can paintings.
Marilyn Monroe commits suicide.

Ludwig Erhard succeeds Konrad Adenauer as West German chancellor.
Kennedy delivers "Ich bin ein Berliner" speech.
Kennedy assassinated in Dallas, Texas.
Betty Friedan publishes *The Feminine Mystique*.
Beatlemania sweeps Britain.

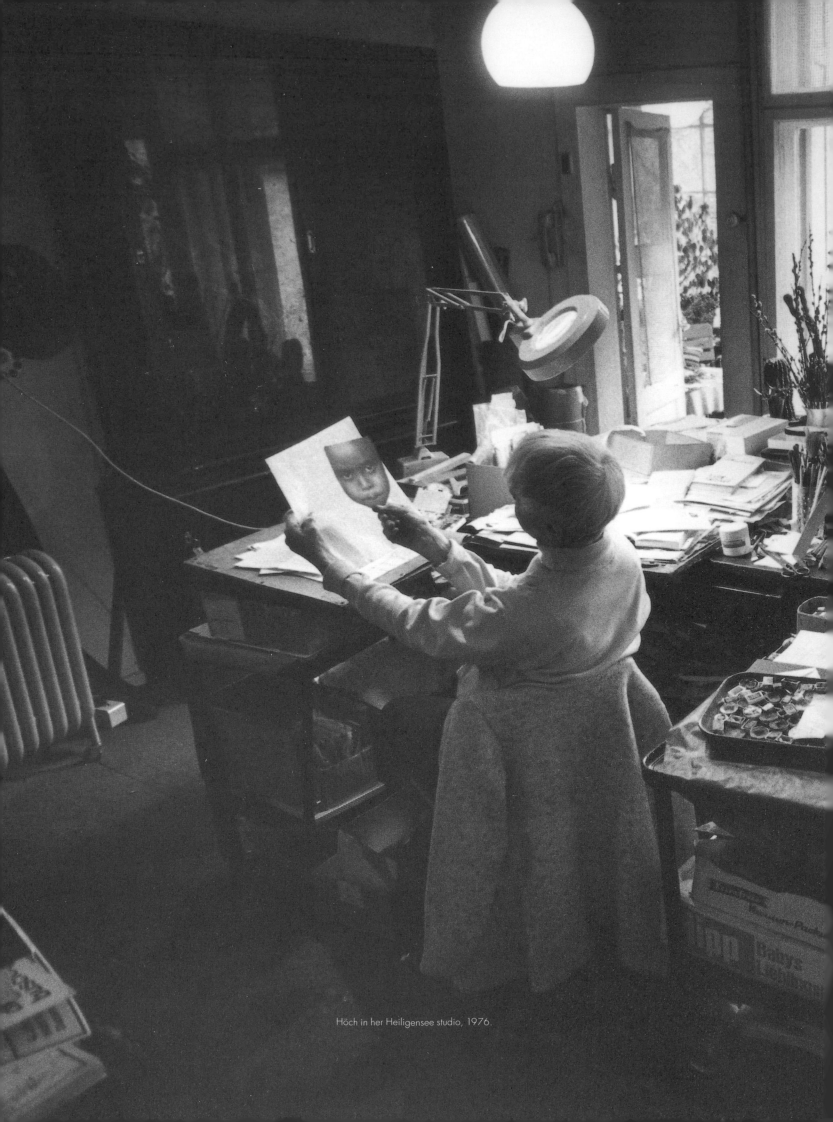
Höch in her Heiligensee studio, 1976.

1964

Visits the international art exhibition *Documenta III* in Kassel, West Germany.

Mies van der Rohe, who travels to Berlin from his home in Chicago to plan for his new building for the Neue Nationalgalerie, visits Höch in Heiligensee.

The largest and most comprehensive retrospective of Höch's work to date, in honor of her seventy-fifth birthday, opens in November at the Galerie Nierendorf in Berlin. The catalogue contains five original linoleum cuts from 1915–1917 which Höch reprints for this occasion.

1965

With Florian Karsch, visits exhibition in the Amerikahaus in Berlin of works by Robert Rauschenberg, which she calls "giant collages à la Dada." Participates with Karsch in a radio show about Hitler and the Arts on RIAS 1 (Radio in the American Sector), in which she discusses the 1938 *Entartete Kunst* exhibition.[111]

Elected on May 7 to the Akademie der Künste (Academy of the Arts) in West Berlin, an appointment she holds alongside such prominent Berlin artists as Karl Hartung, Heinz Trökes, and Hans Uhlmann.

1966

Delivers a lecture in Düsseldorf on her remembrances of the Dada period and Kurt Schwitters.

Is exposed to a wide variety of artists and cultural figures through the numerous activities she attends at the Akademie der Künste—most notably, exhibitions of the painters Rolf Nesch and Ernst Wilhelm Nay, whose original, hand-pulled prints she finds particularly beautiful; a lecture by Theodor Adorno on "Art and the Arts"; and a special eightieth-birthday celebration for the dancer Mary Wigman.[112]

Hans Arp dies in Basel on June 7.

Receives several artists associated with the international Fluxus movement in her home in Heiligensee, including Nam June Paik and Charlotte Moorman in July and Wolf Vostell, Dick and Alison Higgins, and Juan Hidalgo in October.[113]

Decides to return, at last, many of Raoul Hausmann's works to him, including *Mechanischer Kopf (Der Geist unserer Zeit)* (*Mechanical Head [The Spirit of our Time]*, 1919) and *Tatlin lebt zu Hause (Tatlin at Home*, 1920), after receiving several letters throughout the years in which he asserts ethical claims to all of his works in her possession.[114]

1967

Receives a financial award from the Theodor Heuss foundation, which grants her additional awards in 1968 and 1978.

1968

Participates in the exhibitions *Dada, Surrealism, and Their Heritage* at the Museum of Modern Art, New York, and *Realismus in der Malerei der 20er Jahre* (*Realism in the Painting of the 1920s*) at the Kunstverein, Hamburg. In the latter, she is resurrected as a Neue Sachlichkeit (New Objectivity) artist with four still-life paintings from the 1920s.

Heinz Ohff's book, *Hannah Höch*, the most comprehensive account to date of her life, friends, and work, appears as the first volume in the series Bildende Kunst in Berlin (Visual Art in Berlin).

1969

Included in two exhibitions that feature the connections between art and technology: *Art at the End of the Machine Age*, organized by the Museum of Modern Art, New York, and *Industrie und Technik in der deutschen Malerei: Von der Romantik bis zur Gegenwart* (*Industry and Technology in German Painting from Romanticism to the Present*) at the Wilhelm-Lehmbruch-Museum in Duisburg.

Woe, our good Kaspar is dead.

— *Hannah Höch, quoting a poem by Hans Arp from 1912*

Gulf of Tonkin Resolution authorizes President Lyndon Johnson to expand U.S. military presence in South Vietnam. Kruschev ousted as Soviet Prime Minister. Martin Luther King, Jr. wins Nobel Peace Prize. United team represents Germany in Olympics for last time until 1992.

Germany opens diplomatic relations with Israel. Winston Churchill dies. De Gaulle elected president of France. First organized protests against U.S. involvement in Vietnam on college campuses. Race riots in Watts district of Los Angeles.

German government endorses U.S. policy in Vietnam, leading to formation of German protest movement. Christian Democrats and Social Democrats form "Great Coalition" in German parliament; Kurt Georg Kiesinger elected Chancellor. Albert Speer released from prison after twenty-year sentence. De Gaulle requests removal of NATO forces from France. Cultural Revolution launched in China. National Organization for Women founded in U.S. Introduction of the miniskirt.

Arab-Israeli Six-Day War; Israel occupies Sinai and West Bank.

Assassinations of Robert Kennedy and Martin Luther King, Jr. in U.S. Soviet troops suppress "Prague Spring" in Czechoslovakia. Student and worker protests in France. Democratic Convention in Chicago. Deaths of Marcel Duchamp and John Heartfield.

Socialist Willy Brandt, former mayor of Berlin, elected Chancellor of Germany. Apollo 11 astronauts Armstrong and Aldrin become first to walk on moon. De Gaulle resigns as president of France. Woodstock, New York, music festival.

The city of Reinickendorf pays off the mortgage on Höch's home in Heiligensee and offers her an annual sum to help with house repairs. In return, the city assumes ownership of the property, which she can live in until she dies. Receives a new addition to the house, which includes her first proper bathtub.[115]

Last year of creation of oil paintings.

1971

Raoul Hausmann dies in Limoges on February 1.

Asked to become a member of the honorary committee of the Deutscher Künstlerbund, with whom she has exhibited since 1957.

Retrospective of 184 of her collages and photomontages, including some of her latest mini-collages, known as "Minis," at the Akademie der Künste in Berlin. Writes a new essay, "On Collage," for the catalogue.

The photographers Liselotte and Armin Orgel-Köhne visit Höch in Heiligensee in July to take photographs for a planned book (never realized). Höch uses some of these photographs and others made for her by the Orgel-Köhnes in the large *Lebensbild (Life Portrait)* (pages 148–149).[116] At the same time, a film about Höch is being produced by Johannes Freisel for the West German Broadcasting Network (Westdeutscher Rundfunk) in Cologne.

1973

Interview with Höch conducted by Wolfgang Pehnt airs on German radio on March 4 in the series Jene zwanziger Jahre (Those 1920s).

Begins to organize her vast collection of Dada documents, art, catalogues, and other memorabilia; creates scores of lists that detail the exhibitions in which she has participated and the exact locations of art and objects in her collection.

1974

The Berlinische Galerie purchases her 1925 paintings *Rome* and *Journalists* for a sum that astounds and gratifies Höch. Retrospective exhibition at the National Museum of Modern Art in Kyoto, Japan.

Becomes ill with a combination of lumbago and continued heart troubles. In June, she has a laser operation for cataracts, which greatly improves her eyesight. New glasses that she receives in early July allow her to see more colors, although not as distinctly as before. She often uses a magnifying glass. Höch's eyesight will remain blurry until 1977, when she finally receives new contact lenses.[118]

1975

Participates in the exhibition *"Als der Krieg zu Ende war": Kunst in Deutschland 1945–1950* ("When the War was Over": Art in Germany 1945–1950), at the Akademie der Künste in Berlin, with photomontages and a number of posters and catalogues from the period.

1976

Largest retrospective to date, with 169 works in all media, organized by the Musée d'Art Moderne de la Ville de Paris and the Berlin Nationalgalerie, Staatliche Museen Preußischer Kulturbesitz. Awarded the title of "professor" by the mayor of Berlin, Klaus Schütz, on April 23.

1977

Höch's photomontages, collages, and minis are given a separate exhibition in the monumental show *Berlin Now: Contemporary Art 1977*, organized by the Goethe House in New York; her works are also shown in the important exhibition *Women Artists: 1550–1950* at the Los Angeles County Museum of Art.

1978

Hannah Höch, after a career that spanned some sixty years, dies in Berlin at the age of eighty-eight on May 31.

Four-Power Agreement on Berlin.
Willy Brandt wins Nobel Peace Prize.
Erich Honecker becomes head of East German Communist Party.
Open letter in *Der Stern,* signed by more than 300 prominent women testifying to having had illegal abortions, marks the unofficial emergence of the modern women's movement in Germany.
U.S. bombing of Cambodia; invasion of Laos.

East and West Germany establish formal diplomatic relations, both join the U.N.
U.S. Supreme Court upholds women's right to abortion in Roe v. Wade.
Arab-Israeli Yom Kippur war.
Pablo Picasso dies.

Brandt resigns as chancellor of West Germany when one of his aides is found to be an East German spy; succeeded by Helmut Schmidt.
Nixon resigns as U.S. president as a result of Watergate scandal.

Trial of Baader-Meinhof Gang begins in Germany.
North Vietnamese and Viet Cong troops capture Saigon; Vietnam War ends.

Ulrike Meinhof found dead in her jail cell, reported suicide.
Mao Tse-tung dies.
Max Ernst dies.

Andreas Baader found dead in his jail cell, reported suicide.
Egyptian president Anwar Sadat becomes first Arab head of state to visit Israel.

First "test tube baby" born in England.
Sid Vicious kills girlfriend Nancy Spungen.

I'm sick and tired of Dada; slowly it's becoming played out. Everything else that has developed goes unnoticed.

— Hannah Höch, in an interview in "Stern," April 22, 1976

I am an introverted person, but my profound interest in everything that is happening during my time here on earth leads me, to this day, even in my retirement, to participate in everything that is interesting to me.

— Hannah Höch, interview with Suzanne Pagé, 1976

I am deeply indebted to Maria Makela, whose valuable insights, painstaking research, and encouragement made the preparation of this document possible. Information obtained from the following sources was indispensable: *Hannah Höch: Eine Lebenscollage*, vol. 1 (1889–1920), ed. Cornelia Thater-Schultz (Berlin: Berlinische Galerie and Argon, 1989); vol. 2 (1921–1945), ed. Ralf Burmeister and Eckhard Fürlus (Berlin: Berlinische Galerie and Hatje, 1995); and *Hannah Höch: Fotomontagen, Gemälde, Aquarelle*, exh. cat. (Cologne: DuMont Buchverlag, 1980), with bibliographic documentation by Götz Adriani, pp. 7–52.

1 *Lebenscollage*, vol. 1, p. 47.

2 Höch, "Lebensüberblick" (1958), trans. Peter Chametzky, in *Cut with the Kitchen Knife: The Weimar Photomontages of Hannah Höch*, by Maud Lavin (New Haven and London: Yale University Press, 1993), p. 211.

3 Documents for the Unterrichtsanstalt des königlichen Kunstgewerbemuseums at the Hochschule der Künste, Berlin. Höch first appears on the "Aufnahmeliste" as a provisiory student on 20 January 1915, in the middle of the winter semester.

4 Indication of night classes is in the "Aufnahmeliste 1914–15." Description of these courses is in the "Jahresberichte der Unterrichtsanstalt 1900–1916"; both at the Hochschule der Künste, Berlin.

5 Contrary to Höch's assertion in a 1976 interview that Grosz studied with Orlik before she arrived and that, consequently, they did not meet, Grosz was enrolled in Orlik's class at the same time as Höch, from summer semester 1915 to summer semester 1917. Since there were only 16–21 students in this class at any one time, it seems unlikely that the two would not have met at some point. See "Aufnahmeliste 1915–17" at the Hochschule der Künste, Berlin; and Suzanne Pagé, "Interview avec/mit Hannah Höch," in *Hannah Höch: Collages, Peintures, Aquarelles, Gouaches, Dessins/Collagen, Gemälde, Aquarellen, Gouachen, Zeichnungen*, exh. cat. (Paris and Berlin: Musée d'Art Moderne de la Ville de Paris and Nationalgalerie Berlin Staatliche Museen Preußischer Kulturbesitz, 1976), p. 24.

6 "Aufnahmeliste 1919–20," at the Hochschule der Künste, Berlin.

7 *Lebenscollage*, vol. 1, p. 66.

8 See an undated 1916 letter from Höch to Grete Höch, *Lebenscollage*, vol. 1, p. 195 (8.7).

9 These include a design in chenille embroidery in vol. 16, no. 5 (February 1916), p. 126; and a design for colored-silk embroidery in vol. 16, no. 11 (August 1916), p. 262.

10 Dates of abortions are confirmed in a letter from Elfriede Hausmann-Schaeffer and Raoul Hausmann to Johannes Baader, 4 November 1920, *Lebenscollage*, vol. 1, p. 717 (13.61).

11 Letter from Höch to Grete Höch, 18 November 1916, *Lebenscollage*, vol. 1, p. 233 (8.54).

12 An inscription in Höch's hand on the back of a canvas from this year entitled *Der Anfang (The Beginning)* identifies it as her first oil painting.

13 See table of contents to vol. 1, no. 4 (April 1917).

14 From a review in the *Berliner Börsen-Courier*, 13 April 1918, *Lebenscollage*, vol. 1, pp. 367–368 (10.21).

15 See *Lebenscollage*, vol. 1, pp. 426–427 (10.78).

16 Heinz Ohff, *Hannah Höch* (Berlin: Gebr. Mann and Deutsche Gesellschaft für Bildende Kunst e.V., 1968), p. 39.

17 "Vom Sticken," in vol. 18, no. 12 (September 1918); and "Was ist schön?" in vol. 19, nos. 1–2 (October–November 1918).

18 Höch, "Erinnerungen an DADA: Ein Vortrag 1966," in *Hannah Höch 1889–1978: Ihr Werk, Ihr Leben, Ihre Freunde*, exh. cat. (Berlin: Berlinische Galerie and Argon, 1989), p. 205.

19 See *Lebenscollage*, vol. 1, pp. 613–614 (12.53).

20 See vol. 19, no. 7 (April 1919), p. 140; and "Die freie Stick-Kunst" (The Free Art of Embroidery) and "Die stickende Frau" (The Embroidering Woman), both in vol. 20, nos. 1–2 (October–November 1919).

21 Höch notes that such an error was not unusual during this period; see *Lebenscollage*, vol. 1, p. 618 (12.55).

22 See *Lebenscollage*, vol. 1, pp. 658–660 (13.18), and p. 665 (13.24). The dolls featured in *Schall und Rauch* are the ones that were exhibited later in the spring and summer at the First International Dada Fair. If these are indeed the dolls that were sold to Sachs, they must have been sent to Chicago sometime after the close of the Dada Fair in August.

23 Letter from Hausmann to Höch, 21 June 1962, Hannah Höch Archive, Berlinische Galerie, Berlin.

24 Evening edition of 9 July 1920, cited in *Lebenscollage*, vol. 1, p. 684 (13.40).

25 See Ohff, supra, note 16, p. 28.

26 See *Lebenscollage*, vol. 1, pp. 663–665 (13.2).

27 *Lebenscollage*, vol. 1, p. 87 (5.3).

28 The designs, for a pillow cover and a tablecloth, appear in vol. 21, no. 4 (January 1921), pp. 89–90; and vol. 21, no. 5 (February 1921), pp. 110–111.

29 Review from the 10 February 1921 edition of *8 Uhr Abendblatt*, a clipping of which is in the Hannah Höch Archive, Berlinische Galerie, Berlin.

30 See Helga Kliemann, *Die Novembergruppe* (Berlin: Gebr. Mann Verlag, 1969), pp. 18, 109, and cover.

31 "Lebensüberblick," supra, note 2, p. 213.

32 Vol. 49, no. 9 (February 22), p. 21.

33 30 August–5 September, per an "Ausstellerkarte," an exhibitor's card, in the Hannah Höch Archive, Berlinische Galerie, Berlin.

34 John Elderfield, *Kurt Schwitters* (London: Thames and Hudson, 1985), p. 125.

35 See letters from Schwitters to Höch, 1 May 1923 and 17 July 1923, *Lebenscollage*, vol. 2 (pt. 2), p. 120 (23.5); and pp. 124–125 (23.15).

36 Höch, "Erinnerungen an DADA," supra, note 18, p. 210.

37 Ibid. Later accounts suggest that the "Goethe grotto" consisted of a re-creation of one of Goethe's legs, presented like a reliquary item and surrounded by pencil stubs. See Schwitters, "Ich und meine Ziele" (1931), in *Kurt Schwitters: Das litterarische Werk*, vol. 5, ed. Friedhelm Lack (Cologne: DuMont Verlag, 1973–1981), pp. 344–345.

38 Peter Krieger, "Freundschaft mit der Avantgarde: Schwitters, Arp, van Doesburg, Moholy-Nagy," in *Hannah Höch 1889–1978*, supra, note 18, p. 31.

39 Includes design of stuffed dog "King Charles," vol. 50, no. 12 (late March 1923), p. 20; insert of net embroidery for a curtain, blanket, or pillow, vol. 50, no. 15 (mid-May 1923), p. 21; designs for two runners, vol. 50, no. 16 (late May 1923), p. 21; and tablecloth and two doilies, vol. 50, no. 18 (late June 1923), p. 18.

40 Ohff, supra, note 16, pp. 27–28.

41 See *Lebenscollage*, vol. 2 (pt. 2), p. 122 (23.8) and p. 143 (23.55).

42 Ohff, supra, note 16, p. 28.

51 See *Lebenscollage*, vol. 2 (pt. 2), p. 241 (25.54).

52 Höch, "Die Revue: eine der Reisen mit Kurt Schwitters," in *Dada: Dokumente einer Bewegung*, exh. cat. (Amsterdam: Stedelijk Museum, 1958). Höch recounts that this activity took place in 1924, but letters suggest it was more likely in 1925 and 1926. See Eberhard Roters, "Kurt Schwitters," in *Lebenscollage*, vol. 2 (pt. 1), pp. 134–143.

53 Höch, "Erinnerungen an DADA, supra, note 18, p. 211.

54 Letter from the Novembergruppe to artist members, 11 November 1926, *Lebenscollage*, vol. 2 (pt. 2), p. 267 (26.26).

55 While Höch's pocket calendar does not specifically mention a trip to Monte Verita, it does cite a stop at Lago Maggiore, the lake upon which Ascona sits. Monte Verita was a destination for many bohemian artists and dancers, including Sophie Taeuber and Mary Wigman, during the early decades of the century. See *Lebenscollage*, vol. 2 (pt. 2), p. 299 (27.13).

56 Elderfield, *Kurt Schwitters*, supra, note 34, p. 194.

57 Review by F. M., 1 June 1929, from an unknown source; *Lebenscollage*, vol. 2 (pt. 2), p. 364 (29.32).

58 Membership card and letter from the Reichsverband, 14 November 1931, confirming new membership, Höch Family Archive.

59 See Maria Makela's essay in this volume, p. 79 n127.

60 Letters from Nelly van Doesburg, 26 April 1932, and Helma Schwitters, 6 October 1932, *Lebenscollage*, vol. 2 (pt. 2), p. 452 (32.7) and p. 461 (32.22).

61 Text on film censorship and letter from Höch to Kalivoda, 14 October 1932; both in František Kalivoda Correspondence, Municipal Museum, Brno, Czech Republic.

62 See letters from Gertrud Ring, 20 June 1933; Otto and Hildegard Nebel, 22 October 1933; and Thomas and Gertrud Ring, 28 October 1933; *Lebenscollage*, vol. 2 (pt. 2), p. 487 (33.14), p. 492 (33.18), and p. 493 (33.19).

63 Letter from Höch to Will Grohmann, 29 September 1964, Hannah Höch Archive, Berlinische Galerie, Berlin.

64 Letters from Kalivoda to Höch, 6 March 1934, and 5 June 1934, Hannah Höch Archive, Berlinische Galerie, Berlin.

65 Letters from Kalivoda to Höch, 10 July 1934, and 12–13 July 1934, *Lebenscollage*, vol. 2 (pt. 2), pp. 539–540 n1.

66 Ohff, supra, note 16, p. 25.

67 *Lebenscollage*, vol. 2 (pt. 2), pp. 575–593 (37.14).

68 In Höch's journal entry of 14 December 1937, she refers to this building as the "Luftschiffahrtsministerium." See *Lebenscollage*, vol. 2 (pt.2), p. 592 (37.14).

69 Letter from Alan E. Steinweis to Maria Makela, 1 November 1995. The questionnaire Höch completed for admittance into the Reichskammer der bildende Kunst in February 1942 reiterates that she had works in the collection of the Reichsluftfahrtministerium (photocopy of document in the Berlin Document Center provided by Alan Steinweis). See Steinweis, *Art, Ideology and Economics in Nazi Germany* (Chapel Hill: University of North Carolina Press, 1993).

70 Diary entry of 1 April 1938, *Lebenscollage*, vol. 2 (pt. 2), p. 598 (38.1); and draft of letter from Höch to Heinz Kurt Matthies, p. 663 (42.3).

71 See Edouard Roditi, "Interview mit Hannah Höch," *Der Monat* 12, no. 134 (November 1959), p. 60.

72 Journal entry from 28 September 1939, *Lebenscollage*, vol. 2 (pt. 2), p. 637 (39.12).

73 Steinweis, *Art, Ideology and Economics*, supra, note 69, p. 127.

74 See Christoph Sachse and Florian Tennstedt, *Der Wohlfahrtsstaat im Nationalsozialismus: Geschichte der Armenfürsorge in Deutschland*, vol. 3 (Stuttgart, Berlin, Cologne: Verlag W. Kohlhammer, 1992), p. 118. Thanks to Professor Alan E. Steinweis for making us aware of this reference.

75 Peter Krieger, "Hannah Höch," in *Zwischen Widerstand und Anpassung: Kunst in Deutschland 1933–1945*, exh. cat. (Berlin: Akademie der Künste, 1978), p. 152.

76 See Yule F. Heibel, *Reconstructing the Subject: Modernist Painting in Western Germany, 1945–1950* (Princeton: Princeton University Press, 1995), pp. 87, 172 n18; and Eckhart Gillen and Diether Schmidt, eds., *Zone 5: Kunst in der Viersektorenstadt 1945–1951* (Berlin: Berlinische Galerie and Verlag Dirk Nishen, 1989), p. 157.

77 Reprinted in *Zone 5*, supra, note 76, pp. 171–172.

78 Letter from *Ulenspiegel* editors to Höch, 2 April 1946, Hannah Höch Archive, Berlinische Galerie, Berlin.

79 See Herbert Sandberg and Günter Kunert, eds., *Ulenspiegel: Zeitschrift für Litteratur, Kunst und Satire 1945–1950* (Berlin: Eulenspiegel Verlag, 1978).

80 Letters from the Freunde der bildenden Kunst to Höch, 30 January and 12 March 1947; and from Höch, 1 December 1947 and 6 January 1948, Hannah Höch Archive, Berlinische Galerie, Berlin.

81 See Lothar Klünner, "Zwischen Nullpunkt und Währungsreform: Die surreale Stadt," *Litfaß: Zeitschrift für Literatur* 12, no. 45 (October 1988), pp. 127–128.

82 Letter from Höch to the Schutzverband bildender Künstler, 28 February 1949, Hannah Höch Archive, Berlinische Galerie, Berlin.

83 Letter from the Freier Verband der bildenden Künstler Berlin to the members of the Schutzverband, 30 November 1948, Hannah Höch Archive, Berlinische Galerie, Berlin.

43 Design for embroidered linen pillow, vol. 51, no. 9 (mid-February 1924), p. 20; small net-darning tablecloth, vol. 51, no. 10 (late February 1924), p. 21; abstracted design for wool embroidery with deer, houses, flowers, and geometric shapes, vol. 52, no. 5 (late November 1924), p. 29; and floral embroidery design, vol. 52, no. 6 (early December 1924), p. 29.

44 Höch, "Erinnerungen an DADA," supra, note 18, p. 202; and *Lebenscollage*, vol. 2 (pt. 2), p. 184 (24.37).

45 See *Lebenscollage*, vol. 2 (pt. 2), pp. 177–190 (24.37).

46 Loose note dated April 22, found in the Hannah Höch Archive, Berlinische Galerie, Berlin. The year is not given, but since this is the only of Höch's Paris trips to have taken place during April, it is safe to assume this event took place during the 1924 visit.

47 Eberhard Roters, "Paris-Reisen," in *Lebenscollage*, vol. 2 (pt. 1), p. 158.

48 Letters from Höch to the van Doesburgs, 5 June 1924 and 7 October 1924, Theo van Doesburg Archives, Rijksbureau voor kunsthistorische Documentatie, The Hague, the Netherlands. I wish to thank Marcia Zaaijer for allowing me access to this material.

49 Designs for two round doilies, vol. 52, no. 8 (early January 1925), p. 24; design of Dutch women with trees and animals, vol. 52, no. 10 (early February 1925), p. 24; design for a round tablecloth, vol. 53, no. 4 (November 1925), p. 24.

50 *Lebenscollage*, vol. 2 (pt. 2), p. 233 (25.51); and *The Little Review* 12, no. 1 (Spring–Summer 1926), inside front cover. In the 1920s, Jane Heap exhibited art of the German Expressionists and Russian Constructivists at the Little Review Gallery, at 66 Fifth Avenue, in New York. See Margaret Anderson, *My Thirty Years' War* (New York: Covici, Friede, 1930), p. 265.

93 Letter from Arp to the Hauptkunstamt, 14 February 1954. Stiftung Hans Arp und Sophie Taeuber-Arp, Bahnhof Rolandseck, Rolandseck, Germany.

94 Letters from Huelsenbeck to Höch, 10 July 1954, and Höch to Huelsenbeck, 17 August 1954, in the Richard Huelsenbeck Correspondence, Getty Center for the History of Art and the Humanities, Santa Monica, California. I would like to thank Kirsten Hammer for making these letters available to me.

95 Dr. Kohn, the curator at the Folkwang Museum, was particularly interested in the photomontages, but did not purchase any. Journal entry, 23 April 1955, Hannah Höch Archive, Berlinische Galerie, Berlin.

96 See correspondence of August 1963 from Rose Fried to Höch; and Höch's journal entry, 9 August 1963, both in the Hannah Höch Archive, Berlinische Galerie, Berlin.

97 Heibel, *Reconstructing the Subject*, supra, note 76, p. 180 n114.

98 Letter from Höch to the Deutscher Künstlerbund, 12 August 1959, Hannah Höch Archive, Berlinische Galerie, Berlin.

99 See, for example, journal entries of 5 October 1957 and 1 February 1958, Hannah Höch Archive, Berlinische Galerie, Berlin.

100 See copies of letters from Huelsenbeck to Höch, 28 April 1958, and from Höch to Huelsenbeck, 3 April 1958, Richard Huelsenbeck Correspondence, Getty Center for the History of Art and the Humanities, Santa Monica, California. It is unclear which book was meant here. Höch's account of a trip with Kurt Schwitters appears in Huelsenbeck's *Dada: Eine literarische Dokumentation* (Hamburg: Rowohlt, 1964), pp. 255–257. "Lebensüberblick" was not published during her lifetime. Huelsenbeck's *Mit Witz, Licht und Grütze* appears in English translation as "Dada Drummer" in the book *Memoirs of a Dada Drummer*, ed. Hans J. Kleinschmidt, trans. Joachim Neugroschel (New York: Viking Press, 1974).

101 "Die Revue: Eine der Reisen mit Kurt Schwitters," in *Dada: Dokumente einer Bewegung*, exh. cat. (Amsterdam: Stedelijk Museum, 1958), unpaginated.

102 Review by Heinrich ten Losen in *Das Kunstwerk* 13, nos. 2–3 (August–September 1959), p. 66.

103 Journal entries, 10 February and 4 November 1959, Hannah Höch Archive, Berlinische Galerie, Berlin.

104 The interview also appeared in translation in the December issue of *Arts Magazine* in 1959 and in Roditi's book *More Dialogues on Art* (Santa Barbara, California: Ross-Erikson, 1984).

105 See letters from Huelsenbeck, Hans Richter, and others in *Der Monat* 12, no. 136 (January 1960), pp. 94–96.

106 Letter from Höch to Hans Arp, 10 December 1959, Hannah Höch Archive, Berlinische Galerie, Berlin. The interview did not appear in this 1960 volume, but in the subsequent *More Dialogues on Art*, supra, note 104.

107 Sketch of letter from Arp to Höch, 6 January 1960, Stiftung Hans Arp, Bahnhof Rolandseck, Rolandseck, Germany. Arp writes: "If I had let myself be influenced by all the abusive language, slander, and sensitivities the Dadaists exchanged among one other, I would have lost all joy in Dada."

108 Letter from the Bundespräsidialamt to Höch, 8 March 1960, Hannah Höch Archive, Berlinische Galerie, Berlin.

109 Journal entry, 11 April 1961, and an undated entry from 27–30 April 1961, Hannah Höch Archive, Berlinische Galerie, Berlin.

84 Reinhard and Elli Franz, well-known Communist sympathizers since 1928, opened their gallery in October 1946 in the rooms of a former boxing school in the Eastern sector of Berlin. They were thrust into the forefront of the art debates in Berlin when they accepted the defectors of the Galerie Gerd Rosen (Hartung, Mammen, Thiemann, Trökes, Uhlmann, and Zimmerman) in the *Zone 5* exhibition of September 1948, an action that called for a zone outside the four occupation zones that would be free from political and ideological entanglements. The gallery became increasingly left-wing during the early 1950s and was closed by the authorities in 1951. See Gillen and Schmidt, *Zone 5*, supra, note 76, pp. 195–205.

85 Journal entry, 17 March 1950, Hannah Höch Archive, Berlinische Galerie, Berlin.

86 Journal entries, 26 August, 4 November, and 16 November 1950; and undated letter from Höch to the Kunstamt Charlottenburg, spring 1950, Hannah Höch Archive, Berlinische Galerie, Berlin.

87 See Ursula Rüter, "'Müssen Malerinnen häßlich sein?' Bildende Künstlerinnen im Berlin der Nachkriegszeit," in *Professione ohne Tradition: 125 Jahre Verein Berliner Künstlerinnen* (Berlin: Berlinische Galerie, 1992), p. 180.

88 Journal entry, 24 October 1951, Hannah Höch Archive, Berlinische Galerie, Berlin.

89 Journal entry, 28 October 1952, Hannah Höch Archive, Berlinische Galerie, Berlin.

90 Draft of letter from Höch to the Reinickendorf Bezirksamt, 10 March 1953, Hannah Höch Archive, Berlinische Galerie, Berlin.

91 Letters in the Stiftung Hans Arp und Sophie Taeuber-Arp, Bahnhof Rolandseck, Rolandseck, Germany. I would like to thank Walburga Krupp for allowing me access to this material.

92 Letter from Höch to Karl Friedrich Borée, 15 August 1954, Hannah Höch Archive, Berlinische Galerie, Berlin.

110 See, for example, letter from Hausmann to Höch, 2 June 1962, Hannah Höch Archive, Berlinische Galerie, Berlin.

111 Journal entries, 9 January and 25 February 1965, Hannah Höch Archive, Berlinische Galerie, Berlin.

112 Journal entries, 9 March, 23 June, and 13 November 1966, Hannah Höch Archive, Berlinische Galerie, Berlin.

113 Journal entries, 19 July and 4 October 1966, Hannah Höch Archive, Berlinische Galerie, Berlin.

114 For example, letters from Hausmann to Höch, 14 October 1965 and 5 January 1967, Hannah Höch Archive, Berlinische Galerie, Berlin. See also her journal entries from 12 September and 28 October 1966, which suggest she was relieved not to have the responsibility or burden of these objects anymore.

115 Heinrich Rössner, in communication with Maria Makela.

116 Journal entries, 15 and 24 July 1971, Hannah Höch Archive, Berlinische Galerie, Berlin.

117 Florian Karsch, "Hannah Höch: jetzt wäre sie 90 Jahre alt," in *Hannah Höch zum Neunzigsten Geburtstag*, exh. cat. (Berlin: Galerie Nierendorf, 1979), p. 4.

EXHIBITION HISTORY

An asterisk indicates a corresponding entry for the
exhibition catalogue in the Bibliography.

SOLO EXHIBITIONS

1929 *Hannah Hoch.* Kunstzaal De Bron, The Hague. 11 May–7 June.
Approximately fifty works (paintings, watercolors, drawings).
Catalogue with text by Höch.* Traveled to: Rotterdamsche
Kring, Rotterdam, 7–25 September; and Kunstzaal Van Lier,
Amsterdam, 28 September–18 October.

Hannah Höch. Kunstzaal d'Audretsch, The Hague. Closed
15 November. Photomontages.

1934 *Výstava fotomontáží Hannah Höch.* Exhibition room
at Masaryk's student housing, Brno, Czechoslovakia.
23 February–2 March. Forty-two photomontages.

Hannah Höch. Kunstzaal d'Audretsch, The Hague. May–
12 June. Thirty watercolors.

1935 *Aquarelle en Fotomontages door Hannah Höch.* Kunstzaal
d'Audretsch, The Hague. 13 November–14 December. Water-
colors and photomontages.

1949 *Hannah Höch und Dada.* Galerie Franz, Berlin. Opened
26 November. Nineteen works (paintings, watercolors,
drawings, photomontages). Catalogue with text by Höch.*

1955 *Hannah Höch zeigt Aquarelle und Zeichnungen.* Galerie Spitta
und Leutz, Berlin. 25 February–19 March. Nineteen water-
colors, three drawings.

1957 *Hannah Höch: Collagen.* Galerie Gerd Rosen, Berlin.
18 February–8 March. Twenty-six photomontages. Catalogue.*

1959 *Hannah Höch: Collagen 1956–59.* Galerie Gerd Rosen, Berlin.
Opened 5 June. Thirty-five photomontages. Catalogue.

1961 *Hannah Höch: Bilder, Collagen, Aquarelle 1918–1961.* Galerie
Nierendorf, Berlin. 30 April–15 June. Eighty-five works.
Catalogue.

1963 *Dada–Hannah Höch–Dada.* Galleria del Levante, Milan.
[May–June]. Fifty-three works (photomontages, watercolors,
paintings). Catalogue with texts by Höch and Edouard Roditi.
Traveled to: Galleria d'Arte Moderna "Il Punto," Turin,
opened 21 June; and Rome.

1964 *Hannah Höch zum 75. Geburtstag.* Galerie Nierendorf, Berlin.
6 November 1964–January 1965. Thirty-three paintings, forty-
four photomontages. Catalogue.*

1966 *Hannah Höch.* Marlborough Gallery, London. January. Fifty-
five photomontages. Catalogue.*

1968 *Hannah Höch: Aquarelle, Zeichnungen, Linolschnitte aus den
Jahren 1915–65.* Galerie im Schinkelsaal, Berlin-Tegel.
10 May–7 June. Forty-nine works. Catalogue with text by
Heinz Ohff.

1969 *Hannah Höch: Ölbilder, Aquarelle, Collagen, Gouachen.*
Kunstverein, Kassel. 18 May–14 June. 135 works. Catalogue
with text by Heinz Ohff.

1971 *Hannah Höch: Collagen aus den Jahren 1916–1971.* Akademie
der Künste, Berlin. 28 May–4 July. 184 works. Catalogue.*
Traveled to: Städtische Kunsthalle, Düsseldorf, 29 October–
28 November.

1973 *Hannah Höch: Fotomontagen und Gemälde.* Kunsthalle,
Bielefeld. 6 May–1 July. Fifty-nine works. Catalogue.*

Hannah Höch: Aquarelle, Zeichnungen. Städtische Sammlungen,
Rheinhausen. 1–31 August. 110 works. Catalogue.

1974 *Hannah Höch.* National Museum of Modern Art, Kyoto.
3 April–12 May. 158 works. Catalogue with text by Eberhard
Roters.

Hannah Höch: Collagen + Zeichnungen. Galerie Elke Dröscher,
Hamburg. 29 November 1974–31 January 1975.

1975 *Hannah Höch: Noch nicht gezeigte Blätter: Aquarelle, Collagen,
Zeichnungen.* Galerie Nierendorf, Berlin. 8 September–
22 November. 125 works. Catalogue with text by Heinz Ohff.

1976 *Hannah Höch: Collages, Peintures, Aquarelles, Gouaches,
Dessins/Collagen, Gemälde, Aquarellen, Gouachen, Zeichnungen.*
Musée d'Art Moderne de la Ville de Paris, 30 January–
7 March; Nationalgalerie, Staatliche Museen Preußischer
Kulturbesitz, Berlin, 24 March–9 May. 169 works. Catalogue.*

Hannah Höch. Muzeum Sztuki, Lodz, Poland. 3 December 1976–
9 January 1977. Eighty works. Catalogue.*

1977 *Hannah Höch: Collages and Photomontages* (part of *Berlin Now:
Contemporary Art 1977* exhibition). Goethe House, New York.
18 March–19 April. Fifty-eight works. Catalogue with text by
Eberhard Roters.*

Hannah Höch. Carus Gallery, New York. 24 September–
29 October. Photomontages and watercolors.

1978 *Hannah Höch: Aquarelle.* Graphothek Berlin. 23 April–26 May.
Forty-seven watercolors. Catalogue.

Hannah Höch: Ein Leben mit der Pflänze. Städtisches Museum,
Gelsenkirchen. 11 May–11 June. Watercolors and paintings.
Catalogue with text by Heinz Ohff.

1979 *Hannah Höch: Dada Berlin.* Museo Diego Arogena Pignatelli
Cortes, Goethe House, Naples. 1–30 November. 146 works.
Catalogue.

Hannah Höch zum neunzigsten Geburtstag. Galerie Nierendorf,
Berlin. 1 November 1979–5 February 1980. Catalogue.*

1980 *Hannah Höch: Collagen, Aquarellen.* Galerie Alvensleben,
Munich.

Hannah Höch: Fotomontagen, Gemälde, Aquarelle. Kunsthalle,
Tübingen. 23 February–4 May. 193 works. Catalogue.*
Traveled to: Kunstmuseum Hannover mit Sammlung
Sprengel, Hanover, 18 May–22 June; Von der Heydt-Museum,
Wuppertal, 20 September–19 October; and Kunstverein,
Frankfurt am Main, 16 December 1980–31 January 1981.

1982 *Hannah Höch: Gemälde, Collagen, Aquarelle, Zeichnungen,
Dokumente.* Galerie Remmert und Barth, Düsseldorf.
Catalogue.*

*Hannah Höch: Collagen, Aquarelle, Gemälde, Zeichnungen aus
sieben Jahrzehnten.* Galerie Nierendorf, Berlin. 22 November
1982–12 February 1983. Catalogue with text by Eberhard
Roters.

1983 *Hannah Höch.* Fischer Fine Art Ltd., London. June–July.
Forty-three works. Catalogue.*

Hannah Höch: Oil Paintings and Works on Paper. Helen Serger
La Boetie, New York. 15 October–December. Catalogue.*

1984 *Hannah Höch 1889–1978 Collagen.* Institut für
Auslandsbeziehungen, Stuttgart. 13 February–9 March.
Catalogue.* Traveled to: Bonn, 1985; Centro de Arte Moderna,
Lisbon, 1989; Musée des Augustins, Toulouse, France, 1991;
Goethe House, New York, 10 September–6 October 1992;
Presentation House, North Vancouver, Canada, 10–23
December 1993 and 5–23 January 1994.

Hannah Höch zum 100-jährigen Bestehen. Kunstverein,
Backnang. 18 November–8 December.

1985 *Hannah Höch: Frühe Bilder*. Galerie Alvensleben, Munich. 15 October–29 November. Catalogue.

1988 *Hannah Höch: 1889–1978*. Galerie Welz, Salzburg. 9 March–4 April. Eighty works. Catalogue with text by Peter Beckmann.

Hannah Höch zum 10. Todestag: Zeichnungen, Aquarelle, Gemälde. Museum der Stadt, Schopfheim. April–May. Catalogue with text by Dieter Rössner.

1989 *Hannah Höch zum 100. Geburtstag*. Galerie Bodo Niemann, Berlin. 11 March–29 April. Catalogue.*

Hannah Höch: 100 Werke zum 100. Geburtstag. Galerie Remmert und Barth, Düsseldorf. 24 October–23 December.

Hannah Höch 1889–1978: Ausstellung zum 100. Geburtstag: Ölbilder, Aquarelle, Collagen, Zeichnungen. Rathaus, Berlin-Reinickendorf. 27 October–15 December. Traveled to: Stadt Museum, Soltau, 6 January –25 February 1990.

Hannah Höch zum 100. Geburtstag. Kunstverein der Stadt Backnang. 5–26 November.

Hannah Höch (1889–1978): Ihr Werk, Ihr Leben, Ihre Freunde. Berlinische Galerie, Berlin. 25 November 1989–14 January 1990. Catalogue.*

1992 *Hannah Höch*. Galerie Alte Kanzlei, Albstadt-Ebingen. 11 September–10 October.

Hannah Höch. Kunstmuseum, Kanton Thurgau. 8 November 1992–24 January 1993. Ninety-six works. Travelled to: Ittingen.

1993 *Hannah Höch*. Schloß Friedenstein, Gotha. 7 August–7 November. Catalogue.*

1994 *Hannah Höch*. Schloß Friedenstein, Gotha. 26 July–16 August.

Hannah Höch. Schloßmuseum, Murnau. 26 July–16 October.

SELECTED GROUP EXHIBITIONS

1919 *Erste Berliner Dada Ausstellung*. Kunstkabinett I. B. Neumann, Berlin. May. Abstract watercolors.

1920 *Große Berliner Kunstausstellung* (Novembergruppe division). Landesausstellungsgebäude am Lehrter Bahnhof, Berlin. 21 May–late September. Four watercolors, wooden sculpture.

Erste internationale Dada-Messe. Kunsthandlung Dr. Otto Burchard, Berlin. 30 June–25 August. Photomontages, relief collages, dolls. Catalogue.

1921 *Große Berliner Kunstausstellung* (Novembergruppe division). Landesausstellungsgebäude am Lehrter Bahnhof, Berlin. Opened 19 April. Three paintings. Brochure.

1922 *Erste Internationale Kunstausstellung*. Atrium of the Tietz department store, Düsseldorf. 28 May–3 July. Brochure.

Entwurfs- und Modellmesse. Leipzig. 30 August–5 September.

Große Berliner Kunstausstellung (Novembergruppe division). Landesausstellungsgebäude am Lehrter Bahnhof, Berlin. Opened 4 September. One painting, one watercolor.

1923 *Große Berliner Kunstausstellung* (Novembergruppe division). Landesausstellungsgebäude am Lehrter Bahnhof, Berlin. 19 May–16 September. Five paintings and drawings.

Juryfreie Kunstschau. Landesausstellungsgebäude am Lehrter Bahnhof, Berlin. 6 October–11 November. Two watercolors. Catalogue (Höch misidentified under the name Hoerle).

1924 *Erste Allgemeine Deutsche Kunstausstellung in Sowjet-Rußland* (Novembergruppe division). Moscow. Opened 18 October. One watercolor, one painting. Catalogue.

1925 *Novembergruppe*. Berlin Secession, Berlin. 30 May–late June. Two paintings.

Juryfreie Kunstschau. Landesausstellungsgebäude am Lehrter Bahnhof, Berlin. 19 September–8 November. One painting, two watercolors. Catalogue.

1926 *Deutsche Kunstgemeinschaft*. Berlin. May. One painting.

Große Berliner Kunstausstellung (Novembergruppe division). Landesausstellungsgebäude am Lehrter Bahnhof, Berlin. May. Two paintings.

1928 *De Onafhankelijken*. Stedelijk Museum, Amsterdam. 3 March–1 April. Two paintings, one drawing.

Deutsche Künstler in Ausland. Kunstverein, Cologne. June. Three paintings, one watercolor. Traveled to: Essen, Wiesbaden, and Barmen.

De Onafhankelijken. Stedelijk Museum, Amsterdam. 10 November–9 December. One painting.

1929 *De Onafhankelijken*. Stedelijk Museum, Amsterdam. 11 May–10 June. One painting, one watercolor. Catalogue.

Film und Foto International Exhibition. Neue Städtische Ausstellungshallen am Interimtheaterplatz, Stuttgart. Organized by the Deutscher Werkbund. 18 May–7 July. Approximately eighteen photomontages. Catalogue. Traveled through 1931 to: Zurich, Berlin, Vienna, Danzig, Agram, Munich (as *Das Lichtbild*), Tokyo, and Osaka.

1930 *Große Berliner Kunstausstellung*. Schloß Bellevue, Berlin. Fifteen photomontages, two paintings.

1931 *Die Resonanz* (artists' self-help group). Berlin. 22 February.

Fotomontage. Atrium of the former Kunstgewerbemuseum, Berlin. 25 April–31 May. Photomontages. Catalogue.

Novembergruppe. Neues Haus des Vereins Berliner Künstler, Berlin. 3 July–3 August. Two paintings. Catalogue.

Das Lichtbild Essen 1931. Austellungshallen Norbertstraße 2, Essen. 11 July–23 August. Nine photomontages from the Berlin *Fotomontage* show.

Frauen in Not. Haus der Juryfreien, Berlin. 9 October–1 November. Two paintings, one photomontage, two drawings. Catalogue.

1932 *Gemälde, Aquarelle und Plastiken lebender deutscher Künstler* (auction of works by members of the Novembergruppe). Auction House of Paul Graupe, Berlin. 17–21 May. Painting.

Exposition internationale de la photographie. Palais des Beaux-Arts, Brussels. 2–31 July. Eight photomontages. Catalogue. Traveled to: Ghent, Leiden, and Rotterdam.

Weihnachtsmarkt Berliner Künstler. Ausstellungshallen am Kaiserdamm, Berlin. 3–11 December. Brochure.

1933 *Der Tanz: Gotik bis Gegenwart*. Künstlerbund Hagen, Vienna. Late January–March. Watercolors. Catalogue (*Moderne Welt* 14, no. 5 [February 1933]).

Deuxième exposition internationale de la photographie et du cinéma. Palais des Beaux-Arts, Brussels. June–July. Eight photomontages. Catalogue.

Deutsche Kunstgemeinschaft. Schloß Charlottenburg, Berlin. [November 1933–February 1934]. Seven drawings, one watercolor.

1936 *Fantastic Art, Dada, and Surrealism*. Museum of Modern Art, New York. 7 December 1936–17 January 1937. One photomontage. Catalogue.

1945 *Reinickendorfer Künstler stellen aus! Malerei Graphik Plastik*. Volksbildungsamt Reinickendorf in Argus-Gebäude, Berlin-Reinickendorf. 2–22 December. Twenty paintings and watercolors. Catalogue.

1946 *Fantasten-Ausstellung*. Galerie Gerd Rosen, Berlin. February. Catalogue.

Frühjahrsausstellung in der Kamillenstraße. Kamillenstraße 4, Berlin-Lichterfelde. 17 March–end May. Eleven watercolors. Checklist.

Kunstschau: Malerei, Graphik, Plastik. Rathaus, Berlin-Weißensee. 31 March–20 April. Painting. Catalogue.

Graphik: Schwarz-Weiss und Farbig. Gabr.-von-Bülow-Schule, Berlin-Tegel. 25 August–25 September. Twenty-nine watercolors and drawings. Catalogue.

Ausstellung Berliner Künstler in Potsdam. Kulturbund, Potsdam. 27 October–24 November. Three paintings and watercolors. Catalogue.

Schutzverband bildender Künstler. Verlagshaus E. A. Seemann, Leipzig. November 1946–January 1947. Three watercolors.

Fotomontage von Dada bis heute. Organized by Höch. Galerie Gerd Rosen, Berlin. 23 December 1946–January 1947. Catalogue.

Schöneberger Kunstausstellung: Malerei Graphik Plastik. Neues Rathaus, Berlin-Schöneberg. 28 December 1946–31 January 1947. Two watercolors. Catalogue.

1947 *Phantasie und Illustration*. Räume des Kulturbundes, Berlin-Hermsdorf. 21 June–July. Eleven watercolors, six photomontages. Catalogue.

Maler sehen die Frau: Die Frau in Wort, Werk und Bildnis. Organized by the Zehlendorfer Frauengruppe. Haus am Waldsee, Berlin-Zehlendorf. 31 August–30 September. Eight watercolors. Checklist.

1948 *Reinickendorfer Kunst: Ausstellung Reinickendorfer Maler/Graphiker/Bildhauer*. Gerichtssaal des Bezirksamtes, Berlin-Reinickendorf. 29 August–19 September. Seven watercolors.

Collage. Museum of Modern Art, New York. 21 September–5 December. Three photomontages.

1949 *Berliner Künstlerinnen- und Milly-Steger-Gedächtnis-Ausstellung*. Archivarion in the German Archiv-Bibliothek der Edition Rolf Roeingh, Berlin. Opened April 9. Four watercolors. Catalogue.

Berliner Kunstausstellung Weihnachten 1949. Schloß Charlottenburg, Berlin. 3 December 1949–8 January 1950. Two watercolors. Catalogue.

1950 Memorial exhibition on the 30th anniversary of the founding of the Novembergruppe. Kunstamt Charlottenburg, Berlin. November. Two watercolors.

Berliner Kunstausstellung, Weihnachten 1950. Schloß Charlottenburg, Berlin. Opened 1 December. One watercolor. Catalogue.

1951 *Allgemeine Neuköllner Kunstausstellung*. Berlin-Neukölln. February–4 March. Watercolors.

Der RING Bildender Künstler Berlins. Haus am Waldsee, Berlin-Zehlendorf. 23 June–19 August.

1952 *Der RING bildender Künstler Berlins*. Amerika-Haus, Berlin. Opened 5 April. Three drawings.

Eisen und Stahl. Düsseldorf. 30 April–2 June. Two watercolors. Catalogue (Höch's works mistakenly omitted).

Der RING bildender Künstler Berlins. Haus am Waldsee, Berlin-Zehlendorf. Opened 25 October. Three watercolors.

Weihnachtsverkaufs-Ausstellung 1952. Schloß Charlottenburg, Berlin. 30 November–23 December. Two watercolors.

1953 *Landschaft und Stilleben: Plastik und Porträt*. Neuköllner Rathaus, Berlin. 31 January–28 February. Two watercolors.

Dada 1916–1923. Sidney Janis Gallery, New York. 15 April–9 May. Five photomontages. Catalogue.

Exhibition for the Berliner Ärztinnen-Bund. Zoo-Sälen, Berlin. 1–3 May.

Ausstellung Reinickendorfer Künstler. Rathaus, Berlin-Reinickendorf. 22 July–21 August. Three paintings. Catalogue.

Juryfreie Kunstausstellung Berlin 1953. Ausstellungshallen am Funkturm, Berlin. 7–23 August. Two paintings. Catalogue.

Weihnachtsverkaufs-Ausstellung 1953. Schloß Charlottenburg, Berlin. 5–23 December. One painting.

1954 *Der RING bildender Künstler Berlins*. Haus am Waldsee, Berlin. January.

Juryfreie Kunstausstellung Berlin 1954. Ausstellungshallen am Funkturm, Berlin. 15–30 July. One painting. Catalogue.

Weihnachtsverkaufs-Ausstellung 1954. Schloß Charlottenburg, Berlin. 9–30 December. Two watercolors.

1955 *Der RING bildender Künstler Berlins*. Böttcherstraße, Bremen. 22–24 February.

Juryfreie Kunstausstellung Berlin 1955. Ausstellungshallen am Funkturm, Berlin. 1–17 July. One painting. Catalogue.

Ausstellung des Reinickendorfer Künstlerbundes. Stadtbücherei, Berlin. July–14 August.

1956 *Collages: International Collage Exhibition*. Rose Fried Gallery, New York. 13 February–17 March. Photomontages. Checklist.

Ausstellung des RINGS Berliner Künstler. Erholungshaus, Leverkusen. March. Painting and watercolor.

Große Berliner Kunstausstellung. Ausstellungshallen am Funkturm, Berlin. 25 May–1 July. Watercolors and one painting.

1957 *Große Berliner Kunstausstellung*. Ausstellungshallen am Funkturm, Berlin. 20 April–19 May. Two paintings.

Deutscher Künstlerbund. Hochschule für bildende Künste, Berlin. 7 July–22 September. Two drawings.

1958 *Große Berliner Kunstausstellung* (RING bildender Künstler division). Ausstellungshallen am Funkturm, Berlin. 5 May–4 June. Two paintings, one watercolor. Catalogue.

Deutscher Künstlerbund. Ausstellungshallen an der Gruga, Essen. 17 May–13 July. Three paintings, five drawings. Catalogue.

Dada: Dokumente einer Bewegung. Kunstverein für die Rheinlande und Westfalen, Düsseldorf. 5 September–19 October. Approximately twenty watercolors, collages, and photomontages. Catalogue. Traveled to: Frankfurt; and Stedelijk Museum, Amsterdam, 23 December 1958–2 February 1959.

Ausstellung Berliner Künstler: Malerei und Plastik. Rathaus Spandau, Berlin. 12–26 October. Three watercolors.

1959 *Große Berliner Kunstausstellung* (RING bildender Künstler division). Ausstellungshallen am Funkturm, Berlin. 24 April–24 May. Three paintings.

Deutscher Künstlerbund. Gemäldegalerie des Städtischen Museums, Wiesbaden. 9 May–5 July. One painting, two drawings. Catalogue.

Exposition internationale du Surréalisme. Galerie Daniel Cordier, Paris. 15 December 1959–29 February 1960. Two paintings.

1960 *Ideen, Studien, Entwürfe, Zeichnungen, Illustrationen*. Exhibition of the RING bildender Künstler; special section devoted to Höch's 70th birthday with works from Dada to present. Haus am Waldsee, Berlin-Zehlendorf. 6–27 January.

Kunst des XX. Jahrhunderts aus Berliner Privatbesitz. Haus am Waldsee, Berlin-Zehlendorf. 1 February–6 March. One photomontage. Catalogue.

Ungegenständliche Photographie. Gewerbeschule und Gewerbe-museum, Basel. 27 February–April. Five photomontages.

Berlin, Ort der Freiheit für die Kunst: Der dynastische Realismus und das Auftreten Edvard Munchs in Berlin. Organized by the Nationalgalerie der ehemals Staatliche Museen, Berlin, and the Hochschule für bildende Künste, Berlin. One painting. Catalogue. Traveled to: Recklinghausen, 2 June–17 July; Vienna, 2 August–4 September; Berlin, 18 September–6 November; Städtisches Museum, Oslo, mid-January–mid-February 1961; Schloß Styrum, Helsinki, late February–early April 1961; and Mülheim (Ruhr), Fall 1961.

Deutscher Künstlerbund. Staatliche Kunsthalle, Baden-Baden. 6 August–2 October. Four watercolors. Catalogue.

Deutscher Künstlerbund (special exhibition *Das frühe Bild: Malerei und Plastik*). Haus der Kunst, Munich. 18 October–11 December. Paintings and watercolors. Catalogue.

1961 *The Art of Assemblage*. Museum of Modern Art, New York. 2 October–12 November. One photomontage. Catalogue. Traveled to: Dallas Museum of Contemporary Art, 9 January–11 February 1962; and San Francisco Museum of Fine Arts, 5 March–15 April 1962.

1962 *Juryfreie Kunstausstellung Berlin 1962*. Ausstellungshallen am Funkturm, Berlin. [April or May]. One painting.

Bemalte Postkarten und Briefe deutscher Künstler. Altonaer Museum, Hamburg. June–September. Catalogue.

Scripturale Malerei. Haus am Waldsee, Berlin. 25 September–20 November. Six photomontages. Catalogue.

1963 *Schrift und Bild*. Stedelijk Museum, Amsterdam. 26 April–9 June. Catalogue. Traveled to: Staatliche Kunsthalle, Baden-Baden, 16 June–4 August.

Deutscher Künstlerbund. Kunstgebäude am Schloßplatz, Stuttgart. 18 May–30 June. Two paintings. Catalogue.

Kunstdiktatur: Gestern und heute. Galerie S (Ben Wargin), Berlin. 16 June–10 July. Painting. Catalogue.

Juryfreie Kunstausstellung Berlin 1963. Ausstellungshallen am Funkturm, Berlin. 21 June–21 July. Three paintings. Catalogue.

Werbegrafik 1920–30. Göppinger Galerie, Frankfurt. 27 June–20 July. Photomontage. Catalogue.

1964 Exhibition for *Woche der Brüderlichkeit* (Week of Fraternity). Rathaus Steglitz, Berlin. Opened 9 March. Three watercolors.

Deutscher Künstlerbund. Hochschule für bildende Künste, Berlin. 21 March–3 May. Two paintings. Catalogue.

Proben, Skizzen, Möglichkeiten (special exhibition of the Deutscher Künstlerbund). Haus am Waldsee, Berlin-Zehlendorf. [May]. Three works. Catalogue.

Club International Féminin. Musée d'Art Moderne de la ville de Paris, 12 May–10 June. Paintings.

Cinquante ans de "collage": papiers collés, assemblages, collages, du cubisme à nos jours. Musée d'art et d'industrie, Saint-Étienne, France. 23 June–13 September. Four collages. Catalogue. Traveled to: Musée des Arts Décoratifs, Paris, opened November 6.

Le Surréalisme: Sources, Histoire, Affinités. Galerie Charpentier, Paris. Watercolor. Catalogue.

1965 *Recent Acquisitions: Assemblage*. Museum of Modern Art, New York. 19 April–13 June. Four photomontages. Checklist.

Signale-Manifeste-Proteste im 20. Jahrhundert. Städtische Kunsthalle, Recklinghausen. 12 June–25 July. Two photo-montages. Catalogue.

Dada bis heute. Europäisches Forum, Alpach, Austria. 22 August–8 September. Nine watercolors and photomontages. Catalogue. Traveled to: Neue Galerie der Stadt Linz, Wolfgang-Gurlitt-Museum, Linz, Austria, 16 September–17 October; and Neue Galerie am Landesmuseum Joanneum, Graz, Austria, 23 October–21 November.

1966 *Dada*. Moderna Museet, Stockholm. 3 February–27 March. Four photomontages and collages. Catalogue.

Deutscher Künstlerbund. Ausstellungsgelände an der Gruga, Essen. 1–31 July. Three paintings and watercolors. Catalogue.

Dada 1916–1966: Documents of the International Dada Movement, curated by Hans Richter. Goethe Institute, Munich. [September]. Photographic documents. Catalogue. Traveled to: Galeria Nazionale d'Arte Moderna, Rome, November; National Museum for Modern Art, Tokyo, 1 June–14 July 1968 (with three original photomontages); and through 1970 to 36 countries in Europe, the Middle East, North America, and South America.

Dada: Ausstellung zum 50-jährigen Jubiläum. Kunsthaus, Zurich. 8 October–17 November. Ten photomontages and collages. Catalogue. Traveled to: Musée National d'Art Moderne, Paris, 30 November 1966–30 January 1967.

Exhibition of Berlin Artists to benefit Austrian flood victims. First National City Bank, Europa-Center, Berlin. 13–22 December. One watercolor.

1967 *Deutscher Künstlerbund*. Badischer Kunstverein and the Markthalle, Karlsruhe. 23 September–29 October. Four paintings. Catalogue.

Collage 67. Städtische Galerie im Lenbachhaus, Munich. 4 November–31 December. Two photomontages. Catalogue.

Berlin: Zwanziger Jahre: Malerei-Graphik-Plastik. Haus am Lützowplatz, Berlin. 8 December 1967–14 January 1968. Three paintings. Catalogue.

1968 *Dada, Surrealism and Their Heritage*. Museum of Modern Art, New York. 27 March–9 June. Two photomontages. Catalogue. Traveled to: Los Angeles County Museum of Art, 16 July–8 September; and Art Institute of Chicago, 19 October–8 December.

Von der Collage zur Assemblage. Städtische Kunstsammlungen, Nuremberg. 29 March–28 April. Two photomontages. Catalogue (*Prinzip Collage*).

Collagen aus sechs Jahrzehnten. Kunstverein, Frankfurt. 6 April–19 May. Collages. Catalogue.

Juryfreie Kunstausstellung Berlin 1968. Ausstellungshallen am Funkturm, Berlin. 23 April–15 May. Catalogue.

L'art en Europe autour de 1918. L'Ancienne Douane, Strasbourg, France. 8 May–15 September. Photomontage. Catalogue.

Graphik des XX. Jahrhunderts: Neuerwerbungen des Berliner Kupferstichkabinetts 1958–68. Staatliche Museen Preußischer Kulturbesitz, Kupferstichkabinett, Berlin-Dahlem. 30 May–13 October. Linoleum cuts. Catalogue.

Dada. National Museum for Modern Art, Tokyo. 1 June–14 July. Three photomontages. Catalogue.

Collagen: Die Geschichte der Collage. Kunstgewerbemuseum, Zurich. 8 June–18 August. Collages and photomontages. Catalogue.

Die Generation und ihre Verantwortung für unsere Umwelt. Organized by the Deutscher Werkbund. Akademie der Künste, Berlin. 11–13 October.

Realismus in der Malerei der 20er Jahre. Kunstverein, Hamburg. 19 October–1 December. Four paintings and watercolors. Catalogue. Traveled to: Kunstverein, Frankfurt am Main, 14 December 1968–2 February 1969.

The Machine: As Seen at the End of the Mechanical Age. Museum of Modern Art, New York. 25 November 1968–9 February 1969. Photomontage. Catalogue. Traveled to: Rice University and University of St. Thomas, Houston, 25 March–18 May 1969; and San Francisco Museum of Art, 23 June–24 August 1969.

Berlin XXe siècle: De l'expressionisme à l'art contemporain. Musée cantonal des beaux-arts, Lausanne, Switzerland. 27 November 1968–5 January 1969. Six paintings and photomontages. Catalogue.

Akademie 1968: Die Mitglieder der Abteilung bildende Kunst und ihre Gäste zeigen Arbeiten aus den Jahren 1958–1968. Akademie der Künste, Berlin. 8 December 1968–12 January 1969. Four paintings. Catalogue.

1969 *Die Fotomontage: Geschichte und Wesen einer Kunstform.* Ausstellungsräume Stadttheater, Ingolstadt. 11 January–5 February. Photomontages. Catalogue.

Industrie und Technik in der deutschen Malerei: Von der Romantik bis zur Gegenwart. Wilhelm-Lehmbruck-Museum, Duisburg. 7 May–13 July. One painting, two photomontages. Catalogue. Traveled to: Muzeum Narodowe, Warsaw, May 1970; and Wroclaw, Poland, 1970.

1970 *Künstler sehen Reinickendorf.* Rathaus, Berlin-Reinickendorf. 2–30 October. Nine watercolors and drawings. Catalogue.

1971 *Métamorphose de l'Objet: art et anti-art 1910–1970.* Palais des Beaux-Arts, Brussels. 22 April–6 June. Catalogue. Traveled to: Nationalgalerie, Berlin; Museum Boymans-van Beuningen, Rotterdam; Palazzo Reale, Milan; Kunsthalle, Basel; and Musée des Arts Décoratifs, Paris.

Deutsche Avantgarde 1915–35 (Konstruktivisten). Gallery Gmurzynska and Bargera, Cologne. 22 September 1971–January 1972. Catalogue.

1972 *Konstruktivismus: Entwicklungen und Tendenzen seit 1913.* Gallery Gmurzynska and Bargera, Cologne. 14 September–end December. Five gouaches, watercolors, and drawings. Catalogue.

Twin Towns Art 1972: Greenwich, Maribor, Reinickendorf. Woodlands Gallery, Greenwich, England, 16 September–17 October; Berlin-Reinickendorf; Umetnostna Galerija, Maribor, Yugoslavia. Three watercolors. Catalogue. Traveled to: Razstavni Salon, Rotovz, 29 October–18 November, with addition of twelve photomontages.

1973 *Medium Fotografie: Fotoarbeiten bildender Künstler von 1910 bis 1973.* Schloß Leverkusen, Leverkusen. May–5 August. Catalogue. Traveled to: Hamburg, Wolfsburg, and Munich in Germany, and Vienna, Innsbruck, and Graz in Austria.

Das kleinste Museum der Welt: Tabu Format. Kunstverein Wolfsburg im Schloß Wolfsburg. 24 June–22 July. Six mini-collages. Catalogue.

Collage and the Photo Image: A Selection from the Collection. Museum of Modern Art, New York. 17 July–11 September. One photomontage.

Prisma '73. Organized by the Deutscher Künstlerbund. Akademie der Künste, Berlin. 8 December 1973–20 January 1974. Mini-collages.

1974 *Realismus und Sachlichkeit: Aspekte deutscher Kunst 1919–1933.* Nationalgalerie, Berlin (East). Catalogue.

Exhibition of Academy members. Akademie der Künste, Berlin. March–April.

Große Kunstausstellung München 1974. Haus der Kunst, Munich. 13 June–22 September. Five drawings. Catalogue.

Vordemberge-Gildewart Remembered. Annely Juda Fine Art, London. 4 July–14 September. Catalogue.

1975 *Stilleben aus der deutschen Malerei des XX. Jahrhunderts.* Hessisches Landesmuseum, Darmstadt. 16 May–13 July. One painting. Catalogue.

"Als der Krieg zu Ende war": Kunst in Deutschland 1945–1950. Akademie der Künste, Berlin. 7 September–2 November. Watercolors, collage book, and painting. Catalogue.

1976 *240 Werke von 50 Künstlern des zwanzigsten Jahrhunderts.* Galerie Nierendorf, Berlin. 18 June–4 September. Four collages, one drawing. Catalogue.

The Artist and the Photograph. Israel Museum, Jerusalem. September–November. Catalogue.

Berliner Malerei der zwanziger Jahre: Eine Ausstellung der Berlinischen Galerie. Haus an der Redoute, Bonn-Bad Godesberg. 15 October–14 November. Two paintings, three photomontages. Catalogue.

Deutsche Zeichnungen der klassischen Moderne aus der National-galerie Berlin Staatliche Museen Preußischer Kulturbesitz. Städtisches Kunstmuseum, Bonn. 14 December 1976–23 January 1977. Two works. Catalogue.

Women Artists: 1550–1950. Los Angeles County Museum of Art. 21 December 1976–13 March 1977. One collage, one photomontage. Catalogue. Traveled to: University of Texas Art Museum, Austin, 12 April–12 June 1977; Carnegie Institute, Pittsburgh, 14 July–4 September 1977; and Brooklyn Museum, Brooklyn, New York, 8 October–27 November 1977.

1977 *Berlin/Hanover: The 1920s.* Museum of Fine Arts, Dallas. 26 January–13 March. One collage, one photomontage. Catalogue.

Schauplatz Deutschland: Die Dreißiger Jahre. Haus der Kunst, Munich. 11 February–17 April. Two paintings, one collage. Catalogue. Traveled to: Museum Folkwang, Essen, 30 April–3 July; and Kunsthaus, Zurich, 15 July–18 September.

Künstlerinnen international 1877–1977. Orangerie Schloß Charlottenburg, Berlin. 8 March–10 April. Ten collages and photomontages. Catalogue.* Traveled to: Kunstverein, Frankfurt am Main, 29 April–12 June.

240 Werke von 30 Künstlern des zwanzigsten Jahrhunderts. Galerie Nierendorf, Berlin. 16 May–16 August. One watercolor, one drawing. Catalogue.

Dada: Dada in Europa: Werke und Dokumente. Akademie der Künste, Berlin. 14 August–16 October. Eleven photomontages, one painting. Catalogue.* Traveled to: Städtische Galerie im Städelschen Kunstinstitut, Frankfurt am Main, 10 November 1977–8 Januuary 1978.

Der Anteil der Frau an der Kunst der 20er Jahre: Gemälde, Aquarelle, Zeichnungen, Graphik und Plastik. Galerie Pels-Leusden, Berlin. 5 September–19 October. Ten watercolors and drawings.

Art of the Dadaists. Helen Serger La Boetie, Inc., New York. 27 September–November. Catalogue.

Deutsche bildende Künstlerinnen von der Goethezeit bis zur Gegenwart. Nationalgalerie, Berlin (East). Three works. Catalogue.

1978 *Dada and Surrealism Reviewed.* Hayward Gallery, London. 11 January–27 March. Five photomontages and collages. Catalogue.

Dada–International–Exposition. Goethe Institut, Paris. 16 February–17 March.

Paris–Berlin: 1900–1933. Centre National d'Art et de Culture Georges Pompidou, Paris. 12 July–6 November. Photomontages. Catalogue.

Berlin in Bottrop: Grosz, Heartfield, Höch, Uhlmann. Quadrat Bottrop, Staatliche Kunsthalle Berlin. 19 August–30 September. Eight collages, one painting. Catalogue.

Zwischen Widerstand und Anpassung: Kunst in Deutschland 1933–45. Akademie der Künste, Berlin. 17 September–29 October. Catalogue.*

The Twenties in Berlin: Johannes Baader, George Grosz, Raoul Hausmann, Hannah Höch. Annely Juda Fine Art, London. 8 November 1978–27 January 1979. Catalogue.*

1979 *Kultur und Gesellschaft der Weimarer Republik.* Moderna Museet, Stockholm. 17 February–22 April.

Film und Foto der 20er Jahre. Württembergischer Kunstverein, Stuttgart. 17 May–8 July. Catalogue. Traveled to: Museum Folkwang, Essen, 5 August–9 September.

Dada Photographie und Photocollage. Kestner-Gesellschaft, Hanover. 6 June–5 August. Catalogue.

Das Prinzip Collage. Galerie Brusberg, Hanover.

1980 *3 Sammlungen: Sammlung VEBA: 14 Kunstwerke 1930–58; Nachlaß Conrad Felixmüller; Nachlaß Hannah Höch*. Berlinische Galerie, Berlin. 8 January–10 February. Thirty works. Catalogue.

1982 *Fyra engagerade i Berlin: Hannah Höch, Käthe Kollwitz, Jeanne Mammen*. Konstakademien för de fria konsterna samt författarna, Stockholm. 13 February–28 March. Catalogue.

Elendsjahre: Kunst in Berlin 1937 bis 1956. Overbeck-Gesellschaft, Lübeck. 8 August–12 September. Four paintings, one collage. Catalogue.

1984 *Hannah Höch, Sarah Schumann*. Galerie Brusberg, Berlin. 17 January–18 July.

"Primitivism" in Twentieth-Century Art. Museum of Modern Art, New York. 19 September 1984–15 January 1985. Catalogue. Traveled to: Detroit Institute of Arts, 23 February–19 May 1985; and Dallas Museum of Art, 15 June–8 September 1985.

Dada–Constructivism: The Janus Face of the Twenties. Annely Juda Fine Art, London. 26 September–15 December. Fifteen works in various media. Catalogue.

Dada and Surrealism in Chicago Collections. Museum of Contemporary Art, Chicago. 1 December 1984–27 January 1985. Catalogue.

1985 *Vom Klang der Bilder: Die Musik in der Kunst des 20. Jahrhunderts*. Staatsgalerie, Stuttgart. 6 July–22 September. Two photomontages, one drawing. Catalogue.

Literatur und Kunst im Dialog. Museum der bildende Künste, Leipzig. 12 August–22 September. Catalogue. Traveled in 1986 to: Schloßmuseum Schloß Friedenstein, Gotha; Staatliche Galerie, Halle; and Roter Turm, Moritzburg.

1986 *Deutsche Kunst im 20. Jahrhundert: Malerei und Plastik 1905–1985*. Staatsgalerie, Stuttgart. 8 February–27 April. Catalogue. Traveled to: Royal Academy of Arts, London, 11 October–22 December.

Kunst in Berlin von 1870 bis heute. Berlinische Galerie, Berlin. Opened 30 November. Catalogue.

The University of Iowa Museum of Art: 101 Masterworks, Iowa City. Catalogue.

1987 *Kunst in Berlin: 1648–1987: Ausstellung anläßlich der 750 jährigen Bestehens von Berlin*. Staatliche Museen zu Berlin, Altes Museum, Berlin (East). 10 June–25 October. Catalogue.

Exotische Welten—Europäische Phantasien. Württembergischer Kunstverein and Institut für Auslandsbeziehungen, Kunstgebäude zum Schloßplatz, Stuttgart. 2 September–29 November. Catalogue.

1988 *Hannah Höch, Manfred Henninger and Oskar Kreibich*. Kleine Orangerie, Schloß Charlottenburg, Berlin. 30 July–3 September.

Stationen der Moderne: Die bedeutenden Kunstausstellungen des 20. Jahrhunderts in Deutschland. Berlinische Galerie, Berlin. 25 September 1988–8 January 1989. Catalogue.*

Dada and Constructivism. Seibu Museum of Art, Tokyo. 8 October–13 November. Catalogue. Traveled to: Seibu Tsukashin Art Hall, Amagasaki, Japan, 19 November–21 December; Museum of Modern Art, Kamakura, Japan, 5 January–12 February 1989; and Museo Nacional Centro de Arte Reina Sofía, Madrid, 10 March–30 April 1989.

1989 *Der Traum von einer neuen Welt: Berlin 1910–1933*. Museum-Altes-Rathaus, Ingelheim am Rhein. 23 April–4 June. Catalogue.

Glanzlichter. Städtisches Kunstmuseum, Bonn. 8 September–22 November.

Art in Berlin 1815–1989. High Museum of Art, Atlanta. 14 November 1989–14 January 1990. Catalogue.

1990 *Mozart in Art 1900–1990*. Mozarts Geburtshaus, Salzburg. 6 January–7 October. Six works. Catalogue. Traveled to: Bayerische Vereinsbank, Palais Preysing, Munich, 8 November 1990–12 January 1991; Barbican Center, London, opened 13 February 1991; Kölner Philharmonie, Cologne, 11 April–9 June 1991; and Bad Urach, 27 September–20 October 1991.

The Louise Noun Collection: Art by Women. University of Iowa Museum of Art, Iowa City. 25 May–5 August. Three photomontages, one collage, one painting, one watercolor. Catalogue.*

Künstlerinnen des 20. Jahrhunderts. Museum Wiesbaden. 1 September–25 November. Catalogue.

1991 *Rollenbilder im Nationalsozialismus: Umgang mit dem Erbe*. Frauen Museum, Bonn. 17 November 1991–12 January 1992. Catalogue. Traveled to: Mülhäuser Museen, Mülhaus, 23 February –22 March 1992; Kunsthochschule, Berlin-Weisensee, 2–20 November 1992; and Kulturreferat der Stadt, Munich, 5 October–7 November 1993.

1992 *Montage and Modern Life 1919–1942*. Institute for Contemporary Art, Boston. 7 April–7 June. Catalogue.* Traveled to: Vancouver Art Gallery, Canada, 19 August–18 October; and Palais des Beaux-Arts, Brussels, 3 November 1992–3 January 1993.

Professionen ohne Tradition: 125 Jahre Verein der Berliner Künstlerinnen. Berlinische Galerie, Berlin. 11 September–1 November. Nine works. Catalogue.

1993 *Surrealism: Revolution by Night*. National Gallery of Australia, Canberra. 12 March–2 May. Catalogue. Traveled to: Queensland Art Gallery, Brisbane, 21 May–11 July; and Art Gallery of New South Wales, Sydney, 30 July–19 September.

Der weibliche Blick: Gemälde, Zeichnungen, Druckgraphik 1897–1947. Galerie der Stadt Aschaffenburg. 13 March–18 April. Catalogue.

Unter anderen Umständen: Zur Geschichte der Abtreibung. Deutsches Hygiene Museum, Dresden. 1 July–31 December. Catalogue.

160. Jubiläums-Ausstellung. Mannheimer Kunstverein, Mannheim. September–October.

Dada: Eine internationale Bewegung 1916–25. Organized by Kunsthaus, Zurich. Five works. Catalogue. Traveled to: Kunsthalle der Hypo-Kulturstiftung, Munich, 4 September–7 November; Sprengel Museum, Hanover, 21 November 1993–6 February 1994; Kunsthaus, Zurich, 12 August–6 November 1994 (exhibition and catalogue titled *Dada global*).

1994 *Three Berlin Artists of the Weimar Era: Hannah Höch, Käthe Kollwitz, and Jeanne Mammen*. Des Moines Art Center, Des Moines, Iowa. 23 April–17 July. Twenty-two works (photomontages, collages, watercolors, lithograph). Catalogue.* Traveled to: Galerie St. Etienne, New York, through 5 November.

Fotografieren hiess teilnehmen. Museum Folkwang, Essen. 16 October 1994–8 January 1995. Catalogue. Traveled to: Fundacio La Caixa, Barcelona, 23 January–26 March 1995; and Jewish Museum, New York, 23 April–31 July 1995.

1995 *Kampf der Geschlechter: Der neue Mythos in der Kunst 1850–1930*. Städtische Galerie im Lenbachhaus, Munich. 7 March–7 May. Catalogue.*

1996 *Inside the Visible: An Elliptical Traverse of 20th-Century Art*. Institute for Contemporary Art, Boston. 30 January–12 May. Three photomontages. Catalogue.*

BIBLIOGRAPHY

ARCHIVES

Hannah-Höch-Archiv, Berlinische Galerie, Landesmuseum für Moderne Kunst, Photographie und Architektur, Berlin

Höch Family Archives, Germany

Stiftung Hans Arp und Sophie Taeuber Arp, Bahnhof Rolandseck, Rolandseck, Germany

Til Brugman Correspondence, Germanisches Nationalmuseum, Nuremberg

Theo van Doesburg Archives, Rijksbureau voor kunsthistorische Documentatie, The Hague, the Netherlands

Raoul Hausmann–Doris Hahn Correspondence, Staatsbibliothek Preußischer Kulturbesitz, Berlin, Handschriften-Abteilung

Richard Huelsenbeck Correspondence, Getty Center for the History of Art and the Humanities, Santa Monica, California

International Dada Archive, University of Iowa, Iowa City

František Kalivoda Correspondence, Municipal Museum, Brno, Czech Republic

Kurt Schwitters Archiv, Stadtbüchereien, Stadt Hannover, Hanover, Germany

SELECTED WRITINGS AND LECTURES BY HANNAH HÖCH

"Vom Sticken." *Stickerei- und Spitzen-Rundschau* 18, no. 12 (September 1918), p. 220.

"Was ist schön?" *Stickerei- und Spitzen-Rundschau* 19, nos. 1–2 (October–November 1918), pp. 8–16.

"Weiss-Stickerei: Mit technischen Erläuterungen zu den preisgekrönten Arbeiten unseres vierten Wettbewerbes." *Stickerei- und Spitzen-Rundschau* 19, no. 3 (December 1918), pp. 45–52.

"Die freie Stick-Kunst." *Stickerei- und Spitzen-Rundschau* 20, nos. 1–2 (October–November 1919), p. 22.

"Die stickende Frau." *Stickerei- und Spitzen-Rundschau* 20, nos. 1–2 (October–November 1919), p. 26.

"Italienreise." *NG: Veröffentlichung der Novembergruppe*, no. 1 (May 1921), pp. 15–17.

[Foreword]. In *Hannah Höch*. Exhibition catalogue. The Hague: Kunstzaal de Bron, 1929. Reprinted in German in *Hannah Höch*, exh. cat. (Berlin: Galerie Franz, 1949); and in *Hannah Höch: Fotomontagen, Gemälde, Aquarelle*, edited by Götz Adriani, exh. cat. (Cologne: DuMont Buchverlag, 1980). English translation in *Collages: Hannah Höch 1889–1978*, exh. cat. (Stuttgart: Institute for Foreign Cultural Relations, 1985).

"O filmové censuře." *Index: List pro kulturní politiku* (Czechoslovakia) 4, no. 11 (November 1932), p. 91.

"Nekolik poznámek o fotomontázi." *Středisko* (Czechoslovakia) 4, no. 1 (April 1934), unpaginated. Translated by Jitka Salaguarda as "A Few Words on Photomontage" in *Cut with the Kitchen Knife: The Weimar Photomontages of Hannah Höch*, by Maud Lavin (New Haven and London: Yale University Press, 1993), pp. 219–220.

"Fantastische Kunst." In *Fantasten–Ausstellung*. Exhibition catalogue. Berlin: Galerie Rosen, 1946. Reprinted in *Zone 5: Kunst in der Viersektorenstadt 1945–1951*, edited by Gillen Eckhart and Diether Schmidt (Berlin: Berlinische Galerie and Verlag Dirk Nishen, 1989), pp. 171–172.

"Die Fotomontage." In *Fotomontage von Dada bis heute*. Exhibition catalogue. Berlin: Galerie Rosen, 1946. Reprinted in *Hannah Höch 1889–1978: Ihr Werk, Ihr Leben, Ihre Freunde*, exh. cat. (Berlin: Berlinische Galerie and Argon, 1989), pp. 218–219.

"Lebensüberblick" (1958). In *Hannah Höch 1889–1978: Ihr Werk, Ihr Leben, Ihre Freunde*, pp. 195–199. Exhibition catalogue. Berlin: Berlinische Galerie, 1989. Translated by Peter Chametzky as "A Glance Over my Life" in *Cut with the Kitchen Knife: The Weimar Photomontages of Hannah Höch*, by Maud Lavin (New Haven and London: Yale University Press, 1993), pp. 211–215.

"Die Revue: Eine der Reisen mit Kurt Schwitters." In *Dada: Dokumente einer Bewegung*. Exhibition catalogue. Amsterdam: Stedelijk Museum, 1958. Reprinted in *Dada: Eine literarische Dokumentation*, edited by Richard Huelsenbeck (Hamburg: Rowohlt, 1964), pp. 255–257; and in *Hannah Höch 1889–1978: Ihr Werk, Ihr Leben, Ihre Freunde*, exh. cat. (Berlin: Berlinische Galerie and Argon, 1989), pp. 215–217.

"Erinnerungen an DADA." Lecture, Düsseldorf, 1966. In *Hannah Höch 1889–1978: Ihr Werk, Ihr Leben, Ihre Freunde*, pp. 201–213. Exhibition catalogue. Berlin: Berlinische Galerie and Argon, 1989.

"Zur Collage." In *Hannah Höch: Collagen aus den Jahren 1916–1971*. Exhibition catalogue. Berlin: Akademie der Künste, 1971.

SELECTED INTERVIEWS AND DISCUSSIONS WITH HANNAH HÖCH

Freisel, Johannes. Radio interview broadcast on Deutsche Welle, 2 July 1970. Unpublished transcript in the Hannah Höch Archive, Berlinische Galerie, Landesmuseum für Moderne Kunst, Photographie und Architektur, Berlin.

Gebhardt, Heiko, and Stefan Moses. "Ein Leben lang im Gartenhaus: Heiko Gebhardt and Stefan Moses besuchen Hannah Höch, die große alte Dame der einstigen Protest-Kunst Dada." *Stern*, 22 April 1976, pp. 96–103.

Orgel-Köhne, Liselotte, and Armin Orgel-Köhne. Taped conversations with Hannah Höch, 1973. Liselotte and Armin Orgel-Köhne, Berlin.

Pagé, Suzanne. "Interview avec/mit Hannah Höch." In *Hannah Höch: Collages, Peintures, Aquarelles, Gouaches, Dessins/Collagen, Gemälde, Aquarellen, Gouachen, Zeichnungen*, pp. 23–32. Exh. cat. Paris and Berlin: Musée d'Art Moderne de la Ville de Paris and Nationalgalerie Berlin Staatliche Museen Preußischer Kulturbesitz, 1976.

Pehnt, Wolfgang. "Jene zwanziger Jahre: Ein Gespräch mit Hannah Höch." Radio interview broadcast on Deutschlandfunk, 4 March 1973. Unpublished transcript in the Hannah Höch Archive, Berlinische Galerie, Landesmuseum für Moderne Kunst, Photographie und Architektur, Berlin.

Roditi, Edouard. "Hannah Höch und die Berliner Dadaisten: Ein Gespräch mit der Malerin." *Der Monat* 12, no. 34 (November 1959), pp. 60–68. Published in English as "Interview with Hannah Höch," *Arts* 34, no. 3 (December 1959), pp. 24–29; reprinted in *Dialogues: Conversations with European Artists at Mid-Century*, by Edouard Roditi (San Francisco: Bedford Arts, 1990), pp. 65–74.

WRITINGS ABOUT HANNAH HÖCH

Books

Dech, Gertrud Jula. *Schnitt mit dem Küchenmesser DADA durch die letzte weimarer Bierbauchkulturepoche Deutschlands: Untersuchungen zur Fotomontage bei Hannah Höch*. Münster: Lit Verlag, 1981.

———. *Hannah Höch: Schnitt mit dem Küchenmesser Dada durch die letzte weimarer Bierbauchkulturepoche Deutschlands*. Series "kunststück," edited by Klaus Herding. Frankfurt am Main: Fischer Taschenbuch Verlag GmbH, 1989.

Dech, Gertrud Jula, and Ellen Maurer, eds. *Da-da zwischen Reden zu Hannah Höch*. Berlin: Orlanda Frauenverlag, 1991. Essays by Hanne Bergius, Rita Bischof, Jula Dech, Erica Doctorow, Myriam Everard, Hanna Gagel, Margarethe Jochimsen, Annegret Jürgens-Kirchhoff, Maud Lavin, Annelie Lütgens, and Ellen Maurer; and proceedings of a panel discussion with Höch's contemporaries.

Faber, Elmar, and Hans Marquardt, eds. *Fange die blauen Bälle meines Daseins: Aquarelle, Texte, Notate und drei Original-linolschnitte/Hannah Höch*. Berlin: Sisyphos-Presse, 1994.

Hannah Höch: Eine Lebenscollage. Archive edition. Volume 1 (1889–1920) (2 parts). Edited by Cornelia Thater-Schulz. Foreword by Eberhard Roters. Berlin: Berlinische Galerie and Argon, 1989.

Hannah Höch: Eine Lebenscollage. Archive edition. Volume 2 (1921–1945) (2 parts). Part 1: Texts by Eberhard Roters and Heinz Ohff. Part 2: Documents, edited by Ralf Burmeister and Eckhard Fürlus. Berlin: Berlinische Galerie and Hatje, 1995.

Lavin, Maud. *Cut with the Kitchen Knife: The Weimar Photomontages of Hannah Höch*. New Haven and London: Yale University Press, 1993.

Maurer, Ellen. *Hannah Höch: Jenseits fester Grenzen: Das malerische Werk bis 1945*. Berlin: Gebr. Mann Verlag, 1995.

Ohff, Heinz. *Hannah Höch*. Berlin: Gebr. Mann and Deutsche Gesellschaft für Bildende Kunst e.V., 1968.

Selected Solo Exhibition Catalogues

Adriani, Götz, ed. *Hannah Höch: Fotomontagen, Gemälde, Aquarelle*. Cologne: DuMont Buchverlag, 1980. Texts by Götz Adriani, Jula Dech, Peter Krieger, Heinz Ohff, Eberhard Roters, and Karin Thomas.

Collages: Hannah Höch 1889–1978. Stuttgart: Institute for Foreign Cultural Relations, 1985. Includes translations of essays by Götz Adriani, Peter Krieger, Eberhard Roters, and Karin Thomas that first appeared in the exhibition catalogue *Hannah Höch: Fotomontagen, Gemälde, Aquarelle*.

Hannah Höch. Kunstblätter 6. Berlin: Galerie Nierendorf, 1964. Text by Will Grohmann, with five original linoleum cuts by Höch.

Hannah Höch. London: Marlborough Gallery, 1966. Text by Will Grohmann.

Hannah Höch 1889–1978. London: Fischer Fine Art Ltd., 1983; New York: Helen Serger, La Boetie, 1983. Text by Frank Whitford.

Hannah Höch 1889–1978: Ihr Werk, Ihr Leben, Ihre Freunde. Berlin: Berlinische Galerie and Argon, 1989. Texts by Hanne Bergius, Peter Krieger, Maud Lavin, Pavel Liška, Jörn Merkert, Heinz Ohff, Chris Rehorst, Eberhard Roters, Armin Schulz, Cornelia Thater-Schulz, and Bernd Weise.

Hannah Höch: Ausstellung zum 100. Geburtstag. Berlin: Galerie Bodo Niemann, 1989. Text by Delia Güssefeld.

Hannah Höch: Collagen. Berlin: Galerie Rosen, 1957. Text by Herta Wescher.

Hannah Höch: Collagen aus den Jahren 1916–1971. Berlin: Akademie der Künste, 1971. Texts by Hannah Höch and Eberhard Roters.

Hannah Höch: Collages, Peintures, Aquarelles, Gouaches, Dessins/Collagen, Gemälde, Aquarellen, Gouachen, Zeichnungen. Paris and Berlin: Musée d'Art Moderne de la Ville de Paris and Nationalgalerie Berlin Staatliche Museen Preußischer Kulturbesitz, 1976. In French and German. Texts by Hanne Bergius and Peter Krieger, interview by Suzanne Pagé.

Hannah Höch: Fotomontagen und Gemälde. Bielefeld: Kunsthalle, 1973. Text by Hans Georg Gmelin.

Hannah Höch: Gotha 1889–1978 Berlin. Gotha: Museen der Stadt Gotha, 1993. Texts by Götz Adriani, Jula Dech, Hannah Höch, Peter Krieger, Ellen Maurer, and Kamen Pawlow.

Hannah Höch zum neunzigsten Geburtstag. Berlin: Galerie Nierendorf, 1979. Text by Florian Karsch.

Remmert, Herbert, and Peter Barth. *Hannah Höch: Werke und Worte*. Berlin: Frölich und Kaufmann, 1982.

Selected Articles and Essays

Beckett, Jane. "Hannah Höch." In *The Twenties in Berlin: Johannes Baader, George Grosz, Raoul Hausmann, Hannah Höch*. Exhibition catalogue. London: Annely Juda Fine Art, 1978.

Benson, Timothy O. "Hausmann–Höch: Begegnung als Künstler." In *"Wir wünschen die Welt bewegt und beweglich,"* edited by Eva Züchner, pp. 30–44. Raoul Hausmann Symposium. Berlin: Berlinische Galerie, 1995.

Bergius, Hanne. "Schrankenlose Freiheit für Hannah Höch." In *Das Lachen Dadas: Die Berliner Dadaisten und Ihre Aktionen*, pp. 130–143. Giessen: Anabas Verlag, 1989.

Bosch, Mineke, and Myriam Everard, eds. *Lust en Gratie*. Special issue on Hannah Höch and Til Brugman. *Lesbisch Cultureel Tijdschrift* 19 (Fall 1988).

Carrick, Jill M. "Re-figuring Medusa's Head: Hannah Höch's *From an Ethnographic Museum* and *Portrait* Series." In *Weimar Culture: Issues of Modernity and the Metropolis*, edited by C. Gannon and S. Melton, pp. 123–130. Proceedings of conference, 15–17 April 1994. Tucson: Department of German Studies, University of Arizona, 1995.

Dietrich, Barbara. "Ausstellungsbesprechung Hannah Höch." *Pantheon* 34, no. 3 (1976), pp. 243–244.

Federle, Courtney. "'Kuchenmesser Dada': Hannah Höch's Cut Through the Field of Vision." *Qui Parle* 5, no. 2 (Spring–Summer 1992), pp. 120–134.

Gerber, Jerry. "Onward from Dada: A Day with Hannah Höch." *Art Voices* 2, no. 10 (October 1963), p. 11.

Güssefeld, Delia. "Hannah Höch (1889–1978)." *Lust en Gratie* 19 (Fall 1988), pp. 18–23.

Hoffmann-Curtius, Kathrin. "Michelangelo beim Abwasch: Hannah Höchs Zeitschnitt der Avantgarde." In *Die Verhältnisse der Geschlechter zum Tanzen bringen*, edited by Daniela Hammer-Tugendhat et al., pp. 59–80. Rundbrief Frauen Kunst Wissenschaft, no. 12 (1991).

Hubert, Renée Riese. "The Revolutionary and the Phoenix: Hannah Höch and Raoul Hausmann." In *Magnifying Mirrors: Women, Surrealism, and Partnership*, pp. 277–307. Lincoln: University of Nebraska Press, 1994.

Krieger, Peter. "Hannah Höch." In *Zwischen Widerstand und Anpassung: Kunst in Deutschland 1933–1945*, p. 152. Exhibition catalogue. Berlin: Akademie der Künste, 1978.

Lavin, Maud. "Androgyny, Spectatorship, and the Weimar Photomontages of Hannah Höch." *New German Critique* 51 (Fall 1990), pp. 62–86.

———. "Strategies of Pleasure and Deconstruction: Hannah Höch's Photomontages in the Weimar Years." In *The Divided Heritage: Themes and Problems in German Modernism*, edited by Irit Rogoff, pp. 93–115. Cambridge: Cambridge University Press, 1991.

———. "The Mess of History or the Unclean Hannah Höch." In *Inside the Visible: An Elliptical Traverse of 20th Century Art in, of, and from the Feminine*, edited by M. Catherine de Zegher, pp. 117–124. Exhibition catalogue. Boston and Cambridge: Institute for Contemporary Art and MIT Press, 1996.

Lindner, Ines. "Beobachtungen zum Hannah Höch–Symposion vom 16.–19.11.1989 in Berlin." *Kritische Berichte* 1 (1990), pp. 92–96.

Lütgens, Annelie. "Hannah Höch: Totentanz und Friedenstaube." In *Zone 5: Kunst in der Viersektorenstadt 1945–1951*, edited by Eckhart Gillen and Diether Schmidt, pp. 77–80. Berlin: Berlinische Galerie and Verlag Dirk Nishen, 1989.

Makela, Maria. [Object annotations]. In *The Louise Noun Collection: Art by Women*, pp. 24–34. Exhibition catalogue. Iowa City: University of Iowa Museum of Art, 1990.

———. "Hannah Höch." In *Three Berlin Artists of the Weimar Era: Hannah Höch, Käthe Kollwitz, Jeanne Mammen*, pp. 13–26. Exh. cat. Des Moines: Des Moines Art Center, 1994.

———. "The Misogynist Machine: Images of Technology in the Work of Hannah Höch." In *Women in the Metropolis: The Female Experience of Modernity*, edited by Katharina von Ankum, pp. 106–127. Berkeley: University of California Press, 1996.

Maurer, Ellen. "Dadasoph und Dada-Fee: Hannah Höch und Raoul Hausmann, Eine Fallstudie." In *Der Kampf der Geschlechter: Der neue Mythos in der Kunst 1850–1930*, edited by Barbara Eschenburg, pp. 323–328. Exhibition catalogue. Munich: Städtische Galerie im Lenbachhaus, 1995.

Paulsen, Gerritt P. "Hannah Höch: Achtzig Jahre alt und noch modern." *Die Welt der Frau*, 1 January 1970, pp. 16–17.

Petersen, Karin, and Inge Schumacher. "Dada-mann dada-frau. . . oder warum das Wasser wieder einmal den Bach hinunter lief." In *Künstlerinnen International 1877–1977*. Exhibition catalogue. Berlin: Schloß Charlottenburg, 1977.

Pierre, José. "Hannah Höch et le photomontage dadaiste berlinois." *Techniques graphiques* (Paris) (November–December 1966), pp. 351–362.

Rempel, Lora. "The Anti-Body in Photomontage: Hannah Höch's Woman without Wholeness." In *Sexual Artifice: Person, Images, Politics*, edited by Ann Kibbey et al., pp. 148–170. Genders 19. New York: New York University Press, 1994.

Roters, Eberhard. "Hintergrundanalyse der Collage 'Schnitt mit dem Küchenmesser' (1920) von Hannah Höch." In *Prinzip Collage*, edited by Franz Mon and Heinz Heidel, pp. 42–44. Neuwied and Berlin: Hermann Luchterhand, 1968.

———. "Hannah Höch: Eröffnungsrede zur Retrospektive in der Aademie, Juni 1971." *Neue Deutsche Hefte* (Berlin) 18, no. 3 (1971), pp. 219–227.

———. "Hannah Höch: Collages and Photomontages." In *Berlin Now: Contemporary Art 1977*, pp. 19–25. Exhibition catalogue. New York: Goethe House, 1977.

———. "Hannah Höch." In *3 Sammlungen: Sammlung VEBA: 14 Kunstwerke 1930–1958; Nachlaß Conrad Felixmüller; Nachlaß Hannah Höch*, pp. 17–18. Exhibition catalogue. Berlin: Berlinische Galerie, 1980.

———. "Bildsymbolik im Werk Hannah Höchs." In *Fabricatio nihilil oder Die Herstellung von Nichts: Dada Meditationen*, pp. 175–191. Berlin: Argon Verlag, 1990.

Ruhmer, Eberhard. "Hannah Höch: Eine Außenseiterin." *Die Kunst und das Schöne Heim* 60 (December 1961), pp. 108–111.

Schmidt, Doris. "Nonsens als Waffe." *Emma: Zeitschrift für Frauen von Frauen*, no. 7 (1980), pp. 54–58.

Sello, Katrin. "Bubikopfmuse im Männerclub." *Die Zeit*, 9 June 1978, p. 38.

Thompson Wylder, Viki D. "Hannah Höch: A Familiar Struggle, A Unique Point of View." *Athanor* 5 (1986), pp. 33–41.

Theses and Dissertations

Doctorow, Erica. "Hannah Höch and Berlin Dada." Master's thesis, City University of New York, 1981.

Güssefeld, Delia. "Hannah Höch: Freunde und Briefpartner 1915–1933." Master's thesis, Freie Universität Berlin, 1984.

Johnson, Melissa. "Constructing an Alternative Frame of Reference: Critical Strategies of Juxtaposition and Mimicry in the Photomontages and Scrapbook of Hannah Höch." Master's thesis, Brn Mawr College, 1994.

Kallos, Kay Klein. "A Woman's Revolution: The Relationship between Design and the Avant-Garde in the Work of Hannah Höch 1912–1922." Ph.D. diss., University of Wisconsin–Madison, 1994.

Lange, Sabine. "Die Entwürfe Hannah Höchs zur Anti-Revue." Master's thesis, Albertus-Magnus-Universität, Cologne, 1984.

Lorenz, Marianne. "Hannah Höch's Dada Photomontages: An Iconography of the Berlin Years." Master's thesis, University of Colorado, 1981.

Maurer, Ellen. "Symbolische Gemälde von Hannah Höch aus den Jahren 1920–30." Master's thesis, Ludwig-Maximilians Universität, Munich, 1984.

———. "Das malerische Werk von Hannah Höch bis 1945." Ph.D. diss., Ludwig-Maximilians Universität, Munich, 1991.

Owen, Nancy. "Hannah Höch's Images of Women, 1916–1933." Master's thesis, School of the Art Institute of Chicago, 1991.

Schmid, Lynda Joanna. "The Photograph as a Source: An Examination of the Collage Works of Hannah Höch and the Painting of Francis Bacon." Master's thesis, University of Iowa, 1978.

Stewart, Mary Bridget. "Hannah Hoch: Experimentation as Style." Master's thesis, University of Iowa, 1986.

Sturm, Gesine. "'Ich verreise in meinen Garten': Der Garten von Hannah Höch: Pflegekonzept für einen Künstlergarten." Ph.D. diss., Technische Universität Berlin, 1993.

GENERAL REFERENCES

Ades, Dawn. *Photomontage*. New York: Pantheon Books, 1976.

Benson, Timothy O. *Raoul Hausmann and Berlin Dada*. Ann Arbor, Michigan: UMI Research Press, 1987.

Bergius, Hanne. "Der Da-Dandy: Das 'Narrenspiel aus dem Nichts.'" In *Tendenzen der Zwanziger Jahre*, pp. 3.12–3.29. Berlin: Dietrich Reimer, 1977.

———. *Das Lachen Dadas: Die Berliner Dadaisten und Ihre Aktionen*. Giessen: Anabas Verlag, 1989.

Bridenthal, Renate, Atina Grossmann, and Marion Kaplan, eds. *When Biology Became Destiny: Women in Weimar and Nazi Germany*. New York: Monthly Review Press, 1984.

Brugman, Til. *Scheingehacktes*. Illustrated by Höch. Berlin: Rabenpresse, 1935.

Dada: Dada in Europa: Werke und Dokumente. Exhibition catalogue. Frankfurt am Main and Berlin: Städtische Galerie im Städelschen Kunstinstitut and Diedrich Reimer Verlag, 1977.

Doherty, Brigid. "Fashionable Ladies, Dada Dandies." *Art Journal* 54, no. 1 (Spring 1995), pp. 46–50.

Frevert, Ute. *Women in German History: From Bourgeois Emancipation to Sexual Liberation*. Oxford and Providence: Berg Publishers, 1988.

Gillen, Eckhart, and Diether Schmidt, eds. *Zone 5: Kunst in der Viersektorenstadt 1945–1951*. Berlin: Berlinische Galerie and Verlag Dirk Nishen, 1989.

Hays, Michael. "Photomontage and its Audiences, Berlin, Circa 1922." *Harvard Architectural Review* (1987–1988), pp. 19–31.

Hiepe, Richard. *Die Fotomontage: Geschichte und Wesen einer Kunstform*. Exhibition catalogue. Ingolstadt: Kunstverein Ingolstadt, 1971.

Hildebrandt, Hans. *Die Frau als Künstlerin*. Berlin: Rudolf Mosse Verlag, 1928.

Hoffmann-Curtius, Kathrin. "Geschlechterspiel im Dada-ismus." *Kunstforum*, no. 128 (October–December 1994), pp. 166–169.

Huelsenbeck, Richard, ed. *Dada: Eine literarische Dokumentation*. Hamburg: Rowohlt, 1964.

Kaes, Anton, Martin Jay, and Edward Dimendberg, eds. *The Weimar Republic Sourcebook*. Berkeley, Los Angeles, and London: University of California Press, 1994.

Mehring, Walter. *Berlin Dada: Eine Chronik mit Photos und Dokumenten*. Zurich: Verlag der Arche, 1959.

———. *Ich habe die Welt zu malen, nicht zu ändern*. 2 vols. Hanover: Postscriptum, 1990.

Montage and Modern Life: 1919–1942. Exhibition catalogue. Boston and Cambridge: Institute of Contemporary Art and MIT Press, 1992.

Motherwell, Robert, ed. *The Dada Painters and Poets: An Anthology*. New York: Wittenborn, 1951.

Richter, Hans. *Dada: Art and Anti-Art*. Translated by David Britt. London: Thames and Hudson, 1966. Reprint, New York and Toronto: Oxford University Press, 1978. Originally published as *Dada: Kunst und Antikunst* (Cologne: DuMont Schauberg, 1964).

———. *Begegnungen von Dada bis heute: Briefe, Dokumente, Erinnerungen*. Cologne: DuMont Schauberg, 1973.

Riha, Karl, and Günter Kämpf, eds. *Am Anfang war Dada*. 2nd ed. Gießen: Anabas Verlag, 1980.

Rosenblum, Naomi. *History of Women Photographers*. Paris and New York: Abbeville Press, 1994.

Schulz, Bernhard, ed. *Grauzonen: Kunst und Zeitbilder: Farbwelten, 1945–1955*. Berlin and Vienna: Medusa Verlagsgesellschaft, 1983.

Sobieszek, Robert. "Composite Imagery and the Origins of Photomontage, Part 1: The Naturalistic Strain." *Artforum* 17, no. 2 (September 1978), pp. 58–65. "Part 2: The Formalist Strain." *Artforum* 17, no. 3 (October 1978), pp. 40–45.

Stationen der Moderne: die bedeutenden Kunstausstellungen des 20. Jahrhunderts in Deutschland. Exhibition catalogue. Berlin: Berlinische Galerie and Nicolaische Verlagsbuch, 1988.

Steinweis, Alan E. *Art, Ideology and Economics in Nazi Germany: The Reichschambers of Music, Theater and the Visual Arts*. Chapel Hill: University of North Carolina Press, 1993.

Wescher, Herta. *Die Collage: Geschichte eines künstlerischen Ausdrucksmittels*. Cologne: Verlag M. DuMont Schauberg, 1968.

Willett, John. *Art and Politics in the Weimar Period: The New Sobriety, 1917–1933*. New York: Pantheon Books, 1978.

INDEX OF WORKS BY HANNAH HÖCH

Page numbers in boldface type indicate illustrations.

REPRODUCTION CREDITS

All works by Hannah Höch © 1996 Artists Rights Society (ARS), New York/VG Bild-Kunst, Bonn

Courtesy Akademie der Künste, Berlin; Photo B. Kuhnert, Berlin; © 1996 Artists Rights Society (ARS), New York/VG Bild-Kunst, Bonn 12 (top)

Courtesy Berlinische Galerie, Landesmuseum für Moderne Kunst, Photographie und Architektur, Berlin 13 (top and bottom), 14, 42, 66, 90, 97 (left), 100, 106, 118, 143 (left), 176, 182, 193 (left and right), 196 (top), 197 (top); Photo Hermann Kiessling, Berlin: 19, 26, 162 (right), 167, 171; Photo Ilona Ripke, Berlin: 30, 54, 55, 59, 97 (right), 162 (left); Photo © Berlinische Galerie Archiv: 51 (top left), 56, 84 (source), 119 (source), 146, 186 (right), 187 (all), 188 (top and bottom), 189 (right), 190 (top and bottom), 191, 194, 195 (top left and right), 196 (bottom), 197 (bottom), 199, 202; Photo Christina Bolduan: 51 (bottom right), 195 (bottom right)

Courtesy Merrill C. Berman, Scarsdale, N.Y. 45, 53

Courtesy Reinhold Brown Gallery, New York 48

Courtesy Bundesministerium des Innern, Bonn 103

Courtesy Peter Carlberg, Hofheim 58; Photo Das Studio Torsten Hegner, Neu-Isenburg: 82, 142, 154, 179

Courtesy Castelli Gallery, New York; Photo © 1996 Robert Rauschenberg/Licensed by VAGA, New York 147

Courtesy Des Moines Art Center 38 (Photo Ray Andrews), 92

Photo © 1976 Dover Publications, Inc., New York; © 1996 Artists Rights Society (ARS), New York/ADAGP, Paris 71

Courtesy Barry Friedman Ltd., New York 124, 157

Courtesy Galerie Alvensleben, Munich; Photo © 1996 Richard Beer, Munich 52 (bottom left), 166

Courtesy Galerie Berinson, Berlin 12 (bottom), 35, 89, 120

Courtesy Galerie Michael Hasenclever, Munich; Photo Otto E. Nelson, New York 63

Courtesy Galerie Remmert und Barth, Düsseldorf 168, 170

Courtesy Galleria Nazionale d'Arte Moderna e Contemporanea, Rome; Photo Giuseppe Schiavinotto, Rome 96

Courtesy Germanisches Nationalmuseum, Nuremberg 9 (top and bottom), 16 (left and right), 51 (top right), 52 (top left), 52 (top right), 52 (bottom right), 102, 132 (all), 156, 175, 183 (right)

Photo Karlheinz Grünke, Hamburg 29, 31, 34, 44

Courtesy Hans-Joachim Hahn, Berlin; Photo Markus Hawlik, Berlin 183 (left)

Courtesy Hamburger Kunsthalle; Photo © Elke Walkford, Hamburg 39 (right), 125

Courtesy Harvard University Art Museums, Cambridge, Mass. 39 (left)

Photo Markus Hawlik, Berlin cover, 110

Courtesy Dr. Peter J. Heindlmeyer, Berlin; Photo Markus Hawlik, Berlin 169

Courtesy Herzog Anton Ulrich-Museum, Brunswick; Photo B. P. Keiser 95

Courtesy Institut für Auslandsbeziehungen, Stuttgart 28, 41 (right), 81, 84, 88, 94, 109, 117, 126, 127, 140, 143 (right), 153, 158, 159, 161, 164, 172, 173, 177, 180

Courtesy Institut für Zeitungsforschung der Stadt Dortmund 62, 68, 145; source images: 30, 34, 90, 93, 97, 98, 99, 100 (left and center), 102, 103, 104, 105 (left), 106, 107, 109, 113, 116, 117, 153 (left), 154, 159, 166

Courtesy Dakis Joanou, Athens 111

Courtesy Jean-Paul Kahn, Paris 101

Courtesy Kunsthalle Wien 8

Courtesy Kunsthaus Zürich 114

Courtesy Landesbank Berlin 17 (top and bottom); Photo Jens Neumann and Edgar Rodtmann: 18, 155, 163, 178, 181, 184

Courtesy Library of Congress, Washington, D.C. source images: 167, 171, 173, 175, 177, 178, 182, 183, 184

Courtesy Greil and Jenelle Marcus; Photo Ben Blackwell, Oakland 86

Courtesy The Mayor Gallery, London 43

Courtesy Modern Art Museum of Fort Worth 85

Photo Stefan Moses, Munich 6, 204–205

Courtesy H. Marc Moyens, Alexandria, Virginia 8

Courtesy Musée d'Unterlinden, Colmar; Photo O. Zimmermann 136

Courtesy Musée National d'Art Moderne, Centre Georges Pompidou, Paris 105

Courtesy Museum Folkwang, Essen 104

Courtesy Museum für Kunst und Gewerbe, Hamburg 137

Courtesy Museum of Fine Arts, Houston 108

Courtesy The Museum of Modern Art, New York 47, 83, 107

Courtesy The Museum of Modern Art/Film Still Archive, New York 69

Courtesy National Gallery of Art, Washington, D.C. 36

Courtesy National Gallery of Australia, Canberra 10, 115

Photo © Liselotte and Armin Orgel-Köhne, Berlin 148–149

Courtesy Guido Rossi 67

Courtesy Sprengel Museum Hannover 138

Courtesy Staatliche Kunsthalle Karlsruhe 113

Courtesy Staatliche Museen zu Berlin, Kupferstichkabinett 46, 123, 160; Photo Jörg P. Anders: 37, 41 (left), 98, 99

Courtesy Staatliche Museen zu Berlin, Bildarchiv Preußischer Kulturbesitz 189 (left); Nationalgalerie, Photo Jörg P. Anders: 25; Kunstbibliothek: 51 (bottom left), 57; source images: 35, 36, 37 (Photo Dietmar Katz), 100 (right), 153 (right), 176

Courtesy Staatsgalerie Stuttgart 112, 119

Courtesy Arturo Schwarz, Milan; Photo S.A.D.E. Archives, Milan 32, 33

Courtesy University of Iowa Museum of Art, Iowa City 11, 91 (Photo Mark Tade)

Courtesy Walker Art Center, Minneapolis; Photo Glenn Halvorson 87 (left and right), 116, 128, 156 (left), 165, 174

Courtesy Thomas Walther, New York 121, 122